How Designers Are Transforming Healthcare

Evonne Miller • Abbe Winter • Satyan Chari
Editors

How Designers Are Transforming Healthcare

Editors
Evonne Miller
QUT Design Lab, School of Design
Queensland University of Technology
Brisbane City, QLD, Australia

Abbe Winter
QUT Design Lab
Queensland University of Technology
Brisbane City, QLD, Australia

Satyan Chari
HEAL, QUT Design Lab
Queensland University of Technology
Brisbane City, QLD, Australia

ISBN 978-981-99-6810-7 ISBN 978-981-99-6811-4 (eBook)
https://doi.org/10.1007/978-981-99-6811-4

Queensland University of Technology

This Springer imprint is published by the registered company Springer Nature Singapore Pte Ltd.
The registered company address is: 152 Beach Road, #21-01/04 Gateway East, Singapore 189721, Singapore

Paper in this product is recyclable.

Design Dictionary

Design Mindset	A mindset is a way of being and thinking. Design mindsets are action-orientated, solution-focussed, positive, and imaginative—focussed on creating a desired, improved future.
Design Thinking	A creative, human-centred structured approach to complex problems, defined by six iterative steps: Empathise—Define—Ideate—Prototype—Test—Implement.
Design Doing	As Don Norman (2013) preaches, "We need more design doing"—design thinking is not magic and does not free us from actual design doing—creating and implementing change in collaborative partnerships.
Design Visioning	By nature, designers are futurists: we create ideas that do not yet exist. We use that ability to shape our collective imagination and to inspire optimistic, future-focussed dialogue about "what might be".
Design Prototyping	A prototype is the tangible representation of an actual idea. Design prototypes vary in their degrees of fidelity—the level of detail and functionality. Low-fidelity prototypes may be made from paper and cardboard, while high-fidelity prototypes are closer to the final version.
Participatory Human Centred Co-Design	Designing with, not for, people means participatory engagements, sharing power, prioritising relationships, and building capability—and such participatory partnerships often lead to breakthrough innovations (Fig. 1).

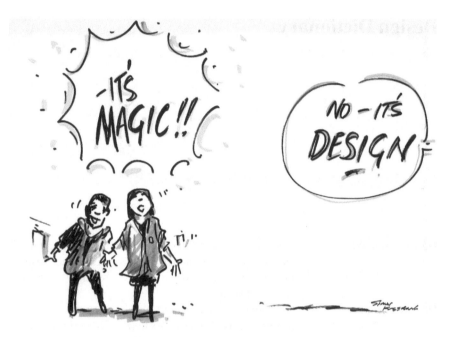

Fig. 1 It's magic …why design is an agent of transformation in healthcare

Acknowledgements

Many people have made this edited book possible. First, thank you to all the consumers who have engaged with us, so honestly and generously sharing their experiences, hopes, and expectations for the future of healthcare. We greatly appreciated your participation and candour. Second, we are immensely grateful for the engagement and support of the healthcare workforce at the Healthcare Improvement Unit at Clinical Excellence Queensland and the Hospitals and Health Services across Queensland Health who partnered on these projects—as you will see, we have been fortunate to work alongside exceedingly smart, creative, and committed people who share a passion to improve healthcare and an interest in design-led approaches. Fig. 1. and Fig. 2. outline our vision for this design-led approach, where we have partnered with clinicians and consumers in a journey of learning and transformative, collaborative change. We thank and acknowledge the Healthcare Improvement Unit at Clinical Excellence Queensland, for funding and supporting the Healthcare Excellence AcceLerator (HEAL), 2020–2023, a visionary act which made these design-led collaborations possible. Third, our gratitude goes to all the authors of this book, whose hard work and contributions have resulted in an exciting demonstration of the potential of design-led approaches in healthcare. Finally, we would like to acknowledge the Turrbal and Yugara people, the traditional owners of the lands in central Brisbane where much of this design-led research was conducted and this book was written. We pay respect to their elders' past, present, and emerging and extend that respect to other Australian Aboriginal and Torres Strait Islander and Indigenous people reading this.

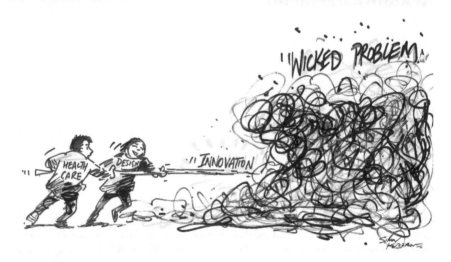

Fig. 2 Wicked problems facing healthcare, and how innovation is the result of designers, clinicians, and consumers collaborating

Contents

Part V Instigators

Part VI Practitioners

List of Figures

List of Tables

Changemakers: Designers in Healthcare

Evonne Miller and Abbe Winter

Across the globe, healthcare systems are under pressure: escalating costs, the increasing burden of chronic disease and more complex health conditions, ageing populations, systemic inequities in healthcare access and outcomes, workforce shortages, system fragmentation and the under-utilisation of primary care means that providing timely, efficient, and effective healthcare is increasingly challenging—especially during 'Covid times'. There is an urgent need for a fresh approach, for different thinking that improves health outcomes and ensures the sustainability of our health system.

This book argues for a design-led approach to transforming healthcare. Design is a method and mindset for creativity and innovation, simply defined by Herbert Simon as the "transformation of existing conditions into preferred ones" [1, p. 11]. As healthcare systems need continuous innovation, health is particularly suitable for the iterative, human-centred and interdisciplinary methods of design—where (1) challenges are reframed as opportunities for discovery and innovation, with (2) a focus on ongoing engagement, co-creating, testing, and refining implementable solutions, through (3) empathy, visual thinking, and rapid prototyping. Inherently optimistic, user-centred, and experiential, a design-led approach is a constructive new approach to healthcare innovation, and for creating transformative solutions with and for end-users: consumers and clinicians.

While a growing and diverse range of governments, industries, and organisations have engaged and applied the creative process and methods of design to identify opportunities, co-design problem-solve and foster innovation, surprisingly, to date, there are only a handful of documented examples of design-led innovation

E. Miller (✉)
QUT Design Lab, School of Design, Queensland University of Technology, Brisbane City, QLD, Australia
e-mail: e.miller@qut.edu.au

A. Winter
QUT Design Lab, Queensland University of Technology, Brisbane City, QLD, Australia
e-mail: a.winter@qut.edu.au

(specifically partnerships with professional designers) in healthcare [2–4]. This edited book addresses this knowledge gap, contributing to the emergent literature by outlining the origins, processes, and impact of a novel Australian initiative which connected healthcare professionals with designers to positively transform health-care—the Healthcare Excellence AcceLerator (HEAL).[1]

A collaboration hub, HEAL was designed to connect healthcare professionals with designers, who worked together using design approaches to transform think-ing, spaces, places, processes, and products, thus positively transforming healthcare and accelerating healthcare improvement efforts. As the diverse chapters in this book will reveal, these cross-disciplinary design-led industry-academic collabora-tions—from innovative approaches to telehealth, co-designing prototypes of child-friendly personal protective equipment to playful wayfinding murals on the walls and floors of a large children's hospital—have fostered true innovation, unlocking new ways of thinking, doing, innovating, improvising, and creating at the 'sharp end' of healthcare.

Before reflecting on these projects, their processes, and impacts, it is important to reflect on terminology and approaches. For several decades now, design thinking and human-centered co-design processes have been identified as critical to fostering creativity and innovation; the positive of this has been the amplification of user voices, especially in a healthcare context [5–7]. Figure 1 outlines the six key steps of the design thinking process, which are frequently deployed—by both

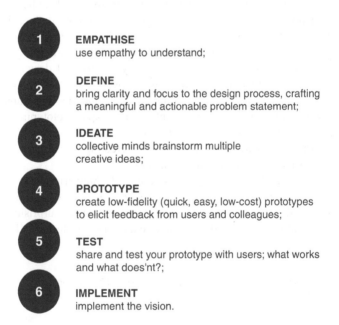

Fig. 1 The six iterative stages of the design-thinking process, adapted from d.school (creative commons 4.0)

[1]HEAL was a funded research collaboration, financially supported by Queensland Health's Healthcare Improvement Unit (HIU) at Clinical Excellence Queensland, from 2020–23.

professional designers and others—to create creative solutions to challenges. The unexpected negative of this raised awareness and acceptance of design methods, as Bason and Skibsted [8] explain below, is that the unique skillsets and mindset offered by professional designers is at times missed:

> However, the concept has increasingly been reduced to a simple set of methods and processes that anyone and principal can apply as a way to empathize with users, cocreate new ideas with others, and build prototypes of potential solutions. Design thinking has served to democratise the field of design in many ways professional designers had never imagined (and many are uncomfortable with). On a positive note, this has propelled an understanding of basic design concepts into C-Suites around the world. On a negative note, it risks projecting a limited and reductive image of what design not only is, but can be [8, p. 24].

What distinguishes our design-led approach in HEAL, therefore, is the active collaboration between designers, clinicians, and consumers; it is this unique collaboration—with its emphasis on co-design, design thinking, design doing, prototyping, and implementation—that is facilitating the innovative and transformative change needed in healthcare.

1 Why a Design-Led Approach Is Needed in Healthcare

Before describing the rationale, processes, and impact of HEAL's design-led approach, we must first acknowledge two key facts. Firstly, there is an urgent need for our healthcare system to change—to become more agile, responsive, and innovative. Healthcare systems across the globe are under immense pressure: costs are rising, health budgets are diminishing, and populations are ageing, with more chronic and complex health problems (diabetes, heart disease, obesity, drug use, mental illness), and growing care disparities for vulnerable and marginalized populations: Indigenous, culturally and linguistically diverse, LGBTQ+ communities, younger, older and low-income people, as well as those residing in regional, rural, and remote locations [9, 10]. At the same time, there is an under-utilisation of primary care combined with high levels of system fragmentation—and technology (specifically the possibility of virtual and integrated care) is still not being used to its full potential.

2 The Promise and Perils of Technology

We are currently living through the fourth industrial revolution: an extraordinary time of change and challenge, with the fusion and blurring of boundaries between the physical, digital, and biological worlds. Advances in artificial intelligence, robotics, the Internet of Things, 3D-printing and more are radically transforming the design, delivery, and experience of healthcare [11]. Healthcare technology trends often support patient engagement and empowerment (for example, wearable biometric devices and apps enable patients to track and monitor their own health), and the increasing uptake of such technologies will and is transforming healthcare.

Douglas Adams, author of the science-fiction series *The Hitchhiker's Guide to the Galaxy*, has outlined an interesting set of rules which describe our relationship to technology:

1. *Anything that is in the world when you're born is normal and ordinary and is just a natural part of the way the world works.*
2. *Anything that's invented between when you're fifteen and thirty-five is new and exciting and revolutionary and you can probably get a career in it.*
3. *Anything invented after you're thirty-five is against the natural order of things* [12, p. 95].

Adams' rules, while humorous, outline the human-technology interface challenge facing healthcare: we are on the precipice of massive, disruptive change, and educating and engaging clinicians, administrators, and consumers with such rapid technological advances will not be straightforward for, as Shaw and Chisholm [13] astutely have noted, complex health systems struggle to adapt to such disruptive innovations.

3 The Challenge of Changing Healthcare

Changing healthcare—which requires "spending money, diverting staff from their daily work, shifting deeply held cultural or professional norms, and taking risks" [14, p. 1]—is notoriously difficult. Critically, however, over the past two decades, healthcare improvement and knowledge translation efforts have moved away from simple linear 'cause and effect' narratives to the more nuanced complex adaptive systems approach, which recognises complexity, patterns, and interrelationships as the system develops, adapts, and changes in a constant, dynamic cycle of change. This complexity-informed systems thinking approach explicitly acknowledges that—for change to work—the people in the system need to be engaged and inspired to rethink existing practices; after all, as *Kramer* et al. [15] tellingly explained, there is no "systems change without organizational change and no organizational change without individual change" (p. 16.).

Thus, whilst healthcare has traditionally improved itself through (medical) evidence-based practice paradigms, in recent years, there has been the widespread adoption of improvement science [16], process engineering methodologies [17], knowledge translation frameworks [18], implementation science [19], and consumer-oriented clinical service innovation, actively engaging with consumers through design-thinking and experience-based co-design approaches [5]. A contemporary view, drawn from complexity science, is that previous improvement efforts have mistakenly attempted to address complex, interlinked, dynamic, and systemic issues with tools, thinking, and approaches that are best suited to mechanical or procedural problems. As Chari [20] explains:

Healthcare's preoccupation with statistical, process-driven and behavioural (incentive and punitive) strategies has failed to move the needle on safety or quality. Why? Because clinicians aren't 20th century factory workers, patients aren't motor cars and hospitals aren't assembly lines. Fundamentally, healthcare is a human sector—enmeshed within layers of social, technical and structural complexity. Performance, safety and risk are connected in such dynamic ways that simple improvement methods and conventional compliance measures have little chance of success (np).

Further, in situations where evidence is either limited or high-level and generalised, established approaches have failed to advance the capacity of large-scale systems to create novel, local solutions [21]. Traditional notions of reach and scale in health services research have tended to generalise approaches, and obscure the importance of creative, context-specific, adaptive solutions, which are vital to resolving evidence-based problems in practice [22, 23]. While there is no sole "magic bullet" to create a more adaptive, integrated, agile and innovative healthcare system, the chapters in this book argue that designers—with their creative design mindset and skills—could be the transformative change agents needed to accelerate health service innovation.

4 Designers as Agents of Change

Design is a diverse field, which encompasses a broad range of distinct disciplines including architecture, landscape architecture, interior design, industrial (product) design, interaction and digital design, visual communication, fashion design, and service design, as well as design management, strategy, and education. What unifies these diverse disciplines is how they think: regardless of their specialist disciplinary training, designers share an iterative design process and a unique approach to problem-solving that privileges visualisation and the processes of making.

Critically, as Herbert Simon [24] explains below, designers are agents of change: design is the practice of conceiving, creating, and planning *what does not yet exist* by creating and transforming environments, products, interfaces, services, processes, and systems.

Our task is not to predict the future; our task is to design a future for a sustainable and acceptable world, and then devote our efforts to bringing that future about. We are not observers of the future; we are actors who, whether we wish to or not, by our actions and our very existence, will determine the future's shape [24, p. 1].

Design offers powerful human-centered tools for innovation, as it focuses on making places, products, and services (and our interactions with them) more effective, efficient, and accessible. As Brown [25] explains, human-centered design involves an empathetic understanding of users (service providers and clients) and drives innovation in three stages:

- *Inspiration*—considering challenges or issues through design thinking processes
- *Ideation*—the process of idea generation and testing

- *Implementation*—setting out the path to market or sustainable change in the organisation.

Healthcare has been early to recognise the potential of design methods as a tool for collaboration and innovation, with *elements* of design now commonplace in health. The human-centered design approaches of design thinking and experience-based co-design (EBCD) have been used to engage diverse stakeholders in empathising, ideating, problem-solving, co-creating, innovating, prototyping, envisioning, and iterating. While these are the foundational principles and processes of design practice, often these processes are led by enthusiastic non-designers, who tend to focus more on the first part of the design process (inspiration and ideation) than fully applying the power of design in tangible outcomes and implementation.

This means that, to date, design has not yet shown its *full impact* in healthcare. As Jones [26] notes in his book *Designing for Care*, designers have not yet been "given the latitude to practice creatively and meaningfully in healthcare institutions … as valuable contributing members of the care team" (p. xviii). This is a missed opportunity that HEAL was developed to address—with the following chapters outlining the processes, strategies, tools, and outcomes. Critically, while there are a handful of books on using design-led thinking to improve healthcare [see 4, 27], this book is unique in presenting 19 case studies of people- (rather than technology) led design projects in healthcare, integrating the description of the design process with the actual situation it was used for, with reflections on practice from both the designers and the clinicians, all within the overall umbrella of a single guiding initiative.

As each chapter demonstrates, a design-led approach offers a fresh lens to the wicked challenges facing healthcare. Our lens is always human-centered; that said, we agree with the recent proposition from Bason and Skibsted [8] which calls for a more expansive outlook on problem-solving and more disruptive leaps of imagination to create the future we desire. Arguing that we need to go beyond human-centeredness, Bason and Skibsted [8] call for more 'expansive thinking' across six 'expansion domains' of time, proximity, value, life, dimensions, and sectors. Expansive thinking emphasises the importance of:

> imagining alternative futures and going beyond the safe, stale, and culturally determined mindsets that typically take root in existing systems, sectors, and organisations. It means innovating on a more systematic level, figuring out what people, communities, and ecosystems need as a whole, and testing, improving, and scaling new approaches. Expansive thinking means challenging assumptions and preventing intellectual inertia [8, p. 24].

We concur. While not explicitly drawing on Bason and Skibsted's recent expansion thinking framework, a defining feature of HEAL projects is working creatively and collaboratively to reimagine current practice, explore and test potential possibilities, leverage the potential of technology, and challenge assumptions. Additionally, alongside a strong awareness of co-design, design thinking and systems thinking, HEAL projects frequently encompass a futures-thinking perspective, with our co-design and design-thinking approaches often stepping beyond the typical five or six

step design thinking structure (empathize, define, ideate, prototype, test, implement) to include an explicit futures lens.

Futures thinking and foresight methods emphasize processes of forecasting, imagining, planning, and building probable, preferable, and possible futures; the goal is to take action to create the futures we prefer while avoiding the undesired futures. Futurist Joseph Voros [28] developed a 'futures cone' which defines 7 types of alternative futures:

- **potential** (as future is undetermined, not inevitable, everything is a potential future)
- **probable** (based on current trends/quantitative data, likely to happen)
- **preferable** (based on our values, should and want it to happen)
- **projected** (the default, current business as usual)
- **plausible** (could happen, based on current understanding of how world works)
- **possible** (not currently, but might happen)
- **preposterous** (improbable, impossible, will never happen).

In imagining all these different potential futures, Voros [28] also suggests adding 'wildcards' which are sometime also termed black swan events: an unpredictable event that has severe consequences. As Taleb [29] defined them, black swan events must (1) *be an outlier; (2) must have a major impact; and (3) must be declared predictable in hindsight). The value of engaging with the futures cone, 'wildcards' and 'black swan' events is that it provides a framework, process, and place for thinking explicitly about 'the future'.*

A futures perspective is grounded in the belief that the future (purposely plural until one becomes the present) can be influenced, with long-term thinking encouraged as alternative futures and pathways or solutions for changes are collaboratively explored. As the UK's innovation agency NESTA explains, this participatory futures approach is designed to "draw out knowledge and ideas about how the future could be" and "help people diagnose change and develop collective images of the futures they want" [30, p. 7]. Dunne and Raby [31], for example, have intentionally integrated a futures thinking lens into design practice with their concepts of speculative and critical design, which deploys futuristic and alternative scenarios (design fiction) to challenge assumptions and ask 'how the world could be'. That was the aim of many of the projects described in this book, which as well as developing finalised design outcomes and prototypes, also provided the space, time and structure for clinicians and consumers to reflect on current and future healthcare experience, and how it should and could be creatively redesigned.

5 How to Read this Book

There is no one right way to read this book, which is divided into six unequally sized categories covering four distinct design approaches of design thinking, design doing, prototyping, and implementing. Projects have been grouped into six diverse

categories—*Placemakers, Makers, Advocates, Strategists, Instigators, Practitioners*—which best describes their primary focus. While you can read the book from start to end, you may also choose to focus on a specific topic and read chapters in that section as a set of stand-alone narratives. Each chapter covers an important issue, with the relevance varying depending on your interests. In the overview that follows, we describe the purpose of each section and briefly summarise the main contributions of each chapter.

The book is purposely written in a conversational, informal and practical style, so regardless of your own disciplinary background, the information is accessible. However, we recognise that even within the common language of change and transformation there are disciplinary differences between designers' and clinicians' use and meaning of words, so we have tried to ensure that any technical terms have a simple explanation, making this book readable for both designers who are thinking of working within healthcare and clinicians and allied health workers who are thinking that they might need the help of a designer to unpick a wicked problem in their healthcare practice.

At the outset, it is important to note that the projects described here largely occurred during 2020 and 2021, at the height of the Covid-19 global pandemic. As you can imagine, hospitals were often closed to visitors, focused on pandemic preparation and response. Australia was fortunate to not have a large rate of infection, in part because of its physical location as an island a long way from most of the rest of the world, and in part because many of its states took swift action to close their borders and impose lockdowns on the populace. This meant that, although for many it moved to home, business continued largely as usual for the state of Queensland— so long as we followed public health protocols, such as physical distancing, mask wearing, and good hand hygiene. Thus, the collaborations described in this book proceeded in a unique time and place, and as a mix of remote and in-person work. In addition, almost all of the projects described here came directly from HEAL, with the exception of two unique contexts: the explanation of how prisoners access healthcare in Chapter "Agency and Access: Redesigning the Prison Health Care Request Process", and clinicians' experiences of palliative care in Chapter "Co-designing the Palliative Care Hospital Experience with Clinicians, Patients, and Families: Reflections from a Co-design Workshop with Clinicians", where design academics from the HEAL team deployed design tools in these different settings.

The book is written to make it easy for you to take these design-led principles and find ways to apply them in your own workplace, whether that is a hospital or clinic, an office, a university, or somewhere else. We, of course, recommend collaborating with design professionals, with this book primarily written for two key audiences: (1) the healthcare clinician or administrator who wishes to experiment with a design-led approach in their workplace, and (2) designers who are, or wish to be, working in healthcare. Brown has observed that design thinking often involves "a great deal of perspiration" [25, p. 2], and we will see that in each of these reflective, practice-based chapters which deployed a wide range of design methods in healthcare—during the global Covid-19 pandemic. The chapters are frequently

co-authored by designers and clinicians, sharing the origins and intentions of each project, with a focus on what was planned and intended, what actually happened, and reflections on how it could have worked better.

6 Part 1: Placemakers

All HEAL projects were guided by a participatory human-centred co-design approach, which acknowledges that health service users (consumers and staff) are experts of their own lived experience, and harnessing this expertise, knowledge and ideas is critical to design-led innovation. Engagement and participation, and related concepts of co- production, co-creation, co-design, and co-innovation is the "new Zeitgeist—the spirit of our times in quality improvement" [6, p. 247], for, as Don Berwick [32] wisely suggested nearly two decades ago, healthcare "workers and leaders can often best find the gaps that matter by listening very carefully to the people they serve: patients and families".

Participatory human-centered co-design methods emphasize first- hand investigation, understanding who you are designing for—and designing in partnership with them—alongside an iterative, experimental approach of collecting data, making discoveries, and organizing ideas. Critically, the process emphasizes discovering the right problem to solve, by investing in both problem-finding and problem-solving to understand—at both a human and systems-level—where and how we might have the most leverage. In this first section, we start with four thought-provoking chapters on architectural and visual design responses to place-based challenges in healthcare.

In Chapter "Parrot Murals and Feather Floors: Co-designing playful wayfinding in the Queensland Children's Hospital", Seevinck and colleagues describe their experience designing and implementing playful placemaking and wayfinding, where previously monochromatic floors and walls were replaced by charismatic illustrations of parrots and natural landscapes around Queensland to provide a uniquely playful wayfinding design strategy, as depicted in Fig. 2. This chapter discusses the collaborative and research-led creative processes, focusing the significant turning points, the engagement process (between the academic design and research team, creative health and visual design staff at the hospital, and the wider hospital community and stakeholders), design outcomes, and the hospital staff and client reactions to the design.

Chapter "'It Takes a Village': The Power of Conceptual Framing in the Participatory Redesign of Family-Centred Care in a Paediatric Intensive Care Unit" is the first of three chapters giving different perspectives on the Paediatric Intensive Care Unit's (PICU) Partnership Project at the Queensland Children's Hospital (QCH). In it, interior designer Wright and colleagues describe how current spatial layout, visuals and wayfinding did not support easy navigation for parents to rooms, nor any understanding about the spaces available for parents to use for self-care. The location and lack of storage (leading to clutter) in rooms and corridors makes it

Fig. 2 Playful parrots on
the walls of Queensland
Children's Hospital. Photo
credit: Sarah Osborn

more difficult for parents to find anything, including each other. There was a need for storage solutions for parents' personal belongings, and to better locate equipment and supplies in corridors and rooms. The chapter describes the innovative engagement and storytelling strategies, which provided insight into how the design of the space supports (or not) social and emotional needs, as well as an interior design and wayfinding concept proposal.

With the aim of creating a more therapeutic (comfortable, effective, meaningful, and supportive) physical, social, and digital environment for parents and families (and the staff caring for them) at a time of crisis, the PICU Partnership projects focused on how the spatial environment and visual communication could improve the delivery of family-centred care.

Chapter "Designing Hospital Emergency Departments for a Post Pandemic World: The Value of a BaSE Mindset—Biophilia (Natural), Salutogenesis (Healthy), and Eudaimonia (Contentment) in Architectural Design", by Burton and colleagues, focuses on how the Emergency Room Exits and Entrances might be redesigned to develop better flow for vulnerable patients (elderly, mentally ill, children, neurotypically diverse, indigenous people) and support staff in delivering quality healthcare. Clinicians described how the design and layout of the waiting room impacted the patient experience—a well-placed triage desk, a children's play area, screen for 'health propaganda', a taxi phone, a phone charger and multiple port adaptors and the addition of a waiting room nurse to improve communication with the waiting public were all initiatives they felt improved the ED experience. Wayfinding and placemaking was often a challenge, so Chapter "Designing Hospital Emergency Departments for a Post Pandemic World: The Value of a BaSE Mindset—Biophilia (Natural), Salutogenesis (Healthy), and Eudaimonia (Contentment) in Architectural Design" shares some solutions in terms of schematics of architectural design solutions that create flexibility and one-way flows.

Finally, Chapter "Transforming the NICU Environment for Parent and Staff Wellbeing: A Holistic & Transdisciplinary Supportive Design Approach" by Johnstone and colleagues, rounds out the Placemaking section of the book by describing spatial and other critical space-related issues related to the Neonatal

Intensive Care Unit (NICU) at the Royal Brisbane and Women's Hospital (RBWH). The chapter describes the transdisciplinary and holistic design approach taken to develop solutions with benefits for both staff and parents in the neonatal environment.

7 Part 2: Makers

This section turns to design prototyping projects, where the goal is to develop a real-world model or prototype to use for iterating improvements to a design concept. Prototyping is making a preliminary model of something, from which other forms or products are developed. It is a representation of a design idea, used to generate learnings for the final development or build. Prototyping is action oriented, with the intention of creating a tangible product. It moves people beyond talking into active creating and design doing. Typically, prototypes are built in iterative processes, where the lessons learned from one iteration informs the build of the next version. Prototypes are usually cheap (with a minimal investment of money or resources), quick (with a minimal investment of time), and generative (with the focus on learning). The design question for prototyping is always: what can be learned from this model?

In Chapter "Prototyping for Healthcare Innovation", Chamorro-Koc describes her prototyping process, through the particular lens of the importance of prototyping as a step in the design research process. Particularly, she reflects on two projects: one on the creation of fun and playful facial PPE (Personal Protective Equipment) for paediatric wards to use, and the other on the development of a prototype interactive device for assessing children's pain through physical readings of bodily functions, also for use in the context of a paediatric ward. Figure 3 shows one of the PPE prototypes—Sunny.

Chapters "Graphics and Icons for Healthcare with a Focus on Cultural Appropriateness, Diversity, and Inclusion" and "Agency and Access: Redesigning the Prison Health Care Request Process" document two innovative visual design in healthcare projects. In Chapter "Graphics and Icons for Healthcare with a Focus on Cultural Appropriateness, Diversity, and Inclusion", Scharoun and colleagues share the process of re-designing a graphic poster that shows people how to correctly collect urine—thus reducing contamination rates. Feedback on an existing poster—designed for the Emergency Department—was that it was overly graphic, especially for use with children and in different cultural contexts, and so the design team redesigned and simplifying the poster, using a gestural drawing approach, as well as reduced the number of steps and combining what had been separate posters for men and women into the one poster.

In Chapter "Agency and Access: Redesigning the Prison Health Care Request Process", Scharoun and colleagues describe how visual design might improve prisoners' access to healthcare. Globally, 10.74 million people are currently in prison (either as pre-trial detainees/remand prisoners or convicted and sentenced), with rehabilitation a critical component of the criminal justice system. In Queensland,

Fig. 3 The "sunny" child-friendly PPE prototype

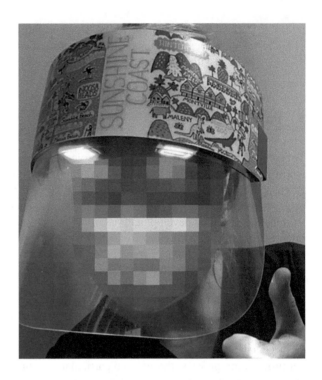

prisoners currently access non-emergency health access via a paper-based form, writing in their health concern. Prisoners generally have limited literacy, yet this process is reliant on prisoners being able to convey key information about their health, in writing, which health staff then use to determine when they should be seen (a triaging process). Confidentiality issues also arise if prisoners request assistance to complete the form. Chapter "Agency and Access: Redesigning the Prison Health Care Request Process" describes co-design activities with prisoners and staff, to reimagine the entire heath access process, as well as how the form was redesigned with icons and pictograms, to provide access to those with low literacy levels and be more suitable for future digital applications as part of a screen-based icon-system.

8 Part 3: Advocates

The third section showcases four hands-on projects we have grouped as *Advocates*— the co-creation and enactment of design-led change initiatives through working with people who are advocating on behalf of others. The first three chapters focus on projects that delivered outcomes that altered the cultural features of the hospital space in some way—whether through use of services or underlying principles about workflow. Two of those chapters take a broader view of the purpose of design and align it to issues of equity by using animated videos. The final chapter in this section

moves us into the territory of end-of-life and the advocacy and decisions that can be supported by good design for our final healthcare experience.

In Chapter "In a Heartbeat: Animation as a Tool for Improving Cultural Safety in Hospitals", Taboada and colleagues reflect on the process of developing an animated video that could be used in Cultural Safety training with clinicians. In Australian, First Nations persons, as well as patients from cultures outside the dominant one, often feel culturally unsafe in addition to the usual anxieties about going to hospital. The animated video is designed to increase clinicians' awareness of the need for Cultural Awareness and Cultural Sensitivity, in order to enable consumers to feel Culturally Safe in hospital.

Chapter "Co-creating Virtual Care for Chronic Disease" describes the application of human-centered design methods in the development of the Virtual Outpatient Integration for Chronic Disease (VOICeD) project. VOICeD is a telehealth service designed to meet the needs of people with diabetes, by allowing them to see *multiple* healthcare practitioners in *one* virtual appointment. Through a series of experience-design journey mapping sessions, a participatory design workshop, and user testing, design methods were used to foreground the patient experience, streamlining, and humanising the transition to a digital platform.

In Chapter "Improving Interpreter Service Uptake and Access to *Just* Healthcare for CALD consumers: Reflections from Clinicians and Designers on Animation and Experience-Based Co-design (EBCD)", Rieger and colleagues address the under-utilisation of interpreter services by customers. After data reviews and mapping clinical incidents, the team were able to use the lived experience of clinicians in combination with the first-hand insights gained from their data collection and the design skills within the team to develop an innovative, animated video response to address the issue, and enable greater access to healthcare for all.

Chapter "Co-designing the Palliative Care Hospital Experience with Clinicians, Patients, and Families: Reflections from a Co-design Workshop with Clinicians", by Miller and colleagues, shifts our attention to a healthcare experience that most are unprepared for until it arrives—the palliative care experience at the end-of-life. Focusing on activities and staff perspectives from a co-design workshop on redesigning the palliative care experience, the chapter describes the collection of exceptional moments, the use of personas and empathy mapping, brainstorming of wild ideas to disrupt the hospital system, and then unpacking more pragmatic barriers to their implementation, before brainstorming new solutions and prototyping a preferred idea.

9 Part 4: Strategists

In this chapter, we outline how designers can be strategists, enabling clinicians and consumers to reimagine the future, and co-design how the experience and delivery of healthcare could be positively transformed. The approaches outlined in these projects are designed to "simulate our imaginations and expand the range of

decision-making options available to us" [8, p. 41], and often use personas and future-focussed scenario-based speculative design activities in this process. By nature, designers are futurists: creating ideas that do not yet exist. Design visioning activities provides teams with the time and space to have focussed, reflective, and meaningful discussions around the future—to see new possibilities and think bigger about the impact of changing technologies, processes, and cultures, through optimistic future-focussed dialogue and storytelling about "what might be".

While many of the projects described in this book required months of extended engagement, Chapter "Empathy in Action: A Rapid Design Thinking Sprint for Paediatric Pain—Perspective-Storming, Pain Points, and the Power of Personas" describes a different approach. Miller outlines the process, tools, and value for a rapid co-design sprint, held during the Queensland's Children's Hospital 2020 Ideas Festival. While design "sprints" are normally 3–5 days in length, enabling a deep dive, with creative and strategic thinking about issues, priorities, and responses, this event was much shorter. The aim of this rapid one-hour co-design sprint was to help clinical stakeholders understand, brainstorm, and design better ways to achieve optimal procedural care, reducing procedural pain (short-lived acute pain associated with medical investigations and treatments, e.g., blood tests, immunisations, IVs/ Port access, dressing removals/changes, nasogastric tube insertions) for children and youth. A critique of design thinking is that it simply takes too long: this chapter approach shows the value of a condensed version, to introduce multiple stakeholders to the design-led innovation process.

Chapter "Asking the Right Questions: Cancer Wellness and Stroke Care", by student designer Jessica Cheers, focuses on the importance of asking the right questions when designing new service delivery models, using examples from two projects. In the cancer wellness project, designing an authoritative evidence-based virtual home for wellness information, programs, and services for one large Brisbane hospital involved four key phases: Mapping, Visualising, Co-Designing and Evaluating, with a focus on understanding how current and emerging needs of end-users (people with cancer and patients at the hospital) would be met through an online offering.

The second case, on stroke care, reflects on how, after four virtual and in-person human-centered co-design workshops with clinicians across Queensland, Cheers created communication tools highlighting the complexity of stroke care and identifying areas where variation exists. Three different infographics (using the persona of Jenny who had suffered an ischemic stroke and required an endovascular clot retrieval) and seven patient journey maps were developed, showing the difference in care and the timeline of delivery depending upon where our persona—Jenny—had her stroke and which hospital she was transferred to. Across the state, more than a seven-hour difference in initial treatment time for the endovascular clot removal was described in the patient journey maps, depending upon the referring and receiving sites for treatment.

Chapter "The Art of Transformation: Enabling Organisational Change in Healthcare Through Design Thinking, Appreciative Inquiry, and Creative Arts-Based Visual Storytelling", by Miller, Johnstone, and Winter, continues the focus on

tools for engagement—but this time, with a purposeful focus on the value of a positive psychology-inspired appreciative inquiry approach for communicating change. The authors illustrate the value of innovative visual methods, with participants drawing and sharing a moment of "exceptional practice" (when they were engaged, excited, and proud of their work) and then creating a storyboard of healthcare through the medium of a comic. Clinicians, consumers, and their families were also asked to photograph their rehab experience and share their stories of learning to walk, eat and speak again, with this chapter highlighting the value of arts-based methods and design storytelling in triggering meaningful dialogue between clinicians and consumers.

Chapter "Thinking Differently: Six Principles for Crafting Rapid Co-design and Design Thinking Sprints as 'Transformative Learning Experiences in Healthcare'", by Miller, rounds out this section and provides six principles for creating transformative experiences using co-design and design thinking sprints. Using reflective learning from the more-than-30 rapid co-design and design thinking workshops that she has run as part of the broader HEAL project over the past 4 years, Miller explains what transformative learning experiences in healthcare can look like, and provides detailed guidance through six key principles for those wishing to develop a healthcare design sprint of their own.

10 Part 5: Instigators

This section takes a future-view of the change that needs to happen in healthcare, turning to future-focussed scenario-based speculative design activities that engage consumers, clinicians, and policymakers. By nature, designers are futurists: creating ideas that do not yet exist. Design visioning activities provides teams with the time and space to have focussed, reflective, and meaningful discussions around the future—to see new possibilities and think bigger about the impact of changing technologies, processes, and cultures, through optimistic future-focussed dialogue and storytelling about "what might be".

The three chapters in this section describe projects that helped clinicians and consumers conceptualise healthcare possibilities in new ways, using a hand-on user-centred design thinking framework as a problem-solving tool to spark creative innovation. Best conceptualized as three processes—(1) understand, (2) explore, and (3) materialize, the popular Hasso-Plattner Institute of Design at Stanford (d.school) model of design thinking breaks the process down into six iterative stages, as depicted earlier in Fig. 1 [33].

In Chapter "Bringing the University to the Hospital: QUT Design Internships at the Queensland Children's' Hospital Paediatric Intensive Care Unit (PICU)", the second of the three PICU Partnership Project chapters, Tyurina and colleagues share how she set up a WIL (Work-Integrated Learning) unit project to assist with the development of visual communication and interactive design collateral to support the co-design of a more healing environment for PICU families and staff scaffolded

by the six-step design thinking model. This specifically related to parent/staff engagement and storytelling activities to inform and activate and re-imagine key areas of shared spaces, as well as concepts for more long- term strategies for communication to parents and families in PICU and post-discharge, for example materials, posters, flyers, data visualisations and infographics.

Chapters "Exploring Clinical Healthcare Challenges and Solutions Through a Design Thinking Education Program for Senior Health Professionals" and "Co-designing Design Thinking Workshops: From Observations to Quality Improvement Insights for Healthcare Innovation" juxtapose this student-led approach by describing the process of introducing design thinking to two different cohorts of healthcare stakeholders. In Chapter "Exploring Clinical Healthcare Challenges and Solutions Through a Design Thinking Education Program for Senior Health Professionals", Matthews and Wright provide a perspective on training a larger and more diverse group of clinicians, and describe two iterations of a design thinking workshop developed to introduce senior health professionals and program administrators to the ways that they could use co-design principles in their everyday work. In contrast, in Chapter "Co-designing Design Thinking Workshops: From Observations to Quality Improvement Insights for Healthcare Innovation", Chamorro-Koc and colleagues describe the way that she and her team upskilled the Clinical Services Development Service within Queensland Health's Metro North Hospital and Health Service, giving them hands-on experience with a unique observation strategy and a co-design workshop protocol that they could then use for their future staff development offerings.

11 Part 6: Practitioners

This final section concludes the book by taking a moment to reflect on the HEAL project's processes thus far, before looking to the future and taking a future-view of the change that needs to happen in healthcare. Chapter "NICU Mum to PICU Researcher: A Reflection on Place, People, and the Power of Shared Experience" is the final of the three chapters based on the PICU Partnership Project, and is a personal reflection from a team member whose own infant daughter spent time in a PICU. Ness Wilson, who paused her Master's degree to engage as the HDR (Higher Degree Research Intern) on this project, reflects on her experience, and how this deep empathy impacted the design process and her development of the framing for the final project delivery, as PICU Care, PICU Connect, and PICU Comfort.

The final chapter in this volume, by Chari, focuses on the macroscopic effects of the HEAL initiative and specifically how, through the medium of tangible design innovation, the HEAL initiative has shifted mindsets, broken down silos, sparked creativity, and seeded collaborations in ways that are enhancing the conditions for future 'designability' within our health system. In essence, HEAL is catalysing a fundamental transformation in healthcare so that it is less resistant to redesign and more conducive to innovation. Chari reflects on the importance of these virtuous

cycles in creating and scaling generative change within complex systems like healthcare and how working with designers will be even more critical in coming decades.

Healthcare is an enormously complex system, which is very resistant to change. However, as the chapters in this edited collection show, engaging with design and designers is a novel and promising strategy for tackling the ill-defined, complex, and wicked problems facing healthcare, providing a novel, action-oriented way of facing complexity while systematically conceiving, developing, and driving forward new practices for undertaking large-scale transformation. Over a decade ago now, sociologist Norman K. Denzin challenged researchers to "trigger a discourse that troubles and positively changes the world" [34, p. 10]. That is the aim of the chapters in this edited collection, which collectively offer new thinking and techniques to transform healthcare—*by design, in partnership with designers.*

References

1. Simon HA (1996) The sciences of the artificial, 3rd edn. MIT Press
2. Jones P (2018) Contexts of co-creation: designing with system stakeholders. In: Systemic design: Theory, methods, and practice. Springer, Japan, pp 3–52
3. Ku B, Lupton E (2020) Health design thinking: creating products and services for better health. MIT Press
4. Nusem E, Straker K, Wrigley C (2020) Design innovation for health and medicine. Palgrave Macmillan
5. Bate P, Robert G (2007) Bringing user experience to healthcare improvement: the concepts, methods and practices of experience-based design. Radcliffe Publishing
6. Palmer VJ, Weavell W, Callander R, Piper D, Richard L, Maher L et al (2019) The participatory zeitgeist: an explanatory theoretical model of change in an era of coproduction and codesign in healthcare improvement. Med Humanit 45(3):247–257
7. McKercher KA (2020) Beyond sticky notes: doing co-design for real–mindsets, methods and movements. Beyond Sticky Notes
8. Bason C, Skibsted JM (2022) Expand: stretching the future by design. BenBella Books
9. Anell A (2005) Swedish healthcare under pressure. Health Econ 14(S1):S237–SS54
10. Hollnagel E, Braithwaite J, Wears RL (2018) Delivering resilient health care. Taylor & Francis
11. Miller E, Polson D (2019) Apps, avatars, and robots: the future of mental healthcare. Issues Ment Health Nurs 40(3):208–214
12. Adams D. The salmon of doubt: hitchhiking the universe one last time: harmony; 2002
13. Shaw B, Chisholm O (2020) Creeping through the backdoor: disruption in medicine and health. Front Pharmacol 11:818
14. Greenhalgh T, Papoutsi C (2019) Spreading and scaling up innovation and improvement. BMJ:365
15. Kania J, Kramer M, Senge P (2018) The water of systems change. FSG, Reimagining Social.
16. Eccles M, Mittman B (2006) Welcome to implementation science. Implementation Science BioMed Central 1:1
17. Kopach-Konrad R, Lawley M, Criswell M, Hasan I, Chakraborty S, Pekny J et al (2007) Applying systems engineering principles in improving health care delivery. J Gen Intern Med 22:431–437
18. Wensing M, Grol R (2019) Knowledge translation in health: how implementation science could contribute more. BMC Med 17(1):1–6

19. Braithwaite J, Churruca K, Long JC, Ellis LA, Herkes J (2018) When complexity science meets implementation science: a theoretical and empirical analysis of systems change. BMC Med 16:1–14
20. Chari S (2023) The case for innovation. Nuansys Healthcare. [Available from: https://www.nuansys.com/about-us
21. Plsek P (2003) Complexity and the adoption of innovation in health care. Accelerating quality improvement in health care: strategies to accelerate the diffusion of evidence-based innovations. In: Management foundation and National Committee for quality in health care. National Institute for Healthcare, Washington, DC
22. Braithwaite J (2018) Changing how we think about healthcare improvement. BMJ:361
23. Greenhalgh T, Wherton J, Papoutsi C, Lynch J, Hughes G, Hinder S et al (2017) Beyond adoption: a new framework for theorizing and evaluating nonadoption, abandonment, and challenges to the scale-up, spread, and sustainability of health and care technologies. J Med Internet Res 19(11):e8775
24. Simon HA (2000) Forecasting the future or shaping it? (Complex Information Processing Working Paper No 550) [Internet]. Available from: https://www.cs.cmu.edu/~mmv/SimonForecasting.pdf
25. Brown T (2008) Design thinking. Harv Bus Rev 86(6):84–92, 141
26. Jones P. Design for care: innovating healthcare experience: Rosenfeld Media; 2013
27. Ku B, Lupton E (2022) Health design thinking: creating products and services for better health, Cooper Hewitt
28. Voros J (2017) Big history and anticipation: using big history as a framework for global foresight. In: Handbook of anticipation: Theoretical and applied aspects of the use of future in decision making, pp 1–40
29. Taleb N (2009) The black swan: the impact of the highly improbable. Penguin Books
30. Ramos J, Sweeney JA, Peach K, Smith L. Our futures: by the people, for the people. 2019
31. Dunne A, Raby F (2013) Speculative everything: design, fiction, and social dreaming. MIT press
32. Berwick DM (2003) Improvement, trust, and the healthcare workforce. BMJ Quality & Safety 12(6):448–452
33. Stanford University Hasso Plattner Institute of Design (2018) The design thinking bootleg. Available from: https://dschool.stanford.edu/resources/design-thinking-bootleg
34. Denzin NK (2010) The qualitative manifesto: a call to arms. Routledge

Professor Evonne Miller is Co-Director of the HEAL (Healthcare Excellence AcceLerator) initiative and Director of the QUT Design Lab. Professor of Design Psychology at Queensland University of Technology, Evonne is a leading voice on the value of arts and design-led innovation in healthcare transformation, bringing a collaborative, pragmatic, and fresh interdisciplinary approach to problem solving. She is the author, co-author, or editor of 4 books, exploring how we can create places that foster planetary and human health.

Dr Abbe Winter is a results-driven writing specialist, collaborative mentor, and independent researcher, skilled in the analysis of words and data for user needs. Abbe is a researcher trainer, leader, and mentor, with over 20 years' experience in quality assurance, and change and project management. While her PhD focused on what helps workers in higher education cope with large-scale organisational change, and she was part of the small team that created and developed the concept of academagogy (the scholarly leadership of learning), her more recent research has focussed upon professional identity, developing writing skills, and reflective practice.

Part I
Placemakers

From redesigning the emergency department and paediatric intensive care spaces, to playful navigation in the children's hospital, this section illustrates the value of thoughtful, intentional architectural, and the importance of placemaking. As the quote from Christopher Day below reminds us, architecture is more than the appearance of buildings: it is how they are experienced as places to be in—the spirit, the multi-sensory ambience and spatial experience all combine so that, at their best, the architectural design supports and enhances the user experience. Fig. 1 outlines the power of HEAL's 'design doing' process - moving from collaborative co-design and design thinking processes to the creation of change, of practical solutions and tangible outcomes. The projects in this section remind us that, with intention, we can intentionally re-design healthcare spaces so that they better support end-users: consumers and clinicians. As Day explains, the design of buildings, spaces and places matters:

"Architects tend to think architecture matters. Not everyone does. To many people, buildings are expensive, but not very interesting. It's what goes on *inside* them that matters. The argument continues that it's better to have a good teacher (or craftsperson, parent, designer, manager etc) in an ugly shed, barrack, pre-fab, tower-block, flat etc., than a poor one in a beautiful room. But few of us are exceptionally good or exceptionally bad; we're middling, so we need support" [1, p. 1].

Fig. 1 Design doing. (Credit: Simon Kneebone)

Reference

1. Day C (2014) Places of the soul: architecture and environmental design as healing art. Routledge, New York

Parrot Murals and Feather Floors: Co-designing playful wayfinding in the Queensland Children's Hospital

Jennifer Seevinck, Evonne Miller, Kirsten Baade, Gillian Ridsdale, Lynne Seear, and Matthew Douglas

With their intricate layouts, numerous departments, units, and floors, hospital environments can be challenging to navigate—especially for visitors, who are already dealing with illness, injury, and/or emotional stress, and often find themselves "getting lost". Ineffective wayfinding in hospitals can result in missed appointments, frustration, and stress for patients and their families, as well as reduced productivity for hospital staff who provide directions [1, 2]. This chapter outlines the origins, processes, learnings, and impacts of a project designed specifically to improve the hospital wayfinding experience at Queensland Children's Hospital (QCH), a specialised 389 bed paediatric hospital in Brisbane, Australia that provides tertiary and quaternary-level care for the state's sickest and most seriously injured children.

Completed in 2014, the multi-award winning twelve-level 95,000m^2 QCH was designed with two generous atriums, numerous double-height spaces, and a series of roof terraces featuring public and private gardens, multiple playgrounds and green spaces, and a signature green sloping roof. Conceptualised around a 'living tree' nature-inspired design, the two atriums stand like two distinguished tree trunks, featuring a network of plant-inspired cladding, wildlife-themed artworks,

J. Seevinck (✉) · K. Baade · G. Ridsdale
QUT, Brisbane, QLD, Australia
e-mail: jennifer.seevinck@qut.edu.au; k.baird@hdr.qut.edu.au; g.ridsdale@qut.edu.au

E. Miller
QUT Design Lab, School of Design, Queensland University of Technology, Brisbane City, QLD, Australia
e-mail: e.miller@qut.edu.au

L. Seear · M. Douglas
Queensland Health, Brisbane, QLD, Australia
e-mail: Lynne.Seear@health.qld.gov.au; Matthew.Douglas@health.qld.gov.au

23

and double-height trunks and branches to assist wayfinding, with several large Eclectus parrot sculptures perched up through five floors. Despite design thematics intended to assist with wayfinding, the hospital reported that visitors could still get a little lost navigating to the non-clinical spaces that comprised the Entertainment Precinct on Level 6.

The Entertainment Precinct is co-located with several clinical spaces, including neuroscience, child development, oral health, and allied health outpatient services. It features three separate, dedicated places to facilitate play: Starlight Express Room, Kidzone, and Radio Lollipop studio. These three charities offer purpose-built facilities for patients and their families, providing options to engage, play, learn, and relax. These lively environments are filled with artmaking, music, dance, play areas, radio, and distraction methods across a wide spectrum of activities—fun places to experience and explore for children of different ages. There were, however, consistent problems with newcomers having difficulty finding these spaces—which resulted in fewer visitors and less opportunity for children to access the playful experiences essential to their treatment journeys. Six years after the hospital opening, staff and families reported that finding one's way to each charity organisation was challenging. Additionally, the floor as a whole was not communicating the desired atmosphere of playfulness and wellbeing—there were no visual cues to signal that this area offered spaces for fun and games. For example, as Fig. 1 illustrates, the Level 6 lift entrance to the space communicated an arrival experience that was similar to every other floor in the hospital, rather than the desired atmosphere of fun and play on offer at the Entertainment Precinct.

As the Entertainment Precinct is an important area for supporting the children and families attending the hospital, the project team was tasked with the challenge of creatively reimagining wayfinding for this space. This chapter details this hospital wayfinding and placemaking project, highlighting the critical importance of taking a co-designed and holistic approach in developing effective, user-friendly, and playfully creative navigation solutions for hospitals. The specific goals of this project were to change the current experience of Level 6, in order to (1) better direct visitors to specific locations on that floor and (2) shift it towards an atmosphere of play that could enable distraction from the challenges of health treatment. It also needed to (3) create a strong visual identity that complements and extends the hospital architecture, character, and branding. This combination of aims meant that not only was a new wayfinding design intervention required, but additionally it needed to be a playful and joyful wayfinding experience.

Play is recognised by paediatricians as a fundamental part of a child's development and relationship with their family (e.g., [3]), and their rights by the United Nations [4]. The child's development and growth does not stop when they are in hospital undergoing treatment for a health condition. This highlights the critical opportunity to design paediatric hospital experiences for children to support their ongoing development through play while also alleviating the stress from ill health— and indeed, as we will show, children's hospitals across the globe are increasingly turning to creative/playful wayfinding and placemaking to do so.

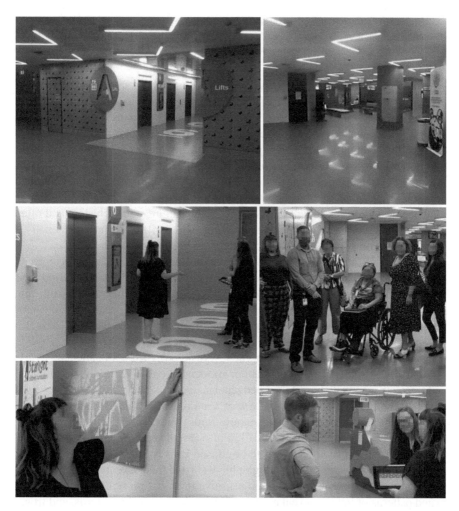

Fig. 1 The lift entrance A on Level 6 Entertainment Precinct, QCH—before any wayfinding interventions (top), QUT Design and QCH hospital team members in Level 6 Entertainment Precinct (middle and bottom)

1 Wayfinding in Children's Hospitals

Wayfinding is the system that assists people to find their way from one place to another, often through a complex or new environment. It is a design specialisation, also known as environmental graphic design, sign-systems design, or architectural graphics, that effectively directs people through a space. The phrase was originally coined by urban planner Kevin Lynch [5] who argued that wayfinding is the process where one forms a mental picture of a place based on memory and sensation:

> In the process of way-finding, the strategic link is the environmental image, the generalized mental picture of the exterior physical world that is held by an individual. This image is the product both of immediate sensation and of the memory of past experience, and it is used to interpret information and to guide action [5, p. 3].

Wayfinding tools, such as maps, placards, and route signs are designed to assist people in navigating through space, and, with technological advances, now include moving images, GPS, and web connectivity, as well as more transdisciplinary, socially aware, and creative imagery/branding [6]. Contemporary approaches to enhance the hospital wayfinding experience typically include: (1) integrating way-finding visuals on all surfaces, including the floors and roofs; (2) playful wayfinding; and (3) integrating a narrative and/or memorable landmarks at key navigational decision points, thus creating journeys that are easily describable in one simple sentence. Designs seek to acknowledge diversity, culture, and inclusion, and often use digital technology (e.g., interactive screens in multiple languages, personalised hospital maps on apps showing the path from car park to ward).

For example, at Evelina Hospital in London, the 'Evelina Gang'[1] are cartoon characters who welcome young patients and their families and help them find their way around. While the original 2005 wayfinding designs included colourful, fun, non-clinical names and pictures for each floor and lift signs (ocean, beach, forest, arctic), families still found navigation challenging—so the 2013 redesign led by Bill Greenwood Ltd. focussed on developing the novel and child-friendly 'Evelina Gang' of varying ages and abilities, which were co-designed with patients.

Also in the United Kingdom, Landor Associates created different illuminated and interactive animal characters—hedgehogs, horses, rabbits, and more—to assist with wayfinding at *Great Ormond Street Children's Hospital* (GOSH), and co-created short stories about their adventures with patients, their families, and staff (both paper and audio books). GOSH has also installed a 50-metre digital 'nature trail', a LED-illuminated wall (created by Jason Bruges Studio) on the way to the operating theatre. A mix of custom graphic wallpaper and seventy integrated LED panels at varying heights, this motion-sensitive interactive installation creates animated patterns of light to reveal animals (horses, deer, hedgehogs, birds, and frogs) through the trees and foliage of the digital forest.

In America, the Nationwide Children's Hospital[2] approach to wayfinding, place-making, and identity was inspired by flora and fauna native to Ohio. Designed and detailed by RAA, it features large-scale double-height wooden trees and animals, and three-dimensional experiences/media projections (of glittering leaves and fireflies), as well as a soundscape of rain and wind, and leaves on the floor for fun wayfinding. As research has shown that children across all stages of cognitive development consistently preferred art with nature [7], and of course nature is intrinsically calming—see biophilic design [8], it is perhaps not surprising that hospital wayfinding schemes often centre around our natural world.

[1] https://billgreenwood.co.uk/portfolio/art-worked-illustrations-evelina-gang/

[2] https://raai.com/project/nationwide-childrens-hospital/

Interestingly, despite growing awareness of the importance of designing hospitals as humane, salutogenic (health-promoting) places [8], and the importance of thoughtful architecture, art, and design in this process, only a handful of studies have documented the process and impact of creative approaches to wayfinding in hospital. In New Zealand, Short et al. [9] focused on how communication design could improve the outpatient experience in a children's hospital where the current experience was challenging: wayfinding instructions were often given verbally by staff, with the route complex and unintuitive, with poor placement and overwhelming visual stimuli making it difficult for visitors to identify important waiting area signage communication. There was no cohesive design identity as vinyl art works and ad hoc posters competed for attention. Short et al. [9] completed an experience journey map documenting the current outpatient experience, from referral to the service to leaving the building, and then mapped possible interventions against the wayfinding task. They tested a revised appointment letter and a large blue vinyl wayfinding sign, which ultimately was not implemented into practice. In reflecting on the project challenges, Short et al. noted that hospital stakeholders in a traditional, hierarchal organisation were not familiar with the collaborative process and potential of design, that building trust across such different professions/approaches takes time, and there was "often a tension between balancing the design process (the focus on making and understanding the user) and stakeholder buy-in" [9, p. 2567].

2 Our Approach: Co-Designing Playful Wayfinding at the QCH

Prior to this project, the QUT team had built trust and buy-in through other collaborations with hospital stakeholders. This was extended as all parties continued with further investment: the HEAL project—a joint effort between QUT Design Lab and state government body Clinical Excellence Queensland provided a paid internship for a research student, while the hospital design team also had a production budget available for the print and installation of final vinyl decal designs. We were therefore able to use these resources to support Kirsten Baade—an artist and design research student—to create and produce a playful wayfinding strategy for the QCH Entertainment Precinct, mentored by her design supervisor and academics along with the hospital's design team as we collaborated on this interdisciplinary project.

The collaborative approach was a fundamental tenet in how we worked, and stakeholders from charity partners, clinicians, children, and their families, as well as strategic hospital committees, were consulted and engaged with throughout the process. The space we were designing for includes two lift areas (places of arrival and departure on Level 6, as pictured in Fig. 1—top), junction points along corridors where people would change direction depending on where they were headed, and the outside surrounding each of the three charity partners.

Firstly, the new experience design for this precinct needed to signal to the children, young people, and their families that they have entered an area that is a place for fun, while also assisting people with finding their way through the precinct. The design research team engaged in multiple site visits and photography to gain a better understanding of key junction points and the experience design challenges, with artist and designer Kirsten Baade embedded into the hospital team—spending significant time on site, designing as a creative resident alongside the hospital's Design Manager Matthew Douglas. As the project progressed, Kirsten—who created the imagery—returned to measure walls and doorways for high accuracy in planning out the visual designs so these would fit around doorways and fixtures. This creative making was highly situated and bespoke to the hospital, the specific floor, and diverse stakeholders, something that was likely critical for a successful design outcome and staff acceptance.

Secondly, in directing people to the precinct partners, the design would also need to provide appropriate graphic representation for those partners and to playfully direct visitors across the floor, and, in the case of the Starlight Express Room and Radio Lollipop, around the corner. Thirdly, sensitivity to the aesthetic context was a critical consideration, as any proposed design solution would need to complement the existing artistic scheme for the hospital with its 'living tree' design, network of architectural 'trunks and branches' coming off the interior atrium, and its differently-coloured floors. QCH also has a contemporary art collection installed throughout. This aesthetic sensibility provided further context and opportunity for a creative design solution, as we employed a range of creative arts-based approaches in the workshops and in creative design processes in trying to come up with opportunities for designs that would create a playful experience to engage and distract the children and their families.

Finally, pragmatic and clinical concerns also informed the design—solutions would additionally need to meet the hospital's health and safety requirements, such as to be non-invasive, antimicrobial, able to support deep cleaning, and fall within the hospital's allocated budget for decal printing of visual design solutions. The clinical services on Level 6 treat children and young people with sensory processing disorders, developmental delays, and neurological conditions that can be triggered by particular visual stimuli. Consequently, intense consultation was necessary with local clinical teams both before and after design development, and this feedback was quite influential. It is also important to note that this project ran during the Covid-19 pandemic (across 2020–2021), which added another layer of complexity to the engagement, consultation, and design processes, as access to the hospital was restricted to visitors (not including parents and guardians), and the health service itself was preoccupied with pandemic planning and management.

3 The Collaborative Design Ideation Process for Playful Wayfinding at QCH

We conducted workshops with various stakeholders. The design academics led three workshops with key stakeholders including the hospital team, charity partners, and representatives from the executive leadership team and other senior managers, with special attention from the Arts in Health Committee. As previously mentioned, the hospital team additionally conducted early stakeholder interviews and workshops with hospital precinct partners, clinicians, and consumers, alongside multiple follow-up discussions about their experience subsequent to the design completion. Team members worked closely together, as well as independently, to pursue a thoughtful design outcome that was informed by best practice and reflected our shared values of collaboration in design.

The first onsite workshop was entitled "Inspiration and Ideation", led by four HEAL team members with expertise in design for health, interaction design, art, the built environment, and creative placemaking. Approximately 15 key stakeholders (representatives from all precinct partners, QCH engagement and communication team members, and architectural representatives) engaged in this collective brainstorm about how we could potentially redesign the space so that the wayfinding experience was more fun and distinctive. To set the scene and show the diversity of design ideas available (the inspiration component), the HEAL team started by sharing images and concepts from innovative wayfinding from across the globe (the 'Evelina Gang' at Evelina Hospital, Great Ormond Street Children's Hospital, and the Nationwide Children's Hospital in Ohio, as well as non-hospital examples of wayfinding in public places), and examples of previous portfolio artworks by the team. This process started an ongoing and important conversation about ensuring that any wayfinding strategy on Level 6 was cohesive, coherent, and consistent with the existing QCH design identity—but also reflected the playful, fun identity that was integral to the Entertainment Precinct.

This first workshop discussed existing exemplars, overall site values/priorities, and desired features: for example, should the wayfinding on the floor be lines, shapes, fun characters, or perhaps connected to the nearby Brisbane river out the window, through a river shape and/or leaves? We also discussed clues in wayfinding, noting how at the Evelina Children's Hospital: "Whole creatures such as butterflies are to be found at the major arrival point and then progressively dissected as you go further in. Eventually a child might find perhaps one wing under the bed. To get back to the main arrival point, you put the creature back together" [10, p. 101].

We also brainstormed multiple ideas for the wall and floor content and outlined different approaches—from relatively simple mural content to more interactive digital approaches, and large central installations (for example, the large trees that are part of Nationwide Children's Hospital). Hospital team member Lynne Seear led a reflective discussion about the hospital design and values, which prompted significant thought about whether and how to link to the hospital's central atrium space, which features large sculptures of Eclectus Parrots. While we knew that we

wanted to transform Level 6 into a place of fun and joy, we were, at the start, very open to the types of things to create. We explored ideas such as murals, interactive art, and kinetic sculptures. One idea we considered was a giant nest that people could sit inside. However, there were restrictions on anything that could be touched. There were also budget restrictions, and restrictions relating to public art—it had to be sturdy, sustainable, and people-proof. The problem focuses on creating a sense of fun and joy resonated well with the artist's painting aesthetics, which often feature bright saturated colours, with contrast and patterning for detail, visual rhythm, and overall harmony of the mural composition.

Figure 2 shows how workshop participant input fed into a bespoke brief for this wayfinding design. Participant ideas were represented on post-it notes by colour (Fig. 2—top) and then the design approach was to cluster, organise, and re-organise these to identify different themes across the ideas and participant groups

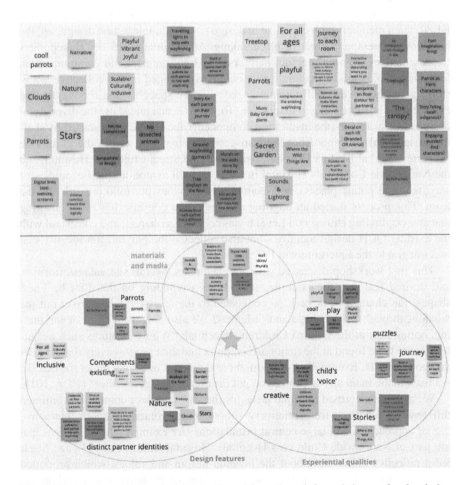

Fig. 2 Workshop participants insights (top), and how these informed themes for the design (bottom)

(Fig. 2—bottom). Through this bottom-up approach, drawing on emergent visual thinking [11] and thematic mapping [12], the different 'voices' of workshop participants could be interpreted into some guiding concepts for the design. The emerging themes—in black text in Fig. 2, (bottom)—were play, puzzles, journey, creativity, stories, nature, having a child's voice, parrots, being inclusive, complementing existing elements, and having distinct partner identities. These would be presented back to the participants as part of tracing the progeny of the wayfinding co-design outcomes.

Further clustering was conducted to consider even higher-level categories. These focused more on the 'medium' than the 'content' (features) of the design. They were a useful thinking tool internally for the design team to explore possibilities for realising the different qualities that were coming up. For example, while parrots and nature could clearly be implemented through visual content solutions, aspects such as play and puzzles or a journey required thinking about the invisible yet critical aspect of how to 'experience' the place (e.g., to be playful, a journey, from a child's perspective, etc). Additionally, during this early ideation stage, there were many workshop ideas around the medium and materials that we could draw upon for final realisation of the visuals and experiences, from vinyl decals through to interactive art, sculptures, and digital screens.

4 Sharing Design Power: Tracing and Negotiating for Best Outcomes

The collaborative workshops and codesign process were highly effective at identifying concepts to drive the design explorations, and ultimately, design outcomes. A number of potential ideas were raised for the space: there was a little bit of disagreement about the best path forward and whose voice would be dominant in the design decisions—negotiating those kinds of tensions and ensuring that everybody has an equal voice and equal say was a really important priority. As discussed above, by showing how participant suggestions actually constituted the themes such as nature and parrots—tracing those themes back to direct quotes—we could facilitate continued progress, 'buy-in', and enthusiasm in the group.

As designers we also had ideas of what could work well, and one of the most challenging parts of the project for us was negotiating on clear design ideas that we had, and how appropriate these were or how these might be applied in a hospital environment. That is part of co-design, but was at times challenging. For example, an initial exciting idea centred on native animals and recent endangered species— but the group quickly focused in on parrots, to connect with a large existing central parrot sculpture that was key to the hospital design—and highly visible and familiar, particularly from Level 6.

Similarly, some of the working group members from the Health Service felt the need to reinforce their obligation to follow mandated internal protocols around

approvals and procedures to ensure the outcome would be as risk-free as possible for patients and families. This sometimes meant that things moved slowly. This is the fundamental nature of healthcare (except in emergency situations), and in the end allowed more time for creative development. Any tensions between these different approaches were always resolved by open and clear communication.

Once parrots and nature (specifically the architectural design of a tree which was common across QCH's existing interior design) had been agreed on as core guiding concepts, in the second and third workshops discussion centred on the visual brand and visual wayfinding designs—to look at parrots within the trees.

Parrot-related characteristics and stories were explored both behind the scenes in further design sketches, and in a collaborative way with the stakeholders in a second workshop. Workshop 2 was centred on co-designing the parrot activities—what were they doing on the walls and floors? What would they look like? The second design workshop explicitly tested these ideas, and the QUT team engaged with the QCH team and stakeholders for their ideas as well on the activities or stories about things the parrots might be doing. We presented mock-ups and gained feedback, which would drive Kirsten's mural illustrations, and many possibilities were discussed. Parrot activities included singing, playing music in a band, playing sport, blowing bubbles, hanging out, having a birthday party, going for a walk, flying in a flock, reading a book, looking at an iPad, fishing, and painting.

There was much excitement about how this concept would enliven the area, enhancing wayfinding but also potentially providing different ways to connect with the parrot theme. This could include competitions for children to name the parrots, associated colouring-in activities and drawings shown on screens, extending the theme with VR/AR, and large fixed items, such as tree and nature-themed internal seating areas. Through the first two workshops, it became apparent that each precinct partner could have their own parrot in similar colours to their branding: red for Radio Lollipop, purple for Starlight, and green for Kidzone. In response, Kirsten created some early parrot designs for feedback. Each different parrot would lead the way to the specific space, through visual cues on the floors. She designed these wayfinding cues as different coloured feathers, marking out the "journey to fun" at each precinct partner location.

The workshop collaborations enabled the direct, active involvement of the broad stakeholder team in the design process, while the QUT Design team continued with design ideation and content creation in parallel and in response to those sessions through sketching and mock-ups. At the same time, senior hospital staff conducted extensive collaboration with families, patients, and clinicians, seeking input on awareness of the services and subsequently on the design proposal. Detailed feedback from those sessions was incorporated into the final design. This feedback gave the artist a very clear sense of what hospital stakeholders would like to see. While perhaps an unusually collaborative approach to the artistic creative process, it aligns

well with the ethos of using co-design in healthcare. As Kirsten noted, she had to dive deeply into the habits of parrots, the adventures they could get up to, and the importance of empathetically listening to stakeholders:

> To be more aware of the idea of telling a narrative with my illustrations. Initially, my ideas were too abstract. People want to see and engage with characters doing things. This is feedback I received. So I learnt how to make parrots look expressive. I learnt a lot about Australian parrots. The hospital already had large sculptures of Eclectus Parrots hanging in the atrium. Australian parrots are playful and intelligent. They will hang upside-down for fun. They are colourful. Some of them gather in huge flocks—budgies and rainbow lorikeets do this. They are noisy. They are cavity nesters. They don't make nests, rather they use holes in trees. These are all things I depicted in the illustrations ...I learnt how to change their eyes and beaks to make them look cheeky or surprised or joyful. I figured out how to draw parrots doing human activities like playing the violin or reading a book or going fishing. I gave a parrot a broken arm even though parrots don't have arms. I personified the parrots (see Figure 3—top right).

Learning to let go is an integral part of both collaborating with others and design. Many early ideas were discarded as we worked through the project. We also had some pre-existing ideas of scenes and activities for the parrots at play on the walls—for example, wearing red and white hats to symbolize Christmas, and parrots cycling, or with a broken arm, or Easter eggs etc. There was feedback that some parents aren't religious (also echoed in the literature about designing for cultural inclusion), and so the final design does not include such features.

Playing in nature was an important value all stakeholders agreed on, and we collaboratively ideated how the design outcome might relate to its context. Initially, we followed a common architectural practice to look at the immediate physical site and worked to connect the concept and imagery to the views of nearby South Brisbane's Cultural Centre, streets, and civic parklands outside. Images of parrots riding bicycles in the park or hanging out across bridges were explored. The workshop participants felt this more reflective of inner-city Brisbane (the hospital site) and not reflective of Queensland; so these images were also discarded, as the hospital services and represents the larger state-wide context. The emergent interest in nature as a theme therefore became a great inspiration as we explored this for a Queensland context. Some of this included exploring depictions of native fauna, such as the Cassowary from Far North Queensland through to the Sea Turtle in mid-Queensland. As the group discussion shifted to focus on the parrot (emblematic as it is embodied through the atrium sculptures) and tree (reflected in the architectural spatial layout), we ended up shifting our exploration of nature to look at habitats or Queensland places instead of fauna. The rainforest and the Southern Downs were the result—and these two iconic places came to characterise each of the lift zones respectively.

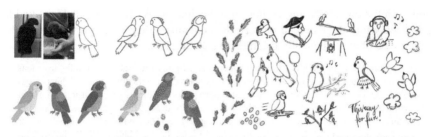

Welcome to level 6 – lifts become places

"I came in at the waterfall"

Lift A > rainforest **Lift B > the bush**

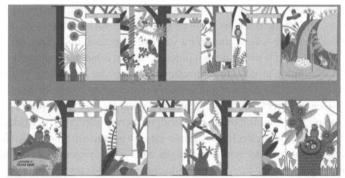

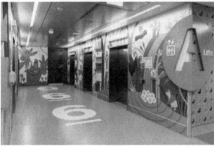

Fig. 3 Parrot drawings for form and project partner identities, illustrations by Baade (top left), explorations of parrots doing human activities, illustrations by Baade (top right), initial concept mock-up for the lifts as places, image by Seevinck and Baade, (second from the top), work in progress template for lift A, by Baade (third image from top), and final 'waterfall' design for Lift A zone on Level 6 features waterfall imagery adjacent lift doors and on the wall opposite, photographic images by Sarah Osborn (bottom image)

5 The Lift Zones: Arrival Landmarks

Level 6 of the QCH has two main points of access, the A and B lifts. These became a focus for design consideration: they are significant as navigation landmarks with strong potential for conveying the atmosphere of play. As Fig. 1 shows, the level was somewhat a 'blank canvas', however some walls and floors were taken up with existing artwork and the wayfinding colour orange which denotes this floor across the whole building.

One of the challenges we quickly realised was that whatever we put on the wall was going to have to work with the existing signage, art works, and architectural finishes—from notices for hand washing to art decals on varnished plywood. This challenge was particularly significant around the two elevator zones, as these spaces have the added features of signage: lift call buttons, emergency exit information, orange coloured flooring, and a large orange number "6". The design solution would therefore need be both complementary to these features and finishes, while at the same time distinctive.

The design team developed playful and unique design solutions to make these lift areas spatially distinctive, in fun ways e.g., "*come in at the waterfall lift*" or come in at "*the bush/garden lift*". This design approach makes these places easily describable as journeys—consistent with the best practice we found in our review of contemporary wayfinding design. Many design sketches and concept mock-ups were developed, as possibilities and aesthetics were worked through. As shown below in Fig. 4, we have the original concept presented for discussion at workshop 2, and the final design in situ.

In looking at art murals such as the graffiti of artist Banksy, we also realised that the existing constraints could be leveraged creatively. The aim therefore became to integrate the decal imagery with the existing environmental features. This would be a point of difference to the existing patterning artwork on the plywood walls, to instead leverage the physical and spatial features of the area, such as by having parrots peek out from behind lift openings etc. Also, as a more character-based than pattern-based approach, this would further differentiate this artwork from the existing decal artwork on the plywood. As Kirsten describes:

> I wanted the parrots and background elements to fit around the elevators in a precise way. I took measurements several times to ensure everything was in the right place in the design file…. noting the layout of features that would need to be worked around such as elevator doors and signage. I then made templates of the spaces in Adobe Illustrator.

Kirsten's creative process was fluid and intuitive, using the drawing techniques facilitated by an interactive stylus and tablet to sketch up the ideas. She then took these back to the more precise, desktop environment for vectorising and print preparation—a painstaking aspect of work that, in the end and due to the scope of illustrations she created, became a joint effort with the hospital's design team:

> I transferred the templates from Illustrator into Procreate on my iPad and used Procreate to sketch and then fully illustrate the designs. Once complete, I transferred the designs back to Illustrator and aligned them with the templates. The final step was to convert the images to

Fig. 4 The final design. Bottom images demonstrate the design alongside the central hospital atrium where the Eclectus parrot sculptures reside (photographic images by Sarah Osborn)

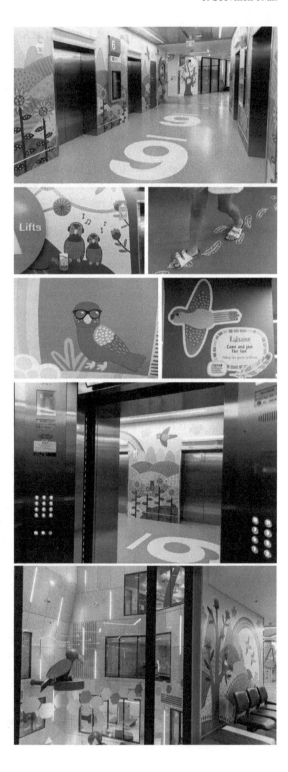

vectors to make them suitable for large-scale printing. The vectorizing was a joint effort between myself and Children's Hospital Queensland staff.

The approach to design with the existing architectural design elements led to some novel solutions and creations. In one effort, Kirsten innovated to add images of petals around the large, round orange '6' at lift B, effectively turning it into a sunflower.

Another innovation was her design response to the two-storey pillar in the wayfinding space, which she used as a means to create a tree full of birds doing playful activities. It was inspired by a flock of rainbow lorikeets chattering and playing in a tree. Later, an opportunity arose to introduce animation by adding a large digital screen to a key wall space. In this case, it was created so that the screen could be seamlessly positioned within the illustrated wall decals, with timber bevels extending out from the wall around the lip of the screen. Decals of tree branches extend onto the screen, where three parrots sit. They sometimes move, shuffling, stretching their wings, or singing. They also display messages via speech bubbles. Usefully, these messages can be updated depending on what information needs to be communicated at the time.

6 The Value of Mock-Ups

Communicating new visual design concepts required visual means. Words and verbal explanations only convey so much, so members of the design team created collages. These superimposed images of artwork, or sketches, or design mock-ups onto and into photographs of Level 6. They were at various levels of fidelity, from quick assemblages 'mashing up' visuals in Powerpoint to quickly capture an idea (e.g., see Fig. 3–second image from top), through to highly synthesised simulations in Photoshop where perspective and lighting were corrected across the whole.

We created mock-ups early on for discussion, and later for final design presentation and approval. Visual artists Kirsten and Jen both created these, they enabled exploration within the design team and communication with the hospital team. For example, we used photography-based mock-ups to explore ideas of having the parrot imagery interact with building attributes like lift switches, doors, and floors.

Mock-ups support conversation around the concepts that you intend to communicate, as well as prompting new insights. For example, the idea of having the lift zone be a place in nature was initially captured and communicated to the hospital team using photomontages such as those shown. While this immediately communicated the concept behind that, it also raised discussion about the aesthetics and 'visual density' of the final design—because it prompted the hospital team to share their knowledge of patients' sensitivity to sensory overload. This was not something the design team thought to bring up, and having this feedback early on saved considerable time exploring concepts.

Mock-ups were also integral to gaining approval for the design finalisation. While Kirsten finalised her designs on templates from her wall measurements—readily interpreted by printing professionals—it is another matter to understand how the designs might actually look in the space. That need to visualise in three dimensions is typically restricted to the visual designer and artist, but we needed to communicate to the broader hospital team. A mechanism for visualising the designs to assist that communication was needed, and our solution was to create mock-ups. These superimposed the final rendered illustration/design onto a photograph of the space, taken with identical front-on angles. The images were colour-and shape-corrected for lighting and perspective to create a highly convincing visualisation of the outcome. They were highly beneficial to the hospital team's consideration, and ultimately for final hospital Board approval to go ahead with the design.

7 The Final Design

The final wayfinding design and mural illustrations required approval at QCH prior to being printed and installed on the sixth floor, a process which took additional time but was necessary to satisfy the healthcare service's careful governance systems. In this design solution, red, green, and purple feather decals populate the floor, while similarly-coloured parrots on the walls lead children, their families, clinicians, and visitors to the lively precinct areas of fun: the red parrots and feathers to Radio Lollipop, green to Kidzone, and purple to Starlight Express. Nature scenes and parrots engaged in various activities—singing, reading, flying, listening to music, cuddling chicks—are located along the corridor walls and columns, distracting the patients and families from their troubles and accompanying them in their journey to fun! (Fig. 4)

8 Conclusion

This design research project occurred at the intersection of creativity and collaboration in design and in health. It is rare for the processes of hospital wayfinding and placemaking initiatives to be documented, with this chapter providing rare insight into the uniquely collaborative co-design process in this project. Co-design in this context is very much about 'checking your ego at the door' and remembering that 'all of us are smarter than one of us'; this was a collaborative process of iteratively 'reframing' the possibilities and developing a clear understanding of what the hospital partners really wanted and what could be done to get there. Clearing the path for easy conversation that gives rise to the salient topics forms an integral part of the process. Mock-ups of ideas in context are great to quickly engage people with the topic or idea at hand. As shown, they can also reveal new opportunities and insights.

Such contextual visualisations are most efficient for getting feedback about ideas, often also revealing new time and cost saving insights.

When working in a collaborative design context as a designer, success means that the team takes complete ownership of the design solution. Integral to the importance of consultation and the willingness to be collaborative was the willingness to actually change course—something that gave rise to personal and professional challenges. For example, the role of the designer and artist changes in a collaborative project. Normally, in a traditional design project, the artist/designer voice is dominant, but here the voice of the users is a critical part. For a visual artist like Kirsten working in the design context, this required an acceptance of other views and ideas that needed to be incorporated into the final design—as she explained: *"it is difficult having to hand over your artwork and step back. I did not like having to trust other people to install my artwork designs in the way I intended. Some things were done differently to my intentions, and I have to be OK with that."* Similarly, the design interaction is less about execution and more about facilitation, as keeping your team engaged and invested is key to project success. As shown, enabling them to see how their ideas influence the design—such as by tracing the progeny of the concepts through the design themes—is a great way to do this.

In the end, the redesign of Level 6 has been extremely positive: as well as being brighter, more welcoming and fun, easy to navigate, and a distinctive, memorable space, visitors and staff have praised the design. Parents have said that their child enjoys going to this space (following the feathers, and spotting different parrots at play), while occupational therapists are bringing their clients down there and having them talk to the parrots on the walls! By documenting our process, learnings, and outcomes, our hope is that other design and health teams will work in partnership to implement more creative wayfinding strategies in hospitals across the globe.

References

1. Chaudhury H, Mahmood A, Valente M (2009) The effect of environmental design on reducing nursing errors and increasing efficiency in acute care settings: a review and analysis of the literature. Environ Behav 41(6):755–786
2. Watts R, Wilson S (2009) Impact of the physical environment in paediatric hospitals on health outcomes: a systematic review. JBI Evidence Synthesis 7(20):908–941
3. Ginsburg KR (2007) Child CoPAo, health F. The importance of play in promoting healthy child development and maintaining strong parent-child bonds. Pediatrics 119(1):182–191
4. United Nations (1989) Convention on the rights of the child. United Nations, Treaty Series 1577(3):1–23
5. Lynch K (1960) The image of the environment. In: The image of the city, vol 11, pp 1–13
6. Gibson D (2009) The wayfinding handbook: information design for public places. Princeton Architectural Press
7. Eisen SL, Ulrich RS, Shepley MM, Varni JW, Sherman S (2008) The stress-reducing effects of art in pediatric health care: art preferences of healthy children and hospitalized children. J Child Health Care 12(3):173–190

8. Abdelaal MS, Soebarto V (2019) Biophilia and Salutogenesis as restorative design approaches in healthcare architecture. Archit Sci Rev 62(3):195–205
9. Short EJ, Reay S, Gilderdale P (2017) Wayfinding for health seeking: Exploring how hospital wayfinding can employ communication design to improve the outpatient experience. The Design Journal 20(sup1):S2551–S2S68
10. Lawson B (2010) Healing architecture. Arts Health 2(2):95–108
11. Seevinck J (2021) Making reflection-in-action happen: methods for perceptual emergence. The Routledge International Handbook of Practice-Based Research: Routledge, pp 440–457
12. Braun V, Clarke V (2006) Using thematic analysis in psychology. Qual Res Psychol 3(2):77–101

Associate Professor Jennifer Seevinck is a practitioner and researcher in Interaction Design and Visual Communication at QUT School of Design, and the QUT Design Lab. Her interests include creative health, interactive experience, visualisation, science communication, and art, drawing on applications and concepts around health, hybrid place, environment, and emergence.

Professor Evonne Miller is Co-Director of the HEAL (Healthcare Excellence AcceLerator) initiative and Director of the QUT Design Lab. Professor of Design Psychology at Queensland University of Technology, Evonne is a leading voice on the value of arts and design-led innovation in healthcare transformation, bringing a collaborative, pragmatic, and fresh interdisciplinary approach to problem solving. She is the author, co-author, or editor of 4 books, exploring how we can create places that foster planetary and human health.

Kirsten Baade is a practicing artist whose work includes electronic installations, sculptures, and murals. Her research at QUT is focused on robotic art, light art, and perceptual experiences.

Gillian Ridsdale has published widely on program development, learning, and engagement strategy. Gillian is passionate about capability transfer between research and practice in arts and health, and the delivery of innovative healthcare outcomes for clinicians, patients, and community. The key focus of her HEAL initiative work was the development and implementation of engagement programs and events that showcase the project outputs and build strategic partnerships.

Lynne Seear is the Manager of the Arts in Health Program for Children's Health Queensland. She is also Co-Chair of the Arts Health Network Queensland and the state representative on the Australasian Arts and Health Community of Practice for AusHFG. Her professional interest in the therapeutic benefits of art and creativity within healthcare settings was inspired by a long career as a senior curator, writer and arts bureaucrat, including ten years as the Deputy Director of the Queensland Art Gallery/Gallery of Modern Art (QAGOMA).

Matthew Douglas is an innovative and creative project manager and leader with experience working across a range of industries including public sector, healthcare, and creative advertising and marketing. A strategically driven professional who is future-focused and capable of identifying emerging trends and opportunities, Matt has proven experience interpreting strategies into tangible results and is a strong advocate for human-centred design.

'It Takes a Village': The Power of Conceptual Framing in the Participatory Redesign of Family-Centred Care in a Paediatric Intensive Care Unit

Natalie Wright, Leighann Ness Wilson, Anastasia Tyurina, Jane Harnischfeger, Sarah Johnstone, and Judy Matthews

When the HEAL team was invited to work with the Paediatric Intensive Care Unit (PICU) at Queensland Children's Hospital (QCH) in Brisbane, Australia in 2020–2021, the 'PICU Liberation' Team were already incorporating an innovative rehabilitation bundle of eight complementary steps to 'liberate' children from critical illness, including the engagement and empowerment of families in their child's care [1]. However, they were concerned that the quality of their family-centred care (FCC) was being influenced by the constraints of the hospital systems, communication tools, and physical environment.

Family-centred care (FCC) concepts currently underpin the foundation of paediatric healthcare in many countries globally [2], however FCC practices vary worldwide and there are limited studies which demonstrate the impact the physical and social environments of the PICU can have on the development of collaborative parent-Health Care Professional (HCP) relationships. Butler, Copnell, and Hall [3] suggest that family-centred care principles be used to guide the design and development of both new and existing PICU environments, exploring both the physical layout and hospital policies and procedures, with attention given to elements that may exclude or restrict parental or family presence. Olausson, Ekebergh and Lindahl [4] further stress the importance of studying phenomenological perspectives (understanding the lived experiences of phenomena within the life-world) of patients, next-of-kin, and staff in the PICU when designing these complex, highly technical work and visiting spaces for care, recovery, and well-being. Despite this, paediatric intensive care unit environments in Australia are rarely designed to accommodate

N. Wright (✉) · L. N. Wilson · A. Tyurina · S. Johnstone · J. Matthews
QUT, Brisbane, QLD, Australia
e-mail: n.wright@qut.edu.au; lm.murray@hdr.qut.edu.au; anastasia.tyurina@qut.edu.au; sarah.johnstone@qut.edu.au; jh.matthews@qut.edu.au

J. Harnischfeger
Queensland Health, Brisbane, QLD, Australia
e-mail: jane.harnischfeger@health.qld.gov.au

© The Author(s) 2024
E. Miller et al. (eds.), *How Designers Are Transforming Healthcare*,
https://doi.org/10.1007/978-981-99-6811-4_3

the user experience of families and staff with a focus on nurturing collaborative parent-HCP relationships. In this way, families and staff are not considered 'equal' in the design process.

Driven by these aspirations, and the three core principles of FCC: partnership, participation, and protection [5], the PICU Partnership Project transpired to enable the creation of a more therapeutic (comfortable, effective, meaningful, and supportive) physical, social, and digital environment for parents and families, meeting basic human needs in times of crisis, and providing a positive psychological long-term impact on families, their children, and the staff caring for them.

This chapter describes the process and outcomes of this values-led participatory design project to optimise family-centred care quality, utilising the early adoption of a metaphor, visualised as an architectural parti, to galvanise the collaboration of families (past and current), staff, hospital administration, and the design team in the process. Based on this diagram, four engagement and storytelling strategies were devised and implemented by professional and student designers, with derived findings informing idea generation for various communication and wayfinding tools and an interior redesign concept. The chapter highlights the value of using metaphor as a participatory design method focused on conceptualising a PICU culture embracing the true spirit of the African proverb 'it takes a village to raise a child'.

1 The Design of Environments for Paediatric Family-Centred Care

The admission of a child into a critical care hospital setting can be extremely stressful for the child, parent, and family, especially if the illness is chronic, life-limiting, life-threatening, or where end-of-life care decisions or death occurs [6]. For parents, stress and anxiety, not only due to their child's illness, treatment, their parental role change, and potentially their child's appearance, but also the healthcare environment and relationships with HCPs [7], have shown to impact on their ability to comprehend information, make informed decisions, and function as normal [8–10]. When designing a PICU environment, it must be considered that some individuals cope by seeking or monitoring information and others by distracting themselves [9].

Family-centred care (FCC) asserts that unlimited presence and involvement of the family, as equals in the child's hospitalised care, will optimise the best outcomes for the child, family, and institution [11]. This is based on the principles of partnership—relating to the relationships of trust, honesty, equality, and respect upheld between the family, HCPs, and child in regards to care decisions [12]; participation—relating to the family and child having choice in the desired level and type of involvement; and protection—relating to upholding the rights of the child and parent to receive the best psychosocial, emotional, physical, and spiritual care [13].

While attitudes of both parents and HCPs no doubt impact upon relationships, numerous studies are identifying the influence of contextual elements such as the

physical and social environment on the types and quality of relationships, sometimes reducing parents to the status of 'visitor' or 'watcher' instead of equal [3, 14]. For parents whose children's conditions require them to spend protracted periods in hospital, these factors can have profound impacts on aspects of the three 'P's.

Findings suggest [3, 11] that in order to support the development of a collaborative parent-HCP relationship, primarily PICUs need to provide a welcoming, informative, and orienting environment for parents, with unrestricted access to their child, positive staff attitude, and simple entry procedures. Comfortable chairs, adequate bed spaces, and privacy facilitate prolonged visits and help maintain engagement in parental roles. The provision of resources for parental self-care, including facilities for showering, laundry, breaks, and the provision of food and drinks, also helps to foster positive relationships. Parents have identified that having a place to sleep in the hospital or PICU is an important yet frequently unmet need [15]. Encouragement to personalise the child's bed space with items brought in from home enhances feelings of comfort and ownership of the environment, and increases parental sense of belonging [3]. It is also important to provide a child-friendly atmosphere to alleviate the stress for sibling visitation [15].

Family conferences are considered an essential forum for shared decision-making during a child's stay in the PICU, from admission to after a child's discharge or death. This necessitates a private place for meeting with interdisciplinary allied health professionals, allowing families adequate time, providing emotional comfort, and respecting cultural sensitivities around end of life [15]. Spaces for individual counselling by health professionals and peer support [9], as well as spaces for spiritual needs and play therapy [11], are also recommended.

Research also suggests that a PICU culture, subtly influencing these parent-HCP relationships, can also be demonstrated through the appropriate relaying of communication provided to parents explaining the environment and 'rules' [3]. The types and amount of information needed by parents during a PICU stay are wide ranging and include details of the child's condition and care plans, language, long-term post discharge, and end-of-life discussions. This can be provided using many sources and mechanisms [9], with social media having potential benefits for caregivers of the critically ill [16].

2 The Queensland Children's Hospital (QCH) PICU Partnership Project Design Challenge

To obtain an initial bird's eye view and a quick understanding of the functioning and extent of the space, a floor plan of the QCH PICU was requested by the design team. This has been colour-coded (Fig. 1) to illustrate spatial zoning.

As a first impression, visitors enter the ward through a secure entrance on Level 4 of the hospital and must have pre-arranged access with administration staff or a social worker, as the current reception desk, which straddles both sides of this

Fig. 1 QCH PICU Level 4

entrance, is largely unmanned and unwelcoming. A parent lounge, located adjacent but outside the main entrance (denoted in red), is able to be used by day surgery patients also using level 4, and is not dedicated to the PICU. From this central main corridor parents and families visit their child in either a Riverside (blue) room or Hillside (green) room.

Parents can freely access a large, shared balcony accessible by staff from their staff room (yellow), providing fresh air and an external view, at the end of the main corridor. This space is also used, with the aid of temporary screening, when required for end-of-life ceremonies. Other parental care spaces (denoted in yellow) are a small family room, including a kitchenette with seating and a dining table in a remote corner of the Riverside rooms, and a tiny enclosed expressing room for nursing mothers located near the main corridor with no access to natural light. Parents may meet social workers at a closed office near the entrance and be guided into enclosed hospital-controlled interview rooms for meetings with them or HCPs, again with no access to external views or natural light (denoted in orange).

An existing room (denoted in purple) at the rear of the Riverside rooms, equipped with shower, toilet and laundry facilities for parents, is now inaccessible and used for storage, which means parents and families must exit the PICU to use a bathroom shared with the day-surgery waiting area and then re-enter the ward with assistance from staff due to swipe card security protocols. They do not currently have access to any shower or laundry facilities. The QCH has been designed to store medical

supplies and equipment in the basement, however, as these supplies are not accessible on weekends, this has resulted in spaces (e.g. corridors) in the ward being used for excess storage.

Initial guided observation around the QCH PICU along with the limited data collected from past parents and provided by the 'PICU Liberation' team, suggested five critical issues needed to be addressed in regard to their environment and communication, in order to improve their family-centred care. These issues relate to three identified key phases of 'Welcoming expertise', 'Becoming a team', and 'Gradually disengaging' [3] in the PICU:

- Entry to PICU requires remodelling to improve the 'hello' and 'goodbye' experience through spatial identity and to signal a culture of support.
- The spatial layout, visuals, and wayfinding provided in the PICU do not support easy navigation for parents to rooms, nor any understanding about the spaces available for parents to use for self-care. Access to assistance from various staff is also unclear, implying parents are unwelcome.
- A central space, which houses easily-accessible parental self-care facilities such as kitchens, bathrooms, and laundry facilities, is required to service both Riverside and Hillside rooms. Additionally, more options for both private and public meeting and rest spaces for families to grieve or seek support from other families are required.
- The location and lack of storage (leading to clutter) in rooms and corridors makes it more difficult for parents to find anything, including each other. There is a need for storage solutions for parents' personal belongings, and to better locate equipment and supplies in the corridors and rooms of both Riverside and Hillside.
- The visual communication for the PICU is inconsistent and unclear. Quick and easy support information and social media opportunities could be provided to parents when they enter the PICU to assist with navigation of the environment, post-discharge information, and the building of a support community for parents.

3 Defining the Conceptual Approach for Participation in the PICU Partnership Project

At the outset, to guarantee the success, ownership, and sustainability of the PICU Partnership Project, a *HEAL PICU Partnership Key Stakeholder Committee* was formed as a bridge between QUT Design Lab, HEAL, and QCH leadership for approvals, assistance, and guidance from the administrative arms of the hospital, including Facilities Management and Marketing Communications. Logistical participation of these 15 people, as well as the QCH PICU Liberation team (8 people), the QUT Design Lab team (7 people) QUT work-integrated learning students (7

people), and countless current and past parents and family members who consented to be involved in this project, demanded a transparent approach to inspire and galvanise a large group of participants towards shared values, common language, and mutually beneficial goals to enhance relationships.

With some understanding of family-centred care and evidence-based research on the design of PICU environments, the HEAL team, with approval from the 'PICU Liberation' team, agreed on a values-led participatory design (PD) approach for this project. A combination of an evidence-based approach and public participation in the development of interior design briefs for healthcare environments is advocated to ensure they support psychological and behavioural aspects relevant to patients' healing processes, user perceptions of the healthcare experience, and staff, patient, and visitor morale and well-being [17].

Participatory Design (in the Scandinavian tradition) is a value-centred design approach committing to the democratic and collective shaping of a better future, in which the design process is as important as the final result and increases the chance that the outcome represents the values and meaning of the future users [18]. Participation empowers stakeholders and allows them to feel connected to the design process. But it is not just this participation that qualifies it as PD, but more importantly the negotiation of values—a 'moral proposition' [19] realised through participation. The HEAL project team aspired to the PD's guiding principles, summarised as:

- Equalising power relations
- Utilising democratic practices
- Paying attention to situation-based action which highlights people's expertise of the day-to-day activities in work and other practices
- Enabling mutual learning [20]

Values-led PD [21] further cultivates values and uses them to drive the approach, methods, and participation, not only considering the users' and stakeholders' values in the design process, but also taking into account the values that designers bring to the process during and after the design intervention and prior to action, in preparation for the process. In this approach, the designer assumes an *a priori* commitment using their "appreciative judgment of values" [21, p. 90] to cultivate and shape values though the dialogical process of emergence, development, and grounding. This dialogical approach is used to overcome value conflicts, with discussions, observations, visualisations, and interpretations creating opportunities for co-designers to question and renegotiate their values, sometimes leading to new conceptualisations [18]. Van der Velden and Mörtberg [18] discuss the 'frontloading' of certain values as part of design briefs in healthcare projects, understanding the design process as a 'contact zone' or space for value pluralism.

In architectural design projects, the designer's personal interpretation using metaphor is considered to be an effective 'frontloading' problem-solving tool for dealing with design tasks, particularly in the creation of design concepts and the framing of design challenges, the definition of goals and constraints, and the mapping and

application of structural relationships [22, 23]. Metaphors help designers (and co-designers) to understand abstract, unfamiliar, and ill-structured design problems by juxtaposing them with familiar situations, and can radically modify perceptions of a situation, bringing to mind new, unconventional ways of considering things to encourage creativity and novel solutions [22, 24].

In the case of the PICU Partnership Project, the design team very quickly extracted a logical spatial diagram from the provided floor plan (Fig. 2) to understand how the functional spatial relationships could be understood. Likening the layout of the hospital ward to a village, with Riverside and Hillside townships surrounding a central 'Village Square', enabled the project team to visualise and come to a collective agreement about a reduced scope and the desired outcomes for the initial project in the timeframe available. In architectural terms, this 'parti', derived from the French expression *prenedre parti* meaning 'to make a choice', represents a reductive abstraction or visual organising principle reflecting the subjective, quintessential, and formal expression of the core idea. It refers to the central and salient motif capturing the spirit of a design project.

In this project, reimagining the 'Village Square' of the PICU (traditionally an open and identifiable public space commonly found in the heart of a town and used for social community gatherings and communication), became the metaphor for activating the main central foyer and surrounding spaces of the PICU as a parent and staff hub—a welcoming, meaningful, healing environment supporting family and staff self-care and social connection. Once agreed by the project team and hospital administration, this 'village approach' became the driving brief for the project, galvanising designers and co-designers in a shared vision toward transforming this abstract concept into concrete innovative design solutions for FCC in the PICU.

The perspective of a 'village approach' has been discussed in health contexts in relation to service responses for families experiencing multiple adversities [25]. The phrase "it takes a village to raise a child" originates from an African proverb and conveys the meaning that it takes an entire community of people ('the village') to

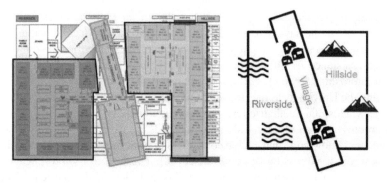

Fig. 2 'The Village' Parti Conceptualisation

provide a safe and healthy environment which enables children to flourish and realise their hopes and dreams [25]. This phrase became our larger design concept for the project, steering both design process and outcomes.

Our 'village environment', with principles intuitively aligned to those of Reupert et al., [25], aimed to provide support and guidance to families living with the adversity of a sick child. This included conceptual principles of interdisciplinarity and interagency, assuming the collaboration of allied professionals and coordination of other family support, such as education and accommodation. The 'village approach' is developmental, strength-based, and prevention-focused, and promotes parental agency and empowerment, while also giving children a voice. It is also culturally sensitive, with feedback and evaluation processes built into village-focused practices and policies. In using this metaphorical reasoning for the purposes of the PICU Partnership Project, the designers assumed that all 'villagers' or visitors to the village had a shared responsibility to provide care to the children and/or support the parents to care for the children, thus aligning beautifully with the ideals of family-centred care.

4 Participatory Design Methods

PD methods and activities are central to creating an inclusive and democratic design process for the emergence of values and in engaging designers and co-designers in the expression and exploration of these values. All methods elicit "information, discussion, reflection and learning", and some are particularly suited for "expressing, exploring and materialising values by engaging co-designers in telling, making and enacting use" [18, p. 11]. To support the initial observations and site audit, adhere in process to the principles of FCC, and to hone the interior design and visual communication brief around the 'village' concept, the HEAL design team instigated four engagement and storytelling strategies to encourage the participation of parents and staff [17] and gain different types of data providing insight into the themes of (1) Spatial, (2) Social, and (3) Emotional needs. These activities, in an attempt to prototype the space itself as a community hub/village square, were largely situated around the designated area of the ward but also included some other community spaces located in the Riverside and Hillside 'townships'. The visual communication engagement artifacts (Fig. 3) required to co-ordinate these activities were developed with the assistance of QUT Work Integrated Learning students as part of their Design Internships at the QCH PICU (more detail about this is provided in Chapter "Bringing the University to the Hospital: QUT Design Internships at the Queensland Children's' Hospital Paediatric Intensive Care Unit (PICU)").

Interactive Static Displays—Mapping methods are used to holistically map and explore local knowledge and enable consumers to be actively involved in the design process through expression of their values [18]. These were used to engage both visitors and staff in sharing analogue thoughts and ideas about particular current spaces in 'real space' (as opposed to 'real time'), including:

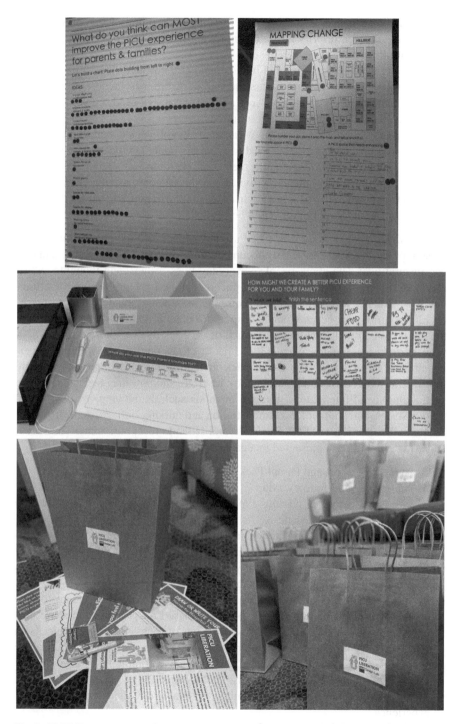

Fig. 3 PICU Engagement Artefacts

- 'Prioritising Change' display installed in the staff room encouraging staff to place red dots on priority areas for improving the PICU experience for parents and families.
- 'Mapping Change' chart located in the main entry corridor, illustrating the floor plan of the ward and asking visitors and staff to record their favourite space in the PICU using numbered blue dots and 'a PICU space that needs enhancing' using numbered red dots, and related descriptions.
- 'Lounge Learnings' sheet aimed at parents and siblings situated in the existing family room and asking them to indicate visuals related to their use of the PICU parent lounge and to illustrate how they could be improved.
- 'Caring for the Carer' display provided on the balcony, asking participants to finish the sentence 'I wish I had…' in order to inform how a better PICU experience for parents and families might be created.

Parent Pack—This strategy was based around the concept of 'cultural probes' or 'design probes', a visual or verbal documentation method used to capture and collect inspirational data about people's everyday lives, values, and thoughts, which allows designers to understand human phenomena and explore design opportunities. This strategy was adopted to minimise the presence of the designers/researchers [26], to limit time-commitment and stress for parents and family members (with the option to complete as little or as much of the pack as they chose during a two-week period), and to allow current PICU parents to be participants without triggering unnecessary trauma. The 5-part pack invited current PICU parents to share information about their family, where they are from, and how they feel about certain spatial and social interactions, through methods such as drawing, writing, visual 5-point scales, and photovoice. Administration and nursing staff assisted with distribution and collection via both Riverside and Hillside reception areas. The Parent Pack (Fig. 3—bottom), presented in a paper bag, included:

- Overview of Project and Parent Pack Participant Information Sheet
- 'Home-to-Hospital Journey' Map
- 'How do you feel about' various experiences in PICU, asking parents to choose appropriate emojis on a scale
- 'Information Finding', an activity designed to gauge opinion on PICU experiences by colouring in on a Likert scale
- 'Draw your Family at Home' Family Portrait designed to test interest in a personalisation tool which could be displayed in patient rooms
- PhotoVoice instruction sheet asking parents to use their smart phones to take photos of positive and negative experiences based on prompts and share to a Gmail address with accompanying explanations of each photo. Photo voice is an effective technique used in healthcare improvement in which photography becomes a means of translating local concerns into a community 'voice', legible to a wider audience of policy makers and clinicians [27]
- 'Share' sheet asking parents or siblings to draw or write about their PICU experience
- Small gifts e.g., QUT Design Lab pen and tea bags

PICU Pop-up Marketplace—This strategy consisted of four drop-in playful activities, hosted in the PICU main corridor adjacent the balcony over two days (9:00 am-3:00 pm), and utilised an Appreciative Inquiry (AI) Methodology, which offers a strength-based approach to promoting positive organisational change by building effective partnerships and collaboration [28]. It evolved in response to disruptions caused by a COVID lockdown, as well as the stressful nature of an Intensive Care environment where commitments of time and forward planning are not possible for past and current parents, the 'PICU Liberation' team, PICU staff, and allied health workers. It aimed to generate informal community conversations and envision possibilities in response to provocative visuals and quotes gathered though ethnography and site audits. QUT Work Integrated Learning students, as part of their Design Internships, assisted the design team with engaging participants in these activities. The PICU Pop-up Marketplace activities (Fig. 4) included:

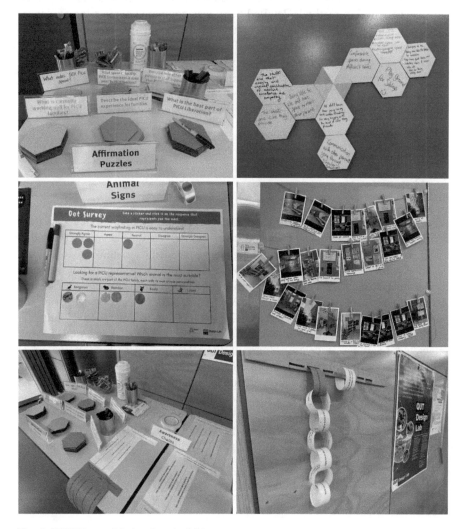

Fig. 4 PICU Pop-up Marketplace Activities

- 'Affirmation Puzzles' which asked participants to acknowledge the good and envision possibilities
- 'Photo Talk' which utilised a series of visuals of the existing space collected during observation as stimulus for discussion and response. This research method of photo-elicitation used in healthcare enables participants to communicate aspects of their lifeworld which may not be easily verbalised, such as emotional expression or tacit knowledge [27]
- 'Awareness Chain' which asked participants to select from a series of phrases to identify priorities in terms of facilities and wayfinding
- 'Animal Signs' which asked participants to describe and 'vote' on an animal hero mascot for PICU based on an existing 'PICU Liberation' strategy.

A synthesis of the triangulated conceptualisations of staff and parental experiences with touchpoints in the PICU, based on the data captured via the varied participatory design methods detailed here, was compared against the evidence-based data. This provided an enriched local definition of 'user experiences', including attendant cognitive, emotional, and sensorial responses to these experiences, the relationship of these responses to their expectations of the service and, finally, how these experiences and their evaluation relate to the principles of family-centred care. This definition foregrounds the multimodality of the construct of user experience, and the heterogeneity of interactions within the intended service.

5 Outcomes

Raw data from each data set was collated (and for focus group/interview data transcriptions checked against audio recordings) and analysed using an emergent thematic analysis [29], essentially examining the data to identify, name, categorise, and describe patterns in the text. Thematic outcomes from the triangulation were utilised to provide recommendations for priorities to formulate the final Interior Design Brief and a concept design proposal; a Wayfinding and Signage Design Brief and proposed scope of work; and a Visual Communication Collateral Brief and proposed scope of work. The latter two scopes of work were developed by QUT Work Integrated Learning students as part of their Design Internships at the QCH PICU. Additionally, in order to synthesise and visualise findings collected from each of the design methods for presentation to both the 'PICU Liberation' team and the HEAL PICU Partnership Key Stakeholder Committee, these students provided a data visualisation presentation for each of the PD activities (more detail about the student projects is provided in Chapter "Thinking Differently: Six Principles for Crafting Rapid Co-design and Design Thinking Sprints as 'Transformative Learning Experiences in Healthcare'").

Forty-two 'Prioritising change' responses revealed that functional and spatial issues were of most concern, with spaces such as parent rooms and public amenities the most frequently mentioned issues. 'Caring for the Carer' responses indicated a desire to improve social space and activities including a family area with music, games, cheap food, coffee machines, and a big TV. Results gathered from 'Affirmation puzzles' again indicated a focus on functional aspects as well as social. Aspects such as better wi-fi and charging access, provision of a toilet, and a covered outdoor area for families for the delivery of bad news, express room for nursing mothers, more quiet spaces, a large comfortable lounge area and workstation for adults, and a support station for assistance were all mentioned. In regard to social requirements, a space to communicate and meet with other parents, with live chat technology, more access to social workers and allied health professionals, and the inclusion of a visual appreciation of the medical excellence and empathy shown by staff, were desired. The 'Awareness Chains' activity revealed spatial, social, and functional requirements, the spatial focus on providing a colourful environment with artwork, more functional facilities, but also a need for a hub to connect staff and parents, which could provide daily care updates, milestone celebrations, group therapy, and family support.

Drilling down further using focus group interview data and observation findings, the recurring themes for spatial requirements, including their specific needs for equipment and furniture, were summarised into the three zones to be considered in the re-configuration of shared spaces to embrace the spirit of the design concept "it takes a village to raise a child". Three spatial zones were created to relate to the three 'P's' of family centred care: participation, partnership, and protection. This is explained in more detail in Chapter "NICU Mum to PICU Researcher: A Reflection on Place, People, and the Power of Shared Experience". Based on these three zones, concept floor plans with image boards depicting the proposed look and feel of these spaces were presented, offering up to three space planning options for each zone, for feedback from the PICU Liberation team and larger committee. At the end of the project, the hospital could not prioritise funding to develop the concept design towards interior refurbishment, and the HEAL PICU Partnership Key Stakeholder Committee has expressed a desire for Hospital Foundation funding to be sought to further the conceptual direction in the future.

6 Reflections on the Importance of Design Concepts and Metaphors for Participatory Health Design Projects

Family-centred care is a multi-faceted philosophy grounded on creating an equal relationship between family members and health-care professionals, allowing for parental presence and participation and open and honest communication, and requiring collaboration between all healthcare professionals, the child, and their family. As studies indicate, many PICUs advocate a family-centred care policy;

however, in reality, medical practice and the environment that supports it do not always meet the ideal [2]. There is a need for further research to ensure that this important aspect of care remains contemporary and evidence-based, and expands to include more research about the participatory design of the environments in which this care is provided.

In the PICU Partnership project, the addition of a design research team enabled the enhancement of quality improvement by aligning culture with strategy, using the aforementioned guiding principles of a participatory design approach [20]. Democratic practices and design methods were utilised to create a shared design space in which co-designers' psychological and behavioural needs were expressed, informed the design brief, and materialised in the concept design for the service. Furthermore, by equalising power relations and paying attention to situation-based expertise and activities through the genuine engagement of families and staff throughout the whole design process (via appropriate participatory methods), ownership and responsibility for the project was improved and likelihood of success of the future service was strengthened.

In addition, incorporating a values-led focus enabled the design team to apply a design concept, visualised as a metaphor and architectural parti, as a starting point in the design process. In alignment with the roles of the design concept identified by Pekkala and Ylirisku [30] in service design, the early introduction of the design concept "it takes a village to raise a child", along with the parti designating the main entrance as the central parent/staff communication hub or 'village square' functioned very successfully in the PICU Partnership Project in the following eight (8) ways:

- **Anticipating future**—creating a collective vision and outlining an impression of the future that enabled the team to understand and anticipate the kind of approvals, resources, and assets which were going to be needed at each stage of the process.
- **Implementing design**—defining the service for implementation and later as a guiding material in implementation of the interior concept design. Participants generally drew upon existing experiences of the healthcare environment, so the integration of an abstract design concept allowed for alternative ideas to be conceived.
- **Training**—capturing and supporting the essential features of the design process and roles in a way that was easy to understand, communicate, implement and act on, to suit the varying capabilities and knowledge of participants.
- **Engaging in dialogue**—improving engagement in informal dialogue with participants to clarify vague challenges and to generate preliminary proposals. Using metaphor and visual narrative fostered a safe yet playful environment where participants felt comfortable and at ease sharing deep insights.
- **Setting goals**—presenting a roadmap and focusing discussion on topics proposed, in relation to expected participant value. The concept clarified and reframed the direction and scope of an ill-defined and multi-pronged design

brief, and reduced the number of possible solutions to be handled during the process.

- **Establishing vocabulary**– clarifying ambiguity and providing a shared language to help outline and visualise common goals and stay on track.
- **Planning and securing resources**—supporting approval from management to initiate and develop the project with less resistance from hospital administration.
- **Linking projects**—integrating ongoing projects conceptually and outlining direction for next phases and future projects. Discussion between QCH CEQ Fellows and other hospital units led to interest in integrating this methodology in the waiting space for juvenile arthritis on Level 1 and seeking funding to develop a cross-hospital model to assess family-centred care environments at QCH. Management staff, seeing the success of the interventions held in the 'village square' space, were also inspired to incorporate other village marketplace activities such as leadership meetings in this space instead of hidden in meeting rooms.

Importantly, the project also provided many opportunities for enabling mutual learning [20]. PICU Staff were inspired by the disruptive integration of design thinking as a methodology to drive positive impact and guide family-centred care interventions in the unit. The team lead for QCH PICU Liberation noted that:

> HEAL's methodology shifts the paradigm ... and explores how facilities and environment can be re-designed to address families' basic needs for food, shelter and sleep; for information and safety; and for belonging connection and esteem—the humanistic theories we learn about as health professionals and then fail to meet in reality. QUT Design Lab is helping us provide true holistic care with a positive and psychological impact on families, and in turn, the staff caring for them. This design methodology offers a wealth of potential for improving healthcare experiences.

The project provided insight for the designers into the value of 'sitting' in the empathy phase of the design process. Visiting the PICU regularly, listening to the stories, experiences and perspectives of both staff and families in this environment, while emotionally demanding, gave the design team greater understanding of how this type of space functions, and how people need it to emotionally support their sometimes-traumatic experiences. It was imperative to tread lightly and interact with the deepest respect and empathy in this intense environment, where notions of family, culture, hope, despair, kindness, and the fragility of life are entwined on a daily basis. Unexpectedly, interactions in the research briefing phase of the project gave both parents and staff the opportunity to tell their stories, and perhaps, in the process, assist in their processing of stressful events and memories related to the PICU. In assisting with the research, families demonstrated their commitment to contribute to quality improvement as a way of giving back some of the care they received from staff during their experiences, however painful. Co-designers may not be able to predict how the physical design of an environment may affect their behaviour and evaluations, so the designers' role, combining participation alongside evidence-based design research, made a valuable contribution.

The designer's role requires clear framing of the project to enable appropriate choice of design methods for research that consider the specifics of all participants and the constraints of the policies and procedures of the hospital. While the design team advocate for this approach, there is no one-size-fits-all, and research activities need to be particularly sensitive to avoid triggering trauma, as well as respectful of the time and emotional capacity that both parents and staff can dedicate to them. The affects of the COVID-19 Pandemic on the operation of, and access to, the hospital during this project meant that design methods needed to be adjusted or changed on the fly. The PICU Pop-up Marketplace, previously scheduled as a face-to-face workshop to facilitate staff and family collaboration in another space in the hospital, was delayed and translated into a more informal, and in hindsight more valuable, activity hosted in the main corridor space proposed to become the parent/staff hub, thereby successfully prototyping its function with co-designers. Additionally, the original design methods conceived did not effectively capture the perspectives of past and regional PICU parents, and therefore during the project, the parent pack was electronically customised as an ongoing data collection tool to allow parents to have access and time to contribute to the improvement of the PICU environment, and seek support online.

In addition to aiding the development of an interior design brief through a values-led participatory design approach for the case study hospital unit, the research process encapsulated here is transferable to the design for other healthcare providers, and adds to the call for developing models for similar family-centred care service environments. This will require interior and visual communication designers to develop additional knowledge, skills, and empathetic mindsets to empower the voice of parents, family members and staff, as well as consumers (where possible) and hospital administration, in the design of PICU and other FCC environments. It also requires healthcare providers and allied professionals to become familiar with design language and to understand that extra time, resources, and budgets are required in the briefing phase of projects to enact this process. Ultimately, embracing a "village approach" [25], which aims to create a connected and supportive community, will best support the growth and recovery of children in a safe and healthy environment. The members of the PICU Partnership Project team are certainly now better equipped to understand how we all contribute to the building of the village that supports healthcare partnership, participation and protection.

References

1. Walz A, Canter MO, Betters K (2020) The ICU liberation bundle and strategies for implementation in pediatrics. Curr Pediatr Rep 8:69–78
2. Butler A, Copnell B, Willetts G (2014) Family-centred care in the paediatric intensive care unit: an integrative review of the literature. J Clin Nurs 23(15–16):2086–2100

3. Butler AE, Copnell B, Hall H (2019) The impact of the social and physical environments on parent–healthcare provider relationships when a child dies in PICU: findings from a grounded theory study. Intensive Crit Care Nurs. 50:28–35

4. Olausson S, Ekebergh M, Lindahl B (2012) The ICU patient room: views and meanings as experienced by the next of kin: a phenomenological hermeneutical study. Intensive Crit Care Nurs 28(3):176–184

5. Franck LS, Callery P (2004) Re-thinking family-centred care across the continuum of children's healthcare. Child Care Health Dev 30(3):265–277

6. Abela KM, Wardell D, Rozmus C, LoBiondo-Wood G (2020) Impact of pediatric critical illness and injury on families: an updated systematic review. J Pediatr Nurs 51:21–31

7. Saied H (2006) Stress, coping, and social support and adjustment among families of CHD children in PICU after heart surgery. Case Western Reserve University

8. Colville G, Orr F, Gracey D (2003) "The worst journey of our lives": parents' experiences of a specialised paediatric retrieval service. Intensive Crit Care Nurs. 19(2):103–108

9. Laudato N, Yagiela L, Eggly S, Meert KL (2020) Understanding parents' informational needs in the pediatric intensive care unit: a qualitative study. Prog Pediatr Cardiol 57:101172

10. Studdert DM, Burns JP, Mello MM, Puopolo AL, Truog RD, Brennan TA (2003) Nature of conflict in the care of pediatric intensive care patients with prolonged stay. Pediatrics 112(3):553–558

11. Foster M, Whitehead L, Maybee P (2016) The parents', hospitalized child's, and health care providers' perceptions and experiences of family-centered care within a pediatric critical care setting: a synthesis of quantitative research. J Fam Nurs 22(1):6–73

12. Coyne I, Cowley S (2007) Challenging the philosophy of partnership with parents: a grounded theory study. Int J Nurs Stud 44(6):893–904

13. Corlett J, Twycross A (2006) Negotiation of parental roles within family-centred care: a review of the research. J Clin Nurs 15(10):1308–1316

14. Macdonald ME, Liben S, Carnevale FA, Cohen SR (2012) An office or a bedroom? Challenges for family-centered care in the pediatric intensive care unit. J Child Health Care 16(3):237–249

15. Meert KL, Clark J, Eggly S (2013) Family-centered care in the pediatric intensive care unit. Pediatr Clin 60(3):761–772

16. Cherak SJ, Rosgen BK, Amarbayan M, Plotnikoff K, Wollny K, Stelfox HT et al (2020) Impact of social media interventions and tools among informal caregivers of critically ill patients after patient admission to the intensive care unit: a scoping review. PLoS One 15(9):e0238803

17. Payne SR, Mackrill J, Cain R, Strelitz J, Gate L (2015) Developing interior design briefs for health-care and Well-being centres through public participation. Archit Eng Des Manag 11(4):264–279

18. Van der Velden M, Mörtberg C (2015) Participatory design and design for values. In: Handbook of ethics, values, and technological design: Sources, theory, values and application domains, pp 41–66

19. Carroll JM, Rosson MB (2007) Participatory design in community informatics. Des Stud 28(3):243–261

20. Kensing F, Greenbaum J (2012) Heritage: Having a say. Routledge international handbook of participatory design: Routledge, pp 21–36

21. Iversen OS, Halskov K, Leong TW (2012) Values-led participatory design. CoDesign 8(2–3):87–103

22. Casakin HP (2006) Assessing the use of metaphors in the design process. Environ Plann B Plann Des 33(2):253–268

23. Casakin HP (2006) Metaphors as an unconventional reflective approach in architectural design. Des J 9(1):37–50

24. Casakin HP (2007) Factors of metaphors in design problem-solving: implications for design creativity. Int J Des 1(2):21–33

25. Reupert A, Straussner SL, Weimand B, Maybery D (2022) It takes a village to raise a child: understanding and expanding the concept of the "village". Front Public Health 10:424

26. Mattelmäki T (2006) Design probes. Aalto University
27. Papoulias C (2018) Showing the unsayable: participatory visual approaches and the constitution of 'patient Experience' in healthcare quality improvement. Health Care Anal 26(2):171–188
28. Cooperrider DL (1986) Appreciative inquiry: toward a methodology for understanding and enhancing organizational innovation (theory, social, participation). Case Western Reserve University
29. Braun V, Clarke V (2006) Using thematic analysis in psychology. Qual Res Psychol 3(2):77–101
30. Pekkala J, Ylirisku S (2017) The role of design concepts in the development of digitalized industrial services. Des J 20(sup1):S2813–S2S22

Dr Natalie Wright is a Senior Lecturer in Interior Architecture in the QUT School of Architecture and Built Environment with 20 years commercial Interior Design practice experience gained in Australia, Japan and the UK. Her engaged research explores design thinking and design-led educational innovation approaches in K-12, tertiary and professional education environments, as a framework for inclusion, wellbeing and adaptivity in the twenty-first century.

Leighann Ness Wilson is an interior designer and educator who inspires future primary educators through design thinking and creativity. She also works independently as an education consultant, developing and providing workshops and learning experiences to students and teachers. Currently Leighann is researching the impact of design thinking as a pedagogical approach on pre-service primary teachers for her Doctor of Philosophy (PhD).

Dr Anastasia Tyurina is a Senior Lecturer in Visual Communication at the QUT School of Design, and the QUT Design Lab. As a design researcher and a new media artist, she is interested in creating visual experiences that promote social change, better health and wellbeing.

Jane Harnischfeger is a Nurse Educator in the Paediatric Intensive Care Unit at the Queensland Children's Hospital and Healthcare Improvement Fellow (Clinical Excellence Queensland). She has a Master of Nursing (Clinical Teaching) and is a nursing lead for PICU Liberation.

Dr Sarah Johnstone is a design strategist, at the QUT Design Lab. She specialises in 'designing for diversity', co-design processes, and designing accessible/low-fi creative/arts-based community and stakeholder engagement tools.

Associate Professor Judy Matthews from the School of Management in the QUT Business School, facilitates human-centred systems design with individuals, groups, and organisations, through action research, creating inclusive, collaborative strategic and operational leadership and management practices. With an extensive background in human services, Judy has worked with government and non-government agencies to identify and overcome barriers to innovation, developing, testing, and embedding proactive agentic behaviour and practical customised solutions.

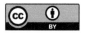

Designing Hospital Emergency Departments for a Post Pandemic World: The Value of a BaSE Mindset—Biophilia (Natural), Salutogenesis (Healthy), and Eudaimonia (Contentment) in Architectural Design

Lindy Osborne Burton, Evonne Miller, Jane Carthey, and Scott Schofield

Take a moment to imagine the following… a dearly beloved family member has been in an accident and is in an ambulance being rushed to hospital. You are following in your car, you don't know what is wrong or what will happen when you arrive. You feel physically ill, and you are panicking.

While for an Emergency Physician this is just another day in the office, for most people an emergency presentation is a terrifying experience, at one's most vulnerable time. The often overcrowded and unfamiliar sterile clinical environment with harsh bright lights, busy clinicians (cloaked in personal protective equipment during the Covid-19 pandemic) directing chaos and surrounded by unfamiliar equipment feels both disorienting and frightening. In this chapter, we propose that the standard design of these types of spaces should be reconsidered, to improve the experience for all users, both the consumers and the clinical staff. After a review of academic literature investigating the role and design of the Emergency Department (ED), and drawing upon our qualitative research, which included interviews with clinicians to understand if and how ED spatial environments facilitated or hindered their delivery of positive healthcare, we propose a new approach for designing EDs in a post pandemic world. Our BaSE Mindset is an integrated salutogenic (health promoting) approach, grounded in an awareness of the importance of biophilic (nature centred), and eudaimonic (facilitating contentment) architectural design principles.

L. O. Burton (✉) · J. Carthey
QUT, Brisbane, QLD, Australia
e-mail: lindy.burton@qut.edu.au; jane@janecarthey.com

E. Miller
QUT Design Lab, School of Design, Queensland University of Technology, Brisbane City, QLD, Australia
e-mail: e.miller@qut.edu.au

S. Schofield
Queensland Health, Brisbane, QLD, Australia
e-mail: scott.schofield@health.qld.gov.au

© The Author(s) 2024
E. Miller et al. (eds.), *How Designers Are Transforming Healthcare*,
https://doi.org/10.1007/978-981-99-6811-4_4

63

1 Flexible and Adaptive Spatial Environments in Hospital Emergency Departments

Typically located at the front entry to a hospital, vulnerable, stressed, and frightened patients who are often also in pain and confused, create their first impression of healthcare facilities based on the ED. Improving the experience of Eds requires a two-fold investigation: (1) considering how patients (and their families) encounter the ED; and (2) understanding the requirements for a functionally optimised workplace for the clinical staff. The ED is a complicated spatial environment, which must comprise entry, exit, admissions, triage, and discharge areas for patients, while also operating as a workplace for clinical staff. A careful consideration of workflows, task efficiencies and productivity, and improved healthcare delivery is critical to facilitate good patient experiences, in additional to reviewing the design of patient waiting areas, and treatment spaces. Importantly, we applied a lens of health promotion and stress reduction, to our review of pandemic adaptation principles, which have impacted the physical facilities required and how EDs need to operate.

The COVID-19 pandemic impacted the operation and design of healthcare facilities suddenly and without and warning. In the scramble to manage the unknown implications of the pandemic, protecting clinical staff and patients from the spread of infectious pathogens, resulted in functionality becoming the primary consideration for hospitals, and EDs in particular. Fear of the unfamiliar fuelled our reactions to preventing virus spread, from diagnosed (and undiagnosed) patients, both within the community and the hospital setting. The health system's primary reaction was to expand the capacity of hospitals, to admit, triage, and treat patients infected with the coronavirus, while minimising viral spread to the uninfected.

Health system policy and facility issues are outlined in Nigel Edwards' report, in which he discussed the impact of this pandemic on the UK National Health Service (NHS). He noted that "searching questions will need to be asked about the UK's overall COVID-19 response, in particular around testing, supply of protective equipment, care home policies and the large numbers of excess deaths" [1, p. 1]. Edwards [1] highlighted the impact of architectural design on infection control and staff capacity issues, including: (1) the necessity for an adaptive/flexible design approach; (2) generous circulation spaces to facilitate staff and patient movement and flow; (3) the provision of a majority of single bed wards to quarantine/isolate infectious patients; and (4) wider corridors to accommodate physical distancing requirements. More specifically, EDs require: (5) more generous waiting areas which facilitate physical distancing; (6) increased provision of isolation and enclosed treatment bays; and (7) flexibility to enable parallel assessment streams for infectious and other patients. Furthermore, (8) other facilities across the hospital must be adaptable, to allow efficient duplication or enlarging, to manage a rapid influx of patients. This may include extra imaging capacity, supplementary waiting areas, and additional lifts to minimise the number of people using each car.

Omar Nadarajan et al. [2] observed how the COVID-19 pandemic highlighted gaps in the design and operation of EDs, which could impact patient care and staff

safety and create public health risks. In response, they propose a framework for ED design and workflow, to address the threats posed by infectious disease outbreaks, both now and in the future. This framework built upon four fundamental principles: (1) system—workflow, protocols and communication; (2) staff—human resources; (3) space—infrastructure; and (4) supply—logistics. In the pursuit of 'healthcare pandemic resilience', it is important to consider how additional spaces can be rapidly modified to provide temporary ED-intensive care units. Future strategies for providing pandemic resilience include the rapid provision of temporary facilities, This can be achieved by identifying and delivering flexible non-healthcare spatial environments that can be easily re-organised, to ensure adequate healing environment standards, even in a crisis. Flexibility and adaptability, "sectionable" units, multiple facility entry points, and rooms with direct outside access are additional suggested strategies. Furthermore, reconsideration of the design of waiting areas to respond to the specific needs of visitors and families, and the impact of salutogenic design on the stress levels of patients and staff, is critical [3]. Finally, the Danish Ramboll project provides case study examples of European hospitals which adapted in response to the Covid-19 crisis, and note the need for quick organisational responses that include:

creating entirely new modular hospitals, adding extensional spaces to hospitals, transforming existing hospitals or even transforming non-healthcare buildings, such as exhibitions halls, sports halls and convention centres into healthcare facilities, in some cases in only a matter of days [4].

2 The Importance of Healing Architecture

The healthcare system is inherently complex, with the ED delivering an amplified example of unpredictability and the need for dynamic and constant change. Historically, the regulatory, programmatic, and economic constraints of healthcare design provide barriers to accommodating this flexibility, leading to physical spaces that are inflexible, and not easily adaptable for alternative purposes. The design and construction of hospitals is immensely challenging, given the scale and complexity of the projects, expedited timeframes, strained budgets, and continuous and rapid advances in treatment and technologies. In response, some architects now draw on evidence-based design (EBD) practices, to scaffold their hospital design development. In tandem with an awareness of the ecological context (cultural, social, environmental), EBD practices incorporate research evidence; the practitioners design expertise; participatory co-design principles; and a high-level understanding of the organisational context, resources, population, and unique needs [5, 6]. To design resilient, adaptable, and pandemic-ready hospitals and EDs of the future, there is an emerging awareness of and sensitivity to the importance of healing architecture:

Healing design is highly important, or maybe even more important, during a crisis such as a pandemic... The adaptation of newly built hospitals, with

high-quality daylight and views, access to outdoor spaces and well-planned staff areas, have exemplified how flexibility goes hand in hand with healing architecture [4].

Our argument here is that, as hospitals and EDs are (re)designed in response to the pandemic, a healing architecture approach is critical. Also known as therapeutic architecture, healing architecture prioritises the thoughtful design and construction of buildings, spaces, and places, to promote physical, emotional, and mental well-being, and actively support healing. Healing architecture focuses on the design of indoor environment qualities such as natural lighting, ventilation, acoustic comfort, connection to nature, and the deliberate integration of colour, texture, and other sensory elements, to create calming, soothing environments. As Lawson explains, for our hospitals to become truly healing environments, they must be designed "in harmony with the care models and procedures themselves" [7, p. 107]. Lawson advocates for what he describes as the 'lofty' goal of architecture: "making places so well that people feel better" [7, p. 107].

We argue that creating truly healing spaces will require architects and designers to adopt what we term, a BaSE mindset: explicitly considering how each architectural design decision can purposefully integrate *Biophilia* (natural), *Salutogenesis* (healthy), and *Eudaimonia* (contentment) considerations and elements, to improve the physical and mental health of building occupants. As described below, the three components of the BaSE Mindset and integrated architectural design method, are:

- *Biophilic Architecture* purposefully engages with and integrates nature, to help to promote health and well-being as well as regenerative physical environments, while positively contributing to the earth's ecosystems (Kellert et al. 2011). Integrating Biophilic design results in positive outcomes including: increased productivity, focus, creativity and mental restoration, and reduction in absenteeism, low mood and poor health (Kellert et al., 2011).
- *Salutogenic Architecture* actively facilitates improved health and wellbeing rather than solely providing environments where illness is treated, or healthcare occurs. Through examining comprehensibility, manageability, and meaningfulness, salutogenic architecture provides human-centred, healthy, easily navigated environments.
- *Eudaimonic Architecture* inspires happiness, and a deep contentment with oneself and one's life, promoting human fulfilment and flourishing. Recognising that fulfilment does not always imply psychological wellbeing, eudaimonic environments help people to live well, through considering their experiences (how well a person feels), and functioning (how well a person does).

3 Biophilic Architecture: Element One of the BaSE Mindset

Edward O. Wilson [8] believed that "biophilia" is a fundamental human aspiration. People are attracted to life and nature, and this binds us to other living species. Some architects and designers extrapolate these beliefs to underpin the hypothesis

that natural environments attract people, and biophilic design attributes will be restorative and health-promoting. In the preface to a book of edited essays, Kellert, Heerwagen [9] examined the linkages between the built environment and the natural environment, and how these impact human experience and aspirations. Specifically, they were interested in how to "achieve sustained and reciprocal benefits between the two" Kellert, Heerwagen [9].

With its emphasis on health-promoting and restorative design, biophilic architecture helps to create a salutogenic healthcare environment. Kellert [10] proposed a list of 72 design attributes for a biophilic environment, covering six elements within two overarching biophilic dimensions—organic and place-based. Based on this work, McGee and Marshall-Baker [11] developed a unified language for salutogenic design and a Biophilic Design Matrix (BDM) to assess paediatric healthcare environments. Roger Ulrich, a pioneering advocate for biophilic design, argued that evidence clearly indicates how this approach to designing healthcare facilities improves occupant health outcomes. Furthermore, he contended that biophilia theory provides evidence that exposure to nature and sunlight in healthcare settings, will reduce stress, lessen pain, and foster improvements in other health outcomes. The practical implication is "that designing healthcare environments to incorporate nature and daylight can harness therapeutic influences... resulting in more restorative and healing settings for patients, family, and staff" [12].

More recently, Australian design researchers Abdelaal and Soebarto [13] take this further in proposing "restorative healthcare environmental design (RHED)". Based on findings from a study of the Royal Children's Hospital in Melbourne, Australia, they propose that "Healthcare environments can play a significant role in restoring the four types of human resources: physical, emotional, mental and spiritual". However, design criteria, guidelines and clinical functionality considerations usually focus on the physical types of human resources, and often pay scant attention to the other three domains [13].

4 Salutogenic Architecture: Element Two of the BaSE Mindset

While Antonovsky's term 'Salutogenic' (1979) is becoming mainstream in hospital design contexts, it is beginning to emerge in other architectural design contexts. Antonovsky described the need for a "sense of coherence" (SOC) to improve health and wellbeing. He believed that "...people who develop the salutogenic ability will live longer, perceive that they thrive in life and enjoy a good quality of life" [14]. Although this theory had little initial connection to the quality of the built environment, it has been increasingly applied in this context, in particular, to the design of healthcare environments. Salutogenic Architecture was developed from a model for socio-environmental influences on health, and actively facilitates improved health and wellbeing rather than merely providing environments where illness is treated, or healthcare occurs. For those promoting the concept, creating the built environment should similarly focus on the qualities that promote wellbeing for those using

it. These users encompass the clinical and other staff, the patients, and the broader community who visit or occupy hospital or healthcare facilities.

Using a salutogenic approach to designing healthcare facilities is increasingly claimed by healthcare architects and designers, yet it is often the subject of "marketing spin" by less knowledgeable designers and their clients [15]. Golembiewski [15] notes that salutogenic architecture has the potential to support enhanced patient manageability, comprehensibility, and meaningfulness. By synthesising these processes in a design, the architecture may also help a person through the natural process of recovery. Architecture can be psychologically manipulative, providing a narrative context which affects people's behaviour, how they are treated by others, and how they feel about themselves. Physical restrictions can be deliberately incorporated to moderate societal behaviour [16]. People are impacted psychologically and biochemically when correlating their emotions. Through examining *comprehensibility*, *manageability*, and *meaningfulness* [17, p. 26], salutogenic theory can provide a positive health dimension to architecture by designing human-centred, easily navigated environments.

Unfortunately, patient manageability usually triumphs over other factors, and therefore the opportunity to give or affirm meaning to patients challenged by fear, stress, and other negative emotions, is often missed. An emphasis on saving capital costs, at the expense of ongoing healthcare operational costs, means that aesthetic considerations often receive less attention and may be considered frivolous. Thus, traditional approaches to design, including preferencing functional efficiencies, are favoured over what may be better yet potentially riskier innovations [15]. Mazzi agrees with this perspective, suggesting that there is a misalignment of how scholars define the theory of salutogenesis and how architectural practice reflects it. She suggests "that design practitioners [should] consider salutogenesis as encompassing all theories related to the environment's impacts on wellbeing" [18].

5 Eudaimonic Architecture: Element Three of the BaSE Mindset

The study of wellbeing often focuses on the concepts of "eudaimonia" (with eudaimonia also spelled "eudaemonia" or "eudemonia") and "hedonia". Differentiating between these terms requires considering their commonly held definitions. Eudaimonia is frequently defined as "growth, meaning, authenticity, excellence" as distinct from hedonia, which may be identified as "pleasure, enjoyment, comfort, absence of distress". Both terms describe aspects of a life well-lived or a good life [19]. *Eudaimonia* was extensively espoused by philosophers Plato and Aristotle, when reflecting upon the qualities of good health, with the traditional translation being "happiness". Life's objective, according to these ancient thinkers, was to achieve *Eudaimonia*, best interpreted as fulfilment, human flourishing, or living one's best life.

Twentieth Century philosophers have reinvigorated use of the word, promoting that it adds an important perspective to understanding wellbeing, human fulfilment, and "flourishing", and providing a richer, broader interpretation of the narrower concept of hedonia or "happiness", which refers to pleasure, enjoyment, and the absence of discomfort. Hedonia is a subjective state. Eudaimonia refers to a process, that is, what is worth pursuing in life and its outcomes [19]. Recognising that fulfilment does not always imply psychological wellbeing, but rather, that people focus on living well and realising their full potential (Deci et al. 2008), eudaimonic environments help people to achieve this through considering their experiences (how well a person feels), and functioning (how well a person does).

Huta and Waterman's [19] classification system for analysing definitions of wellbeing consider *orientations, behaviours, experiences, and functioning*. The first two categories—*orientations* (what a person seeks), and *behaviours* (what a person does)—represent ways of living, what a person chooses to do in life. *Eudaimonic Architecture* principles align with the second two categories—*experiences* (how well a person feels), and *functioning* (how well a person does), typically considered wellbeing outcomes.

In terms of clinical care, Murtha, Stein et al. [20] discuss occupational therapy (OT) and applying a eudaimonic approach to OT practice. A eudaimonic method ensures that care is client-centred, providing meaningful activities, and investigating the meaning of wellness and happiness for individual clients. OT is a dynamic activity that encourages self-actualisation and improves a client's quality of life. Both hedonia and eudaimonia are concepts relevant to healthcare environments, and consistent with a salutogenic design approach. Eudaimonia was chosen for this study because it aligns with salutogenesis. It is also dynamic and works actively to engage occupants with the healthcare environment, to create a healing and supportive physical milieu.

6 Our HEAL Project

Grounded in an understanding of healing architecture, and our BaSE Mindset approach, this HEAL project interviewed over twenty clinical, nursing, and allied health staff across Australia, to better understand how they experience their EDs. The interviews focussed on *"what works and what doesn't"*, when considering the design of their ED spatial environments. The interview guide explicitly reviewed the entry, admission, triage, waiting, examination, treatment, recovery, and discharge or transfer areas, in addition to the staff work zones associated with each of these areas. Participants described: their experiences of working in different hospitals; the functionality of their ED environments during challenging times; and the diversity of patients presenting in EDs, with a recurring emphasis on vulnerable users. Recognising that the COVID-19 pandemic (and the introduction of new safety protocols such as social distancing, clear acrylic protective screens, assigned seating, prescribed circulation routes, and increased hand washing/sanitation)

would have an ongoing influence on ED design, we examined how their environments have changed in response to the pandemic. Finally, we asked our participants to suggest how architects could improve the design of EDs, and to explain their visions of an ideal future hospital work environment. Our participants were positioned in hospitals throughout Australia, which provided us with an insight into a range of environments, and different types of patients, that medical professionals encounter in urban, regional, and remote hospital settings.

7 What Works (and What Doesn't) in Emergency Department Design?

Clinicians described how the design and fitout of ED waiting rooms tangibly impacted the patient experience, with these features deemed as critical in enhancing the ED experience for consumers (see: Fig. 1; note, all figures developed by the project team):

- *an approachable, open and clearly visible/positioned triage desk;*
- *a children's play area where infectious disease contamination can be controlled;*
- *digital screens for education purposes and to communicate health advice;*
- *a taxi phone;*
- *phone chargers with multiple port adaptors;*
- *simple access to reliable and free wifi; and*
- *a waiting room nurse who is engaged to facilitate and improve communication with the patients and their families/carers.*

Wayfinding was often described as a 'challenge' which puts pressure on medical professionals who are already feeling over-worked and under-resourced. Wayfinding refers to the process of navigating and orienting oneself in a physical environment. It involves using various cues, signage, landmarks, and spatial information to understand one's location, determine a route, and successfully reach a desired destination.

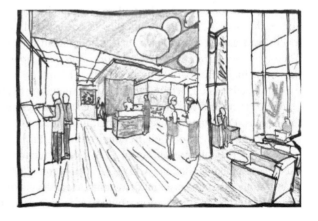

Fig. 1 Supportive environment, welcoming entry, helpful staff (concierge-type service), natural light, self check-in

Wayfinding is crucial in complex spaces like hospitals, to help people navigate effectively. Participants explained that *"currently it is like a maze. We need to have coloured lines on the floor or walls for people to follow"* and *"we would like to put these colour coded lines on the ground where we can say to family 'Follow the light blue line and you'll find the coffee machine at the end of it 'or 'follow the green line and you'll find the exit'. We can't do that in this hospital, so it is difficult to direct family and patients... they all have to be individually escorted inside if they've never been here before."*

Clinicians also valued consistency in design and equipment set-up, citing this as highly important in the ED setting: *"knowing where the buttons are, and not having to really think and look where you are means you can be on autopilot... it makes your job easier to have these uniform sort of panels."* Recalling past workplaces, 'hub-and-spoke organisation design' was perceived as the preferred and most efficient use of space—because of the visibility it provides, as well as the time saving in purposefully locating patients, equipment, computers and staff in a considered way. This organisational design model provides a networked approach to health service delivery. It is provided through a central anchor (hub) which offers a full array of health services, and which is complemented by secondary establishments (spokes) which offer specialised treatment services (see Fig. 2). A clinician explained: *"You can stand in the centre and you can look around you and see everything. Patients that you are in charge of and the equipment that you need. That's better."* In contrast, a 'modular pod layout' approach, where the ED is divided into distinct and separate areas, which are linked by a series of corridors, limited staff's ability to observe their patients continuously and uninterrupted.

Participants described how the Covid-19 pandemic had impacted their practice, with some positive changes cited. For example, one ED reconfigured the placement

Fig. 2 Building form enhances entry of light, surveillance/visibility, and access to external views

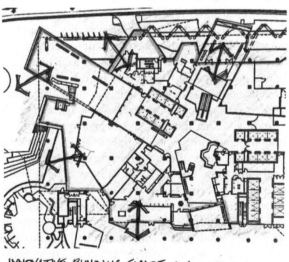

INNOVATIVE BUILDING SHAPE → ACCESS to LIGHT + VIEWS.

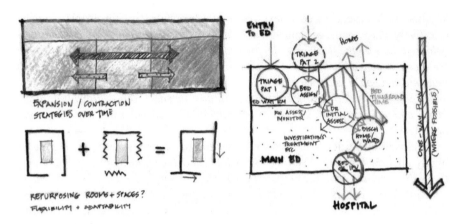

Fig. 3 Flexible use, expansion/contraction strategies, and repurposed spaces (left), incorporate one-way flows, where possible (right)

of the Paediatric Short Stay and Acute departments, to be located side by side, *"bringing all the paediatric nurses and doctors together as a team"* rather than them having to *"walk 50,000 meters between spaces."* An overarching concern was the importance of better meeting the needs of 'vulnerable patients' (including children, elderly, mentally unwell, neurodiverse, culturally and linguistically diverse a.k.a. CALD, and Indigenous peoples). Participants unanimously agreed that design solutions which meet the needs of vulnerable groups also benefit other patients, their families/carers, and staff.

Figure 3 illustrates how architectural design can positively influence the experience of work and care delivery, from thoughtful physical planning, (e.g., creating flexibility and one-way flows) to larger-scale master planning approaches. The architectural design diagrams shown in the Figures (drawn by one of the co-author's, Carthey) illustrate how—although typically unfamiliar with the terminology—participants placed a high value on healing architecture, and embraced the idea of a hospital ED space that was connected to nature (biophilic) (see Fig. 4), fostered health and happiness—especially by offering play spaces for children, and easy, attractive opportunities for clinicians and consumers to easily exercise—and created a positive, happy workspace (salutogenic and eudaimonic).

Ideally, design solutions should endeavour to address all BaSE Mindset considerations which are so closely interlinked. For example, this could be achieved by: (1) framing views of nature from major circulation routes; (2) designing architectural form to purposefully enhance the entry of natural light and ventilation; (3) ensuring that wayfinding is user intuitive to reduce episodes of anxiety and spatial disorientation; and (4) integrating sensory artwork in children's play areas [21].

Although this study concentrated on EDs, the results highlight that these spaces cannot be considered in isolation. Rather, it is essential to consider the department in its entirety, and the linkages and connections between this zone, and the other hospital departments—whether immediately adjacent or separated on a different

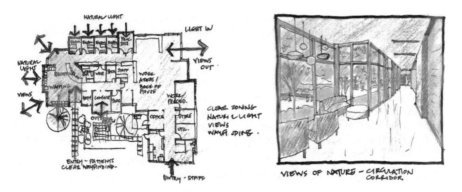

Fig. 4 Health promoting light, ventilation, clear layout, and access to views of nature in circulation corridors

floor or in a different wing. One of the study's limitations was that only staff members were interviewed, and they were asked mainly about their workplaces. If interviewees mentioned patients, it was generally in the context of accommodating their diversity, efficiency, quality and safety issues. Mostly, interviews tended to result in discussions of staff working practices and the environments that accommodate these. Notably, it was evident that there is significant potential for an application of the BaSE Mindset to improve the design of these spaces, and to address many of the concerns that were raised by the participants. While our project explored the critical staff perspective, future studies should ideally include patients in the data collection, to obtain a more balanced perspective on the issues that affect all users and occupants of hospital EDs.

References

1. Edwards N (2020) Here to stay? How the NHS will have to learn to live with coronavirus. Nuffield Trust. Available from: https://www.nuffieldtrust.org.uk/resource/here-to-stay-how-the-nhs-will-have-to-learn-to-live-with-coronavirus
2. Nadarajan GD, Omar E, Abella BS, Hoe PS, Do Shin S, Ma MH-M et al (2020) A conceptual framework for emergency department design in a pandemic. Scand J Trauma Resusc Emerg Med 28(1):118
3. Drumheller BC, Mareiniss DP, Overberger RC, Sabolick EE (2020) Design and implementation of a temporary emergency department-intensive care unit patient care model during the COVID-19 pandemic surge. J Am College Emerg Phys Open 1(6):1255–1260
4. Ramboll Foundation (2023) Pandemic resilience: space adaptation. Available from: https://c.ramboll.com/pandemic-resilience-space
5. Peavey E, Vander Wyst KB (2017) Evidence-based design and research-informed design: What's the difference? Conceptual definitions and comparative analysis. HERD: Health Environ Res Design J 10(5):143–156
6. Ulrich RS (2003) Building the evidence base for evidence-based design. In: Hamilton DK (ed) The four levels of evidence-based practice, vol 32008. Healthcare Design
7. Lawson B (2010) Healing architecture. Arts Health 2(2):95–108

8. Wilson EO (1984) Biophilia. Harvard University Press, Cambridge, Mass
9. Kellert SR, Heerwagen J, Mador M (2008) Biophilic design: the theory, science, and practice of bringing buildings to life, 1st edn. John Wiley & Sons, Inc., Hoboken, New Jersey
10. Kellert SR (2008) Dimensions, elements, and attributes of Biophilic design. In: Kellert S, Heerwagen J, Mador M (eds) The theory, science and pracitice of bringing buildings to life. John Wiley & Sons, New Jersey, pp 3–17
11. McGee B, Marshall-Baker A (2015) Loving nature from the inside out: a biophilia matrix identification strategy for designers. HERD: Health Environ Res Design J 8(4):115–130
12. Ulrich RS (2008) Biophilic theory and research for healthcare design. In: Kellert S, Heerwagen J, Mador M (eds) The theory, science and Pracitice of bringing buildings to life. John Wiley & Sons, New Jersey, pp 87–106
13. Abdelaal MS, Soebarto V (2019) Biophilia and Salutogenesis as restorative design approaches in healthcare architecture. Archit Sci Rev 62(3):195–205
14. Eriksson M, Lindström B (2014) The salutogenic framework for wellbeing: implications for public policy. In: Hämäläinen TJ, Michaelson J (eds) Well-being and beyond: broadening the public and policy discourse. Edward Elgar Publishing Limited, Cheltenham, UK
15. Golembiewski JA (2017) Salutogenic Architecture in Healthcare Settings. In: The handbook of Salutogenesis [Internet]. Springer International Publishing. [267-76]
16. Golembiewski JA (2016) The designed environment and how it affects brain morphology and mental health. HERD: Health Environ Res Design J 9(2):161–171
17. Golembiewski JA (2022) Salutogenic architecture. In: The Handbook of Salutogenesis, pp 259–274
18. Mazzi A (2020) Toward a unified language (and application) of Salutogenic design: an opinion paper. HERD: Health Environ Res Design J 14:1937586720967347–1937586720967349
19. Huta V, Huta V, Waterman AS, Waterman AS (2014) Eudaimonia and its distinction from Hedonia: developing a classification and terminology for understanding conceptual and operational definitions. J Happiness Stud 15(6):1425–1456
20. Murtha A, Stein F, Royeen CL, Stambaugh J (2017) Eudemonic care: a future path for occupational therapy? Open J Occup Ther 5(2):13
21. Seevinck J, Miller E, Baade K, Ridsdale G, Seear L, Douglas M (2024) Parrot murals and feather floors: co-designing playful wayfinding in the Queensland Children's hospital. In: Miller E, Winter A, Chari S (eds) How designers are transforming healthcare. Springer

Associate Professor Lindy Osborne Burton , from QUT's School of Architecture and Built Environment and Design Lab, worked as an architect for 12 years before moving to academia. Her teaching expertise is in Design, Professional Practice and Creative Research Methods, and her research is centred around innovative Health Architecture, transforming Aged Care Facility Design, and optimising Indoor Environmental Quality.

Professor Evonne Miller is Co-Director of the HEAL (Healthcare Excellence AcceLerator) initiative and Director of the QUT Design Lab. Professor of Design Psychology at Queensland University of Technology, Evonne is a leading voice on the value of arts and design-led innovation in healthcare transformation, bringing a collaborative, pragmatic, and fresh interdisciplinary approach to problem solving. She is the author, co-author, or editor of 4 books, exploring how we can create places that foster planetary and human health.

Dr Jane Carthey is an architect, project manager, and researcher who has worked in academia and practice for over 35 years. Her research interests include health care design user groups, the impact of climate change on healthcare facilities, flexible and adaptable hospitals, and post occupancy evaluation techniques.

Dr Scott Schofield (MBBS FRACP (PEM)) is a Paediatric Emergency Physician, and an alumni of the 2019 Clinical Excellence Queensland Healthcare Improvement Fellowship program. He has experience in multiple Australian and Canadian tertiary Paediatric Emergency Departments, as well as Paediatric Aeromedical Retrieval. Scott has a passion for clinical improvement, as the Emergency Department Lead for Quality and Innovation at the Sunshine Coast University Hospital.

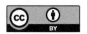

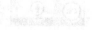

Transforming the NICU Environment for Parent and Staff Wellbeing: A Holistic and Transdisciplinary Supportive Design Approach

Sarah Johnstone, Evonne Miller, Anastasia Tyurina, Leighann Ness Wilson, and Abbe Winter

The importance of creating a supportive and positive environment in neonatal intensive care units (NICUs) has gained increasing attention over the past few decades. This paper explores the transformative impact of a holistic and transdisciplinary supportive design approach to the refurbishment of non-clinical spaces of a NICU environment on the wellbeing of parents and staff. Drawing upon the ongoing research on environmental design in healthcare, in this project the design team focus on strategies to promote positive experiences, rather than merely addressing the discomfort caused by negative aspects of the environment [5]. We also apply a holistic and transdisciplinary approach by considering the visual, spatial, and service experience aspects of design, and bring together individuals from diverse backgrounds, including parents, clinical staff, and a core design team with expertise across interior architecture, visual communication design, service design, and design psychology, to work collaboratively towards a common goal. While neonatal intensive care units draw upon medical expertise to prioritise the care of sick infants, this project applies design expertise to cater to a broader perspective which also encompasses family-centred care, and recognises the significance of supporting the wellbeing of all stakeholders involved in NICU care. In particular, this project acknowledges the importance of caring for the carers, namely staff and parents, and, while it was not a focus of this study, we also recognise that design transformations may result in secondary benefits for infant patients in the NICU, such as improved

S. Johnstone (✉) · A. Tyurina · L. Ness Wilson
QUT, Brissbane, QLD, Australia
e-mail: sarah.johnstone@qut.edu.au; anastasia.tyurina@qut.edu.au; lm.murray@hdr.qut.edu.au

E. Miller
QUT Design Lab, School of Design, Queensland University of Technology, Brisbane City, QLD, Australia
e-mail: e.miller@qut.edu.au

A. Winter
QUT Design Lab, Queensland University of Technology, Brisbane City, QLD, Australia
e-mail: a.winter@qut.edu.au

© The Author(s) 2024
E. Miller et al. (eds.), *How Designers Are Transforming Healthcare*,
https://doi.org/10.1007/978-981-99-6811-4_5

77

caregiver morale and attentiveness, which can positively impact the quality of care provided to the infants.

The following sections of the chapter offer a brief overview of the project aimed at transforming an urban Neonatal Intensive Care Unit through a holistic and transdisciplinary supportive design approach. It also outlines the strategy for engaging with staff and parents, and discusses the Theory of Supportive Design and its application for the design approach. Finally, six supportive design concepts are presented for transforming the Case Study site, along with a reflection on the challenges and limitations of a holistic and transdisciplinary supportive design approach for creating change within a NICU environment.

1 Engaging Differently

One of the first considerations for involving staff and families of a NICU environment in the design process is their capacity to be involved and designing bespoke engagement strategies which meet the unique needs of both user groups. In this project the design team drew upon our experience on a similar project in a *Paediatric Intensive Care Unit*—see Chaps. 3, 17, and 20 [1–3], where we discovered the challenges of designing engagement methods for unpredictable settings. In intensive care settings like PICUs and NICUs, each day is different, as a patient's health can change suddenly, causing staff and parents to move into action—responding to the ever-present patient monitoring alarms.

While workshops are a common tool for co-design, they are not something that staff can necessarily commit to, and do not account for how parents or other family members might be feeling on a particular day.

Therefore, in this project, we built upon the strategy used in the PICU project chapter "'It Takes a Village': The Power of Conceptual Framing in the Participatory Redesign of Family-Centred Care in a Paediatric Intensive Care Unit" [2] involving a bespoke 'marketplace' engagement strategy, which involves setting up mostly self-guided activities in a visible, yet unobtrusive area of the ward to encourage engagement from staff and families, with the design-research team being available to speak to those who wish to engage and giving space to those who do not (see Fig. 1).

The engagement activities comprised three parts:

1. The first part was **Static Interaction Displays,** located in the staff tearoom for staff and in the marketplace for parents. These displays took the form of a **Dot Plot,** where participants placed a dot on the item that they feel could improve the NICU spatial experience the most.
2. The second part consisted of **Guided Activities**, including a **Tree Installation** (Fig. 1—top) where participants responded to six different questions. Additionally, there was a **Photo-Talk** activity (Fig. 1—middle) where participants wrote their perspectives and ideas on printed photos of the current space.
3. The third and final part is described as **Designer Interaction**, which involved inviting staff and families to have an **Unstructured Interview** (Fig. 1—bottom) with a member of the design team or go on a **1:1 Walk-shop**. During the walk-

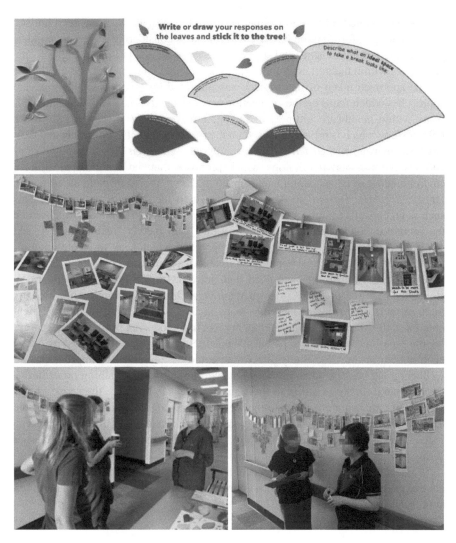

Fig. 1 Tree installation (top), photo-talk (middle), and unstructured interviews & walk-shops (bottom)

shop, a member of the design team took a participant to designated areas throughout the unit to gather feedback based on an embodied response to the environment.

2 A Holistic & Transdisciplinary Approach

While the origin of the term 'holistic design' is unclear, especially given its use across various fields and disciplines over time, its use in the context of healthcare design has increased significantly in recent years, where it refers to a comprehensive and integrated approach that takes into account physical, psychological, and social

factors to promote healing and wellbeing [4]. In this project, we interpret a holistic approach to transforming the NICU environment as considering the complex interplay between spatial, visual, and service experience factors in the redesign of various spaces within the unit, and understanding how they may impact one another.

The approach taken in this project was informed by a variety of theories and approaches which focus on the connection between environmental design and wellbeing within healthcare settings, including: *Environmental Psychology* [5, 6]—a field of study which is broadly focused on the relationship between people and their physical environment; *Ulrich's Theory of Supportive Design* [7]—a specific theory within environmental psychology which proposes that the design of healthcare environments can have a significant impact on the wellbeing of patients, staff, and family; *Biophilic Design* [8]—an approach which incorporates natural elements such as green walls to impact on wellbeing; *Salutogenesis* [9]—a theory focused on the promotion of health and wellbeing rather than merely treating illness; and *Evidence-Based Design* (EBD) [10]—an approach which seek to create environments based on the practical application of theories and research data.

We describe the design approach and outcomes taken in this project, as an '*Evidence-Based Holistic & Transdisciplinary Design Approach*' informed by Supportive Design principles. While many studies on this topic focus on patient outcomes, this project takes a different approach, by focusing primarily on improving the experience of staff and parents. While there are aspects of the existing NICU environment at the Case Study site which could be addressed to improve patient wellbeing and healing outcomes (such as redesigning patient bathing procedures), the complexity of responding to these meant that it fell outside the scope of this project. In narrowing our focus to the wellbeing of staff and parents, we were able to shift away from the design of 'health'-care for the treatment of illness, and instead focus on factors which provide support, 'humanise' the environment, and foster 'Care' [1] in accordance with a Salutogenic approach.

In practice, in addition to the clinical perspectives of staff, and the lived experience of past and present parents, this approach is applied through three main design approaches including *Spatial Design*, *Visual Design*, and *Service Design*:

2.1 Spatial Design

In this project we applied our skills in Interior Architecture to redesign specific spaces to enhance its functionality, usability, and aesthetics, while also being tailored to the specific needs and goals of the users, whether that be parents or staff. In this project, the design of interior spaces involved the redesign of existing spaces including planning, arranging, and reorganising of zones and elements of the space, designing new joinery, and the selection of materials, finishes, and furnishings.

[1] 'Care' with a capital C, represents a broader concept than that of the medical definition, instead referring to the provision of what is necessary for the health, welfare, and maintenance of a person. 8. Johnstone S. Enhancing ecologies of care for CALD women through care-full creative engagement: Queensland University of Technology; 2021.

2.2 Visual Communication Design

This field of design incorporates a broad array of approaches which are used to convey ideas and information. In this project we draw upon our skills in graphic design, branding, image making, and information design through the use of colour and artworks to enhance functional aspects such as wayfinding and creation of an aesthetically cohesive environment.

2.3 Service Design

While service design is typically concerned with the end-to-end 'customer' journey experience, in this project we draw upon service design approaches to narrow in on specific opportunities to improve upon or create better touchpoints to meet the needs and expectations of parents.

3 Developing Solutions with Cross-Benefits for Parents and Staff

One of the ways in which this project responds to a holistic approach is through the development of design solutions which have cross-benefits for both staff and parents. The aim of this project was to design a family-friendly environment that supports family-centred care with an awareness of the impact that such changes would also have on the wellbeing of staff. While we were motivated to find solutions that were specifically aimed at improving the experience of staff, the findings from our engagement indicated that staff were mostly invested in solutions that would improve the wellbeing of parents. This could be attributed to a felt sense of responsibility from staff to provide an environment which reflects the high level of care that they deliver. This is reflected in research that explores the influence that the physical space has on the perceived level of care being delivered, a phenomenon that can felt by both parents and staff. While hospital staff have limited control over the physical environment of hospital spaces, there have been various studies [11–13] which reveal that, regardless of how much control staff actually had over the physical environment, patients believed staff to be at least partially responsible or to have the ability to take some actions to improve the environment. The overall importance of the appearance of hospital spaces was evidenced in a study by Arneill and Devlin [12], who discovered that perceptions of care were greater in attractive spaces than in those which were cold and outdated. During our stakeholder engagement process with staff and parents, we discovered evidence of this phenomena from healthcare staff, rather than parents, and their concern over how they might be perceived by parents for their felt sense of responsibility over factors which they shouldn't necessarily be responsible for.

A felt sense of responsibility can become an emotional, financial, and time bur-den for healthcare staff. During our experience at the Case Study site, we could sense how this perceived feeling of responsibility contributed to feelings of shame, guilt, and anxiety amongst staff. This was evidenced in a conversation about the existing kitchen, when one of the staff stated, *"it's not a space we're proud of"*. We also observed where staff were using their own money to purchase artworks, deco-rations, and even sculptural trees to create seasonal activations and 'brighten the space up'. Finally, we witnessed the burden of time where staff took on additional workload, researching options to upgrade the space and applying for funding—on top of their existing work commitments. We realised that offering design concepts and details to revamp the unit, even if it is solely for family areas, not only reduces the workload on staff but also has the potential to improve their wellbeing. Other studies have discovered that improving the physical environment in healthcare facil-ities like NICUs, beyond providing a more familiar and inviting atmosphere for families, can impact both the behaviour and mood of healthcare staff, potentially influencing patient outcomes [11]. Therefore, the project aimed to improve the pro-vision of support services in the ancillary spaces of the existing unit most utilised by parents and families, including the main entrance corridor, parent kitchen, lounge, and craft areas, as well as the conference and x-ray room.

4 Supportive Design Theory for Neonatal Environments

The design team's response to designing a supportive environment in the Case Study site—an urban NICU, was identified, defined, and justified in alignment with the feedback gathered by our own engagement with staff and families, in addition to the Recommended Standards for NICU Design [14], and Supportive Design Theory.

In his *Theory of Supportive Design* [15], Roger Ulrich—a leading expert in evidence-based healthcare design, cites three factors for designing environments which provide support coping with stress and promoting wellness: (1) Perceived Sense of Control, (2) Positive Distraction, and (3) Social Support Opportunities. A description of these and their application in this project is explained further below.

4.1 Application of Theory: Perceived Sense of Control

According to Ulrich, "humans have a strong need for control and the related need of self-efficacy with respect to environments and situations" [7, p. 100]. However, studies suggest that parents of infants in NICU often feel a lack of control and inde-pendence, which can lead to feelings of helplessness [16]. The NICU environment, with its unfamiliar rules and regulations (e.g., scheduled visiting hours), can con-tribute to these negative emotions, as parents may feel restricted in their ability to care for their child and be in their primary caregiver role. The hospital environment

can often exacerbate these feelings, as parents may struggle with wayfinding, resulting in feelings of agitation, disorientation, and a loss of control [17, 18]. Carter explains that finding solutions to mitigate these negative emotions and create a sense of control for parents, "without actually allowing complete authority, is critical" [19, p. 19].

In order to minimise feelings of helplessness and dependence, and promote feelings of control and independence, Carter recommends applying environmental elements that provide users with 'autonomy, a sense of routine, self-efficacy, and choice' [19, p. 18]. In addition to a clearly articulated wayfinding design, enabling the regulation of room temperature, lighting, and amenities such as television and acoustic systems are common recommendations for cultivating an increased sense of control. Unfortunately, in this project, the building design limited our ability to enable occupants to control temperature, lighting, and sound. Instead, we explored opportunities to enhance their sense of control by humanising the environment, an approach with clear psychological benefits for parents in the care-giving process. While a 'cold and hostile' environment may potentially increase psychological discomfort for parents, a 'warmer and human-friendly' environment could reduce environmental stressors and facilitate emotions that support the healing process [16].

There are obvious limitations on how the nursery spaces within the NICU can be humanised. While parents may personalise small pockets of space with photographs, artwork, and mobiles above the open cribs, these spaces are inherently clinical environments with restrictions in relation to the furnishings and finishes which are allowed to be used. However, there are opportunities to humanise non-clinical parent spaces. Oftentimes, parents may need to step away—take a break or have something to eat, and may not necessarily want to go all the way home. Having a space within the hospital is important, but it does not mean that it should look and feel like a hospital. Family spaces in the Case Study site, including the parent kitchen and lounge, and the parent craft rooms, are an opportunity to create a retreat from the rest of the hospital–somewhere that feels more like home, where parents can feel a sense of ownership over the space and create familiar routines e.g., make a coffee, heat up a meal, or even take a nap.

4.2 Application of Theory: Positive Distraction

While parents' attention in NICU settings will undoubtedly be focused on their child, creating opportunities for parents to have mental breaks, zoom-out, and nurture self is important. There are two main concepts within environmental psychology to describe this, one is 'cognitive refocusing' a coping strategy or technique which directs attention away from negative thoughts to positive or neutral ones, the other is the 'distraction effect', specifically one that is positive [16]. According to Shepley [5]—a leading expert in evidence-based design for healthcare, 'positive distraction' strategies present an opportunity for NICU settings to enable parents to

temporarily redirect their attention from negative healthcare surroundings to more restorative non-medical features such as artworks or views of nature.

There are a number of ways to support positive distraction in the NICU environment, including both mental and physical escapes through going for a walk, taking time to eat and sleep, maintaining relationships with friends or co-workers, and even doing daily tasks such as preparing food or doing the laundry [19]. In this study, we looked for opportunities to design for positive distraction, particularly using colour and artworks of nature.

Colour can be a useful tool to not only provide visual interest and distraction, but also to aid in wayfinding [17, p. 50]. According to a review of literature conducted by the Research Centre for Primary Health Care and Equity in NSW, "building cues and architectural features provide significant prompts, and are more powerful than signage for wayfinding" [17, p. 51]. This is useful in the context of this study, where signage is controlled by the broader hospital, relying on us as a design team to find alternative methods to enhance wayfinding. The research literature also states that "colour should be used as a cue in wayfinding for simple zoning of no more than four main areas of a building" and that "the colours should be easily recognised by their descriptive words (for example blue, red, yellow)" [17, p. 51].

In addition to colour, the provision of art and views of nature are also commonly cited in literature as sources for positive distraction in healthcare environments. Unfortunately, the existing unit was in short supply of views out of the unit, yet alone art, presenting a need to fill this gap, ideally through artworks of nature. Fortunately, there are a large number of studies which support the benefits of pictures, photographs, and videos of nature, and confirm that such images are associated with positive health outcomes, in addition to having benefits for staff [17, p. 42]. The use of images of nature for positive distraction, creating a restorative experience, and humanising the healthcare environment is also referred to as 'pictorial humanisation' [16]. This was the focus of a study in Italy in 2014 which sought to understand the impact of pictorial humanisation for reducing the sense of unfamiliarity by infants' parents, and improving the level of parental distress and affective perception of the NICU environment [16]. Despite showing no differences on parental distress, the parents in the study reported an improved perception of the NICU environment as more 'pleasant', demonstrating the usefulness of images for positive distraction and creating a welcoming environment for both parents and staff.

4.3 Application of Theory: Social Support Opportunities

Being a parent in NICU can be both an isolating and unfamiliar experience. While this is the case for most hospital environments, the NICU unit is a particularly foreign experience, which most parents are introduced to suddenly during the often emotional, stressful, and in some cases traumatic period following the birth of their child.

Research indicates that during the perinatal period, parents (particularly mothers) are at significant risk of developing perinatal generalised anxiety disorder [19],

post-traumatic stress disorder [20], and post-partum depression [21], that could persist for a long time after discharge [16, p. 2]. As so pertinently described by Carter, while a mothers' continual presence in the NICU is seen as crucial to patient development, it "may comprise her own wellbeing" [19, p. 13]. The evolving knowledge on the important role of mothers for patient care has been recognised in the ninth edition to The Recommended Standards for NICU Design [22] which suggests a range of recommendations to further integrate mothers within the NICU care delivery model.

Early in the project we identified the potential to use design strategies to influence the recovery and wellbeing of parents so that they don't go home 'broken', as a clinician told us they often do. Drawing on Ulrich's Theory of Supportive Design, Carter explains that designers can "influence recovery by creating spaces that promote wellness and are 'psychologically supportive'" [19, p. 18], indicating the potential for the redesign or repurposing of hospital spaces to enable parents to begin the process of emotional recovery during their time in hospital, while they are surrounded by healthcare professionals and other parents going through a similar experience.

In this study, we approached this by designing 'experiential' service design solutions through identifying opportunities to improve upon the utilisation or function of existing spaces to facilitate social support activities. The major challenge of this project was the limited available space, which required that existing spaces become more flexible to facilitate multiple purposes. Two such spaces were identified: the X-ray Room and the Conference Room.

5 Transforming the Neonatal Unit: An Overview of Six Supportive Design Concepts

After conducting research and engagement, a long list of possible design concepts was created. However, due to limitations such as budget, timeline, and feasibility, not all concepts could be pursued. A negotiation process was undertaken to determine which concepts were achievable and most critical. From this process, six design concepts were chosen and narrowed down for further development. Table 1 below outlines the selected design concepts and demonstrates how each concept aligns with the three factors of Supportive Design Theory.

5.1 A Place for Parents: Re-Designing the Parent Hub for Dining, Working, and Resting

This initiative focused on a redesign of the parent hub spaces, comprising both the parent kitchen and parent lounge, to create a distinct place for parents to dine, work, and rest. Both spaces required updates, particularly the kitchen, to ensure that they are not only functional, but also welcoming and comforting. This ward is home to

Table 1 Application of supportive design theory to the six design concepts

	Sense of Control	Positive Distraction	Social Support
A Place for Parents: Re-designing the Parent Hub for dining, working, and resting			
From Parent Craft to Parent Retreat: Transforming the Parent Craft into a 'home away from home'			
Placemaking and Creative Wayfinding: Creating zones and a sense of identity for the neonatal unit			
Bringing the Outside-In: Fostering connection to nature through photographic artworks of Australian native flora			
Creating a Comforting Place for Private Conversations: Re-imagining the Xray Room			
Creating a Place for Connection: Re-imagining the Bobby Bevan			

the families for the duration of their baby's care. For some that is a week or two, but for many it can go on for months—long days that need to be supported with warm, comforting facilities that make the families feel valued, cared for, and nurtured.

The existing parent kitchen (Fig. 2) has a worn, tired aesthetic, and though improving wayfinding will help parents find this space, when they do, they may feel underwhelmed. The lighting and colours in this space make it look and feel like an extension of the hospital. It is not a space that staff feel proud of show to new parents on ward tours, in fact many told us they feel embarrassed. The colours and cool lighting are uninviting, there is underused storage, closed cupboards used to store outdated documents and other resources with no apparent home, flaking chipboard on the inside of cupboards, and there is often also broken furniture and equipment lurking in this space. For the kitchen, we proposed a full refurbishment with a reconfigured parent kitchen, new joinery, a new café-style dining space to seat more people, a work pod, and a warmer colour palette.

Unlike the kitchen, the parent lounge (Fig. 3) had recently had a refurbishment, with new timber-look flooring, artworks, fresh paint, and new lounge seating, all done in memory of a colleague. While these changes were an improvement, the lighting and furnishings still made the space feel like an extension of the hospital. There was nothing in the space for siblings, and when we spoke to families, we found that not many use it regularly. Therefore, in the proposed parent lounge (Fig. 3—bottom) we proposed some aesthetic upgrades to make the space feel much warmer and more welcoming, including a lounge in an earthy orange colour where parents can rest or nap, a work pod to enable parents to work or access the internet, or even for siblings to do their homework (which we heard some do). For the siblings, we also propose some floor pads in the centre of the space that can be stacked away or left out, a mural or sensory wall, and a shelf for books, toys, and plants. In addition to the earthy colours, we also proposed timber veneer ceiling tiles and warm lighting to soften the space and distinguish it from the rest of the hospital.

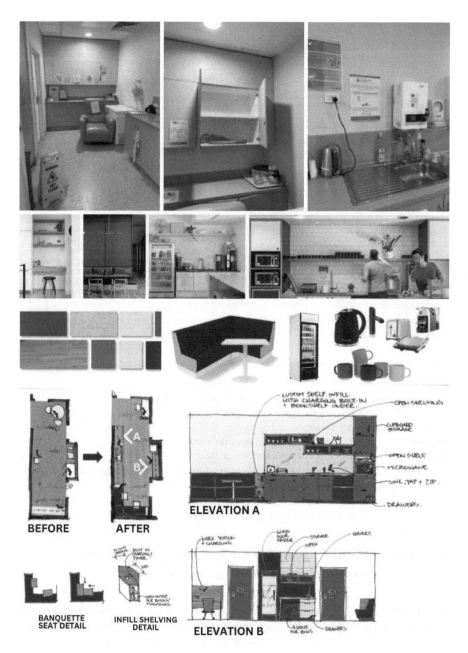

Fig. 2 Existing kitchen (top), proposed kitchen mood board (middle), and proposed kitchen design (bottom)

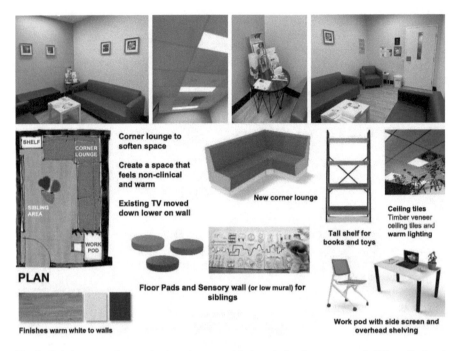

Fig. 3 Existing parent lounge (top), and proposed lounge design for parents and siblings (bottom)

Sense of control	• Comfortable and moveable seating in the dining area.
	• The new design of both spaces creates a distinct family zone to use how they please.
Positive distraction	• In the lounge there are artworks and a library.
	• In both the kitchen and lounge there are work pods.
Social support	• The proposal for the lounge area fosters more social support with a large corner lounge and floor pads for play.
	• The new café-style dining space in the kitchen can host more people.

5.2 From Parent Craft to Parent Retreat: Transforming the Parent Craft into a 'home away from home'

The Parent Craft was another space that needed to be transformed to create a 'home away from home' for parents at what is hopefully, the last stage in their journey before taking their baby home. The NICU Standards suggest that 'Family Transition' room(s) be provided which enables families and infants some time together to prepare for the transition from hospital to home prior to discharge, with access to sleeping facilities for both parents and bathroom facilities [22]. In the urban NICU Case Study, these spaces are referred to as 'Parent Craft' rooms and include two separate rooms, each accessed from the parent kitchen space, with a shared ensuite bathroom. While these spaces are a fantastic facility, the existing spaces are worn, tired, clinical, and underwhelming, and in much need of aesthetic upgrades to make the space more homely,

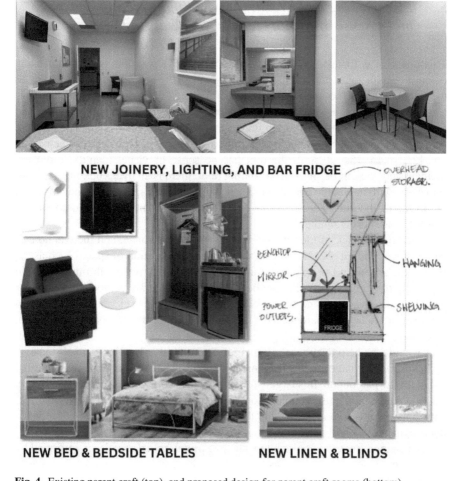

Fig. 4 Existing parent craft (top), and proposed design for parent craft rooms (bottom)

and a retreat from the rest of the hospital. Though the doors to these spaces are often closed, the experiences of neonatal families as they leave the ward need also to be nurturing and comfortable. Our intention with this space was to create a homely hotel suite, replacing hospital furnishings with furniture that wouldn't be out of place in any home, replacing aluminium blinds with new block-out roller blinds, and all new joinery—relocated to the entry—just as you would have in a hotel, enabling the seating area to be positioned by the window and natural light (Fig. 4).

Sense of control	• This is a private space for parents to spend time with their baby to become familiar with breastfeeding and feeding cues, away from the other areas of the unit.
Positive distraction	
Social support	• While these rooms are private, as they are located within the hospital, they enable parents to have access to the support and guidance of staff when needed.

5.3 Placemaking and Creative Wayfinding: Creating Zones and a Sense of Identity for the Neonatal Unit

This initiative is focused on placemaking and creative wayfinding solutions using colour to create zones and a sense of identity across the neonatal unit. According to the International Standards for the design of neonatal units, the design of the entry and reception areas should "contribute to positive first impressions for families and foster the concept that families are important members of their infant's health care team, not visitors", and highlights the importance of signage and art for achieving this [22, p. 14–15]. Overall, the unit has no sense of visual identity. From the moment you walk through the front sliding door, there is an overwhelming sense of sameness, with no visible change in the appearance of the space from the outside to the inside of the unit. The space has been described by both staff and parents as clinical, cold, boring, and dull.

In addition to lack of identity, there is also limited signage, and there is no evidence of wayfinding cues to indicate the location or direction of spaces such as the parent kitchen, or aid people in intuitively directing themselves through the unit, especially for someone who has not been there before. We were shocked, yet unsurprised, to discover that one parent had been there for 6 weeks before they knew there was a kitchen for parents. This is a very stressful time in a parent's life, and, as someone shared with us during our engagement, the current space is not helping. This would also help to support parents for whom written English is an obstacle.

In this case, signage was the responsibility of the hospital, and while we requested a sign for the parent hub, this largely fell outside the scope of this project. Therefore, we recommended the use of colour to create zones through the space to enable parents to have some orientation within the space without the explicit need or reliance upon signage.

As a change from the cool white walls, we proposed warm colours informed by an Indigenous artwork which was scheduled to be installed in the outside corridor leading to the entrance to the unit. In this scheme colour could be used to identify or 'zone' the family spaces throughout the unit such as the Expressing Room, the entrance to the family hub from the entrance corridor, and the Xray room. Ideally, this would enable staff to tell parents "look for the orange walls" or "follow the corridor until you reach the orange wall". While the mock-up images don't show the full concept, the proposal for updating these spaces and transforming the identity of the unit also includes new carpet and ceiling tiles, and new artwork throughout.

Sense of control	• Wayfinding tools enable parents to have an enhanced spatial awareness and enhanced their ability to navigate the space and minimise the need to ask for assistance.
Positive distraction	• The use of colour provides a distraction by distinguishing it from other spaces.
Social support	

5.4 Bringing the Outside-in: Fostering Connection to Nature through Photographic Artworks of Australian Native Flora

As previously stated, the corridors of the unit, particularly throughout the main entrance are bland and clinical, as can be seen in Fig. 5 (top images). In this project, we recommend the use of photographic floral art to bring the outside in. The unit has only one window with a decent view out of hospital, and although many people visit this window, beyond that, there is very little opportunity for positive distraction. In terms of artwork, in the corridors of the clinical spaces (Fig. 5—bottom), staff have supplied artwork to help brighten the place up, but the styles are inconsistent, from a moody photograph of koalas to a bright illustration of cacti, most of which are mostly camouflaged by other visual paraphernalia. In contrast, the corridor of the main entrance has walls entirely blank, and, as a parent described it to us, it does not celebrate life.

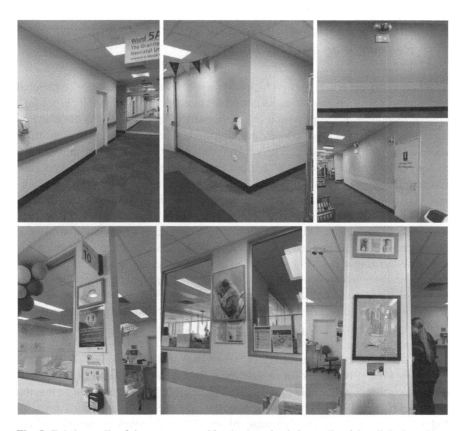

Fig. 5 Existing walls of the entrance corridor (top), and existing walls of the clinical corridors (bottom)

Our solution was to display nature-themed artworks, particularly photographic artworks which respond to both the need for view of nature, in addition to artworks for 'positive distraction'. In addition to bringing nature into the unit, the artworks also celebrate life and diversity. We are inspired by the lyric 'from little things, big things grow' which reflects the hope that parents have for their infants, and the way that could be represented through art in the form of seedpods and flower buds. In reference to the medical setting, we also recommend selecting photographs which use a style emblematic of Xrays and other medical imaging techniques.

Sense of control	• The use of artworks helps to humanise the hospital environment and contribute to making the spaces feel less clinical and more familiar to parents to enable them to feel more comfortable within the space.
Positive distraction	• The artworks contribute to positive distraction through 'pictorial humanisation' and provide additional access to views of nature through art.
Social support	

5.5 Creating a Comforting Place for Private Conversations: Re-Imagining the Xray Room

Standard 16 of the NICU Design Standards responds to the 'extensive' emotional and psychological challenges experienced by families and staff in NICU settings [22]. It recommends the provision of a dedicated support space with comfortable furnishings for counselling services, grieving, and other private conversations, to be accessed by family and staff [22, p. 26]. Unfortunately, the existing unit did not have a designated space for these activities. Furthermore, we discovered from our research that parents are often having 'private' consultations with staff in the hallway in earshot of other parents, and staff we spoke to were concerned that overhearing bad news might be distressing for other parents. We also discovered that there was no dedicated space within the unit to grieve or process heavy emotions. In our design proposal, we identified the 'Xray Room' as a space which could service this gap. The existing space (Fig. 6—top) is a small, internal, non-parent, hospital-controlled space which is used for hosting morning meetings, clinical discussions (over Xrays and other results), and some parent consultations. However, the existing conditions of this room are not great. We identified an opportunity to turn this into a quiet space that can hold parents in these extra difficult times and allow them to feel safe and secure.

Our design solution is two-fold: (1) rebranding of the room, and (2) aesthetic upgrades. Firstly, being known as the 'Xray Room' does not reflect the types of discussions that could be held in this space, and therefore we recommended that the room be renamed to something such as the *'Dadirri'* Room—named after an Indigenous word from the language of the Ngangikurungkurr people, which describes the Aboriginal practice and philosophy of 'deep listening' based on

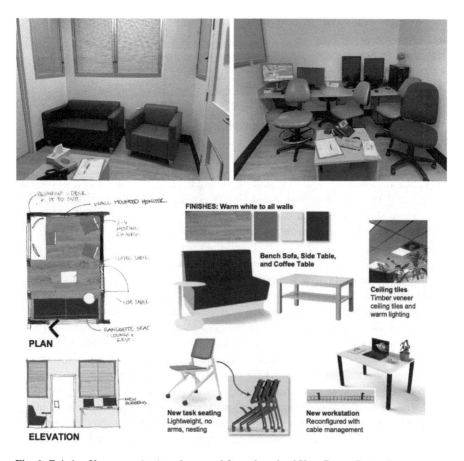

Fig. 6 Existing Xray room (top), and proposal for re-imagined Xray Room (bottom)

respect, inner quiet, still awareness, and waiting [23]. As part of this rebranding, we recommended that this room become more accessible for families and staff when they need a short break from the intensity of the ward, and for facilitating private conversations (e.g., counselling sessions) with speech privacy. [2] Secondly, we proposed a reconfiguration of this room, with new furnishings that reduce the cluttered feel, and promote a softer, more nurturing environment (Fig. 6—bottom).

Sense of control	• The reimagining of this room as the Dadirri room provides parents with a sense of control by providing a place of their own that they can retreat to if and when they need.

[2] Speech Privacy refers to "methods used to render speech unintelligible to the casual listener" 12. Consensus Committee on Recommended Design Standards for Advanced Neonatal Care. NICU Recommended Standards. University of Notre Dame,; 2019. p. 46.

Positive distraction	
Social support	• This room enables parents to get support from staff or spend time with extended family in a private space away from other parents.

5.6 Creating a Place for Connection: Re-Imagining the Conference Room

Providing resources to support parent wellbeing is extremely important. According to Standard 18 of the Recommended Design Standards for Newborn ICU Design [22], a unit should provide a dedicated family education area so that families can learn about health conditions, child development, and parenting issues, in addition to providing parent-to-parent support, and the resources to learn about—and practice—caregiving techniques. However, in the existing unit, there are limited spatial opportunities for facilitating wellbeing or educational sessions for parents.

While the neonatal unit display an abundance of resources and information to support parental wellbeing on various information boards, we discovered that parents don't look at these, and prefer to seek out information from other families—whether that be from other families in the unit, or in online forums. Families shared that hearing stories of other families makes the feel less alone. We also discovered that once a week a volunteer of Life's Little Treasures Foundation was running 'NICU Connections' sessions for parents in the kitchen space, and experiencing the challenges of hosting a morning tea at a small table in the corner which can only fit 2–3 people at a time. The ability to host social activities in this space is further complicated by its location outside of the parent craft rooms where people are expected to keep noise to a minimum.

The NICU standards state that "in order to be present and functional, parents need (at a minimum), rest, good nutrition, psychosocial and educational support, access to social networks, and a way to address everyday needs efficiently" [22, p. 13]. In this project, we envision a space which can host a broad range of information to support parent wellbeing including existing programs such as NICU Connections and new programs focused on nutrition, Baby First Aid training, mental health sessions with visiting psychologists, sessions for dads, and massages for parents and staff.

The conference room of the Case Study site is primarily used by staff for meetings and training sessions. However, during our engagement we discovered that the space was also being used to run lactation information sessions with parents. We identified an opportunity to use this space for other parent and wellbeing-focused sessions. While the existing space is functional, it is clinical like the rest of the unit and not a space where parents would feel comfortable, as evidenced in the images on the left of Fig. 7. Therefore, in this project, we proposed that the existing staff training and conference room be reinterpreted in a similar way to the Xray Room proposal, with a vision to at-minimum broaden the utilisation of the space, and

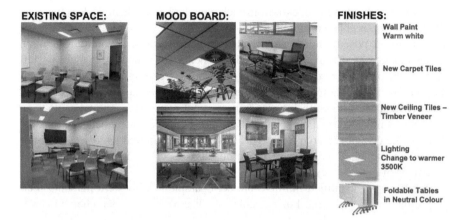

Fig. 7 Design proposal of Case Study Conference Room

at-best make cosmetic changes to improve the feel of the space (Fig. 7—*Mood Board and Finishes*).

Sense of control	• Educational programs for parents such as baby first aid training, and information sessions on sleep and nutrition will foster a sense of control over their own health and equip them with information to help them care for their baby once they take them home.
Positive distraction	• Other programs and services such as craft activities, massages, and social activities can provide parents with a momentary break to focus on their own needs.
Social support	• Providing a larger space for programs such as NICU connections will enable more of the parents to get to know one another, in addition to getting additional support from visiting healthcare professionals and service providers.

6 The Challenges and Limitations of a Holistic & Transdisciplinary Supportive Design Approach for Creating Change within a NICU Environment

In this project, we recognise the challenges and limitations of trying to create change and address complex design problems in environments such as healthcare, which often require input from multiple fields, beyond that of clinicians and consumers. However, we also recognise that a collaborative approach is necessary, and that non-design experts can contribute unique perspectives and knowledge to the design process, leading to more holistic and effective design solutions that address the needs and concerns of all parties involved. Collaboration also fosters innovation and

creativity, as individuals can learn from each other and generate new ideas that may not have been possible working in isolation.

This project posed a number of challenges that extended beyond navigating a complex landscape of stakeholders and departments. In particular, changes in staff roles and the presence of multiple project champions operating in silos created additional complexities that required careful management. Specifically, we encountered a change in staffing when the service improvement manager's contract came to an end and was replaced by a clinician who volunteered as a liaison between the hospital and the design-research team. This shift in roles required us to establish new lines of communication and adapt our approach to accommodate the strengths and limitations of our new key stakeholder.

Moreover, we identified multiple project champions who were pursuing their own initiatives in isolation. For example, we discovered that one champion was pursuing a project involving digital signage and ceiling tiles, while another had already ordered new beds for the parent craft rooms without consulting with the design-research team. These siloed efforts created redundancies and inefficiencies in the project, and required us to engage with the champions to better understand their goals and ensure that their efforts were aligned with the broader project objectives. While having enthusiastic healthcare partners who are eager for change is a positive, the presence of multiple project champions and changes in staff roles underscores the challenges of managing stakeholder engagement in a hospital environment. It also highlights the importance of clear communication, collaboration, and coordination in order to achieve meaningful and sustainable service improvements.

Given the limited budgets of healthcare organisations, the cost considerations also presented a significant challenge in this project, particularly when determining the proposals' scope and the ability to prioritise certain projects. A holistic approach that balanced the value of tangible (comprising spatial and aesthetic design solutions) and non-tangible service design solutions was necessary to deliver maximum value for the available resources and achieve sustainable service improvements. The provision of six supportive design concepts (Fig. 8) aimed to offer the hospital a range of both tangible and non-tangible solutions that varied in cost, including low, medium, and high-cost options. This enabled the hospital to select design solutions that aligned with their available resources while still achieving meaningful and sustainable service improvements.

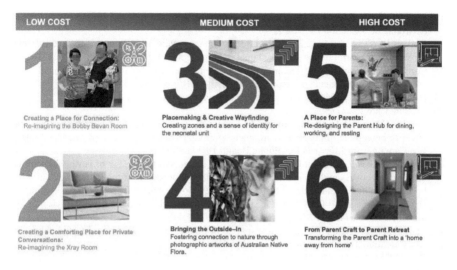

Fig. 8 Six concepts ranging from low cost to high cost

References

1. Tyurina A, Winter A, Ness Wilson L (2024) Bringing the university to the hospital: QUT design internships at the Queensland Children's' hospital Paediatric intensive Care unit (PICU). In: Miller E, Winter A, Chari S (eds) How designers are transforming healthcare. Springer
2. Wright N, Ness Wilson L, Tyurina A, Harnischfeger J, Johnstone S, Matthews J (2024) 'It takes a village': the power of conceptual framing in the participatory redesign of family-centred care in a paediatric intensive care unit. In: Miller E, Winter A, Chari S (eds) How designers are transforming healthcare. Springer
3. Ness Wilson L (2024) NICU mum to PICU researcher: a reflection on place, people, and the power of shared experience. In: Miller E, Winter A, Chari S (eds) How designers are transforming healthcare. Springer
4. Ulrich RS (2000) Evidence based environmental design for improving medical outcomes. Proceedings of the healing by design: building for health care in the 21st Century Conference, Montreal, Quebec, Canada
5. McCuskey SM (2006) The role of positive distraction in neonatal intensive care unit settings. J Perinatol 26(3):S34–SS7
6. Shepley MM, Sachs NA (2020) Physical environments that support the mental health of staff and families in the NICU. J Perinatol 40(Suppl 1):16–21
7. Ulrich RS (1997) A theory of supportive design for healthcare facilities. J Health Care Inter Des
8. Soderlund J, Newman P (2015) Biophilic architecture: a review of the rationale and outcomes. AIMS Environ Sci 2(4):950–969
9. Mazuch R (2017) Salutogenic and biophilic design as therapeutic approaches to sustainable architecture. Archit Des 87(2):42–47
10. Cushing DF, Miller E (2020) Creating great places: evidence-based urban design for health and wellbeing. Routledge
11. Andrade CC, Lima ML, Devlin AS, Hernández B (2016) Is it the place or the people? Disentangling the effects of hospitals' physical and social environments on Well-being. Environ Behav 48(2):299–323

12. Arneill AB, Devlin AS (2002) Perceived quality of care: the influence of the waiting room environment. J Environ Psychol 22(4):345–360
13. Gotlieb JB (2000) Understanding the effects of nurses, patients' hospital rooms, and patients' perception of control on the perceived quality of a hospital. Health Mark Q 18(1–2):1–14
14. Consensus Committee on Recommended Design Standards for Advanced Neonatal Care (2019) NICU recommended standards. University of Notre Dame, p 46
15. Ulrich RS (1991) Effects of interior design on wellness: theory and recent scientific research. J Health Care Inter Des
16. Neri E, Genova F, Stella M, Provera A, Biasini A, Agostini F (2022) Parental distress and affective perception of hospital environment after a pictorial intervention in a neonatal intensive Care unit. Int J Environ Res Public Health 19(15):8893
17. Ampt A, Harris P, Maxwell M (2008) The health impacts of the Design of Hospital Facilities on patient recovery and wellbeing, and staff wellbeing: a review of the literature. Centre for Primary Health Care and Equity, University of New South Wales, Sydney
18. Devlin AS, Arneill AB (2003) Health care environments and patient outcomes: a review of the literature. Environ Behav 35(5):665–694
19. Carter K (2021) Designing supportive spaces for mothers with children in the neonatal intensive Care unit. The Florida State University
20. Dillard DM, Clottey M (2013) Post-traumatic stress disorder and neonatal intensive care. Int J Childbirth Edu 28(3):23
21. Ionio C, Colombo C, Brazzoduro V, Mascheroni E, Confalonieri E, Castoldi F et al (2016) Mothers and fathers in NICU: the impact of preterm birth on parental distress. Eur J Psychol 12(4):604–621
22. White RD, Care CCoRDSfAN. (2020) Recommended standards for newborn ICU design. J Perinatol 40(Suppl 1):2–4
23. West R, Stewart L, Foster K, Usher K (2012) Through a critical lens: Indigenist research and the Dadirri method. Qual Health Res 22(11):1582–1590

Dr Sarah Johnstone is a design strategist at the QUT Design Lab. She specialises in 'designing for diversity', co-design processes, and designing accessible/low-fi creative/arts-based community and stakeholder engagement tools.

Professor Evonne Miller is Co-Director of the HEAL (Healthcare Excellence AcceLerator) initiative and Director of the QUT Design Lab. Professor of Design Psychology at Queensland University of Technology, Evonne is a leading voice on the value of arts and design-led innovation in healthcare transformation, bringing a collaborative, pragmatic, and fresh interdisciplinary approach to problem solving. She is the author, co-author, or editor of 4 books, exploring how we can create places that foster planetary and human health.

Dr Anastasia Tyurina is a Senior Lecturer in Visual Communication at the QUT School of Design, and the QUT Design Lab. As a design researcher and a new media artist, she is interested in creating visual experiences that promote social change, better health, and wellbeing.

Leighann Ness Wilson is an interior designer and educator who inspires future primary educators through design thinking and creativity. She also works independently as an education consultant, developing and providing workshops and learning experiences to students and teachers. Currently Leighann is researching the impact of design thinking as a pedagogical approach on pre-service primary teachers for her Doctor of Philosophy (PhD).

Dr Abbe Winter is a results-driven writing specialist, collaborative mentor, and independent researcher, skilled in the analysis of words and data for user needs. Abbe is a researcher trainer, leader, and mentor, with over 20 years' experience in quality assurance, and change and project

management. While her PhD focused on what helps workers in higher education cope with large-scale organisational change, and she was part of the small team that created and developed the concept of academagogy (the scholarly leadership of learning), her more recent research has focussed upon professional identity, developing writing skills, and reflective practice.

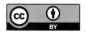

Part II
Makers

Designers are makers. As the projects and reflections in this section illustrate, what differentiates design from other disciplines is our focus on creation: the process of making visually appealing, intuitive, and functional designs.

As Bason and Skibsted [1] remind us below, design used strategically, can have immense impact. Here, designers from the disciplines of industrial, interactive, and visual design, have illustrated how their creations can be powerful agents of transformative change—from the development of prototypes to facilitate reflection (for example, the Fig. 1 shows a rare female CPR manikin with breasts) to the deliberate design of posters educating people how to collect urine samples in the emergency department and the co-creation of visual health request forms to simplify the process for prisoners, the artefacts designers make have impact.

Design has a huge potential to contribute to positive change, if used strategically as well as ethically. It involves a negotiation between technology, policy, systems,

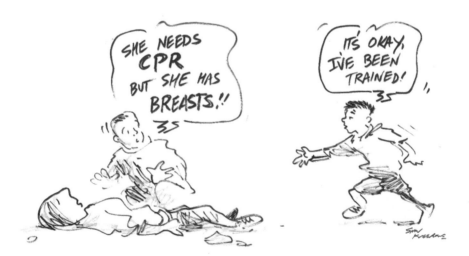

Fig. 1 She needs CPR…. (Credit: Simon Kneebone)

people, and nature to create new futures. A structured design approach can increase the hit rate at the fuzzy front end of innovation in public and private sectors. And design has become incredibly multifaceted, a mechanism for inquiry, for expressing ideas, exploring difficult questions, and addressing global challenges [1, p. 152].

Reference

1. Bason C, Skibsted JM (2022) Expand: stretching the future by design. BenBella Books, Dallas

Prototyping for Healthcare Innovation

Marianella Chamorro-Koc

Design thinking is a problem-solving approach that focuses on empathy and collaboration to develop solutions that are user-centric, feasible, and effective. When applied to healthcare innovation, co-design and design thinking involves understanding the needs and experiences of patients, healthcare providers, and other stakeholders. It also involves prototyping and testing solutions to ensure that they meet these needs and are feasible to implement—and it is co-designing with technology and prototyping for healthcare innovation that is the focus of this chapter.

1 Understanding Prototyping in the Design Research Process

Co-designing with end-users and stakeholders is essential in healthcare innovation. Patients and healthcare providers are the ones who will ultimately use the solutions developed, so their insights and feedback are crucial. By involving them in the design process, healthcare providers can ensure that the solutions developed are user-centric and meet the needs of those who will use them. Prototyping is a crucial step in the design research process, allowing designers to test and refine the functionality and usability of their solutions. It involves creating low-fidelity versions of a solution to test and refine its functionality and usability. It also helps designers to identify potential issues and challenges that may arise during implementation, enabling designers to address them before the solution is fully developed. By creating low-fidelity versions of their solutions, designers can test their ideas and make changes quickly and cost-effectively.

The use of technology is becoming increasingly prevalent in healthcare innovation, and prototyping is critical when designing with technology. Technology can be

M. Chamorro-Koc (✉)
QUT, Brisbane, QLD, Australia
e-mail: m.chamorro@qut.edu.au

complex and difficult to implement, so prototyping can help to identify potential issues and challenges and ensure that the solution developed is feasible and effective. In the following sections, I reflect on how assisting, enabling and learning from people's experiences, prototypes play a vital role in the research process in Design for Healthcare innovation, drawing on two key projects that took place within the HEAL Program which I conducted with a team of design researchers and clinicians from three different hospitals. The first is a facial PPE for Paediatric Wards, and the second is an interactive device for assessing pain in paediatric wards. Drawing on these projects, I reflect on the need of design thinking and prototyping, and then distil the challenges and lessons learned in each project—resulting in four principles to consider in the use of prototyping as part of design thinking session: (i) making for engaging, (ii) meaning making, (iii) making stories, and (iv) making language. Finally, I discuss the role of designers in improving patient experiences in healthcare through the use of co-design, design thinking, and prototypes.

2 Design Thinking, Co-Design and Prototyping in Human-Centred-Design for Healthcare Innovation

Healthcare and patient experience are intimately linked, with positive experiences critical to successful treatment outcomes [1]. Leaving experiences to chance can negatively affect the way patients internalize processes, policies, and services. Designers play a vital role in healthcare innovation, creating tangible objects, digital systems, and designed experiences that directly impact patient and caregiver well-being. By designing patient experiences through all touchpoints of the healthcare service, the work of design researchers and designers can result in patients feeling more comfortable, calm, and secure, improving their overall experience.

As discussed in the chapters in this book, co-design and design thinking are two processes that designers use to achieve this goal. Co-design is a collaborative approach that involves identifying a problem and developing a solution with the end-user through research and exploration [2, 3]. Design thinking, on the other hand, involves comprehending users, questioning assumptions, and redefining problems to identify various solutions in a methodical step-by-step process [3, 4]. While different from co-design, design thinking also leads to improved patient experiences in healthcare.

Improving patient experience in healthcare innovation requires a Human Centred Design (HCD) approach, which has been largely adopted in the healthcare sector for quality improvement solutions. We delve into the discussion of the connections across Design Thinking, Co-design and HCD in Chapter "Co-designing Design Thinking Workshops: From Observations to Quality Improvement Insights for Healthcare Innovation": Co-designing Design Thinking Workshops. Here we further explain that fundamentally, HCD lends a problem-solving approach process that begins with understanding the human factors and context surrounding a

challenge [5]. HCD has been widely adopted in healthcare innovation for its systemic and humane approach, as well as its ability to foster creativity and facilitate change. By bridging the gap between designers and end-users, HCD allows for a better understanding of current practices and enables a collaborative envisioning of an alternative future. Conceptually, my approach to research in Design for Health utilizes Human Centred Design (HCD) principles to gain insight into people's health experiences in the context of the individual, their health, and technology. HCD supports my investigation on how people interact with technology and the healthcare system, and the impact that each of these factors has on the other, where a key part of the HCD process is the use of prototypes.

3 The Value of Prototyping

Prototypes are tangible representations of abstract ideas used in design research to generate knowledge, transforming vague and abstract concepts into concrete forms that can be analysed and evaluated [4]. Prototyping is making a preliminary model of something, from which other forms or products are developed. It is a representation of a design idea, used to generate learnings for the final development or build. Prototyping is action oriented, with the intention of creating a tangible product. It moves people beyond talking into active creating and design doing. Typically, prototypes are built in iterative processes, where the lessons learned from one iteration informs the build of the next version. The design question for prototyping is always: what can be learned from this model? Prototypes can be done with a minimal investment of money or resources, and with a minimal investment of time. Its main power is that prototyping is a generative technique, from which plenty of learning is distilled by all the participating (e.g., PPE with nurses, parents and children, as I discuss later in this chapter).

While prototypes were initially used to refine products before production, they now have diverse applications depending on the design context and purpose. Prototypes are instrumental in developing and realizing new design solutions, serving as a visual representation and validation tool for experimentation. They play a critical role in the transition from idea to final product, particularly in the early exploratory phases of design, providing immediate and factual feedback to move from imagination to reality. Designers use prototypes to envision solutions, explore new fields, and prompt discussions on contemporary issues and potential scenarios.

This principle of transitioning from vagueness to clarity using prototypes is a central tenet of my research in Design for Health because prototypes enable users to experience design solutions and provide a tangible representation of abstract ideas. Prototypes as exploration and proof-of-concept tools allow me to explore and demonstrate possible patient experiences through all touchpoints of the healthcare service. Enabling users to experience desired or potential design solutions can help stakeholders and consumers to envision, discuss and assess profound changes in the

way that people access and perceive healthcare. These changes can ultimately lead to improved treatment outcomes and better patient experiences.

4 My Approach as an Industrial Designer in Design for Health

As a Design for Health researcher, my work centres around the transformation towards patient-centric health services through Design for Health 4.0. which utilises smart technologies to increase access to health care, improve diagnosis and enhance patient treatment. Most of these advances are positioned in the Digital Health realm, which often relies on screen-based design such as Apps. Not much has been developed for personal health technologies for use at home—for example: smart watches or VR platforms for distraction therapy-, where healthcare transformation is currently being challenged by the early abandonment of personal health-tech devices and a lack of independent testing in the market. In response to this, Australia has recognized the need for global competitiveness and expertise to build reliable health-tech for end-users. My research aims to advance Australia's agenda in Health by focusing on user-centred research processes and launching proof-of-concept prototypes to engage stakeholders. By doing so, my work positions Design at the forefront of healthcare innovation.

In this context, my research is focused on co-designing and developing reliable health-tech for end users to advance Australia's innovation agenda in Health. A critical aspect of my work is collaboration with all stakeholders: decision makers and consumers (or end-users) so that solutions meet their needs, clinical requirements and the Healthcare system regulations. My distinctive approach to this is based on my research through proof-of-concept prototypes that engages stakeholders throughout the user centred research and design processes. I develop prototypes as a research tool to: (i) foster and engage teams into developing transdisciplinary methods for research validation, and (ii) engage key stakeholders in user centred research processes design of personal health technologies. All of this is supported by a Human Centred Design (HCD) lens that I employ to understand people's health experiences within the context of the person, health and technology. I investigate people interactions with technology and the healthcare system, and the impact of each of these factors on each other. My HCD approach to design thinking for quality improvement in healthcare recognises that working with clinicians and healthcare system stakeholders require a scaffolded approach, as described in Chapter "Co-designing Design Thinking Workshops: From Observations to Quality Improvement Insights for Healthcare Innovation" [6].

Prioritising the end-user (patient, carer or clinician) in person-centred self-healthcare solutions are crucial to the scalability and effective solutions for healthcare innovation. Understanding people's actions in relation to their healthcare needs and to their of use of technologies in this context, requires examining how people

Fig. 1 Chamorro-Koc's person-centred design for health concept model

engage and use those tools. Engaging end-users and partners is critical in this research process, and my use of generating prototypes as research tools has provided rich insights and increased understanding of people's experiences of health enabled by technologies. This is my ***person-centred design for health*** model, which is represented in the following diagram (Fig. 1):

I apply this model in my Design for Health projects that range from injury-prevention devices in sports to wearable rehabilitation devices for at-home use, interactive training devices for the community, personal protective devices for clinicians, and technology for empathy building in home-based healthcare. I will illustrate the need for person-centred solutions in relation to the two projects discussed next: facial PPE for Paediatric Wards and an interactive device for assessing pain in paediatric wards.

5 Project a: PPE for Paediatric Wards—Co-Designing Child Friendly Facial PPE

The COVID-19 global pandemic made the term Personal Protective Equipment (PPE) ubiquitous. The experience of many at work, in social environments and at work are similar: that PPE make people faceless. Reflecting on the experiences of parents and children during the pandemic, it is evident that the use of PPEs has brought about unique challenges. Parents expressed their difficulty in identifying their children at the school pick up line when they are all wearing masks. This situation is not limited to schools but extends to healthcare environments as well, where a personal connection between healthcare professionals and patients is crucial to therapeutic practices.

5.1 The Need for Person-Centred Solutions: A Mix-Methods Approach

PPE can be scary, unfriendly, and confronting for children, which, in turn, can have a significant impact on the ability of Health Care Professionals (HCPs) to build rapport and a safe, trusting relationship with children and their families. The use of

PPEs affects the communication between healthcare professionals and patients who require lip-reading or are hearing impaired. It also affects the ability of healthcare professionals to recognize their patients and for patients to understand their doctors' instructions. These challenges can impact the trust that is necessary for effective therapeutic treatment. Although much was done globally to provide different solutions for facial PPEs and overcome supply shortages, access issues and debates regarding the efficacy of PPE in a healthcare context, the voice of one group has remained largely silent—children.

Our Child-friendly PPE project addressed these issues and found innovative solutions to help build stronger connections between healthcare providers and patients. In this project, we worked with the Sunshine Coast University Hospital and Queensland Children's Hospital to develop less frightening PPE for HCPs to wear.

Our initial focus was on understanding the experience of children of different ages, their families, and clinicians during the therapeutic process while wearing personal protective equipment (PPE). We wanted to uncover their perceptions and emotions towards PPE and the challenges clinicians faced while interacting with children. We conducted quantitative surveys and virtual qualitative field observations in participating hospitals to gain insights into the interactions between clinicians, children, and their carers while using PPE. The field observations were conducted remotely, adhering to clinical protocols, using smart video tripods that captured the child's emotional responses and the clinician's movements and interactions with the environment. These observations were analysed using specialised software for qualitative analysis in behaviour research.

Our research allowed us to understand the challenges faced by clinicians and the emotional responses of children and their families towards PPE. It gave us an opportunity to create innovative PPE designs that are not only effective but also meet the needs of end-users. The co-design process ensured that the end-users' needs were integrated into the PPE design, allowing us to create PPE that is both functional and comfortable. The findings from the survey and field observation analysis informed and generated new opportunities for PPE design [7]. Our design team participated in a design sprint, resulting in two initial PPE designs and low-fidelity prototypes: Sunny and Buddy (Fig. 2). After the initial prototyping phase, we engaged end-users in a co-design process to develop new PPE design ideas and priorities. Paediatricians, nurses, children, and their carers participated in three co-design workshops, adopting a hands-on approach, creating new designs and quick prototypes that represented their ideas. From these workshops, we developed design recommendations for the design of new facial PPEs for Paediatric Wards, which also included recommendations for their future manufacturing and the environment in which PPEs are used. We hope that our recommendations will be implemented and pave the way for further research and innovation in PPE design.

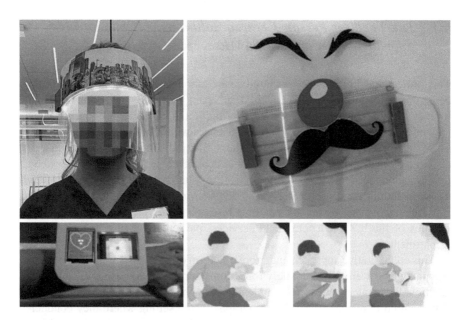

Fig. 2 Sunny and Buddy initial PPE low-fidelity prototypes (top), and TAME initial prototype (bottom)

6 Project B: Assessing Pain in Paediatric Hospital Wards

The way children experience and express pain can be very different from adults, which can pose a challenge in hospital settings where accurate pain assessment is crucial to determining treatment. Children may not be able to articulate their pain as well as adults, and younger children may not be able to express it verbally at all, resorting instead to crying or becoming introverted. Additionally, societal pressures may cause some children to avoid expressing pain or appear tough. This can have a negative impact on the healthcare experience and recovery rates of paediatric patients. Although pain assessment is a core task in paediatric care, studies indicate yet are often poorly assessed and managed [8]. The current protocol of using a 1 to 10 scale or happy to sad faces to assess pain may be influenced by factors such as hospital admission, tiredness, and heightened emotions. To address this issue, our research project TAME aimed to co-design a technology tool to help healthcare professionals assess paediatric pain more accurately and empathetically [4, 9]. The focus was on enhancing the decision-making of clinicians at the initial pain assessment moment in the Emergency Room, and to provide a positive experience for both the child and the clinician. By improving pain assessment, we hope that children recovery rates and overall healthcare experiences will also improve.

6.1 The Need for Person-Centred Solutions: A Collaborative Approach to Designing TAME

This project was borne out of a shared desire amongst healthcare professionals to better understand the experience of children's pain journeys. As we look back at the journey of this project, we are reminded of the initial curiosity that sparked it. The idea of understanding children's pain experiences within hospitals piqued the interest of healthcare professionals and designers. The project provided a unique transdisciplinary approach that brought together healthcare professionals and designers in a collaborative effort to develop innovative solutions. The involvement of end-users, including nurses, doctors, and patients, from the outset of the project was instrumental in ensuring that the resulting research prototypes were grounded in the realities of the hospital context and services, particularly within the Emergency Department.

This collaborative approach undertook the form of interviews with clinicians and parents, which were done remotely (on Zoom) during Covid social restrictions. In addition, these interviews were complemented with a photo ethnographic approach that required clinicians to share photographs of the setting where they conducted their practice. The objective was that they could discuss opportunities and challenges through the photos during the interview. This approach proved to be beneficial as it allowed designers to work alongside healthcare professionals and gain a better understanding of the critical aspects of the problem from their perspective. The result of our collaborative and interdisciplinary approach was the development of TAME, a Paediatric Pain Metric device that utilized sensors to collect basic patient data and displayed it on a screen to indicate the pain and anxiety levels of the child in a simple and user-friendly manner. Looking back, we are grateful for the opportunity to work together and create a solution that could potentially help children in hospitals cope better with their pain. It was a humbling experience that reminded us of the power of collaboration and the importance of considering all stakeholders in the design process.

7 Challenges in Design for Health Research

The following sections discuss the main challenges encountered in the two projects and the lessons learned, before documenting four key principles for prototyping in design thinking sessions. In all projects, there are the challenges of project management and teamwork in large groups that involves academics, healthcare sector stakeholders and consumers in the process—as well as developing relationships and understanding completing timelines and changing priorities. At times, the team encountered the need to overcome the bias that design is only aesthetics, and the need to develop strategies that demonstrate the rigor of design research methodologies.

8 Challenges to the Process of Designing the Paediatric PPE

It has always been challenging for non-health researchers to conduct observations and user research in-hospitals. Ethics clearances, access to hospital sites, and patients whose lived experiences could inform the research, are most times not accessible. COVID exacerbated this problem. Our team comprising designers and clinicians was able to overcome the different access issues. Although the lengthy process of gaining ethic clearances and governance approval to share data across our different institutions, the result of this necessary administrative work was access to conduct observations and co-design sessions. Our research demonstrates that collaboration between clinicians, patients, and designers can lead to meaningful solutions that improve the quality of care provided (Fig. 3).

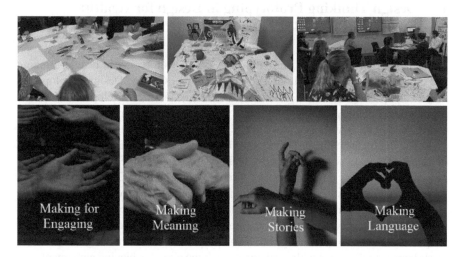

Fig. 3 Co-designing PPEs with children, parents and clinicians in-hospital setting (top), and Four principles for Deisgn Thinking Prototyping (bottom)

9 Challenges to the Process of Designing TAME

The collaboration between designers and health professionals was beneficial in many ways, as it allowed for a more comprehensive understanding of the problem from multiple perspectives, including regulatory frameworks and expertise. Nevertheless, this project faced significant challenges, particularly the restrictions imposed by Covid, which prevented the team from conducting observations within the hospital grounds. However, the team's commitment to design thinking strategies proved essential in enabling them to find alternative ways of collecting data remotely, such as through photo ethnography and retrospective interviews, combined with more traditional approaches like Critical Incident Interviews.

10 Design Thinking Prototyping in Design for Health: Emerging Principles

This chapter concentrated in presenting the use of prototyping in design thinking and co-design process throughout a complete Human-Centred Design development project comprising from idea generation to analysis, product development and testing. Throughout this process, prototyping was employed as a strategy for stakeholders' engagement, as well as a tool integral to the design thinking process.

Reflecting on the entire HCD process and the role of prototyping from the lens of design thinking and co-design process, a critical element required in any prototyping process is clarity on the purpose. As discussed in Chapter "Co-designing Design Thinking Workshops: From Observations to Quality Improvement Insights for Healthcare Innovation", prototyping is part of a scaffolded process where clarity on the purpose and expected outcomes is essential for successful design thinking workshops. Foundational to providing clarity and purpose in design thinking and codesign workshops is to discuss it with participants with the aim of achieving agreement.

In this section I elaborate on the prototyping process only and propose four principles emerging from my experience in these and other projects in Design for Health. Understanding prototypes as the act of 'making', these principles encapsulate four aspects to consider in the use of prototyping as part of design thinking session: (i) making for engaging, (ii) making meaning, (iii) making stories, (iv) making language. Consideration to these four aspects can improve the effectiveness of the process of prototype making in design thinking and co-design workshops.

11 Principle 1: Making for Engaging—Prototyping Is Essential for Stakeholders' Engagement

Throughout all my projects in Design for Health, prototyping has been essential to engage clinicians, administrators and health service consumers in the conversations around the problem and the potential solutions. There are different ways in which

objects and prototypes provoke engagement during a design thinking workshop: as a trigger, as testing device, as a demonstration. An object or a prototype can be used as a trigger in design thinking sessions at the initial stage of a project, or in sessions where familiarisation of participants with each other is required. A *prototype as a trigger* can be thought of as an 'icebreaker' to help everyone involved tune into the problem at hand and to align perspectives on the purpose of the session. A *prototype as a testing device*, can be used mid-way projects, in co-design sessions that aim at elaborating on an initial idea. Such prototype would be a low-fidelity model, one that is not polished, to provoke participants to discuss new ideas around it. A *prototype as a demonstration* is the type of prototype that engage participants into making their ideas into reality. It is a design thinking ideation workshop where participants are provided a clear purpose of the making session and the prototyping process becomes a vehicle for discussion of ideas and demonstration of how things 'might' look like or work. In my experience, a successful use of prototyping for engaging in a design thinking session exceeds the participation element and further, it enables participants to attain a sense of ownership and commitment to the project process.

12 Principle 2: Making Meaning: Prototyping Brings out Context and Knowledge

Through the act of making, we express meaning that represents our lived experiences and knowledge. In Design literature this has been referred as 'artifacts' expressing mental diagrams or mental models of the human experience [10]. This means that prototyping presents a vehicle for participants in a design thinking workshop to communicate what they know from their experience, as a patient or carer, or as a clinician or healthcare administrator. Their views would be captured in what they represent through prototyping. Awareness of prototyping as meaning making is instrumental for facilitators in design thinking workshops to gain insights on the different experiences and perspectives brought to the workshop session, and to the opportunity of further provoking discussion about the context in which such experiences have taken place. It is in this process that participants and facilitators of the design thinking workshop, make knowledge around the table visible to all, helping to promote empathy in participants through the make and use of a prototype to demonstrate their experiences and the context of them.

13 Principle 3: Making Stories: Prototyping Helps Envision Scenarios

Because prototyping is an act of making and it expresses our experience and knowledge, it also provides a vehicle for participants to represent their current experience as well as their dreamed or desired ones. In Chapter "Co-designing

Design Thinking Workshops: From Observations to Quality Improvement Insights for Healthcare Innovation" we discuss a design thinking session with clinical stakeholders where we touched on the use of scenarios. In healthcare, scenarios represent a systems view, patients or process flow, or a therapeutic procedure. In this context, prototyping helps manifest those views, process or procedures. In projects where opportunity for design thinking workshops is provided throughout the life of the project, prototyping can be effectively used in the initial stages to demonstrate those scenarios where the problem is experienced, to the later stages where prototyping is employed to manifest ideal solutions, and later on to test final solutions for refinement. In this manner, prototyping provides: (i) a platform for all different knowledge and experience around the design thinking table, to share their views and solutions on a given problem, and the (ii) opportunity for participants to co-discover alternative or new pathways to different solutions situated into potential scenarios of use. The stories that surround or complement prototypes at design thinking sessions are often extremely memorable, and serve as a unifying catalyst for change.

14 Principle 4: Making Language: Prototyping Is 'Design Doing' in your Own Way

In Chapter "Co-designing Design Thinking Workshops: From Observations to Quality Improvement Insights for Healthcare Innovation" we discussed the use of LEGO bricks in a design thinking workshop with a clinical team. In that project, prototyping was a part of a three-hour session to help the teams to brainstorm solutions. The bricks provided a familiar medium to all participants to make representations of their ideas in a short time. This case provides a good example of the importance of prototyping being presented as an accessible tool. Prototyping in design thinking sessions needs to consider participants' skills, knowledge and experience in order to determine what materials and methods can be employed in the session. It needs be presented to participants as: *accessible, friendly, easy and familiar*. The task of making can be intimidating for many, and therefore, consideration to the prototyping medium (materials, tools and methods) is critical to help participants focus on the ideas and not on challenges around making. In the examples presented in this chapter, design thinking prototyping sessions have been done with clinicians, parents and children, offering different prototyping mediums and achieving a range of different results. In these sessions, a 'designer assistant' was provided, to reassure participants that help was at hand if they felt challenges during the making process. Nevertheless, in all our sessions, participants worked on their own prototypes without requesting help.

15 Conclusions

Prototyping as part of a design thinking process is a transformative experience in itself. As discussed in this chapter, prototyping bridges the gap between the abstract and the concrete, and it helps the process from imagination to reality. Beyond the act of making —or what we called 'design doing'— prototyping is a vehicle that enables all participants to share a transformative experience during the design thinking process. The four principles presented demonstrate how prototyping transform the thinking of the experience into an actual experience. Through the process of prototyping for engaging, revealing lived experiences, sharing stories, dreaming and co-discovering solutions, prototyping is a design thinking that allows facilitators and participants the sharing of and the learning from experiences in real time.

The experience and learnings from these projects have led to many more opportunities for applied design research and design thinking through prototyping in healthcare innovation. One of these opportunities is our recently awarded \$2million government funded three-year grant in collaboration with a leading orthotics manufacturing company for the project: Design-led advanced manufacturing of smart orthotics for remote Australia (2021–2024). This is an Australian Cooperative Research Centre Project (CRC-P) grant that focuses on utilising digital technology to enhance the supply chain of orthotic solutions for Diabetic Foot Disease (DFD) patients in regional hospitals. This project involves a leading QLD based SMEs specialised in digital manufacturing technologies of orthotics —i-Orthotics Pty Ltd—, a regional Queensland hospital — Mt. Isa Hospital at North West Hospital Services (NWHS)— and a Brisbane based Allied Health group —Healthia Group—. The proposed enhanced supply chain would: (i) reduce the waiting time for DFD patients in receiving prescribed footwear components; and (ii) support the production of footwear solutions that are fabricated considering DFD patients' personal requirements utilising advanced manufacturing workflows.

Initiated as a request from Mt. Isa North West Hospital and Health Service and with the support of Queensland Health Bridge Lab and QUT HEAL Program, we conducted a field observation and scoping study to understand the problem and the opportunity to improve health outcomes through design [11]. We uncovered the critical need to undertake a multidisciplinary approach to the project that involves: design research to engage the indigenous community—chiefly the Kalkadoon people of the Mt. Isa region of Queensland, biomedical studies to identify suitable digital technology for foot scanning for orthotics prescription, advanced manufacturing technology for the design and manufacturing of customised orthotics, cultural studies methodology to undertake this project in a cultural responsive approach, and service design and marketing research to develop a digitised workflow that can be adopted by industry and health services. In this project we aim to develop an enhanced patient-centric supply chain of orthotics for DFD patients in regional hospitals, and to improve access and timeliness of clinical data about the use and treatment effectiveness of custom orthotics. Figure 4 outlines the different aspects of our project and pictures our all-female team.

Fig. 4 The CRC-P project and project team

This project addresses the problem of patient compliance with using prescribed footwear in the regions, with impacts including patients' unsuccessful recovery and higher risk of amputation. DFD patients typically fail to comply due to long wait times post-surgery in receiving prescribed footwear, and due to footwear being inadequate to the context of their everyday life activities. The CRC-P project demonstrates the value of design research and design thinking in bringing together all stakeholders in healthcare innovation and developing a multidisciplinary approach to translational research and into applied solutions that can be manufactured. The projects discussed in this chapter provided the evidence to support the CRC-P project bid, effectively demonstrating the role of design and of prototyping in quality improvement in health services. Further, these projects shed light on how a human-centred-design methodology approach can be deployed in collaboration with clinicians towards person-centred care solutions.

As design researchers, we are responsible for the impact our work has on the world: people and planet. From this view, in enacting 'Change by Design', projects like our CRC-P help bring profound impact in industry and healthcare sector, by placing the spotlight on regional communities, those for whom technology advances usually do not consider their needs.

Acknowledgements To my QUT colleagues in the PPE and TAME projects: Associate Professor Rafael Gomez, Isabel Byram, James Dwyer and Erina Wannenburg. And to our HEAL partners in QLD Health: Dr. Julia Clark, Kerri-Lyn Webb and Heidi Atkins at the Queensland Children's Hospital; Dr. Clare Thomas and Dr. Lauren Kearney at Sunshine Coast University Hospital. A special acknowledgement to Dr. Satyan Chari, co-director of the QUT HEAL Program and Program Director of the Clinical Excellence Queensland (CEQ) Bridge Lab Program.

References

1. Solis B (2020) A step by step guide to reinventing patient experience through human-centred innovation 2020. Available from: https://healthcaretransformers.com/patient-experience/human-centered-design-healthcare. Accessed 27 Feb 2022
2. Dam R, Siang T (2021) Why is design thinking so popular? Available from: https://www.interactiondesign.org/literature/topics/challenge-assumptions
3. Miller E, Yates P, Hargraves M, Johnstone S (2023) Co-designing the palliative care hospital experience with clinicians, patients, and families: reflections from a co-design workshop with clinicians. In: Miller E, Winter A, Chari S (eds) How designers are transforming healthcare. Springer
4. Montana-Hoyos C, Chamorro-Koc M, Scharoun L (2023) The role of design in healthcare innovation and future digital health. In: Digital health: from assumptions to implementations. Springer, pp 155–175
5. UNICEF (2020) Human centred design 4 health. Available from: https://www.hcd4health.org/
6. Chamorro-Koc M, Swann L, Haskell N, Dwyer J, Wainwright L, Hosking J (2023) Co-designing design thinking workshops: from observations to quality improvement insights for healthcare innovation. In: Miller E, Winter A, Chari S (eds) How designers are transforming healthcare. Springer
7. Chamorro-Koc M, Gomez R, Kearney L, Byram I, Wannenburg E, Dwyer J. (2021) Child friendly PPE design: more than a cute thing to do
8. Hurley-Wallace A, Wood C, Franck LS, Howard RF, Liossi C (2019) Paediatric pain education for health care professionals. Pain Rep 4(1):e701
9. Chamorro-Koc M, Gomez R, Dwyer J, Wannenburg E (eds) (2021) TAME: Paediatric pain empathy device. Health Excellence Accelerator Lab (HEAL) Symposium: HEAL Showcase
10. Kazmierczak ET (2003) Design as meaning making: from making things to the design of thinking. Des Issues 19(2):45–59
11. Chamorro-Koc M, Byram I, Haskell N (2021) A human centred design approach to podiatric footwear for health 4.0 innovation in regional Australia: a report for QUT Design Lab and Clinical Excellence Queensland Healthcare Accelerator Lab Program (HEAL)

Professor Marianella Chamorro-Koc investigates Industrial Design research that explores people's interactions and engagement with technologies as part of the emerging technological shift to person-centred digital solutions. Her transdisciplinary applied research is demonstrated in proof-of-concept prototypes of health-tech devices for people's self-management of their health, advancing self-health technology innovations and championing viable local manufacturing transformation.

Graphics and Icons for Healthcare with a Focus on Cultural Appropriateness, Diversity, and Inclusion

Lisa Scharoun, Zoe Ryan, and Evonne Miller

Imagine you are entering into a health care facility in an unfamiliar city where the written language is incomprehensible to you. How do you navigate your way through the corridors or read the instructions on the healthcare forms? A 2010 Universal Symbols in Healthcare study explains that: "Today, one of the most important issues facing health care administrators is providing services to Limited English Proficiency (LEP) populations. Helping them navigate complex health care facilities is a key objective" [1, p. 12]. Combining text and visual methods of communication in health communication and processes can increase awareness and can assist patients and practitioners to better navigate complex systems. According to McNicol and Leamy [2, p. 268], "The representation of medical practices or conditions in comics is not new, but since the turn of the millennium there has been growing interest in graphic illness narratives, often known as graphic medicine or graphic pathologies." As such the way that instructions for testing and health processes are represented visually can have great impact on uptake and effectiveness in healthcare.

However, the importance of these images and icons is often not well understood, and great care and consideration needs to be taken in crafting images that respond to cultural sensitivities and are inclusive. With diverse populations, cultural taboos and misrepresentations need to be considered in any graphic solution for healthcare application. A 2014 Lancet Commission on Culture and Health [3, p. viii] argued that "the systematic neglect of culture in health and health care is the single biggest barrier to the advancement of the highest standard of health worldwide." This chapter reviews the history of graphic medical representations and icons. In addition to being useful for individuals with LEP, we discuss how graphic representations of

L. Scharoun (✉) · Z. Ryan
QUT, Brisbane, QLD, Australia
e-mail: lisa.scharoun@qut.edu.au; zo.ryan@qut.edu.au

E. Miller
QUT Design Lab, School of Design, Queensland University of Technology,
Brisbane City, QLD, Australia
e-mail: e.miller@qut.edu.au

© The Author(s) 2024
E. Miller et al. (eds.), *How Designers Are Transforming Healthcare*,
https://doi.org/10.1007/978-981-99-6811-4_7

medical practices can be applied to ensure cultural appropriateness and diversity, using a case study of urine collection posters.

1 A History of Medical Graphics and Icons

Humans are visual learners by nature. Visual information is much more easily digested and retained. In fact, it is 60,000 times faster for our brains to process visuals over text. As text is processed sequentially, it takes around 60 seconds for a human brain to understand 200–250 words, whereas we only need a millisecond to understand an image. This also impacts retention—humans only remember about 20% of what they read but this goes up exponentially to 42% when visual content is present [4]. Not only does visual content help us to understand, it also helps with engagement. Therefore, global advertising agencies are paid large amounts to try to find catchy visuals and colours for products and services, as visual content increases engagement by 180% [4]. As such, use of icons, illustrations, and visuals in medical facilities, education, and practices can be a very effective communication method.

Illustrations have been used for centuries to explain and understand complex elements of the body and human anatomy. According to McNicol and Leamy [2, p. 268], "The representation of medical practices or conditions in comics is not new, but since the turn of the millennium there has been growing interest in graphic illness narratives, often known as graphic medicine or graphic pathologies." Visual representation of medical practices have been found in artifacts from ancient Egypt, on bamboo and silk artifacts from ancient China, on the clay vessels and temples of the ancient Greeks, and in many other mediums throughout the ancient world. These ancient representations are stylised interpretations of the human body as an understanding of anatomy in early societies was minimal because dissection of the human body, was forbidden [5, p. 85]. Realism, and a more-in-depth understanding of human organs and systems, came about in Renaissance Europe. According to Hajar [5, p. 90] "[in the Renaissance] It was not unusual for artists and physicians to collaborate in producing an artistic and scientific work. Artists were interested in the study of proportion; scientists were interested in visualizing the anatomical relationships of various organs as well as depicting their function to understand and promote a particular theory. The symbiotic artist/physician interaction was extremely useful in advancing art and science."

Illustration is still a very important tool in visualising simple to complex medical systems, processes, or procedures. As Hajar [5, p.84] explains: "A graphic representation of any medical subject is a very effective tool in communicating medical knowledge. Medical students depend on illustration to learn anatomical facts and details that may be too subtle for the written or spoken word. Oftentimes, an illustration transmits the pertinent, useful, and important information much more effectively than words. They 'tell a story' through their drawings." Therefore, the use of illustrations and visuals are essential tools in the healthcare industry. They can bring both simple and complex processes and procedures to life, and can be widely distributed for use in global applications.

1.1 Universal Symbols in Medical Graphics

Pictograms are a form of visual language that have been used since ancient times to represent complex messages visually. The first instance of visual language is Cuneiform, discovered on clay tablets dating back to the thirty-second century BCE. In Cuneiform, the simplification of representative symbols enabled a connection between real things and symbols of things [6]. Universal symbols evolved from this concept of picture language, and, in 1936, Otto Neurath together with Rudolf Carnap and Charles W. Morris, formalised a system of symbols that were used and understood as an international visual language. The Isotype (International System of Typographic Picture Education) system remains the standard for not only international diagrams and graphics, but also text and illustrations used in public [7].

The 2010 Hablamos Juntos (HJ) project drew from the Isotype system and applied the symbol testing method recommended by the International Organization for Standardization (ISO) to create a standardised system of medical graphics. Over a period of three-years they carried out a number of studies in U.S. hospitals to create a system of 54 common healthcare symbols. The 54 symbols are broken up into categories: 12 belong to the service category of administration and medical personnel, 32 are categorised as treatment facilities and departments, and the remaining 10 are medical imaging services, such as X-ray examination [1, p. 24]. Interviews undertaken during the 3 years of research for the Hablamos Juntos project uncovered that both English-speaking and non-English-speaking users believed that the graphic symbol set created for the project is "significantly more readable and more understandable than words. Additionally, over 80% of medical personnel interviewed thought that this system helped relieve their workload with regard to giving hospital visitors instructions" [8, p. 19].

Many universal symbols in the HJ model, such as the stethoscope, relate directly to tools of the trade, however a history of more abstract symbols such as The Cadueus and the Red Cross give evidence of abstract symbols related to complex historical and cultural symbolism. The Cadueus is a universal symbol used globally in the medical profession to represent doctors, healthcare facilities, medical insurance agencies and global healthcare organisations such as the WHO. Dating back to 1400 BC, it is based on an image of the 'Rod of Asclepius;' a staff with one snake entwined. In Greek mythology, Asclepius is the god of healing and medicine, and was represented as carrying a staff or 'rod.' The use of a snake as a symbol of health dates to ancient Egyptian culture. Based on this historic understanding, snakes were associated with health treatments and used in ancient Greece for healthcare procedures and rituals [9].

One of the most internationally recognized medical symbols, the Red Cross, is used globally to identify nonpartisan medical services. The Red Cross is used generally as a universal symbol for 'Medical services.' The symbol originates from 1859 when a Swiss entrepreneur named Jean Henri Dunant (1828–1910) witnessed a horrible battle between France and Sardinia. He called for an international nonpartisan group that would attend to the wounded regardless of their affiliations.

Subsequently, the Geneva Society for Public Welfare was founded and adopted the symbol of the Red Cross (as used on the Swiss flag). Their name later changed to the International Committee of the Red Cross. A red cross on a white background was eventually designated as the medical symbol to be used for all non-partisan medical services [10].

Universal symbols, whether literal or abstract, therefore need to employ a simple set of visuals with an emphasis on *clarity, readability, and ease of use.* In his *Thoughts on Design*, Paul Rand explains: "Visual communications of any kind, whether persuasive or informative, from billboards to birth announcements, should be seen as the embodiment of form and function: the integration of the beautiful and the useful" [11, p. 9]. Illustrations and visual symbols assist those who speak different languages and those with limited literacy to navigate the healthcare landscape. However, the cultural implications of these systems should still be considered.

1.2 Cross-Cultural Understanding of Graphic Images and Information

In an increasingly globalised healthcare sector, it is very important to understand the cultural nuances and bias in visuals, and to create representations that are sensitive to these nuances. Awareness of cultural contexts such as socioeconomic status, environmental conditions, age, gender, religion, sexual orientation, and level of education are all essential in creating an effective healthcare service model in a multicultural society such as Australia. "Our experiences of health and well-being are fundamentally influenced by the cultural contexts from which we make meaning," explain Napier et al. [3, p. xi].

"Despite what appears to be a cross-cultural ability to recognize objects depicted in pictures, the visual content of an illustration is frequently a vehicle to communicate a more complex meaning or intention. Unlike the subject content of the picture, this intended meaning may often be misunderstood or unrecognized by the viewer" [12, p. 20]. In a study of the effectiveness of the HJ system in Taiwanese hospitals, researchers found that some of the symbols presented cultural nuances that were not apparent in other cultures. In the study it was found that only 12 of the 53 symbols were able to be understood without modification. And, in the case of symbols that included gynaecology and obstetrics, they were deemed culturally inappropriate and needed to be completely redesigned. Joy Lo et al. [13, p. 133] advise that "Good healthcare symbol designs should aim at enhancing the effects of wayfinding system to avoid causing patients to have unpleasant thoughts. Designers should carefully evaluate the indexical and symbolic meaning of graphic symbols."

"Medical imaging is an invaluable method of conveying information about diseases and pathologic conditions" [14, p. 90.] However, when someone cannot picture themselves in an image, they are not as likely to take up the instructions presented. "Racial bias can distort clinical decision-making and directly impact the

daily experience of patients as well as the quality of the care they receive," explains Massie et al. [14, p. 88]. The Massie et al. [14] study, on race and visual representation in medical imaging, found that that there is lack of diversity in medical images and a significant bias towards a use of Caucasian figures in medical illustrations. In various medical images representing a range of medical fields and geographic regions, Massie et al. [14, p. 90] found that only 18% of images depicted non-white skin tone and there was considerable heterogeneity in the percentage of non-white medical images published from different geographic regions.

In 2017, Nama et al. [15] found that LGBT individuals may avoid seeking medical care, and generally receive poorer healthcare, due to discrimination or perceived discrimination in the healthcare environment. They also explain that transgender individuals may avoid seeking medical care because of their trans-status. Medical forms and graphics can have a negative effect on the LGBT population due to representation of gender. According to the *National LGBT Health Education Centre* [16], "Forms that use images to document pain or areas of concern should make sure those images are gender neutral. Forms could also employ the use of diagrams not having a human outline, such as quadrants. Images that have a specific gender may limit patients from identifying certain medical issues. For example, male/transgender male patients obtaining a breast screening would need a non-female illustration to document/locate the area of interest."

This literature shows that care and consideration is critical in the creation of any type of healthcare graphic, particularly in the case of a multicultural health care facility. In the following case study, we document a recent project for a public hospital system and how the illustrations, universal symbols, and text improved upon an existing system by considering and applying principles of inclusion, equity, and access.

2 Case Study: Innovating Healthcare Design for Diversity and Inclusion

2.1 Introduction

Have you ever had to provide a urine sample for the doctor? Recent research in a Brisbane Emergency Department found that nearly half—41.5%—of all midstream urine samples collected from women were contaminated. While contamination rates vary by site, institution, collection, storage, and transport, poor patient technique—due to inadequate instructions—is a key reason for contamination.

Midstream urine samples are frequently collected from patients in Emergency Departments (EDs) for their diagnostic use. Although a relatively simple and cost-effective examination, research collected across EDs has demonstrated that up to 50% of patient-collected urine samples may be contaminated with bacterial flora [17, 18, p. 3], with higher contamination rates typically found in women [19]. Urine

samples are the most commonly used diagnostic tool within EDs [20], however the bustling surroundings of an ED naturally create obstacles to ensuring that urine samples are containment-free.

Research from a range of sources [18, 21, 22] indicates that a contaminated urine sample can contribute to:

- diagnostic ambiguity or incorrect diagnosis
- inappropriate treatment
- prolonged time for diagnosis and treatment
- poorer patient outcomes, including increased anxiety
- increased antibiotic misuse and resistance
- increased cost (for repeat testing).

Given the sizable number of these examinations performed, reducing contamination rates presents an opportunity to make substantial savings in terms of cost and staff time [22].

In a 2016 pilot study performed by The Princess Alexandra Hospital (PAH), the ED achieved a 15% reduction in contaminated mid-stream urine samples by introducing step-by-step illustrative charts to guide patients on the correct methods for uncontaminated urine collection [23, pp. 921–925]. The success of the charts was expedited into practice, and submitted to the Clinical Excellence Queensland (CEQ) team at Queensland Health (QH) under the PROV-ED (Promoting value-based care in EDs) project, to be distributed for use across all QH EDs.

3 Project Overview

Eley and colleagues [23] from the PAH developed and tested two sets of graphical illustrations to simply explain the urine collection process to male and female patients, with this intervention reducing contamination rates from 40% to 25%. These graphics were disseminated via a leaflet provided to patients; however subsequent implementation was via posters on the back of toilet cubicle doors.

However, when the CEQ-led PROV-ED Project started to explore rolling these posters out to other emergency departments, initial feedback from staff and consumers was that the original designs were overly graphic, especially for use with children and consumers from different cultural contexts (see Fig. 1).

The Design Lab at Queensland University of Technology (QUT) was tasked with redesigning the two (male and female) posters to address the concerns of staff and consumers. This initiative between the PAH ED and QUT Design Lab was given the acronym RedUCE—'Reducing Urine Contamination in Emergency'.

Male Urine Collection Instructions

1. Wash your hands well with soap and water

2. Unscrew the collection cup. Do not touch the inside of the cup of lid

3. Using the towelette provided retract the foreskin and clean the tip with a single wipe

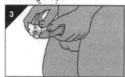

4. Pass a small amount of urine into the toilet

5. Do not touch the inside of the cup with your fingers or penis. Collect your urine until the cup is half full

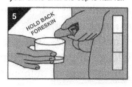

6. Finish your urine stream into the toilet

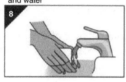

7. Replace the lid on the cup

8. Wash your hands well with soap and water

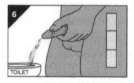

9. Give the specimen to the nurse

© 2019 O.T.

Fig. 1 Original Male Urine Collection Instructions

4 Design Intervention

The team explored several options to improve the experience of urine collection—from an infographic to disrupting the process and designing a different container for urine collection, to developing animations that turned urine collection into a game for children. In the end, we settled on redesigning and simplifying the poster, using a gestural drawing approach (a loose form of sketching that expresses movement by capturing basic form). We combined what had been separate posters for men and women into one poster, and reduced the number of steps, to further simplify the process.

The design elements of this project were largely led by designer and Research Assistant Zoe Ryan, who is a PhD candidate at QUT and works within the Design Lab. Zoe works on a foundation of 'design thinking' that aligns with the QUT Design Lab's focus on a human-centered design methodology. Both approaches enable researchers to understand the complexities of the end user, allowing designers to gain further insight to meet a user's overall social wellbeing at a physical, intellectual, and emotional level [24–26].

Zoe explains their overall design process for the REDUCE project in the following reflective discussion.

5 Discussion

As a researcher focused on a disruptive design process, I (ZG) work to dismantle the systems that underpin contemporary design constructs that we are unknowingly conditioned to. Applying my own methods begins with understanding the needs and scope of a project. In a professional capacity, this begins with an initial meeting with clients to build a relationship that fosters a space for ongoing discussions, engage with the subject matter by asking questions, and request any relevant material needed to further research the brief.

The first meeting with the PROV-ED team enabled me to immerse myself into the realm of Emergency Departments, the nuances of medical practices, and the dimensionality of urine collection. Listening to the requirements of the posters' redesign, I was confident in my personal and professional experience in the LGBTQI+ space and my knowledge of gender, cultural, and social diversity, and I was immediately drawn to the project and its outcomes.

At the end of the meeting our discussions turned to design options and various interventions that would be appropriate for the project. We identified the following requirements for the RedUCE project:

1. Minimising the confrontational nature of the graphics while ensuring they fulfil the intended purpose—i.e., to provide clear, easy to follow instructions on how to collect a midstream urine sample to avoid contamination.
2. Ensuring graphics are widely applicable to different demographic groups, considering factors such as age, gender, ethnicity, literacy, and cultural or religious differences.
3. Be suitable for both adult and paediatric use (anyone who is 'toilet trained').
4. Ability to be used in different modalities e.g., posters, leaflets etc.
5. Include an opportunity or avenue to clarify with staff or ask questions.

The final graphics were trialled by the PAH ED and assessed on their effectiveness, with intention to be reproduced and rolled out to all QH EDs.

6 Design Process

Following on from our ongoing meetings with the PROV-ED team, we explored several options to improve the overall experience of urine collection—from an infographic, to reinventing the process and designing a different container for urine collection, to developing animations that turned urine collection into a game for children. The consensus from the PROV-ED team and The Design Lab was to redesign and streamline the poster design in consideration of the project aims and objectives, with the opportunity to revisit these ideas at a later date if the PROV-ED team wished to do so.

The challenge to create a visually appealing and cohesive design relied upon a combination of theoretical design knowledge, aesthetic considerations, and practical decisions based on academic research and studies to empathise with and understand the needs our target audience. Dividing the visual design choices into a range of categories allowed me to foreshadow when to apply known design principles and when to consult academic literature for more guidance. This strategy permitted a space for ongoing research to take place to make informed decisions within the next stages of the design thinking ideation, prototyping, and testing to take place [27].

7 Poster Layout

First and foremost, the decision was made to combine what had been two separate posters for both sexes (men and women) into one poster, and reduce the number of steps, to further simplify the process and streamline the design. Taking direction from the PROV-ED team on what elements were required within the redesign, I elected to change the orientation of the poster to a portrait format gave a more natural flow and structure to the design, and for ease of display upon a toilet door.

This structure was achieved by creating grids, using the basic design principles of balance, symmetry, and repetition [28]. This sectioning generated a sense of hierarchy by experimenting with spatial allocation that would emphasise the most important information such as the title, boxes for the steps, any additional information needed such as logos and contacts.

The steps of the original poster were reduced from 18 in total (9 for each poster), keeping the first step of guiding the user to wash their hands and then restructured as follows. From step two onward the new poster is broken into two sections adjacent to each other that focus on the two different protocols for each represented sex—male and female. Within these individual sections, three primary steps [2–4] for each sex have been identified by the studies conducted by Eley and colleagues [23] as being crucial to the reduction of mid-stream urine contamination. Steps five and six then return to the same overarching format as the first, directing users to complete the collection sample by finishing urination, screwing the lid onto the container, and washing their hands again.

8 Typography

The typeface chosen for the poster design was Myriad Pro, a humanist sans-serif typeface designed by Robert Slimbach and Carol Twombly, with Fred Brady and Christopher Slye, for Adobe Systems [29, 30].

Overall, Myriad Pro is a well-designed and versatile typeface that has become popular in both print and digital media. Its modern and neutral appearance make it highly legible across a range of environment settings [31]. With its range of weights

The Myriad Font

Condensed
Condensed Italic
Bold Condensed
Bold Condensed Italic
Regular
Italic
Semibold
Semibold Italic
Bold
Bold Italic

1234567890~!@#$%^&*()–{}\":|<>?.,
ABCDEFGHIJKLMNOPQRSTUVWXYZ
A quick brown fox jumps over the lazy dog

Fig. 2 Myriad Pro Example (top), and Final colours chosen for the poster layout (bottom)

and styles, it is a popular choice for branding, advertising, and user interface design [28, 29].

It is available for both personal and commercial use through Adobe (see Fig. 2 below).

9 The Myriad Font

10 Colour Palette

It is well documented that colours have psychological and cultural associations that can affect the emotions and moods of an individual [28, 32, 33]. However, as Dabner et al. [28] write, "While color associations are highly subjective, despite local differences, colors and hues may have some universal characteristics." (p. 99). Combining various studies into colour phenomenon provided a deeper understanding into how I can considerably design for larger demographic groups in respect to age, gender, ethnicity, and cultural or religious differences [31, 34–36].

However, with the poster needing to suit the look and feel of the medical space, I had to do research into the existing Queensland Health (QH) directives on design trends, and cross referenced them to a list of colours that would be appropriate for our audience, resulting in a range of predominately cool-toned colours (such as blues and greens) to choose from. I experimented with different colour variations of blue and green with viewers with different visual abilities [37, 38]. This involved testing combinations for contrast and visibility, as well as considering the use of colour in different types of media, such as print or digital interfaces [39].

Referencing these colours to relevant research revealed that both blue and green are perceived as emotionally calming, soothing, and encourage logical thought [31, 33, 35]. Each colour has a neutral causation across cultural and religious resonance, making them a culturally appropriate choice for the poster background [28, 35]. The use of such bold contrasting colours not only fits in with the QH design trends, but the tonal qualities work to strengthen a sense of the authoritative importance of the poster's overall message.

As a result of this research and testing, a dark blue was chosen for the background, complemented by a striking light green to frame the boxes to create a focal point for the illustrative aspect of the poster design (see first row of Fig. 2—bottom image).

Taking a more conscious approach to the colour selection of the individuals depicted, my attention now shifted towards resolving the bias towards a use of Caucasian figures in medical illustrations, and addressing the lack of inclusivity among the LGBTQI+ community [14, 15]. Referencing existing knowledge of cross-cultural colour theory within the socio-political space of gender and sex, I made the deliberate choice to use an unnatural skin tone to represent the human figures within the steps. Removing the complex symbolisms of the human body does not negate the importance of individual culture and race, but rather its intention is to create a sense of inclusivity for all by using a neutral colour [14].

I investigated a range of colours that complemented the main colour palette, ultimately choosing a cool-toned dark purple hue with low saturation for its perceived passivity and neutrality [35]. A lighter purple in the same hue was used to fill

the figures, while the darker purple was used to outline (see second row of Fig. 2—bottom image).

Adhering to the design intentions I had set out, a cool-toned grey that met the same light and dark colour values of the purple that was used to depict clothing within each figure (see second row of Fig. 2—bottom image). The psychology of the colour purple suggests that it can be both contrastingly calming or stimulating to a viewer, while grey was widely regarded as lacking emotion, making them both a versatile colour in design [33, 35].

Through the final stages of prototyping and testing, some refinements were made at the request of the PROV-ED team. It was at this stage that four colours were added to clarify the two adjacent boxes for each sex. Due to project workloads within the QUT Design Lab, this task was given to another designer within our team. They have chosen the four colours as complimentary to the original palette (see third row of Fig. 2—bottom image).

The carefully curated colour palette seamlessly fits into the realm of the existing QLD Health directives, and aligns with recent studies into the colour preferences of those from different age groups, genders, ethnicities, and cultural and religious differences [34, 40].

The additional colours used within the illustrated steps were chosen exclusively to provide an accurate depiction of the object a person would engage within the ED. For example, the lid of the urine collection container is yellow, while the colour red is used as a directive to follow, along with any additional information needed to be communicated within a step. All of these colour choices were made to reflect the form and function of the ED space, to assist users of all cultural and literacy abilities [11].

11 Illustration and Iconography

This project provided a very important opportunity to address the discourse of inclusivity, equity and access within the healthcare sector, by adopting a stance of awareness. To meet the challenges of reducing the confrontational nature of the previous graphics, a gestural drawing methodology was adopted (see Fig. 3). Gestural drawing as an illustrative technique today is used in art to capture the basic movement and energy of a subject with loose, fluid lines [41].

Like colour, image is interpreted based on the viewer's own experiences; this space for imagination and interpretation within the gestural drawing approach generates a rich space for each person to see themselves represented in what is not left on paper [42]. This gestural drawing practice provides that freedom to illustrate each step without depictions of genitalia, while still creating the same narrative function of each movement and action.

For the female-presenting figure, the results were achieved by colouring the entire figure in one block colour and adding further detail in the arms and legs—doing so shifted the focus away from the genitals. With a similar approach, the

Fig. 3 Adapted from "Amedeo Modigliani, Caryatid, c. 1913– 14, p." (Fig. 3.4). In P. Crowther. (2017). What Drawing and Painting Really Mean: The Phenomenology of Image and Gesture, p. 56

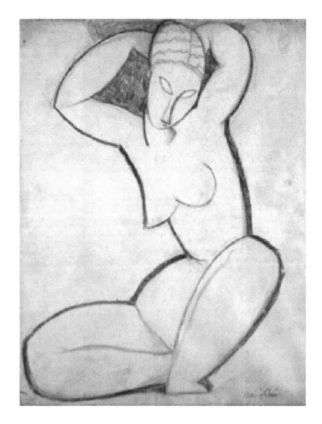

male- presenting figure was carefully angled to minimise the details seen around the genital area and shift the attention towards the details of hand placement and correct technique of collecting the urine (see Fig. 4).

These illustrations went through various phases of refinements based upon feedback from peers, and in consultation with the PROV-ED team to ensure that each figure conveyed an accurate portrayal of each step. The separation of action and deliberate perceived stillness of the body (and not the face) depicted in each step eliminates the problematic connotations of sexual anatomy and cultural and religious sensitivity, while still providing adequate context. Guided by the simplified text generated by the PROV-ED team, I have been able to re-draw the line for heteronormative symbolism of the human form [13, 26, 43].

12 The Final Poster

The design went through multiple rounds of iterative feedback sessions with the PROV-ED team regarding the illustrations, the number of steps, layout, and the narration style to ensure that it effectively communicated the intended message.

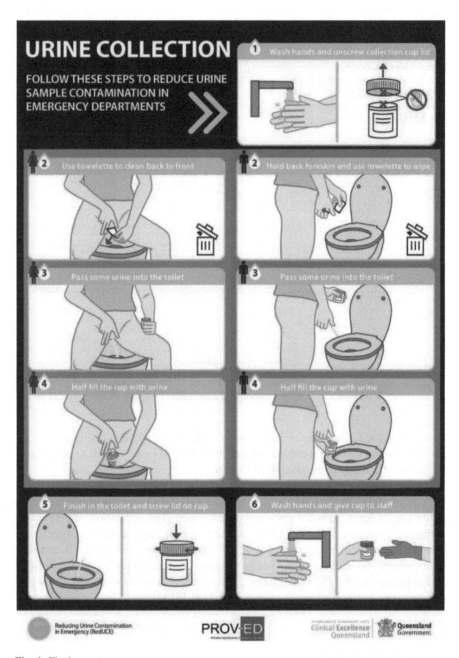

Fig. 4 Final poster

The final poster design (Fig. 4) was completed and displayed as repositionable A3 vinyl posters in ED toilets at a pilot site within PAH ED for a trial period. The completion of this project proved to be successful, and the posters are now being implemented across all Queensland Health EDs.

References

1. Juntos H (2010) Universal symbols in health care workbook. Executive summary. Best practices for sign systems.
2. McNicol S, Leamy C (2020) Co-creating a graphic illness narrative with people with dementia. J Appl Arts Health 11(3):267–280
3. Napier DA, Depledge M, Knipper M, Lovell R, Ponarin E, Sanabria E, et al. (2017) Culture matters: using a cultural contexts of health approach to enhance policy making. 2022(October 12). Available from: https://apps.who.int/iris/handle/10665/344101
4. Blakemore C (2020) The power of visuals in marketing. Available from: https://www.paceco.com/insights/the-power-of-visuals-in-marketing/
5. Hajar R (2011) Medical illustration: art in medical education. Heart Views 12(2):83–91
6. Donaldson T (2008) Shapes for sounds. Mark Batty Publisher
7. Woodham JM (2006) A dictionary of modern design. Oxford University Press
8. Gibson D (2009) The wayfinding handbook: information design for public places. Princeton Architectural Press
9. Prakash M, Johnny JC (2015) Things you don't learn in medical school: caduceus. J Pharm Bioallied Sci 7(Suppl 1):S49–S50
10. International Committee of the Red Cross (2007) The History of the Emblems. Available from: https://www.icrc.org/en/doc/resources/documents/misc/emblem-history.htm
11. Rand P (1947) Thoughts on design. Chronicle Books, San Francisco, USA
12. Malamed C (2009) Visual language for designers: principles for creating graphics that people understand. Rockport Publishers
13. Joy Lo C-W, Yien H-W, Chen I-P (2016) How universal are universal symbols? An estimation of cross-cultural adoption of universal healthcare symbols. HERD: Health Environ Res Design J 9(3):116–134
14. Massie JP, Cho DY, Kneib CJ, Sousa JD, Morrison SD, Friedrich JB (2021) A picture of modern medicine: race and visual representation in medical literature. J Natl Med Assoc 113(1):88–94
15. Nama N, MacPherson P, Sampson M, McMillan HJ (2017) Medical students' perception of lesbian, gay, bisexual, and transgender (LGBT) discrimination in their learning environment and their self-reported comfort level for caring for LGBT patients: a survey study. Med Educ Online 22(1):1368850
16. National LGBT Health Education Centre (2021) Focus on FOrms and policy: creating an inclusive environment for LGBT patients. Fenway Institute, Bostom, MA
17. Bekeris LG, Jones BA, Walsh MK, Wagar EA (2008) Urine culture contamination: a College of American Pathologists Q-probes study of 127 laboratories. Arch Pathol Lab Med 132(6):913–917
18. Curtis J, Perry K, Bower L (2008) Evidence review: clean catch® midstream urine collection device. Centre for Evidence-based Purchasing, London
19. Better Health Victoria (2022) Urinary Tract Infections. Available from: https://www.better-health.vic.gov.au/health/conditionsandtreatments/urinary-tract-infections-uti
20. Turner D, Little P, Raftery J, Turner S, Smith H, Rumsby K et al (2010) Cost effectiveness of management strategies for urinary tract infections: results from randomised controlled trial. BMJ 340
21. Dumoulin C, Hunter KF, Moore K, Bradley CS, Burgio KL, Hagen S et al (2016) Conservative management for female urinary incontinence and pelvic organ prolapse review 2013: summary of the 5th international consultation on incontinence. Neurourol Urodyn 35(1):15–20
22. Jackson SR, Dryden M, Gillett P, Kearney P, Weatherall R (2005) A novel midstream urine-collection device reduces contamination rates in urine cultures amongst women. BJU Int 96(3):360–364
23. Eley R, Judge C, Knight L, Dimeski G, Sinnott M (2016) Illustrations reduce contamination of midstream urine samples in the emergency department. J Clin Pathol 69(10):921–925

24. Arnold JE (1959) Creative engineering seminar. Stanford University Press, Stanford, CA
25. Fuller RB (1969) Operating manual for spaceship earth: Estate of R. Buckminster Fuller
26. McKim RH (1959) Designing for the whole man. Stanford University
27. Auernhammer J, Leifer L, Meinel C, Roth B (2022) A humanistic and creative philosophy of design. In: Design thinking research: achieving real innovation. Springer, pp 1–15
28. Dabner D, Calvert S, Casey A (2012) The new graphic design school: a foundation course in principles and practice. John Wiley & Sons
29. Adobe (2023) Myriad. Available from: https://fonts.adobe.com/fonts/myriad
30. Bringhurst R (2019) The elements of typographic style, 4th edn. Hartley & Marks
31. Haddock S, Hicks A, Barnum A, Oppen F (2012) Graphic design: Australian design manual. McGraw Hill, Australia
32. Fine A (2021) Color theory: a critical introduction. Bloomsbury Publishing
33. Kurt S, Osueke KK (2014) The effects of color on the moods of college students. SAGE Open 4(1):2158244014525423
34. Al-Rasheed AS (2015) An experimental study of gender and cultural differences in hue preference. Front Psychol 6:30
35. Clarke T, Costall A (2008) The emotional connotations of color: a qualitative investigation. Color Res Appl 33(5):406–410
36. Zaragoza IE (2021) Colour and gender: language nuances. Feminismo/s 38:115–147
37. Guilford JP, Smith PC (1959) A system of color-preferences. Am J Psychol 72(4):487–502
38. Ishihara S (1960) Tests for colour-blindness. Kanehara Shuppan Company Japan
39. Fairchild MD (2013) Color appearance models. John Wiley & Sons
40. Ling Y, Hurlbert AC (2007) A new model for color preference: Universality and individuality. Final Program and Proceedings-IS and T/SID Color Imaging Conference; Newcastle University
41. Nicolaides K (1969) The natural way to draw: a working plan for art study. Houghton Mifflin Harcourt
42. Crowther P (2017) What drawing and painting really mean: the phenomenology of image and gesture. Taylor & Francis
43. McKim RH (1980) Experiences in visual thinking, 2nd edn. Cengage Learning

Professor Lisa Scharoun is the Head of School – School of Design at Queensland University of Technology in Brisbane, Australia. A multi-award winning teacher, researcher, and designer with expertise in Visual Communications, Lisa's current research has a focus on Design for Health and Cross-cultural design.

Zoe Ryan is a multi-disciplinary artist, designer, illustrator, researcher, and PhD candidate at QUT School of Design, specialising in subversive deconstructive design methodologies. Their research focuses on game systems, interactive art, tangible media, identity and gender politics, queer theory, and design for social change.

Professor Evonne Miller is Co-Director of the HEAL (Healthcare Excellence AcceLerator) initiative and Director of the QUT Design Lab. Professor of Design Psychology at Queensland University of Technology, Evonne is a leading voice on the value of arts and design-led innovation in healthcare transformation, bringing a collaborative, pragmatic, and fresh interdisciplinary approach to problem solving. She is the author, co-author, or editor of 4 books, exploring how we can create places that foster planetary and human health.

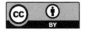

Agency and Access: Redesigning the Prison Health Care Request Process

Lisa Scharoun and Evonne Miller

Globally, 10.74 million people are in prison—as pre-trial/remand prisoners or convicted and sentenced. A prison sentence protects the community, punishes the offender, and deters similar offences, with rehabilitation a critical component of the criminal justice system. As well as addressing the factors that contribute to re-offending, entering prison provides an opportunity to access healthcare and address health issues. However, the problems in prisoners' lives are complicated. Compared to the general population, people in prison are often from economic and socially disadvantaged backgrounds, with lower levels of literacy, poorer physical health and high rates of mental health problems, chronic health conditions and communicable diseases, such as Hepatitis C. Research also shows that, when not in prison, people who have been incarcerated are more likely to use illicit drugs, and engage in tobacco smoking and risky alcohol consumption [1, 2].

Good health is key to successful rehabilitation—and prison can provide the space and time to address health needs. However, the delivery of healthcare in prison is also not straight forward, due to security regimes and differences between prison and healthcare systems and cultures. The United Nations Basic Principles for the Treatment of Prisoners states that: "prisoners shall have access to the health services available in the country without discrimination on the grounds of their legal situation" [3], with this principle highlighting that prisoners should have access to the same level of healthcare as the general community.

L. Scharoun
QUT, Brisbane, QLD, Australia
e-mail: lisa.scharoun@qut.edu.au

E. Miller (✉)
QUT Design Lab, School of Design, Queensland University of Technology,
Brisbane City, QLD, Australia
e-mail: e.miller@qut.edu.au

© The Author(s) 2024
E. Miller et al. (eds.), *How Designers Are Transforming Healthcare*,
https://doi.org/10.1007/978-981-99-6811-4_8

137

1 How Prisoners Currently Access and Experience Healthcare

Surprisingly, across the globe, there is relatively little research regarding prisoner health services. In part, that may be in part due to the diversity of healthcare provision and processes between institutions, and differences in healthcare systems across countries. A recent review identified that the research conducted has been focused more on the *prevalence of* specific health needs, rather than on the *services required* to meet those needs [4]. This resulted in relative consensus of the typical health issues of prisoners, but has not addressed how to ensure prisoners receive the healthcare to treat, alleviate, or manage these conditions whilst in custodial settings.

The task of providing healthcare to prisoners has many interrelating factors that can pose challenges, with "the delivery of effective health care to prisoners is dependent upon partnership between health and prison services" [5 , p. 119]. As White et al., [6] explain:

> The provision and ethics of health care may be compromised by the physical design of the prison, the institutional policies and practices restricting movement of prisoners and practitioners, the focus on maintaining control and security, and the very purpose of the prison and prison system itself (pp. 12-13).

The complex nature of institutions such as prisons, has a significant influence upon healthcare practice, processes and procedures. Of the few studies that have attempted to outline the process for accessing healthcare whilst in prison, it appears that within Australia, the USA, Britain, and Canada—when not requiring emergency care—prisoners are required to complete a written request. This process often results in significant wait times, whilst the request moves through the prison and healthcare administrative processes [7]. Additionally, this requirement to complete a *written request* for healthcare may impede access, as prisoners typically have lower levels of literacy and may finding writing about their health concerns challenging [8].

Interviews with ex-prisoners about their experience whilst in prison identified that some were hesitant to submit healthcare requests to officers (guards), with the perception that the officers had the liberty to decide to process requests or not [9]. The ex-prisoners were more satisfied with healthcare provision in less secure prisons, and when their healthcare needs were eventually met. Communication, or lack thereof, between prisoners and healthcare services has been identified as a key issue, with prisoners citing restrictions on being advised about appointments [10]. Common challenges with providing healthcare in prisons are staffing, funding, security regimes, and prison and healthcare culture clashes [4], all of which can and should be addressed to ensure prisoners receive healthcare similar to the general populations.

2 Why Prison Healthcare Matters: And Current Priorities

More than two decades ago now, and based on the UK system, Watson and colleagues [11, p. 3] outlined a number of 'ingredients' for consideration in the design of a healthcare model for prisoners:

1. *Health promotion as a unifying concept for health care in prisons incorporating health needs assessment;*
2. *Health screening on arrival in the prison system incorporating standardised protocols and validated instruments with an emphasis on mental health;*
3. *Partnership between prison services and health services;*
4. *Telemedicine as one mode of delivering health care in prisons;*
5. *Education of prison staff, including healthcare staff about the health needs of prisoners; and*
6. *Developing a model of prison health care which looks beyond the prison environment to the communities which the prison serves.*

These ingredients remain relevant now, as in a systematic review of re-entry programs, Kendall et al. [12] identified health services in prison as vital in preventing re-entry. Ensuring prisoners have good access to healthcare not only assists with improving their health, but could provide further benefits for re-integration back into the general community—setting prisoners up well for life outside prison.

Flanigan's [4] review of prison healthcare in the United Kingdom concluded it was viewed as easier to access healthcare in prison than in the general community (due to cost, access, stigma etc), which provides an opportunity for prisoners to address health concerns whist in prison. Imagine, for example, a person who is overweight who does not have the health literacy or financial resources to make healthy food choices, enters prison where healthy, balanced and well portioned meals are provided—and there is potentially support for learning how to grow vegetables and cook healthy meals. They could leave prison healthier, with new skills that would support better life choices. Or a person with an opioid addiction may benefit from being placed on the opioid substitution scheme, which could help them overcome their addiction and provide broader positive impacts on their life.

As a key role of prison is to facilitate rehabilitation, prisoners should be given the opportunity to develop skills that could help them function well when re-integrating into the community—including enhancing their health. Establishing good 'recovery capital' for prisoners before re-entering the general community can include resources such as housing and employment; pro-social relationships; pro-social identity; coping skills; community engagement [12]. Addressing some of the key health issues facing prisoners might also help build their 'recovery capital'. Alongside continuity of care models that continue outside of prison, most research on the delivery of healthcare inside prisons has focused on the alternative model of telehealth. Telemedicine has the potential to provide practical and economic benefits by reducing costs through reducing the need to transport and accompany prisoners to appointments outside the prison, to recruit healthcare professionals that do not

need to physically attend the prison or have a prisoner attend their practice. Telemedicine trials within prisons have been positive, with most indicating that the healthcare provided was deemed equivalent or improved quality of care, and telemedicine was even preferred by some prisoners [13].

3 Rethinking the Prison Health Request Process: A Queensland Case Study

Other than trialing telemedicine, however, very little research has been conducted to help practitioners understand how to best design and deliver healthcare services in prisons. In this project, therefore, our focus was to enhance the prisoner health *request process,* using co-design in one case study prison in Queensland, Australia. A collaboration between Queensland Health's Office for Prisoner Health and Wellbeing, the case study prison, Health Consumers Queensland, this project was designed to enhance access and communication by redesigning the health request form—to be trialed in one regional men's prison and then rolled out. The project responded to a Queensland Offender Health Services Review identifying barriers to accessing timely health services, and the use of digital technologies in the Prison System, discussed below. A key issue identified was the lack of agency that prisoners felt in procuring solutions to their health.

Right now, 41,000 Australians are in prison—8657 in Queensland [14, 15]. Australian prisons include high rates of Aboriginal and Torres Strait Islander peoples (29% of prisoners; [14]), which presents a particular cultural and health context. Prisoners, in general, have lower levels of literacy than the general population with 63% of prison entrants in 2018 having an education level of Year 8 or below (aged 13–14 years; [16]), which may add further complexities to healthcare access. And, unfortunately, within 2 years of being released from prison, 45% will be back behind bars [17].

4 The Queensland Prison Health System

Eight Hospital and Health Services are contracted by Queensland Health to provide primary health services in 14 correctional centres throughout the state of Queensland. The nature of these primary health care services is outlined in a Memorandum of Understanding between Queensland Health and Queensland Corrective Services (QCS). In summary, these primary health care services are like that provided by a general practice, in addition to various specific clinic health services including pathology, dispensing medications, and administering medications, as well as (often limited) access to a dentist.

The current system is focused on a paper-based Health Services Request Form, in Fig. 1 to access non-emergency healthcare, prisoners request this paper form (from a guard or health provider), write in their health concern, and submit it once

Fig. 1 Current Health Services Request Form, with annotated comments

a day, where it is processed, and they receive an appointment. Access to these forms is either through a request to a QCS officer or a member of the health staff. Prisoners generally have limited literacy, yet this process is reliant on prisoners being able to convey key information about their health, in writing, which health staff then use to determine when they should be seen (a triaging process). Confidentiality issues also arise if prisoners request assistance to complete the form. Upon receipt of these forms, health staff triage the requests based on the nature of the issue described in the request.

5 Barriers to Accessing Timely and Appropriate Health

A recent Queensland Offender Health Services Review (OHSR) identified that there are numerous barriers to accessing timely and appropriate health services for prisoners, and proposed to review the service evaluation and development system and work to increase offenders' access to health services. Some of the barriers fall within Queensland Health's area of change (e.g., HHS service agreements), and some are regarding QCS processes (e.g., the structured day and infrastructure). The key issues identified that specifically relate to prisoner medical requests and their access to health services include: (1) Limited writing skills providing a barrier to completing the Health Services Request Form, (2) confidentiality issues arise if they request assistance to complete the form, (3) Prisoners report a lack of communication and feedback regarding health requests, and (4) Some prisoners resort to self-harm to get attention from health centre staff.

Similar issues were also identified during consultations with Prisoner Advisory Committees (PAC) conducted by Health Consumers Queensland (HCQ). In early 2021, HCQ conducted 19 PAC discussions in 7 correctional centres across Queensland to listen to the prisoners about their experience of prison health services to find out what is working well, or not so well, and to hear their suggestions for improvements. From a consumer perspective, the Statewide PAC consultations identified six key themes that emerged from the feedback across the seven Correctional Centres visited:

- Medication Management—pain relief, prescription practices and administration
- Dental—Access and treatment options
- Medical Requests—Access to and response
- Communication and Culture
- Mental Health—Access and treatment options
- COVID-19 and vaccination.

In regard to *Theme 3: Medical requests*, key issues identified were (1) not receiving a response to healthcare requests; (2) increased wait times due to higher prisoner numbers but not higher health staff numbers; (3) healthcare requests only being handed in during morning medication rounds; and (4) difficulty completing the form for those with low literacy levels, English as a second language or illiterate,

particularly as they understand triaging is based on what is written on the form. Lack of communication and feedback from health centre staff regarding a prisoner's request for health care was also raised as one of the most significant issues identified from the HCQ consultations. In considering this feedback and data some recurring issues with the process include:

- *Access to medical request forms is contingent on staff providing these forms;*
- *Submission of the medical requests are reliant on staff (QCS or Health staff) to pass on the forms;*
- *Prisoners generally have limited literacy; and*
- *Do not know if their request has been received or what, if any, action is going to be taken.*

Taken together with the complaints data, this suggests that—alongside increasing service availability—providing timely response to medical requests (and information on wait times) may be one strategy to improve patient satisfaction and reduce complaints.

6 Redesigning the Prison Health Request Form

To address some of the key issues identified above, this project redesigned the prison health request process through a design-led, co-design process. As well as interviewing senior sector stakeholders (policymakers and prison clinicians), over two days, co-design workshops were held at the case study site—a regional Queensland men's prison—with groups of offenders (four one-hour workshops), healthcare staff (a one-hour workshop) and prison officers (a one-hour workshop, plus informal conversations), who were engaged in collaboratively developing, testing, and revising ideas and potential solutions for the healthcare request process.

Participatory co-design is about designing with, not for, people; co-design emphasises that—as experts of their own lived experience—end-users must be actively engaged in the design process. The aim was to (1) understand the process and identify key pain points; and (2) collaboratively develop, test, and revise ideas and potential solutions for the healthcare request process. The interviews and workshops uncovered the [1] health request process and [2] key pain points in the existing customer service journey (factors that currently restrict access to health services), many of which were the same as those identified by the HCQ PAC consultations conducted in early 2021. The key pain points are provided below with the main issues for each step outlined in Fig. 2 and Table 1.

There are pain points at all stages of the prisoner health request process. The overarching issues are lack of communication and communication breakdowns. The system pain points are well understood by the custodians of the existing processes and systems, with a strong desire for new, consumer-centric processes supported by a compassionate culture among health and correctional services staff—it is, we acknowledge, more complex than simply designing a new form, there is a need to

address the culture and norms that give rise to some of the most significant pain points. As there was limited information regarding where their form was in the system, prisoners would either: refrain from submitting 'The Form': *"unless it's real bad, you don't bother... you learn to live with it"*; or re-submit the form multiple times (which clogs up the system), or 'play up': *"brothers in pain... they play up for them to call a code"*. These negative outcomes could be addressed with clearer communication between the health staff and prisoners, or greater transparency with the process.

Through visually "journey mapping" the steps in the prisoner health request process—from the views of all users (offenders, officers, and clinicians)—we

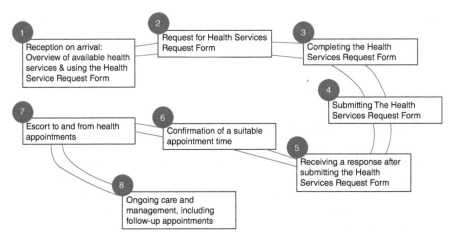

Fig. 2 Prison Health Service Process Steps

Table 1 Pain points in health assessment, access and form process

Pain Point 1:	Pain Point 2:
Time spent with nurses during reception / health assessment on arrival *	Access to 'health services request form' (the form)
• Constrained by static, rigid process • No proactive screening • No induction pack to refer to later • Pen and paper records • Influenced by the culture of the team • Cognitive overload • No opportunity for continuity of care • Constrained opportunity for optimal nursing practice • Limited CALD services	• Via nurse during medication rounds am and pm, two chances per day • Via officers' station during out of cell time (minimal for detention unit) • Form not always available or provided when requested
Pain point 3:	Pain point 4:
Completing 'the form'	Submitting 'the form'

Table 1 (continued)

Pain Point 1:	Pain Point 2:
• Completing the form is particularly difficult for those from CALD backgrounds or who have low literacy or are illiterate • Privacy has to be compromised to seek help completing the form • Difficult to articulate or describe the problem • Very little room to describe or draw etc. • The form itself is 'official', process-driven, intimidating The PAC assisted prisoners with completing the form, as "*a lot of our brothers have trouble writing*", and felt it was sometimes hard to describe the health problem in words.	• Form can be submitted to a nurse directly during morning medication rounds *Questions that arise from prisoners:* • Did the form make it to the triage nurse/health clinic? • Will the form be processed? And what does this even mean? • Will they understand what I wrote? Did I describe it well enough? • Will they take my request seriously? These common questions demonstrate the communication breakdown about the healthcare request process between the prisoners and the healthcare staff. To attempt to gain more time and information about their health concerns, prisoners described waiting at the end of the medication line to submit their forms and to try and have a longer chat with the nurse then, about their health concern. If they took too much time when submitting the form, however, other prisoners during these busy medication rounds would chant: *"It's medication, not consultation."*
Pain point 5:	Pain point 6:
Receiving a response to 'the form'	Confirmation of a suitable appointment time
• PACs felt formal responses are rarely received—many had NEVER seen the notification forms before • In part, this is because there are no notification slips for appointments at nurse clinics—which happen quickly, within a few days • Notification slips are used for major appointments—however there is no governance to ensure this happens and wait times for appointments are long • Next communication for prisoners is usually being told one morning "you have been 'listed' to be seen that day, get ready to be transported"	• Very little communication regarding appointment times • Confirmation is on the day without regard for other activities or obligations • Refusal of appointment is via officers • Reason for refusal not always conveyed to health staff • Appointments may be rescheduled or cancelled for a variety of reasons including codes and lockdowns • Communication of approximate timing would be good enough
Pain point 7:	Pain point 8:
Escort to and from appointments	Ongoing care and follow-up appointments
• Security is prioritized over consumer health • Availability of escorts at appointment times; if the prison goes into "lockdown", prisoners must be in their cells and there is no movement—Which means appointments are missed.	• Limited annual check-up or screening • Appointments for new symptoms via 'the form' • Some chronic conditions missed due to lack of time with consumers • Some chronic conditions not shared with health staff • Some chronic conditions misunderstood or misinterpreted • Access to speciality services, such as dentists, are stretched beyond capacity, especially in regional settings—As the PAC's note: *"Never going to hear about the dentist, the wait is so long..."*

re-designed the Health Services Request Form, using visual icons to more clearly communicate information, building in feedback loops and indicating average waiting times.

7 The New Visual Form

Health records form a permanent account of a patient's illness and their clarity and accessibility are essential for effective communication between healthcare professionals and patients [18]. It is important to note that the electronic patient record has not yet fully replaced the paper-based one in most medical systems. Electronic documentation continues to be used in addition to residual paper-based records. When properly understood and used by patients, these forms are valuable documents for investigating and treating serious to moderate health complaints and ongoing health issues. In the highly controlled space of a prison, the paper-based system is the primary system, and our research above explains why the adoption of a digital system is especially complex. We chose, therefore, to tackle the redesign the procurement form as the first part of a multi-staged approach to a new visual system. The form has been redesigned using icons and pictograms to [1] provide access to those with low literacy levels and [2] be more suitable for future digital applications as part of a screen-based icon-system. Figure 3 shows the modified form, which is purposely visual (to address lower literacy levels) and key changes.

The predominate design feature of the new form is the use of icons and illustrations. According to Hajar [19]: "Oftentimes, an illustration transmits the pertinent, useful, and important information much more effectively than words." A key issue identified by prisoners was that they did not understand some of the services offered, and so the re-designed form uses a set of custom designed icons that visually describe these options. Prisoners also noted low-literacy levels limited their ability to describe pain points; thus, we provided a visual of the male figure to enable the user to pinpoint areas of pain and/or discomfort. The most notable addition to the form, which was directly identified through the co-design process, is a section on indicative wait time indications, so prisoners have a better understanding of when they might see the specific health practitioner. As the form needs to be reproduced internally, we used simple line drawings in black and white so that images would be clear when printed by photocopier/personal printer and is set in an A4 template as a standard paper size for processing and filing.

As a first iteration, this paper-based form enables prisoners to become used to the visual language and approach. An A3 poster was also produced explaining the new system, to be displayed in common areas as part of an onboarding experience. While Covid-19 disruptions have delayed full deployment and testing, initial responses from healthcare professionals and prisoners indicate that this re-designed form will help improve timely access to healthcare for prisoners.

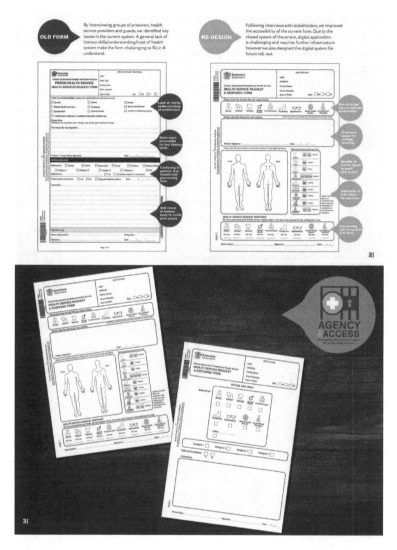

Fig. 3 Re-designed Visual Health Request Form

Elements of the form can form a visual system that can be applied across a range of outputs, lending itself to future applications in a digital system. We are exploring how this can be applied across tele-health and screen-based forms. The bottom of Fig. 4 gives an indication of how the graphic system might be applied to a digital health system.

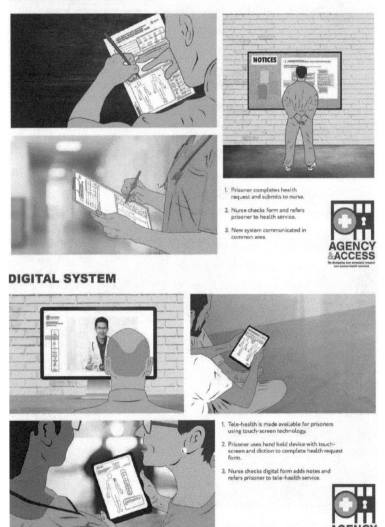

Fig. 4 The paper-based system (top), and the concept for applying the visuals and icons to a digital health system (bottom)

8 Conclusion

This project revealed that service pain points were well understood by both end-users and custodians of the existing processes and systems, with a shared desire for new, consumer-centric processes supported by a compassionate culture among health and correctional services staff. Prison health is a complex system, with change challenging to implement; however, thoughtful, and innovative service (re) design starts with genuinely listening to and understanding the experience of end-users, with the new visual form—currently being trialed—a critical step in delivering more prisoner-centric healthcare.

References

1. Australian Institute of Health and Welfare (2013) The health of Australia's prisoners 2012, Canberra
2. Levy M (2005) Prisoner health care provision: reflections from Australia. Int J Prison Health 1(1):65–73
3. Nations U (1990) Basic principles for the treatment of prisoners. Available from: https://www.un.org/ruleoflaw/blog/document/basic-principles-for-the-treatment-of-prisoners/
4. Flanigan C (2020) Health and healthcare in prison: a literature review 2020:[60 p]. Available from: https://www.scotphn.net/wp-content/uploads/2020/12/Prison-Literature-Review-Dec-2020.pdf
5. Watson R, Stimpson A, Hostick T (2004) Prison health care: a review of the literature. Int J Nurs Stud 41(2):119–128
6. White KL, Jordens CF, Kerridge I (2014) Contextualising professional ethics: the impact of the prison context on the practices and norms of health care practitioners. J Bioeth Inq 11:333–345
7. Ross MW, Liebling A, Tait S (2011) The relationships of prison climate to health service in correctional environments: inmate health care measurement, satisfaction and access in prisons. Howard J Crim Just 50(3):262–274
8. Ahmed R, Angel C, Martel R, Pyne D, Keenan L (2016) Access to healthcare services during incarceration among female inmates. Int J Prison Health 12(4):204–215
9. Memarpour P, Ricciardelli R, Maasarjian P (2015) Government reports versus offenders' experiences: toward the resolution of discrepancies in healthcare and healthcare delivery. Int J Prison Health 11(4):225–242
10. Perrett SE, Gray BJ, Brooks NJ (2020) Exploring health and wellbeing in prison: a peer research approach. Int J Prison Health 16(1):78–92
11. Watson R, Stimpson A, Hostick T, Walsh M. Health care and change management in the context of prisons: rapid reviews of the literature in two parts. 2002
12. Kendall S, Redshaw S, Ward S, Wayland S, Sullivan E (2018) Systematic review of qualitative evaluations of reentry programs addressing problematic drug use and mental health disorders amongst people transitioning from prison to communities. Health Justice 6(1):1–11
13. Edge C, Black G, King E, George J, Patel S, Hayward A (2021) Improving care quality with prison telemedicine: the effects of context and multiplicity on successful implementation and use. J Telemed Telecare 27(6):325–342
14. Australian Bureau of Statistics (2020) Prisoners in Australia. Available from: https://www.abs.gov.au/statistics/people/crime-and-justice/prisoners-australia/latest-release

15. Queensland Government Statistician's Office (2020) Prisoners in Queensland: Queensland treasury, Queensland Government; [cited 2022 November, 21]. Available from: https://www.qgso.qld.gov.au/

16. Australian Institute of Health and Welfare (2019) The health of Australia's prisoners 2018, Canberra

17. Australian Productivity Commission SCftRoGSP (2021) Report on Government Services 2021, Part C, Table CA.4.

18. Abdelrahman W, Abdelmageed A (2014) Medical record keeping: clarity, accuracy, and timeliness are essential. BMJ. Br Med J 348:f7716

19. Hajar R (2011) Medical illustration: art in medical education. Heart Views 12(2):83–91

Professor Lisa Scharoun is the Head of School – School of Design at Queensland University of Technology in Brisbane, Australia. A multi-award winning teacher, researcher and designer with expertise in Visual Communications, Lisa's current research has a focus on Design for Health and Cross-cultural design.

Professor Evonne Miller is Co-Director of the HEAL (Healthcare Excellence AcceLerator) initiative and Director of the QUT Design Lab. Professor of Design Psychology at Queensland University of Technology, Evonne is a leading voice on the value of arts and design-led innovation in healthcare transformation, bringing a collaborative, pragmatic, and fresh interdisciplinary approach to problem solving. She is the author, co-author, or editor of 4 books, exploring how we can create places that foster planetary and human health.

Part III
Advocates

By nature, designers are advocates. Embodying a role that extends beyond the traditional/conventional view of design, designers increasingly champion a user-centric approach and are vocal advocates for positive change. The projects described in this section show how, drawing on design mindsets and approaches (for example, the co-creation of provocative animations or design thinking workshops in the context of palliative care), designers can play a pivotal role in shaping a more thoughtful, inclusive, and compassionate world.

By intentionally, respectfully, and authentically engaging and designing with diverse stakeholders, and including a diverse range of voices, stories, cultures, and images, designers can lead the co-creation of solutions that genuinely and creatively address real-world challenges. As Fig. 1 illustrates, a priority for HEAL designers was to create psychologically safe spaces for knowledge sharing, collaboration, and change. By championing innovation, transformation, and the co-creation of creative solutions to the entrenched 'wicked problems' facing healthcare, designers are passionate advocates of positive change.

Fig. 1 I feel safe. (Credit:
Simon Kneebone)

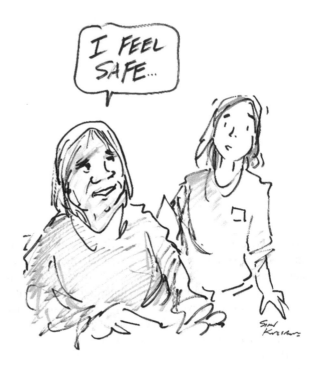

In a Heartbeat: Animation as a Tool for Improving Cultural Safety in Hospitals

Manuela Taboada, Kirsty Leo, Sean Maher, Thalia Brunner, Sue Carson, and Staché Da Costa

The quietness is loud with beeps, hushed conversations, rushed steps and rolling beds. I am half conscious, in a bed, being pushed out of the ambulance, through clean corridors, wards, and reception rooms full of unfamiliar faces. The nurse by my side is very nice, I think he is good looking too, but that might have been a consequence of my concussion. My tooth hurts, my hand hurts, I'm not even mentioning my head. I can't remember anything that happened that afternoon, or how I ended up fainting in the kitchen. Unfamiliar faces everywhere, lots of questions, a few answers. I came alone in the ambulance, my partner had to stay with the kids. No family around, 3am in the morning of Mother's Day Sunday, not fair to call on any friend for help. I think of my 5yo who was very excited to cook breakfast for his mum, who will now, if lucky, have breakfast in bed—a hospital bed. The thought makes me sad, but glad at the same time: I now remember my kids, who and where they are.

Time in hospital is lonely, confusing and full of anxiety for most patients, as this reflection by the first author shows. In Australia, First Nations (FN) patients—as well as patients from non-dominant cultures—deal with a heightened level of discomfort when in hospitals as, on top of all the other uneasy feelings, they also often feel culturally unsafe. Racism, in its many forms, has negative impacts on the treatment of Aboriginal and Torres Straits Islander patients in Australia [1, 2]. Racism and unconscious bias not only obstruct access to service, but also increase distress and anxiety for patients and clinicians [3]. While patients suffer the direct and indirect consequences of racism, reports show that experienced and well-intentioned

M. Taboada (✉) · S. Maher · T. Brunner · S. Carson
Queensland University of Technology, Brisbane, QLD, Australia
e-mail: manuela.taboada@qut.edu.au; s.maher@qut.edu.au; t.brunner@qut.edu.au; sj.carson@qut.edu.au

K. Leo
Queensland Health, Brisbane, QLD, Australia
e-mail: connect@abstarr.com

S. Da Costa
AEF and SAE Institute, South Melbourne, VIC, Australia

© The Author(s) 2024
E. Miller et al. (eds.), *How Designers Are Transforming Healthcare*,
https://doi.org/10.1007/978-981-99-6811-4_9

clinicians also feel uncomfortable and sometimes anxious when treating First Nations patients [4].

Anderson [5] defines "access to service" in healthcare as going beyond the existence of local and affordable services to include cultural safety and appropriateness of service. Cultural Safety has been introduced as a concept in health care by Dr. Irihapeti Ramsden, in New Zealand in the late 1980'and early 1990s, "in response to the poor health status of Maori" and the need for health services to change substantially [6]. Since then, the concept has been embedded into nursing and healthcare charters and into some formal health education efforts. Despite updates and changes applied to cultural concept definitions, there are two core ideas that should guide any effort in applying the concept. The first one relates to the original definition of Cultural Safety by Ramsden [7] as "the effective nursing of a person/family from another culture by a nurse who has undertaken a process of reflection on own cultural identity and **recognizes the impact of the nurses' culture on own nursing practice**" (n.p.). The second one is the understanding that **cultural safety can only be determined by the people receiving care**—specifically Aboriginal and Torres Strait Islander individuals, families, and communities, for the scope of this project. These two premises are important as the former defines the role of the care provider to perceive and understand their own biases and power role; the latter acknowledges that the feeling of safety cannot be determined externally, only the patients—receivers of care—can state their own sense of safety, and this will vary according to each individual.

This focus on the individuals and their particular needs, and the concern with the power relations in health care is reflected in Ramsden's distinction between cultural safety and transcultural nursing, where she points out that the concept of transcultural nursing is centred on differentiating people's 'cultures', usually in a stereotypical way, and assuming that the culture of nurses (usually based on an Anglo, Western training and perspective) is the 'normal' culture, the one that is valid and must be followed [8–10].

Later discussions prioritise the need to deal with the underlying social causes of ethnic health inequities in the health system—such as institutional racism and unconscious bias—in order to mitigate these inequities [3, 11, 12]. These studies recognise the importance of cultural competency and cultural safety in health practices to achieve more equitable health care services. In line with this, the National Scheme's Aboriginal and Torres Strait Islander Health and Cultural Safety Strategy 2020–2025 defines culturally safe practices as:

> the ongoing critical reflection of clinicians and systems knowledge, skills, attitudes, practicing behaviours and power differentials in delivering safe, accessible and responsive healthcare free of racism. [13]

In 2021, as part of the HEAL innovation program, our team was approached by Kirsty Leo, an Aboriginal Woman and QLD Health nurse who has been fighting for the right to cultural safety in hospitals for years. The intention of her project was to create one more channels through which hers and other First Nations voices can be

expressed and heard—to develop a tool to help with raising awareness towards cultural safety in hospitals that could be also used for training and demonstrations. Kirsty's underlying idea for the tool was to show that often, despite the best of intentions, training, attention, and care deployed by most clinicians, unconscious bias and structural racism unintentionally persists in their relationships with FN patients, causing these patients to feel uncomfortable and culturally unsafe.

We devised a collaborative research project to approach cultural safety in hospitals by creating a short, animated video as a pilot to demonstrate and raise awareness. The video was co-created with the clinicians as the main audience. This project navigates the concepts of cultural awareness and cultural sensitivity, building up to the definition, and potential impact of cultural safety. The final video demonstrates the cultural barriers and anxieties from the clinician's and patient's perspectives, provides clear definitions and suggests a pathway to overcoming these barriers through building cultural awareness, cultural sensitivity and an understanding of cultural safety.

The pilot is intended to serve as a provocation piece by initiating discussion amongst the healthcare practitioners on what is the best way to provide information training and support to improve clinicians cultural awareness and sensitivity. We hope, this will help to eventually enable more culturally safe treatment environments.

The QUT Design Lab, with its design for change vision and transdisciplinary approach was able to put together a highly consultative team with capacity to work on short-form video design and production, film and television knowledge, communication advice, visual communication, animation, and writing craft. Associate Professor Sean Maher was involved in the project from its earliest stages, overseeing and recruiting MPhil animation student Thalia Brunner, who joined the team to execute the animations. Thalia embraced the opportunity to employ her skills as an animator to an industry outside of entertainment, showcasing the value they have as an effective communication tool for a complex subject matter. Professor Sue Carson brought her experience with Australian cultural tourism, transcultural communication, and creative writing. Dr. Manuela Taboada's contribution was leadership across the many visual communication elements, spanning illustration and typography to collaborative decolonial design.

Even though we had a transdisciplinary and multicultural team with the minds and the hearts for delivering the project—technical and philosophical backgrounds and experience to reframe the problem and work collaboratively through potential solutions—we were highly cognizant that we comprised a team of non-Indigenous academics to tell an Indigenous story [14].

Kirsty Leo's involvement was therefore decisive in the partnership, encouraging our participation in the project and welcoming a co-design-based methodology. Her role was more than that of a client; through her expertise and Indigenous perspective she acted as the team's mentor and guide throughout the process. Through Kirsty's vision and insights, the team was able to overcome some of the most difficult co-design and critique sessions.

1 Why Animation?

Animation was a natural choice as the media for this project as through animation it is possible to override certain constraints of reality and have complete control over the visual style and aesthetics of the outcome, allowing the team to construct a more compelling story which seamlessly incorporates textual information, illustration, and movement. Animation allows for a lot more flexibility and reduced production costs when compared to creating live-action videos.

Having total control over visual style and aesthetics of the video makes animation an excellent media when communicating sensitive complex issues such as cultural safety. In our case, for instance, it was possible to draw a character that was as androgynous as possible, avoiding the association of the clinician with any gender. Animation enabled the looks of the characters to suit the intended message. The toned down colours and contrast of the background settings helped emphasize character interactions, thoughts and emotions [15]. One of the most striking features of the video is the "bias curtain", which would not have been possible to create with the desired characteristics (movement of the words, transparency, ability for the viewer to read) if not using animation.

Animation is described as a storytelling media that is capable of generating strong emotional connections throughout diverse audiences (age, gender, culture), enabling feelings of empathy and exotopy (where viewers can see themselves outside of themselves as they identify with animation characters) [16]. Such engagement is enabled by the symbolic representations that illustrated characters allow for, instead of relying on actors and directly connecting their identities to the topic or positioning of the video.

Most importantly, animations are highly memorable, as they combine a defined colour palette with usually specific illustration styles, motion, rhythm, and camera movements that, together can permeate the imaginary in a deeper way than live-videos or static images [17]. The combination of these elements with a thought-provoking narrative turn animations into real catalysts for important conversations and institutional change, which is one of the main objectives of this project.

2 Re-Defining the Problem and Designing an Intervention

The first step on this project was to **translate the client's needs into a workable brief** with clear methods, outcomes, and timelines. This was initiated in the earlier phases of the project by A/Prof Sean Maher, Prof Sue Carson and Thalia Brunner responding to Kirsty Leo's requests, with continuous refinement led by Dr. Manuela Taboada to achieve a design-led solution.

Most importantly, the working brief contained Kirsty Leo's expectations for the project, and her vision for the animation style and content, specific statements, and precise wording to be included in the videos. This information was communicated

through a series of meetings and regular follow-up email exchanges that structured the flow of information sharing.

Kirsty declared some specific words with which she would like to introduce the work:

> As a First Nation clinician I have had the privilege to work side by side with hundreds of clinicians across Queensland hospitals. Throughout my career my friends & colleagues have shared with me many of their own clinical experiences and anxieties (worries, concerns) when working with FN consumers.

This statement is the point of departure for the content of the video, and makes clear Kirsty's position, perspective, and experience. This statement, in combination with a well-defined brief in terms of style and storyline, were used by the team to refine the visuals and techniques to be used to produce, what initially would be three short, animated videos on Cultural Awareness, Cultural Sensitivity and Cultural Safety.

3 Step 2: Working Together towards a Script and a Visual Style

In her briefing to the team, Kirsty detailed the content of the three videos, including specific words related to unconscious bias that she wanted included in the story:

Kirsty Leo's suggestions for Video script, style and experiences:
CULTURAL AWARENESS [video 1]
Hospital scene and hospital noises.

> I think we will have to introduce Cultural Safety at the start of the first video- my experience the term does get used interchangeably and there is general confusion and misunderstanding of this framework- it is wordy but critical to provide context to the videos and broaden the understating of cultural safety in the health system. Kirsty Leo.

As the clinician walks towards the hospital bed show quote:

> The process towards achieving Cultural Safety within clinical practice can be evident as a stepwise progression from cultural awareness through to cultural sensitivity and on to Cultural Safety. However, the terms cultural awareness and cultural sensitivity are not interchangeable with Cultural Safety. These are separate concepts" [10].

CULTURAL SENSITIVITY [video 2]
Video 2 should be about the clinician's experience—breathing/heart rate sounds could be increased—hospital noise decreases while looking at the curtain blocking the patient to them.

I think to avoid any ethics issues we can keep this video more about the clinicians realising what Cultural sensitivity is- they could look away from the

curtain of words/example to look at the below statement then look back at the curtain.

Some words could be added to the curtain to refer to the clinician's self-reflection and thoughts.

CULTURAL SAFETY [video 3]

The third Video should be about the experience of the First Nation patient—the view could be from the bed now to the curtain of words perhaps darkening or coming in on them—Breathing and heartbeat are intense, footsteps loud then could black-out or have the curtain or something like that to show the below statement on Cultural Safety. This will leave the viewer with an impact and something to think about.

Words to be used in the videos related to unconscious bias, as specified by Kirsty:

Cultural Awareness (video 1)		
Sovereignty	Critical Race Theory	Stolen wages
Colonisation	Treaty	Exemption cards
Captain cook discovered Australia	Frontier wars	Get over it
Truth telling	Massacres	Burden of disease
Australia day change the date	Institutional racism	Burden on community
Uluru statement from the heart	Research Grants	Crime rates
Decolonisation	White Australian policy	Reconciliation
Sorry day	Stolen generation	Youth justice
Black deaths in custody	Black livers matter	The Australian dream—Adam Goodes
Government handouts	Family violence	Addiction

Cultural Sensitiveness (video 2)		
My own experiences	My own Education	Media Coverage
Unconscious bias	White privilege	Generational knowledge
Saying the wrong thing	No eye contact	What is cultural capability?
Good intentions	Uncomfortable	Frequent flyers
Anxiety	Frustrated	Fear

Cultural safety (video 3)
For the third video, the words of the first videos will show through the curtain and black out to show just the cultural safety definition:

CULTURAL SAFETY is determined by Aboriginal and Torres Strait Islander individuals, families and communities. Culturally safe practise is the ongoing critical reflection of clinicians and systems knowledge, skills, attitudes, practising behaviours and power differentials in delivering safe, accessible and responsive healthcare free of racism (National Scheme's Aboriginal and Torres Strait Islander Health and Cultural Safety Strategy 2020–2025).

The initial storyboarding for the first pilot was created after intense co-design sessions with Kirsty Leo and her colleague Jacinta Thompson. These meetings enabled their knowledge and vision for the video to be captured, as well as their ideas in relation to visual representation, animation effects, and camera movements. From these initial consultations, some animatics tests were developed by Thalia, PhD intern and project animator.

4 Defining a Visual Style

During these sessions, several visual style possibilities were brought to the table for testing, so the team could decide on a colour palette, image style, visual rhythm, animation effects, and potential camera angles and movement.

It was decided that the animations would be based on simple flat style 2-D graphics, with an emphasis on the typographic treatment of the words and thoughts expressed during the videos. As it is aimed at the clinicians, the animation had to maintain a certain corporate feel to it in order to create familiarity and remove the attention from some visual elements which exist as a vessel for the message [18].

A monochromatic palette was chosen to convey the hospital setting, using cold colours such as blue, blue-green and greys. Bright glares through windows and doors give the sense of light and depth, helping create right setting for portraying silhouetted characters. A clean and bold typeface is used throughout the video to optimise legibility, especially when setting up the "bias curtain".

For the words to be legible on the curtains, it was decided that a simple and bold typeface should be used, but one that also carried some personality.

Hanley Pro was chosen for the words on the curtain, and Myriad Pro Bold was used for the subtitles in the final animation as it has a complete uppercase and lowercase set of characters.

5 Animation Resources, Camera Placement and Sound

In the final video characters are minimally animated with the dynamics of the scenes created through camera movement and typographic animation. This creates a feeling that the audience is navigating through a motionless scene where words are depicted and animated to demonstrate feelings and thoughts and moving the story forwards. The virtual, animated camera is oriented "in first person". This subjective vantage point brings the audience straight into the story without the need for sophisticated animation or detailing of characters.

Animation resources similar to the ones used in Anime can be useful to represent thought and reflection. Static scenes, flat 2-D graphics, minimal animation, close-up

of faces, removal of background details and change of colour to represent the switching between the real world and the world of the "mind" are all resources used in Anime style [19–21] that we chose to adapt to the Cultural Safety videos. Similarly, the use of type on screen to verbalise the ideas rather than using narration or dialogue gives the animation a more somber atmosphere which, at the same time, makes the videos social-media ready (where videos usually play without sound first).

Animating the typography so that it looks and behaves as part of the scenes gives the story a sense of truth and is more liable to capture the attention of the viewers. In these videos this was done by animating the text as the curtains, giving the thought quotes a bit of movement when shown with the characters.

The videos make use of hospital ambient sounds such as machine beeps and pulses, and the background rush of carts, beds and people. These hospital sounds are then taken over and silenced by biometric sounds from the human body such as heartbeat, breathing, and blood pumping sounds to depict anxiety.

Single words, simple real quotes, and official definitions of the concepts are depicted in the video. There is no dialogue between the characters. Quotes are used to represent thought and reflection.

6 Creating a Storyline

After a detailed briefing on cultural safety in hospital settings, the project team created storyboards and draft animations to capture the existing knowledge, vision, and ideas regarding visual representation, animation effects, and camera movements.

The original storyline consisted of three separate videos that respectively demonstrated concepts of cultural awareness, cultural sensitivity and cultural safety.

Video 1: on Cultural Awareness, from the perspective of the clinician, showing the barriers that exist between them and FN patients. Barriers presented as words in a curtain between the clinician and the patient.

Video 2: on Cultural Sensitivity, still from the perspective of the clinician, but from a reflective point of view, where the clinician reviews their own thoughts and biases in relation to caring for FN patients.

Video 3: on Cultural Safety, this time from the perspective of the patient, showing the anxieties and feelings of being unsafe in the hospital environment and what cultural safety means.

The three videos could be played independently or together as a longer feature. Figure 1 shows the preliminary storyboards for the three videos.

At this point the team was excited to see the way in which the different disciplinary skills quickly intersected to bring together the initial concepts. The next step was to create a preliminary prototype to show to clinicians during a co-design workshop. The aim of the workshop was to give opportunity to clinicians to help the team refine elements of the video such as the storyline and the clinician's character, and to test the overall idea of the video to assist reception with the target audiences.

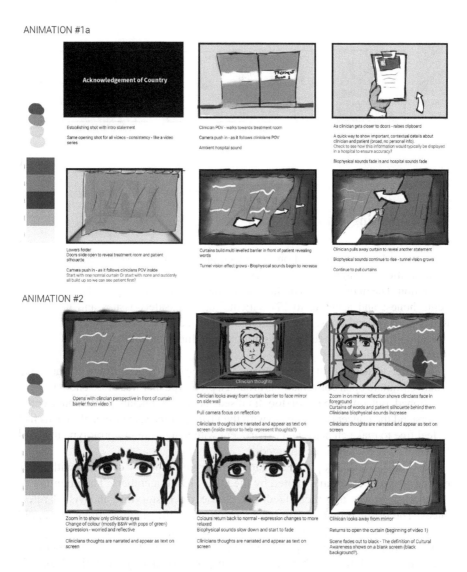

Fig. 1 Storyboards for the three planned videos: animation (1) cultural awareness (top), animation (2) cultural sensitivity (middle), and animation (3) cultural safety (bottom). The three topics evolve as the clinician becomes aware of their own unconscious biases

ANIMATION #3

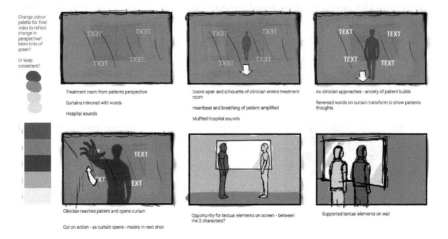

Fig. 1 (continued)

7 Connecting with Users

The Design Lab team worked on the intention of creating a workshop that offered an authentic co-design process with as many opportunities as possible for true collaboration. The main concern of the team at this stage was to keep a balance between being honest and accurate to FN patients' cultural safety issues and needs and Kirsty's vision and aims. The challenge was to balance these objectives without offending the well-intended and highly trained clinicians who are not always conscious of their biases.

In order to achieve these outcomes, the team had to design a workshop that would stimulate open conversations around a prototype that was close enough to the envisioned outcome—but not too finalised, so that clinician participants could understand the concept and engage with the vision. At the same time, clinicians had to feel free to make changes and experiment with a high-fidelity prototype that was still malleable enough to be changed.

A co-design workshop was envisioned to test preliminary concepts with a reference group of clinicians invited by the QLD Health members. The intention of the workshop was to collect feedback on the video storyline and visual references. The original plan was to have participants collectively critique and apply interventions to the proposed video storyline and visuals. After the workshop, the team would incorporate the proposed changes and create the first iteration of the video for the Metro North team. This version would then be refined until it reached the desired state/outcome. Involving clinician participants in the early

stages of the video creation is critical to bringing in the voices and perceptions of the actual audience. It also helped test the designers and creators' own biases and assumptions.

7.1 The Co-Design Workshop with Clinicians

Originally there were three activities planned for the workshop:
Activity 1 Mapping the journey

The aim was to map the journey of the clinicians and FN patients, including feelings, expectations, and anxieties. The team had prepared a storytelling kit for the users to represent clinicians and FN patients' experiences.

Activity 2 Finding the gaps

With the journey maps and story scenes at hand, the second activity involved watching the prototype animation and discussing how it represented the journeys mapped in the first activity and what changes could be made. Participants would be given empty story-boarding sheets where they could draw or describe their own plots and suggestions for the presented storylines.

Activity 3 Visualising the experience

Finally, during the third activity, participants were invited to comment on the current visual style and language, and were welcomed to suggest/design new potential visual concepts for the videos.

Due to Covid-19, the workshop which was planned to be presented in person had to be delivered fully online. This had a strong impact on the involvement of the participants and engagement with the prototype.

Even though the team was prepared to run an online collaborative workshop if needed (in 2021, the pandemic situation was still very critical), a series of technical issues related to access to online tools by both the team and the participants prevented some crucial activities from being held as planned. The negative effect on the perception of the prototype by the participants was significant, and in a way helped the team evaluate more carefully the impacts of the messages.

The workshop involved a small number of participants which was not, by any means, representative of the whole of the clinician population in QLD—it has been evidenced that design projects that involve some level of collaboration tend to offer better and more appropriate responses to the clients and audiences despite the number of people involved in the process [22]. In the end, despite veering from the original path, the issues with perception and participation did not invalidate the findings obtained from the workshop. In fact, the insights from the interaction with the clinicians revealed some weaknesses and strengths in the project that would otherwise may not have surfaced. The insights gained from the workshop with clinicians helped the team re-evaluate and reshape the project, as described below.

7.2 Findings from the Workshop

One of the major impacts of the technical issues is that it prevented participants from undertaking the storyline critique activity, where they would go through each storyboard, share their thoughts and have a chance to intervene on how the story could be told. For example, the text video would only be shown at the end, as a way to search feedback about the visual references and animation style. Apart from inviting participation, this process was planned to help participants become familiar with the story and its context.

Instead, the participants were shown the prototype video straight away, without being introduced to the concept or the complete story. The 15 second video test for the "bias curtain" became the only point for critique, with some participants mistakenly believing that the video was complete and that that was all that was going to be shown and produced.

The responses that the team got from the workshop were not entirely as expected, because the experience offered by the workshop was not the one planned. The responses, however, were still rich and valid, and revealed important issues and a few questions that needed to be considered before the videos were released:

1. The importance of contextualizing the argument
2. The fact that the words on the "bias curtain" and the way it is presented might feel "uncomfortable" and "finger-pointing" to some users
3. The need for visual accuracy and up-to-datedness in relation to how the treatment room, clinicians, and equipment looked like

Most importantly, the workshop revealed the need for an appropriate collaborative design process that takes into consideration some basic empathy and exotopy principles [23], as well as the fact that the process itself needs to be culturally sensitive by being prepared to embrace uncertainty [16], multiple epistemes (ways of thinking and doing) [24, 25], and expectations.

Most importantly, the workshop demonstrated that such profound transformational processes—such as designing tools for revealing unconscious bias— need more time to be delivered and digested before any kind of results can be identified.

It also showed that the proposed animation, with its use of visuals and sounds alone, had quite a strong impact on audiences (some workshop participants expressed surprise, others were a bit taken aback and offended by the video), proving design/animation to be an effective tool for the unique challenges and complexity of the project that needed to be conveyed in a short time frame.

In summary, the feedback from the workshop helped the team see the flaws in our first rendering of the animation and course correct from that point, creating a video that has more impact, was less "in your face", and achieves its aim with more elegance. The changes proposed were not about being less honest, but communicating with clarity the true issues arising from unconscious biases and structural racism, and how these are the root causes of FN patients feeling culturally unsafe.

8 Crafting the Experience

A decisive response to the feedback was settling on one video rather than three separate ones. A single animated film would be more effective by maintaining consistency and cohesiveness of the story. For this to happen, the storyline needed to be slightly modified and refined.

The two characters—clinician and First Nations patient—were retained. The arc of the clinician character is built on the possibility of them building up their cultural awareness and sensitivity to be able to help create a safe cultural environment for all patients. This was made more explicit in the video by adding subtitles that represent the evolution of the thoughts of the clinician. Text for these subtitles were based on direct quotes from actual clinicians, previously collected by Kirsty Leo prior to the engagement of the Design Lab team.

For the final video, the story unfolds in three parts, maintaining some of the plot of the original three-video plan:

Part 1: focuses on cultural awareness from the perspective of the clinician, showing the barriers that exist between them and First Nations patients. Barriers were presented as words in a 'bias curtain' between the clinician and the patient.

Part 2: focuses on cultural sensitivity, still from the perspective of the clinician, but from a reflective point of view, where the clinician reviews their thoughts and biases about caring for First Nations patients.

Part 3: focuses on cultural safety, this time from the perspective of the patient, showing the anxieties and feelings of being unsafe in the hospital environment and what cultural safety means. The story concludes with the clinician and the patient sharing the definition of Cultural Safety.

Similar to the original storyline, in the first part of the video the clinician is confused and not quite sure about how to deal with the FN patient. The first scene is set in the clinician's staff room, where they collect the information for the next patient they need to see, who turns out to be a FN patient. The staff room was added in response to feedback from the workshop and the need to better contextualise the story and to represent the day-in-the-life of the clinician in a way that is closer to their day-to-day routine. As a result of clinician feedback, some of the stresses and anxieties that they themselves go through during their day at the hospital feature in the narrative, showing how clinicians feel they are regularly behind on their schedule.

As the door to the FN patient's room opens, the clinician is faced with the 'bias curtain', where there are words and expressions representing facts and perceptions related to cultural biases towards FN communities and patients (Fig. 2). As they see the curtain, they don't face it straight away, instead they look aside, and as they do so, see their reflection on a mirror/glass on the wall. This moment marks the second part of the video, where the clinician goes through a process of self-reflection, by perceiving their own biases and what has generated it. They

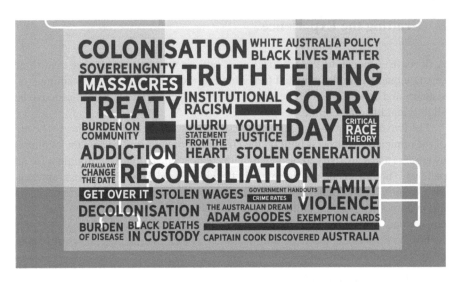

Fig. 2 Bias Curtain

begin to understand that they can change the way they think, act, and perceive FN patients, to deliver improved care through a cultural safe environment. The viewer is taken through the clinicians' thought process by means of subtitles, with deep zooming in to the eye area on the face of the clinician that draws on anime techniques to evoke reflection. These forms of animated storytelling also enable the transition from hospital environmental sounds to inner body sounds like heartbeats and heavy breathing to express stress and anxiety. As the clinician's thoughts evolve and they realise their own unconscious biases and role in perpetuating structural racism, they understand that one way to change the system is to change their own perspective. Once this epiphany happens, they turn back to the patient and open the curtain that reveals a clear view of the patient, unencumbered by the prejudicial words that populated it.

During the third and final part of the animated video the story shifts to the patient's perspective. In the beginning of the video the FN patient can be seen out of focus, sitting on the bed behind the curtain. When the frame cuts to focus on the FN patient, their feeling of anxiety is made clear by the look in their eyes—anxiety for knowing they might be cared for by someone who does not completely understand them and their deeper needs, and will not likely make an effort to do so. They know the biases that some clinicians may carry. After the clinician opens the curtain and comes through to the patient with a different attitude, the curtain is still there, behind the clinician, as seen from the perspective of the FN patient. Slowly the text on the curtain changes from the bias words to the definition of Cultural Safety.

9 The Final Version /Presentation/Current Uses

When the final version of the video was presented in the May 2021 HEAL Symposium, the reception was very positive and encouraging, and the video was greeted as having potential as a useful teaching tool across QLD Health. Any reservations the team held as to its efficacy following the reactions of the co-design workshop with the clinicians was removed. The unanimously positive reception of the animated video shows that creative approaches that generate innovative interventions can be effective responses to complex social and health-related issues, such as communicating cultural safety and unconscious bias.

We were able to achieve the aim of this project to co-design a provocation video that can be used by QLD Health to generate further engagement with clinicians around the state in relation to cultural safety in hospitals. These engagement opportunities will help provide answers to the question: "How might we change the way we work in hospitals to provide a culturally safe environment for First Nations patients and guarantee proper access [5] to care?"

Since its launch, Kirsty Leo has been using the animated video for training, with overwhelming success:

> I share this video all the time and the response is overwhelming - it is part of our orientation for the whole of MNH and I am about to start a new Cultural Safety training package with this video for Charlies where I now work (Leo, 2022, personal communication).

10 Reflections

During this project, our team went through an important collective learning process. The multidisciplinary nature of the team offered great opportunities to engage in areas that we were not particularly familiar with, and the co-design workshop allowed us to re-think and reposition some of our own sets of beliefs and biases.

One of the most evident realisations of the team was that, in a collaborative multi-disciplinary environment, we needed to re-learn how to utilise and expand our creative and technical skills to reach outside of our field and achieve the results and quality designed by the team and expected by the end-users. For example, our team's animation specialists reached into the fields of typography and illustration in order to put together a believable typographic flow in the curtain, while the visual communication expert in the team had to familiarise and go deeper into animation language and styles, in order to articulate their vision of how the video could look.

Similarly, the team realised that sometimes what you have to say with your project is not what the users are expecting to hear, so the message needs to be re-shaped in a way that the users accept and take it in, without compromising its integrity, authenticity, and aims. By listening to the users and understanding the context and

main purpose of the project, we learned how to nuance the message in a way that brings people in, rather than shutting them out, while still keeping with the vision.

In the end, the QUT Team alongside the QLD Health team and with input from potential users, was able to produce a short sharp visual demonstration of the challenges faced by Non-Indigenous clinicians in approaching Indigenous patients in a hospital ward by using images, script, and sound. This project demonstrates, once more, the power of interdisciplinarity and co-design on intervening in wicked problems. Despite the complexity of the issues raised by cultural safety in clinical environments, a collaborative interdisciplinary team, well versed in a variety of expert disciplines and skillsets, can be combined to respond to difficult social, cultural and medical challenges.

The story of this project starts with the need for transforming QLD hospitals into culturally safe environments. A team of academics joined forces with an Indigenous QLD Health nurse to reframe and tackle the issue. She identified a core problem in the form of unconscious bias, something one doesn't know they have until they realise it. The main difficulty when dealing with this kind of user is that the bearer of the bias is well educated and well-intended, and most of the time doesn't know they are doing something that makes others feel unsafe. Our tool in this case was animated storytelling, which enables the telling of stories that challenge audiences' perceptions, improves understanding, and creates an emotional impact, in ways not always possible through live-action or text alone.

Complex cultural issues, especially those related to cultural safety and health, can be sensitive topics for all involved in the design process. As such, considering different perspectives of storytelling and how animation or other creative media can be used to effectively communicate those perspectives in different ways can be extremely valuable to raising the impact of design/animation in other fields. At the same time, recognising the power of the creative demonstration of a problem can complement its critical analysis. This works best if the participants (especially the design team) are able to practice exotopy—the ability to see themselves from the outside and evaluate their own impact in the dynamics of the design process [23].

11 Conclusion

Healthcare is transforming as it responds to the care economy. The opportunities to work in healthcare offer rewarding challenges and partnerships that thrive off some of the fundamentals of design practices such as collaboration and iterative design processes. Healthcare needs input from creatives and designers to meet the needs of twenty-first century well-being and living.

Transdisciplinary relationships are important to not only produce effective content but also for professional/personal growth through the investigation and consideration of different, unique perspectives within the many facets of healthcare. This project demonstrates how the skillsets and capabilities of the creative industry professionals are relevant, and increasingly essential, to solve complex problems in

broad sectors beyond those associates with traditional "creativity" and "entertainment".

The effectiveness of the video created through this project comes from its addressing of the two core premises of cultural safety: (i) the need for healthcare practitioners to reflect on their own standings in their relationship with the recipient of care, and (ii) the fact that only the recipients of care can determine their sense of safety. The video could only achieve that due to the intensive collaboration process through which it was designed.

The Animated Cultural Safety project demonstrates that through deep listening and the ability to transpose abstract concepts, animated storytelling combined with design knowledge and tools can supply beneficial solutions through effective communication of complex topics for the healthcare industry.

View the final video here: https://research.qut.edu.au/heal/projects/cultural-safety/

References

1. Awofeso N (2011) Racism: a major impediment to optimal indigenous health and health care in Australia. Australian Indigenous Health Bulletin 11(3):1–8
2. Downing R, Kowal E (2011) A postcolonial analysis of indigenous cultural awareness training for health workers. Health Sociol Rev 20(1):5–15
3. Mkandawire-Valhmu L (2018) Cultural safety, healthcare and vulnerable populations: a critical theoretical perspective. Routledge
4. Kerrigan V, McGrath SY, Herdman RM, Puruntatameri P, Lee B, Cass A et al (2022) Evaluation of 'ask the specialist': a cultural education podcast to inspire improved healthcare for aboriginal peoples in northern Australia. Health Sociol Rev 31(2):139–157
5. Anderson I (1988) Koorie health in Koorie hands: an orientation manual in Aboriginal health for health-care providers
6. Papps E, Ramsden I (1996) Cultural safety in nursing: the New Zealand experience. Int J Qual Health Care 8(5):491–497
7. Ramsden I (1995) Cultural safety: implementing the concept—the social force of nursing and midwifery. Mai i rangiatea:113–125
8. Ramsden I (2000) Defining cultural safety and transcultural nursing. Nursing New Zealand (Wellington, NZ: 1995) 6(8):4–5
9. Ramsden I (2005) Towards cultural safety. In: Cultural safety in Aotearoa New Zealand, pp 2–19
10. Ramsden I, Whakaruruhau K (1993) Cultural safety in nursing education in Aotearoa. Nurs Prax N Z 8(3):4–10
11. Curtis E, Jones R, Tipene-Leach D, Walker C, Loring B, Paine S-J et al (2019) Why cultural safety rather than cultural competency is required to achieve health equity: a literature review and recommended definition. Int J Equity Health 18(1):1–17
12. Molloy L, Grootjans J (2014) The ideas of Frantz fanon and culturally safe practices for aboriginal and Torres Strait islander people in Australia. Issues Ment Health Nurs 35(3):207–211
13. Phillips G, Brayshaw J, Fletcher M, Callister G (2019) The National Scheme's Aboriginal and Torres Strait Islander health and cultural safety strategy 2020-2025. Available from: https://www.ahpra.gov.au/About-Ahpra/Aboriginal-and-Torres-Strait-Islander-Health-Strategy.aspx
14. Smith LT (2021) Decolonizing methodologies: research and indigenous peoples. Zed Books, London

15. Mohr S, Carter C (2016) Adapting practical aesthetics to the performance animation process. Animation Practice, Process & Production 5(1):57–77
16. Taboada M, Dutra L, Haworth R, Spence R (eds) (2010) Engaging complexity through collaborative brand design. Design & Complexity: DRS2010 Conference Proceedings. Design Research Society
17. Du DY (2022) A theory of suspended animation: the aesthetics and politics of (E) motion and stillness. Discourse 44(1):42–77
18. Warde B (1930) The crystal goblet, or why printing should be invisible. In: Armstrong H (ed) Graphic design theory: readings from the field. Princeton Architectural Press, pp 39–43
19. Cooper-Chen A (2012) Cartoon planet: the cross-cultural acceptance of Japanese animation. Asian J Commun 22(1):44–57
20. Gonçalves J, Navio C, Moura P (2021) The occidental otaku: Portuguese audience motivations for viewing anime. Convergence 27(1):247–265
21. Lim TW (2013) Spirited away: conceptualizing a film-based case study through comparative narratives of Japanese ecological and environmental discourses. Animation 8(2):149–162
22. Dutra LXC, Haworth RJ, Taboada MB (2011) An integrated approach to tourism planning in a developing nation: a case study from Beloi (Timor-Leste). Stories of practice: tourism policy and planning. Routledge, pp 269–293
23. Taboada MB, Rojas-Lizana S, Dutra LX, Levu AVM (2020) Decolonial design in practice: designing meaningful and transformative science communications for Navakavu, Fiji. Des Cult 12(2):141–164
24. de Sousa SB (2014) Epistemologies of the south justice against epistemicide. Paradigm Publishers
25. Escobar A, de Filho S, Marés CF, Nunes JA, Coelho JPB, dos Santos LG et al (2007) In: de Sousa Santos B (ed) Another knowledge is possible: Beyond northern epistemologies. Verso Books

Dr Manuela Taboada , QUT School of Design and QUT Design Lab, has over 15 years' experience in visual communication design, design for change, collaborative design methods and systems thinking. In her research and practice, Manuela uses bespoke collaborative design processes as tools for facilitating innovation and triggering systemic change. She combines systems thinking (complex emergency) with decolonial design theories and concepts of deep ecology to establish the framework for her co-design methods.

Kirsty Leo is a first Nation and South Sea Islander nurse, who has had the privilege to work for the last 20-plus years in the healthcare system, specialising in First Nation health, commencing in 1999 as a Trainee Aboriginal Health Worker in the Northern Territory then moving into nursing in 2008. Kirsty completed a Healthcare Improvement Fellowship at Clinical Excellence Queensland in 2020 which reinvigorated over two decades of healthcare systems thinking to her newly acquired passion to 'foster the conditions for emergence'- (Tyson Yunkaporta). The learnings and immersion into systems thinking from national and international leaders from within and external to health will be invaluable for the next several years. She looks forward to sharing and expanding her opportunities to work across healthcare systems yielding improved outcomes for our First Nations consumers and clinical communities.

Associate Professor Sean Maher brings expertise in Film, Screen & Animation to the HEAL team, from QUT's School of Creative Practice. In 2019 he was ranked as 'Australia's leading researcher in Film' by The Australian newspaper, and has been a Visiting Scholar at the UCLA Film and TV Archives, where he researched his 2020 monograph Film Noir and Los Angeles—urban history and the dark imaginary, published by Routledge.

Thalia Brunner has a passion for creating and sharing stories in engaging and innovative ways. Her skills and interests lie in areas of animation and virtual production, using technology to assist understanding and communication. Her QUT PhD thesis is currently under examination.

Professor Susan Carson has taught in Creative Writing and Literary Studies disciplines, before becoming Academic Program Director in QUT's School of Communication As a former information technology journalist, she maintains an interest in Australian media, and now researches in the field of higher degree research pedagogy as well as in cultural tourism.

Dr Staché da Costa is an animator and educator who specialises in concept animation, creative processes, and production. He played an advisory and mentoring role as a senior animation expert in the cultural safety animation project. He is affiliated with AEF (Animation Educators Forum) and SAE Institute Melbourne.

Co-creating Virtual Care for Chronic Disease

Jessica Cheers, Gaurav Puri, and Brent Knack

Hours spent in waiting rooms, long commutes to the hospital, conflicting medical advice, indecipherable medical "gobbledygook", packed car parks, covered windows, and sterile white coats—these are just some of the things that can make the face-to-face healthcare system less-than-desirable. On the other hand, emerging digital health services that promise more efficient, accessible care may spark feelings of distrust and isolation, or create barriers for those with low digital literacy.

When Dr. Gaurav Puri, Endocrinologist and Chair of the Queensland Diabetes Clinical Network, asked a man on Thursday Island living with diabetes why he couldn't attend his appointments, he replied that he simply "didn't have the time". For those managing chronic disease and multiple co-morbidities, regular appointments with multiple practitioners can become an incredible burden on their quality of life. Realising that this was a problem faced by many Queenslanders, Dr. Puri envisaged what soon became the VOICeD telehealth service—Virtual Outpatient Integration for Chronic Disease. The service was designed to meet the needs of people with chronic disease by allowing them to see multiple healthcare practitioners in one virtual appointment—bringing consistent, accessible care to patients anywhere. The Queensland Diabetes Clinical Network began to lay the foundations for the first iteration of the VOICeD model: Diabetes-Renal-Cardiac. Recognising that the patients who had first inspired and informed VOICeD should be actively involved in designing, prototyping, and testing the service, they reached out to designers from HEAL to meaningfully engage with consumers and clinicians. This

J. Cheers (✉)
QUT, Brisbane, QLD, Australia
e-mail: j.cheers@qut.edu.au

G. Puri · B. Knack
Queensland Health, Brisbane, QLD, Australia
e-mail: gaurav.puri@health.qld.gov.au; brent.knack@health.qld.gov.au

© The Author(s) 2024 175
E. Miller et al. (eds.), *How Designers Are Transforming Healthcare*,
https://doi.org/10.1007/978-981-99-6811-4_10

chapter tells the story of how designers, clinicians, and consumers collectively imagined and implemented the VOICeD telehealth service, what they learned, and the challenges they faced.

1 Process

To design a service that met the nuanced needs of people with complex health conditions, the HEAL team needed to explore both the clinician and consumer perspectives. This exploration was led by Jessica Cheers (an experience designer, PhD candidate, and HEAL intern) and Professor Evonne Miller (Co-Director of HEAL), working closely with Dr. Gaurav Puri and Dr. Brent Knack from the Queensland Diabetes Clinical Network. The collaboration between HEAL and the VOICeD team followed seven phases: *mapping, collaboratively designing, sensemaking, implementing, user testing, improving,* and *expanding.*

1.1 Mapping

As many aspects of the service had already been imagined prior to the collaboration, understanding this vision was a crucial starting point. The vision was simple—a single videoconference appointment to combine diabetes, renal, and cardiac consults for people already accessing these services separately. How would it work? How would it impact the consumer experience, compared to a standard appointment model? Would they consult with the specialists all at once or sequentially? Do any other stakeholders need to be involved? What are the opportunities and barriers from a clinical perspective? Jessica Cheers from HEAL and Dr. Brent Knack from VOICeD sat down remotely with a group of clinicians (Endocrinologist, Diabetes Educator, Cardiac Nurse, and Telehealth Coordinator) from Cairns Hospital to explore the many complexities of a digital service that merges multiple appointments, either synchronous or asynchronous, for varying degrees and types of care. This was the start of a series of intensive journey mapping sessions, questioning and mapping the proposed VOICeD model from every angle.

In the first session, the team created the persona of Ralph—a 54 year-old farmer from the town of Mareeba in far north Queensland—and began to imagine the service journey from his perspective. This persona was based around a "typical" patient that the team would regularly see in their practice at Cairns Hospital—one who struggles to travel to the hospital regularly for appointments, is managing multiple complex health conditions, and is often hearing conflicting medical advice from each of their specialists. To connect more deeply to Ralph and his needs, they considered his personality, interests, tech savviness, previous experience with telehealth, and reasons to use VOICeD. A handyman and caravan enthusiast, Ralph's quality of life was diminishing with the time and costs associated with regular

appointments to manage his type 2 diabetes, heart disease, and stage 3B kidney disease (common comorbidities). He would regularly drive 45 minutes to and from Cairns Hospital to see a Cardiologist, Kidney Specialist, Diabetes Team, or Allied Health professional, as well as regular trips to his GP. He has previously used tele-health at the hospital with assistance from staff. He had also started phone consultations during COVID but struggled with the lack of visual stimulus and connection. His wife Margarie, while very supportive, had her own healthcare appointments to manage. They could feel their retirement plans slipping away.

After the team had added depth and familiarity to the character of Ralph, they began to map out his experience using the VOICeD service. They considered each and every touch point: how he would learn about the service, how he could access VOICeD, any information he might receive via text, email, or traditional posted mail, what device he would use to connect to the service, how he would access tech support, what would happen if there was an unexpected wait time, what would happen before the appointment, how he would interact with each of the specialists, what would happen after the appointment, and how he would schedule his next VOICeD session. The process of intimately considering how Ralph might interact with the service at each touch point unveiled many questions and facets of the journey that were slowly pieced together over subsequent sessions. An additional layer was added, highlighting all of the practitioners and other stakeholders who would be involved at each stage of a VOICeD appointment.

These insights informed the design of an extensive journey map that encompassed both the patient (Ralph) and practitioner experience in considerable detail (Fig. 1). In subsequent workshops, the team created several simplified maps to quickly communicate different service pathways to stakeholders. The condensed maps highlighted a number of other case studies based on different health conditions, appointment needs, or patient support needs. They represented situations in which specialists would see the patient synchronously, asynchronously, or in other more complex configurations, as well as situations in which patients might need in-person support via their local General Practitioner (GP), Aboriginal and Torres Strait Islander Health Worker, or Nurse during the call.

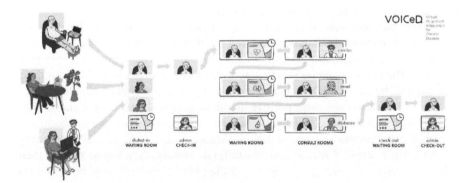

Fig. 1 Journey Map including the patient (Ralph) and practitioner experience

For most of the clinicians who attended each workshop, this was their first introduction to visual design methods for understanding complex healthcare experiences. The process generated a rich, critical discussion, with a level of detailed questioning that led the VOICeD team to reflect on many of the assumptions they had made. It was challenging at first for clinicians to step into the mind of Ralph, and they would often revert to a clinical perspective when describing the benefits of the service. At this stage it was clearly necessary to take a step back, travel to Cairns, and connect with consumers directly, ensuring that their current needs aligned with the VOICeD vision painted by the team.

1.2 Collaboratively Designing

Once the entire service was mapped from a practitioner perspective and visuals had been created to communicate the initial concept to stakeholders and potential patients, the team planned to conduct a 3-hour Participatory Design (PD) session with five people who have chronic conditions and years of experience with healthcare services—potential future VOICeD users. The HEAL designers wanted to better understand the day-to-day lives of people with multiple chronic diseases, their positive and negative experiences with traditional face-to-face treatment, their relationship with telehealth/digital health technologies, changes to their healthcare treatment around COVID, and their ideal healthcare experience 10 years in the future. They designed a *Future Workshop*, a well-known Participatory Design method that was originally employed by researchers such as Jungk and Müllert [1], Dator [2], and Jansson and *et al* [3] to encourage participants to envision possible and imaginary futures. First, participants would critique past and present practice, before moving into the "fantasy phase" where they imagine potential futures. Finally, in the "implementation phase", they consider what changes could be made short-term to work towards their utopian visions. To ease participants into discussions around digital health, chronic disease management, and their aspirations for their healthcare in the future, low fidelity Participatory Design methods like collaging and journey mapping would be employed.

In the "past and present" phase, the first activity was a weekly calendar, designed to better understand the interplay between multiple appointments, procedures, and treatments by visually mapping all of their interactions with the medical system in a week. The second exercise was to map what an appointment looked like for them before and during COVID, including travel and preparation, before labelling which aspects of each journey were positive or challenging with coloured stickers. They would then move into the "fantasy phase", creating a collage to represent both their utopian and dystopian visions of their healthcare future in the year 2030, drawing from a large array of photos and illustrations. Finally, they would present their future visions to the group, and together discuss what principles could be embedded into emerging healthcare services to move towards their utopia (Fig. 2).

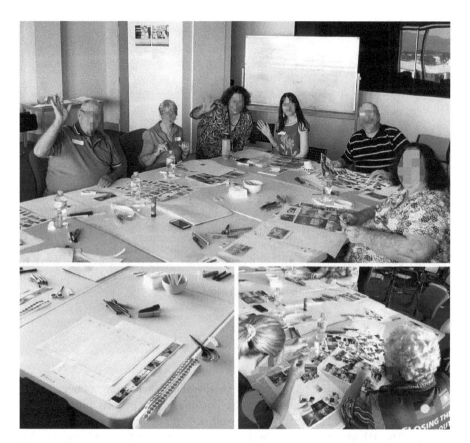

Fig. 2 Workshop in Cairns

Armed with an array of workshop supplies, Jessica and Evonne travelled to Cairns Hospital, meeting with the Statewide Diabetes Network Team in person to facilitate the session. One of the barriers the VOICeD team faced was in the recruitment process—to effectively connect with potential users in person, given they are people who already struggle to attend hospital for appointments, was an obvious challenge. While the workshop was designed for people who have lived experience with multiple chronic diseases including diabetes, the workshop attendees were largely limited to those who were attending the hospital that day, many of whom did not have this experience. This led the HEAL team to adapting methods on the day, deemphasising the weekly calendar—as many participants didn't have multiple complex health conditions—and focussing more on the structure of appointments, their experiences with digital health technologies through COVID, and their aspirations for their care in the future. This was an undeniable challenge, resulting in more broad themes rather than specific recommendations that related to complex chronic disease

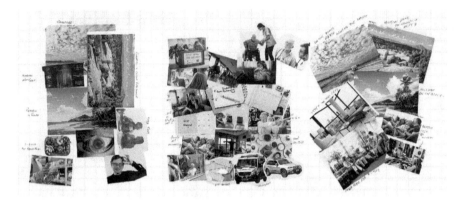

Fig. 3 Collages depicting utopian visions of the future of healthcare

management. Broad themes did, however, make it easy to connect this work to experiences of other telehealth initiatives and guide future development of technical functionality of telehealth software (Fig. 3).

1.3 *Sensemaking*

The workshop was filmed, recorded, and photographed, generating a huge amount of audio and visual data. Insights were also documented on post-its during the discussion towards the end of the session, as well as on the templates provided for each activity. The HEAL team pored over this rich documentation and organised it through the process of thematic analysis, distilling the discussion into key themes and actionable steps to achieve participants' utopian visions. This followed a six-phase approach: (1) familiarisation with the data, (2) generating initial codes, (3) searching for themes, (4) reviewing potential themes, (5) defining and naming themes, and (6) producing the report [4]. Each theme was presented with quotes and exemplifying ideas from the discussion, as well as actionable recommendations, in a comprehensive report given to the VOICeD tea team to inspire and inform the design of the service.

The first theme was *human connection*. Participants shared that they dislike impersonal appointments, the notion of machines replacing humans and losing (or chasing) doctors when they move to other clinics. They wanted more time to spend with those close to them rather than driving hours to and from appointments, wanted to build connections with their practitioners and feel that their care team actively maintained that connection. In relation to VOICeD, participants felt that telehealth should be reserved for more generic appointments. They wanted to meet practitioners before using a virtual service if they were going to be a part of their primary care team. They also wanted follow-ups after their appointments, as well as

elements within the virtual appointment to make it feel more "human"—like an image of their doctor on the wait screen.

The second theme was *time*. Participants were exhausted by hours spent in waiting rooms, particularly when there were no expectations set as to how long the wait time might be. Long access routes from parking to in-person clinics were a problem, as well as all of the issues that come with parking, waiting room systems, traffic, and doctors getting called away from appointments. Interestingly, they also mentioned that waiting until business hours to book an appointment became a significant barrier. Participants suggested that VOICeD appointments could be booked online, creating fewer barriers to care. They also suggested that wait times could be made more transparent to manage expectations, letting them know if the practitioner was running late or about to enter the virtual call. When asked about information, prompts, or entertainment options that could be included on the wait screen, they suggested prompts that would encourage them to make a list of the questions they had for the appointment rather than educational information, which would be "depressing". They also suggested that games like solitaire or crosswords could be a fun and engaging way to pass the time.

The third theme was *accessibility and tech literacy*. Poor mobile service and lack of access to technology were barriers in accessing telehealth during COVID, and reliance on digital gadgetry was challenging. Several participants who had low tech literacy required further support, and noted that there are not measures in place for deaf and blind patients. Forms and medical paperwork could be equally confusing and inaccessible, and the reliance on traditional posted mail could mean that appointments were missed. A good telehealth service would be offered alongside in-clinic services with tech support staff located locally, as well as ease of use on all devices. In order to navigate some of these barriers in the VOICeD service, they suggested that the introductory letter to the service should clearly explain how to use the technology. There should also be a test call before the first session to check that service and tech access were suitable, giving them the opportunity to access the service from a local clinic if needed. They wanted to see a continued push away from traditional posted mail to digital confirmations and information letters, and that the design of all digital touch points was seamless and intuitive.

The fourth theme was *consistency and communication*. Time and time again, consumers struggled to receive consistent and cohesive care. It appeared that practitioners were not communicating with each other, were repeating information, speaking in indecipherable medical "gobbledygook", providing different dietary advice and information, not making follow-up calls, and failing to communicate important information about their treatment. Consumers felt that if all practitioners were adding to the same patient notes and sending them to their GP or other members of their care team, it would reduce the burden of having to mediate conflicting information. Communication could be improved—clearly summarising the outcomes of an appointment and communicating them to patients, as well as making their records more accessible. Finally, follow-ups after the appointment would make participants feel more at ease, especially when they need to adjust or stop medication, require additional testing, or need to change treatment.

The fifth and last theme was *the" medical feeling"*. When speaking about the traditional face-to-face hospital appointment, consumers said that the cold, sterile feeling associated with white coats, covered up windows, and medical equipment made their blood pressure rise before the appointment had even started. They wanted VOICeD to be warm and inviting, using friendly imagery, and emphasising that the service allows them to be comfortable in their own home environment rather than confined in a clinical setting.

Many of these insights mirrored and confirmed clinician expectations, which was an important outcome of session in itself. Beyond this, there were many insights that prompted further discussion and consideration of aspects the team hadn't considered. For example, consumers struggled in telehealth sessions when they weren't warned that the clinician was about to enter the session—if the wait time was longer than expected they might be across the room making tea when the call began. They raised important issues around accessibility for blind and deaf patients, as well as aesthetic considerations that would guide the design of VOICeD imagery.

1.4 Implementing

The VOICeD team began implementing these suggestions in the lead-up to the soft launch of the service. While some of these recommendations couldn't be incorporated before the launch, the continual evolution of the service allows these features to be added over time. Suggestions incorporated before testing included reducing the number of virtual waitrooms, humanising the administration and clinical staff by displaying their picture and names on screen while waiting, and developing the conversations for administration staff before and after seeing the clinicians. Prior to the launch, and after implementing recommendations that were feasible short-term, participants from the first workshop were invited to test the VOICeD service.

1.5 User Testing

Several weeks after the initial workshop, participants were led through the VOICeD appointment experience, as were the HEAL team. This process of user testing would generate additional recommendations that were focused specifically on usability. Consumers experienced the virtual clinic model first-hand, while clinicians learned how to manage consumers between wait rooms and consult rooms.

Participants received instructional documents by email in advance, attended their "appointment", checked in with administrators, and transferred between practitioners. Following their "appointment", each participant then spoke to the HEAL team individually over the phone to gauge their response to the process, following the typical feedback questionnaire that new patients would receive while also allowing for more open-ended discussion. This included questions like "how was your

overall experience with the VOICeD Diabetes-Renal-Cardiac clinic?", "what did you like?", "what didn't you like?", "do you prefer combining 3 consultations into one appointment or 3 separate appointments?" and "how were the waiting rooms? is there anything you would improve? (audio, visuals etc.)".

Participants had very few issues using the service, however their feedback was crucial in refining the technology and consumer experience. Consumers wanted the appointment link to be sent on time or earlier, as some received it later than the appointment. Mobile and desktop experiences were very different—on mobile there was a confusing video-nesting feature that made the call quite disorienting, while desktop was far more seamless. Adding additional questions for each type of device in the feedback survey helped to capture these insights and device-specific issues. The patient letter required a re-design to more clearly communicate exactly what the patient needed to do on the day, perhaps incorporating visuals or videos to explain what the experience looks like. Captioning and translation features needed to be added to address hearing impairments and language barriers, making VOICeD accessible to all consumers. A spinning wheel would appear on the screen to suggest they were about to be connected to the appointment, however for those off on a bathroom break or distracted doing something else, an audio voice-over would be useful to include several seconds prior. Finally, at the end of the appointment, consumers wanted clear communication around the next steps, who they would be seeing for their next appointment, and any additional information they need in the interim. This information is often communicated via traditional posted mail weeks or months later, leaving them in the dark.

Most of the recommendations that came out of this process were implemented through a series of staged software upgrades. Recommendations relating to usability included: simplifying the onscreen layout, controls, and information overlays for consumers; incorporating 'SMS invitations' to be initiated from within the virtual clinic environment; and incorporating inter-specialist text messages that were 'pinned' to the consumer being transferred.

1.6 Improving

From the outset, the VOICeD team had committed to continue to improve, test, and evaluate the service long-term, and are continuing to implement recommendations from the HEAL collaboration. They are also collecting qualitative data from patients on an ongoing basis to better understand the patient experience.

Qualitative measures were developed to focus on the experience of patients and those providing the service. From the beginning of the project, the intention was to adapt how VOICeD was delivered, as the team learned from consumers, clinicians, and others in the health service. The first three clinics trialled substantially different workflows, communication, and prioritisation methods. During weekly post-clinic conversations, the team would collaboratively decide how to operate in the following week, testing and exploring different ways of working. Collective consumer and

clinician experiences soon indicated that a case conference configuration worked best, providing the most supportive experience while reducing administrative complexities. Other aspects of service design continued to be adapted and modified week by week, improving efficiency before, during, and after the clinical interaction.

After the first VOICeD Diabetes-Renal-Cardiac clinic, the team collected information about the experiences of 18 out of 20 consumers. The remaining two chose not to provide feedback. All respondents reported they felt their care was safe and private, and would recommend VOICeD to others. 89% (16) felt that it was easier than travelling to hospital, and 94% (17) preferred one combined appointment. Consumers unanimously liked having fewer appointments and reduced wait times. Surprisingly, they also highly valued seeing their specialists speak to each other and formulate a unified plan for their care, informing the use of a case conference format.

These static experience metrics go only a small way to describing the emotional responses of people accessing care. The ability to access care with support, either with their family at home or within their community, was profound for many people. Stories soon emerged: a participant crying, sharing how supported she felt when specialists came together to provide her care; a young mother who could not physically attend the hospital, no longer having to be re-referred due to not booking or non-attendance; and a man on home oxygen who would normally risk running out of oxygen before reaching his appointments, now dialling into a single appointment from home. The time consumers spent waiting in clinics was reduced by around 350%, creating more time for their life, work, and family.

Feedback from clinicians was also incredibly rich. Like consumers, clinicians valued having a single care plan, and being able to directly discuss the plan with diverse specialists in real time. A short conversation between the specialists (and with the patient) saved months of navigating separate face-to-face appointments as the underlaying health conditions changed or worsened. Clinicians also found they were upskilling, becoming more aware of considerations and management preferences of other specialties. Some clinicians raised that their time spent with one patient was longer in VOICeD than in a traditional face-to-face appointment. From the perspective of a health service, for the same amount of clinician time, VOICeD created 16% more capacity release than face-to-face, reduced the patient time in clinic by 350%, required 3x less appointments per year, and reduced patient travel. Economic analysis showed that standard funding mechanisms could cover the cost of the clinic, making it an attractive service model for a relatively small proportion of the people entering diabetes, renal, or cardiac services.

1.7 Expanding

Since the success of the first VOICeD clinic—Diabetes-Renal-Cardiac—the service has expanded into other contexts: Gestational diabetes care, Diabetes paediatric to adult transition (also known as Adolescent and Young Adult care), and

Child Development. The team have also continued to launch Diabetes-Renal-Cardiac across additional sites. It quickly became clear that VOICeD had the potential to improve consumer experiences beyond the realm of chronic disease, and the team decided to rebrand to *Virtual Outpatient Integration for Care Delivery*.

In 2021, former HEAL intern Jessica Cheers was offered a year-long Experience Design Fellowship with the Healthcare Improvement Unit (HIU) within Clinical Excellence Queensland—an embedded role which was modelled largely on her work on VOICeD and other HEAL projects. As part of the fellowship, she travelled to Rockhampton with Dr. Brent Knack, meeting with health professionals operating in the Central Queensland Hospital and Health Service (CQHHS) to explore opportunities to embed the same multi-clinician telehealth model for patient groups in their HHS. Jessica assisted the team in designing a workshop for the group, acknowledging that there would be many complex dynamics in the room. In group, health professionals would "pitch a patient group", following a template that explored the who, how, why, and what-if's. The pitches would be presented to the room, and after each pitch anyone in the room could adopt the role of "Devil's Advocate" (complete with a paper devil's hat) to critique their proposal, identifying potential issues and opportunities, and challenging the team to overcome them (Fig. 4). This method was very successful in breaking through surface-level discussions and allowing participants to express their concerns comfortably, prompting many continued discussions. It also prompted the group to tangibly document their ideas and bring them to life, beginning the early stages of prototyping what the service could look like for them.

Dr. Gaurav Puri and Dr. Brent Knack have continued their crusade, establishing new VOICeD services across the state. They continue to learn from each experience and make a point of embedding creative design approaches in their practice, having seen the value they bring to service development. VOICeD has become a community, with all project documentation, promotional materials, and lessons shared among the Community of Practice. People interested in establishing a VOICeD service within their own clinical contexts now have direct access to stories and lessons learned across Queensland.

Each location, consumer base, combination of specialists, and local health system has distinct characteristics and ways of working. The VOICeD team champion the use of design methods to rapidly iterate and develop a service that's fit-for-context, rather than assuming "one size fits all" or adopting a scale-and-spread method based on an approved modification of Diabetes-Renal-Cardiac.

While this means that VOICeD is a relatively loosely defined model of care, it has enhanced the ability of the service to deliver value to consumers and the health system by remaining true to the original vision: bringing multiple healthcare providers to people with complex healthcare needs in a way that is easy to access.

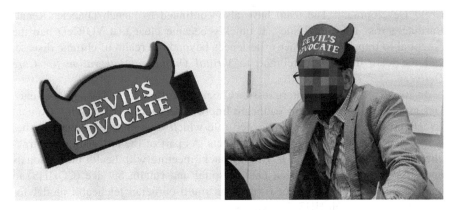

Fig. 4 The 'Devil's Advocate' hat

2 Outcomes

The VOICeD launch was a success, and patients continue to respond positively to the service. 100% of users surveyed would recommend the service, and 83% described it as a "very good experience". The participatory process—including both the in-person workshop and subsequent user testing—allowed the team to test their assumptions around the benefits of the service. Participants largely confirmed the benefits of a multi-practitioner telehealth model, while also challenging aspects of its delivery. The process of thematic analysis following the first workshop can be used as an at-a-glance embodiment of the kind of themes practitioners may want to consider embedding into new digital health services moving forward, and the user testing session gave very specific and actionable improvements to encourage further iteration. The team are continuing to work towards implementing further improvements based on the recommendations. The VOICeD project has won a number of awards, including the Consumer Choice Award at the Clinical Excellence Queensland Showcase in 2021, as well as Department of Health Awards for Reforming Healthcare and Consumer Engagement in 2022.

Each instance of VOICeD has brought unique value and lessons learned. Yet, in each case, the experience and accessibility for consumers has been the highlight. There are many nuanced ways in which the service has improved consumer experiences—making early personal contact with booked patients, facilitating clinical investigations (e.g. blood tests) prior to the appointment, integrating other services such as nurse navigation, and adding technical enhancements to the virtual clinic.

3 What we Learned

The collaboration between VOICeD and HEAL shows how clinicians, designers, and consumers working together can create digital health services that reduce the burden on consumers rather than introducing even more complications to the

day-to-day lives of those managing complex health conditions. It's a case study in rapid iteration, prototyping, and good design—bringing ideas to life and creating robust services that can infectiously influence and spread throughout the healthcare system. The participatory process uncovered broad themes to be embedded in the VOICeD service, as well as specific and directly actionable recommendations. The team are continuing to implement changes, such as accommodating hearing, speech, and vision impairments, restructuring the patient letter for further clarity, implementing voice-overs in the virtual waiting room, and presenting clear and actionable next steps at the end of each appointment.

The VOICeD model was born out of conversations with patients and the clinical experience of diabetes practitioners. However, in initial discussions with the VOICeD team at Cairns Hospital it became clear that the team were making several fundamental assumptions about what people with chronic disease wanted and needed, informed by their perspective as health professionals. When developing personas and mapping the journey of patients, practitioners struggled to step into the patient perspective, projecting their imagined clinical benefits. While many of these assumptions were affirmed by the participatory process, speaking to a group of end-users directly was crucial in challenging the expectations of the team, uncovering surprising nuances and preferences around aspects like the waiting room experience and information delivery.

One of the more fulfilling aspects of the collaboration for HEAL designers was experiencing the lightbulb moments in healthcare practitioners as they went through the lengthy process of intricately mapping the service experience. This process brought to light aspects of the service that they hadn't yet considered, while also bringing the service to life in a tangible way. Initial collaborative maps were extremely exhaustive, representing the role of all practitioners, stakeholders, and end-users in achieving a fluid patient experience. The process of simplifying this information and connecting it to real end-users translated the knowledge into digestible, shareable visualisations that could easily communicate the intention of the service. Similarly, the process of translating the knowledge of workshop participants into actionable recommendations ensured their visions could be directly and concretely implemented.

The HEAL team took away many learnings from the workshops with consumers. They found the future-oriented approach to consumer engagement very beneficial—the *Future Workshop* format allowed participants to consider both their current, emerging, and future needs and desires, which the team could embed in the VOICeD service to ensure it aligned with their aspirations for the future of healthcare. Playful and provocative prompts like the devil's advocate hat used in the CQHHS workshop broke up tensions in the room, and helped to navigate complex dynamics between health professionals while bringing levity to the workshop environment. There were some barriers to achieving a truly co-designed service— namely that consumer engagement didn't occur early in the process, and difficulties around recruitment meant that some participants didn't necessarily have the lived experience needed to engage in the workshop activities as they were designed. In the future, perhaps the format of consumer involvement could be adjusted to involve

more asynchronous engagement or virtual interviews, allowing more perspectives to be captured without the challenges of a face-to-face session.

Finally, the HEAL and VOICeD teams were often surprised by what had the most impact. While the designers produced a number of journey maps, design assets, illustrations, and branding elements for the team to use where needed, a simple slogan—*"Bringing you care, anywhere"*—was one of the contributions that the VOICeD clinicians connected to the most. The early stages of the process were unanimously the most enlightening, pulling apart the vision, beginning the process of its grand design, and realising the need to reconnect with the very people the service was for.

4 Conclusion

The collaboration between HEAL and VOICeD resulted in an exciting and fruitful partnership between designers, health professionals and people with chronic disease, each illuminating new possibilities for the development of future healthcare services. The VOICeD team are continuing to bring on new patients, implement recommendations, and foreground the experience of people using the service at every stage. The successful relationship between designers and health professionals has sparked additional opportunities for collaboration, both in telehealth and across diverse Queensland Health projects.

References

1. Jungk R, Müllert N (1987) Future workshops: how to create desirable futures: Inst. for Social Inventions
2. Dator J (1993) From future workshops to envisioning alternative futures. Futur Res Q 9(3):108–112
3. Jansson M, Mörtberg C, Mirijamdotter A, editors. Participation in e-home healthcare@ north calotte. Proceedings of the 5th Nordic conference on human-computer interaction: building bridges; 2008
4. Braun V, Clarke V (2014) What can "thematic analysis" offer health and wellbeing researchers? vol 9. Taylor & Francis, p 26152

Jessica Cheers is a User Experience designer, PhD candidate at QUT, design educator, and all-round playful human. She has an Honours degree in Interactive and Visual Design from QUT, and her PhD is exploring how varying degrees and types of play—from tangible making to games and role playing—might impact both facilitator and end-user engagement with complex healthcare problems.

Dr Gaurav Puri (MBBS MHLM AFRACMA FRACP) IS an Endocrinologist, Bariatrician, Clinical Trialist and the Clinical Director of Logan Endocrinology And Diabetes Services (LEADS) at Logan & Beaudesert Hospitals. Gaurav is also the immediate past Chair of Queensland

Diabetes Clinical Network and current Clinical Lead GIRFT Diabetes Queensland. Gaurav also holds Master of Health Leadership & Management and is an Associate Fellow of Royal Australasian College of Medical Administrators. He has worked in various health services including NHS and WA health; and has called Queensland his home state since 2016. Nationally, he has contributed towards the development of the Australian National Diabetes Strategy 2021-2031, and he also led the development of Queensland Diabetes Strategy as well as multi award-winning VOICeD program for Clinical Excellence Queensland. Gaurav calls himself an eternal pragmatist who greatly appreciates the joys of practicing medicine, as well as the unpredictability and the fragility of the gift of life. He strongly believes that the clinical outcomes are integrally linked with the experience of the care, and that the experiences of care received by the patients, and the experiences of care delivered by their clinicians, are inseparable. And therefore, any desire to improve health outcomes must emanate through approaches that pivots on the experiences of the of patients and clinicians as one entity.

Dr Brent Knack M.D. is passionate about enhancing the quality and safety of healthcare services using human centered and systems-based approaches. He is experienced in program development and delivery having worked with consumers and clinicians to deliver virtual integrated service designs, the largest inpatient diabetes survey completed in Australia, and numerous clinical decision aids. Brent recently completed the Clinical Excellence Queensland Healthcare Improvement Fellowship to develop skills in diverse methodologies from Human Factors, Resilience Engineering, Systems Safety and human-centered design. Combined with research experience (PhD Biochemistry) these skills enable Brent to engagement actively with complex problems faced by healthcare.

Improving Interpreter Service Uptake and Access to *Just* Healthcare for CALD Consumers: Reflections from Clinicians and Designers on Animation and Experience-Based Co-design (EBCD)

Janice Rieger, Sarah Johnstone, Karen Beaver, Ruby Chari, and Thalia Brunner

The provision of interpreter services is essential for delivering inclusive, equitable, and accessible healthcare to people of Culturally and Linguistically Diverse (CALD) backgrounds. Despite this, there are often barriers to the uptake of interpreter services which can lead to inadequate communication and suboptimal care. This chapter presents an Experience-Based Co-Design (EBCD) project aimed at enhancing access and use of interpreter services in mental health settings. The clinician-led project sought to identify pain-points and barriers to service uptake from a clinical perspective, with the goal of co-designing an engaging, educational, and persuasive communication tool that can effect behavioural change amongst clinicians. By employing EBCD methodology, the project aims to bring together clinicians and designers to collaboratively design a tool that is both meaningful and relevant.

With a desire to develop an educational tool that utilises strengths-based lived experience and narratives of inclusion to encourage wider uptake of interpreter services in healthcare settings, the specific objectives of the project were as follows:

1. Gather data/stories/information on the enablers and barriers to interpreter use for multicultural mental health clients from the perspective of staff (clinicians and administrative).
2. Identify areas for improving access to the existing service (clinician-led).
3. Design an educational tool for improving the existing service based on learnings derived from user engagement and lived experience.

Following an iterative design process, the insights and experiences of clinicians were gathered through a survey in tandem with complimentary EBCD workshops.

J. Rieger (✉) · S. Johnstone · T. Brunner
QUT, Brisbane, QLD, Australia
e-mail: j.rieger@qut.edu.au; sarah.johnstone@qut.edu.au; t.brunner@qut.edu.au

K. Beaver · R. Chari
Queensland Health, Brisbane, QLD, Australia
e-mail: ruby@occthy.com.au

© The Author(s) 2024
E. Miller et al. (eds.), *How Designers Are Transforming Healthcare*,
https://doi.org/10.1007/978-981-99-6811-4_11

The resultant education tool represented a 2D animated video showcasing a real-life example of the positive impact that interpreter services have on consumer experience. Since the project's completion, the animation has received positive feedback from various professional training sessions, ultimately underpinning an expressed desire in healthcare leadership to develop additional animated training resources to address remaining barriers to interpreter access.

1 Context/Problem

Prior clinical incident analysis and data reviews conducted by the Queensland Health Metro South Addiction and Mental Health Services had indicated an ongoing underutilisation of interpreter services by consumers in need of such services. This resultant lack of access to interpreters for healthcare appointments creates significant inequity for CALD consumers, alongside any other individuals who reserve their right to accessible, effective, and equitable healthcare.

Interpreter Services are currently made available to all Queensland Health hospitals and health centres 24 h a day, at no charge to the client, being largely subsidised by Queensland Government agencies, who are required to provide and pay for qualified interpreting services for customers who are hearing impaired or otherwise have difficulties communicating in English. Despite this, some staff continue to hold the belief that the utilisation of interpreter services should be minimised due to associated costs and budgetary constraints. Despite the availability of interpreter services—which also come at no cost to the client—consumers continue to be negatively impacted by both real and perceived barriers which inhibit the uptake of this service. This project, whilst aimed at creating an educational tool to facilitate behaviour change amongst clinicians, is ultimately concerned with facilitating a rights-based approach to service access and inclusion, ensuring that healthcare is Just, [1] equitable, inclusive, and respectful of the rights and needs of all consumers who rely on such services.

2 Background/Literature

2.1 The Rise of Design in Healthcare

The role of design in healthcare has been growing both within Australian and international healthcare systems. While initially originating through the design of functional aspects of healthcare such as ergonomics and productive workspaces, the last two decades have seen a movement towards the additional use of design thinking as

[1] Morally and ethically fair.

an alternative to the traditional problem-solving approach throughout healthcare provision. In parallel, the field of design has slowly grown to incorporate the experiences and perspectives of non-designers within the design process (i.e., co-design) alongside welcoming a recent advent of focusing on non-tangible or non-object aspects of design (service design), both representing significant areas of relevance and adoption for ongoing healthcare service improvement within Australia and internationally.

Studies which focus on how to accelerate healthcare improvement have slowly begun to move away from viewing healthcare systems as rigid, inflexible mechanical systems, instead beginning to view these critical public service infrastructure systems as complex, dynamic, and ultimately, adaptive. In fact, EBCD in healthcare have also been seen as a way to build in the human dimension to healthcare transformation projects [1].

Following this trend, this project looks beyond a mechanical understanding of the interpreter service to understand the human element which may be preventing service uptake. By applying an experience-based lens to better understand the perspectives and experiences of the service users, we can ensure that we develop service design solutions which are most relevant to the service users and capture their ideas for improvement—rather than impose solutions. Furthermore, by focusing solely on clinicians and other healthcare professionals, we can focus on those with the most power to change the situation, internally influencing positive change in direct collaboration with the individuals who contribute to and shape the system from the inside.

2.2 Embedding Lived Experience to Promote a Culture of Access and Inclusion

While service design theory within healthcare has grown rapidly to include a swathe of design-led approaches to service transformation and healthcare quality improvement, this study is concerned with one approach: **Experience Based Co-Design (EBCD)**. According to experts, EBCD involves service users—be that staff, patients, or carers, reflecting on their experiences of a service and working together to identify opportunities for improvement, as well as devising and implementing changes [2]. In this study, this was applied using a *strengths-based* approach to incorporating service users' perspectives and lived experience. In other words—rather than highlight on what staff are not doing well (i.e., not adequately utilising the interpreter service) which may lead to decreased sense of belonging and appreciation in the workplace, or imposing solutions (which they already aware of—as discovered in the survey), our strengths-based approach sought to recognise what staff are already doing well as a way of encouraging more of this behaviour. This approach is less about imposing solutions or strategies, and more about removing any of the barriers

(including myths) that may be getting in the way of staff providing best practice service and delivering the type of care that that would like to.

Beyond benefits for healthcare improvement, this approach sought to promote positive wellbeing outcomes for healthcare professionals and contribute towards the creation of a safe and inclusive workplace culture which values the input, knowledge, experiences, and skills of its staff [3]. In addition to feeling involved, this approach to co-design enables staff to be part of the story, thus avoiding a top-down communication approach [4], contributing to feelings of ownership over the final product [5, p. 15], and increasing the capacity to generate shared understanding and shared language between participants and designers [6, 7]. Therefore, in the process of designing solutions to enhance inclusion for CALD consumers, this study additionally fosters inclusion of clinicians and other staff through embedding their lived experience and expertise in the design process, in addition to the partnership between designers and the Multicultural Mental Health Coordinators throughout the entire process.

2.3 Education Animation in Healthcare for Informing Behaviour Change

The use of animations as an education tool must consider several key factors. Firstly, the audience needs to be considered, then the message being created and the creative methods or techniques that best communicate that message, and finally how the video or animation will be disseminated [8]. Moreover, the purpose needs to be established: is the video being created for empathy building, behaviour change, policy change, design, or environmental changes? Is the video being created for research, advocacy, storytelling, community building, artistic and creative expression, empowerment, agency, or all of the above? [8]. Fortunately, there is an abundance of literature which explores the role and effectiveness of animations as an educational tool and communication strategy in healthcare. A brief review of this literature indicates the potential of animations for informing behaviour change over other formats—particularly through its capacity for being relatable and inclusive, and for fostering engagement and the retention of information, which all help to increase the capacity for persuasive impact.

In terms of its effectiveness as a communication method, current literature highlights that while animation in healthcare is a novel tool in the field of healthcare education, it does have potential. A study from 2022 involving a systematic review of trials using animations compared with other educational delivery methods, suggests that animations show promise in practitioner education for effects of knowledge [9]. On the plus side, they discovered mostly positive outcomes for their impact on attitude, cognitions, and behaviours [9]. Another systemic review of studies of animation in healthcare conducted in the same year by Yi Su also acknowledged the

potential of animations in healthcare, but found that this "powerful media function is not appropriately used" and many of the videos in the healthcare area are "low quality and do not fulfill the intended function" [10, p. 458]. The intended function mentioned here refers to their effectiveness for persuasive impact i.e., the attitude, cognitive, and behaviour change that Knapp and his colleagues discovered in their study.

While the goal of animations for entertainment purposes is to achieve expressive impact (effective functioning or mastery of the medium), animations in healthcare are generally made with the intention of creating 'persuasive impact', which Su defines as information, which is "effectively communicated, resulting in a change in the mental status of the audience and subsequently influencing behaviour" [10, p. 459]. Su also adds that low-quality healthcare animated videos are typically those which solely rely on traditional expressive means, without consideration of persuasive impact. This research by Su [10], explains how the effectiveness of an animation for achieving persuasive impact is not merely about how beautiful an animation is (although that certainly helps) but more about how closely it relates to the audience's condition, and highlights the importance of an taking an inclusive, audience-centred approach. Enabling clinicians to imagine themselves as the characters in an animation increases its capacity for persuasive impact and retention by increasing its relatability, as described by the phenomenon called the *self-referential effect* wherein "people process information by relating it to aspects of themselves" [11, p. 724]. Furthermore, as an accessible medium, videos can also break down attitudinal barriers from unconscious bias, stigma, and stereotypes which often exist in healthcare [7].

Besides fostering inclusion through the content, the animation format is also known for its capacity to enhance accessibility and inclusion. Because a visual language will always be more accessible than text [12], all people—regardless of literacy levels, will find benefit in visual communication methods for 'reducing cognitive load' over those which are text-laden [13]. This is also highlighted in research on healthcare education conducted by Yi Su who indicates that "animation shows a reasonable degree of inclusiveness" compared with text-based animation tools [10, p. 461]. While cognitive load is one way to look at it, attention spans also have a role to play in the choice of animation for educational purposes. Research in the field of visual communication reveal the average human to have an attention span of only 8 s, with a capacity to process visuals 60,000 times faster than plain text [14].

Finally, animations which use a narrative structure, as used in this project, are a useful tool for presenting instructional information in a way that is not only more engaging, but far more likely to be retained. Research conducted by Moreno and Mayer on the impact of personalised multimedia for active learning reveal that instructional information presented as a narrative, or 'conversational style' are more engaging than those in formal style (e.g., on-screen text)—otherwise referred to as 'personalisation principle' and have the potential to increase deep information processing by reducing the cognitive load [11].

3 Project

3.1 Design Process/Stages

The project engaged administrative staff and clinicians from Queensland Health Metro South Addiction and Mental Health Services across the Metro South Health region in South-East Queensland, Australia through a short qualitative survey. This survey provided insight into their frequency of booking and using interpreter services and experiences of using the service, alongside any barriers or enablers in relation to either *booking* or *engaging* interpreters through the service, and ideas for improving the uptake of interpreter usage. The experience-based survey enabled patients' perspectives to be told through clinician accounts and stories of their experiences, thus enabling the project team to centre the experience/s of the patient in the resultant animation.

Additionally, in April 2021, a selection of survey respondents (service users) further participated in a rapid 90-min online workshop which involved interactive quizzes, primarily focusing on 'Myth-busting and Truth-Sharing' in order to clarify some of the findings from the survey. Workshop participants also engaged in rich conversations surrounding possible ideas for 'Tools & Resources' and 'Training & Support' which could increase the effectiveness of the interpreter service system, ultimately informing any efforts to increase service uptake.

Following the results of the qualitative survey, the design team co-developed a storyboard for an educational animation, the basis of which emerged from a story shared by a clinician in the survey. The last phase of the workshop provided participants with an opportunity to share their feedback on a storyboard which was turned into an educational animation video[2] for Metro South Health staff, and possibly the first of a suite of new training videos which are directed at increasing interpreter service uptake (see Fig. 1).

The project followed a standard design process which can be characterised into **four standardised stages:** (1) reflection, analysis, diagnosis, and description; (2) imagination, visualisation, and improvement process; (3) modelling, planning, and prototyping; and (4) action and implementation [15].

[2] https://research.qut.edu.au/heal/wp-content/uploads/sites/353/2021/04/HEAL_CALD_full_ v005.mp4?_=3

APPOINTMENT

Fig. 1 Animation storyboard

4 Reflections on Co-design and Service Design Process

This project produced innovative approaches to inclusive practice, investigating what happens when we ask people about their experience of interpreter services or lack thereof [16]. The project responded to an identified need and demand, as access to interpreter services is still very limited and there are many misconceptions about this service in QLD Health. As we describe, by putting the lived experience and narratives of patients and clinicians at the centre, this project also neatly focused on the adoption of EBCD in effective healthcare service improvement.

What we found—through focusing our approach on lived experience and emphasising the value and importance of creative practice—is that EBCD increases engagement from all stakeholders to create a culture of inclusion and promote *just* access to healthcare, as demonstrated in our reflective sections below.

4.1 Ruby Chari, Multicultural Mental Health Coordinator

We first put our submission in September to get specialist access to designers from the QUT Design Lab through the CEQ Bridge Labs initiative.

Background of problem:

Our health service district is the largest multicultural district in Queensland where every other person either speaks a language other than English or their family of origin is from a Culturally and Linguistically Diverse (CALD) background. Providing an equitable service in such a district needs an extremely high level of awareness and commitment. Working with interpreters in the provision of care has been a vital part of the service delivery but there have been several challenges. Some of the barriers were obvious, but most of the information based on 'corridor' conversations were unclear. As the multicultural mental health coordinators (MMHCs), our need, before we were aware of this opportunity, was to get a better understanding of what the barriers were—perceived and real—with the aim of then working towards solutions to these barriers.

Challenges of doing quality improvement ourselves:

Together my colleague and I had limited idea of how we could go about this process and had decided that putting together a survey would be a good starting point. Coincidentally, at the same time clinical incident analysis revealed an underutilisation of the interpreter service and it was a priority at the executive level, and we stumbled upon this opportunity by word of mouth. The eligibility criteria for the submission were broad and therefore fit our clinical dilemma. The requirement for application was clear and simple. This made it easy to put together in a time constrained environment of being a clinician with limited research experience. Once we got accepted, the meeting with the design staff really prompted us to further clarify our problem clearly. We felt ready to accept 'outside' assistance as we felt the need for new and innovative solutions after many years of trying to address the issues by ourselves. In the initial stages, we were able to collate all the current resources and look for 'what can we do differently.'

We approached these sessions with a range of emotion: excitement, or eagerness to find out more, a bit of anxiety or feeling of uncertainty if there was really anything further, we could do but always with an openness to accept what we would be offered. We felt design was a way to look for solutions outside our current way of thinking. Along the way we faced challenges establishing these new relationships with COVID lockdowns and stretching time constraints.

What took me by surprise was the enthusiasm from clinicians to be involved in the co-design process and their eagerness to provide feedback in a one on one,

confidential setting. Working with the design group was interesting. The storyboard method was a new experience for me, and it really made the clinicians provide feedback on specific and bigger picture issues. All the information we received during that session was valuable and are trying to incorporate these into our role. The time we had during the design process felt short and we would have benefitted from further engagement and support. We have used the end product animation in some presentations, and it was well received and would like to use this in a more structured training package. Our involvement in this project gave the issue of interpreter access further visibility.

4.2 Karen Beaver, Multicultural Mental Health Coordinator

As a Queensland Health clinician I was very excited to have the opportunity to work with the QUT Design Lab and Clinical Excellence Qld (CEQ) on a Healthcare Excellence AcceLerator (HEAL) collaboration.

There was some extra meetings and time spent in the initial interface allocated to building relationships between MMHCs and QUT designers and researchers, and of course understanding the aim of the project. This included focusing on what is achievable and in scope of the MMHC clinical role within MSAMHS.

The MMHC role receives clinical referrals from internal and external services to provide primary, secondary and tertiary consultation for culturally and linguistically diverse (CALD) consumers and their families. The MMHC role also in involved in workforce training and development and maintaining partnerships with local care providers and community-based resources for CALD consumers.

We really wanted to explore some new ideas and add value to what has already been tried in terms of enhancing the access to interpreters and understanding the barriers to uptake, both real and perceived by MSAMHS staff. We started by identifying opportunities to incorporate any resources or strategies developed in the project, in to ongoing MMHC role activities eg. professional development sessions or one on one mentoring.

I was surprised by the willingness of staff to participate and openly respond to the survey questions. I think it was helpful that we in our MMHC roles already had rapport with staff and that trust existed to share their experiences of engaging interpreters for their CALD consumers.

I think it was very beneficial to have the designers (external to MSAMHS) involved in the cofacilitation of the co-design workshop. But at the same time, it was also very important to have the clinician-led (MMHC) input to make it relevant for the service and workforce. In this co design workshop with staff, we could identify what resources would be achievable and realistic to develop.

My final reflection is that I would like to explore opportunities to develop additional animated resources to address other barriers to accessing interpreters, which were identified through the survey and co-design workshop. It has been a wonderful learning opportunity and I really appreciate the QUT Design Lab support as well

as the time they spent on collating the survey and codesign workshop feedback and summation of the project into a report.

4.3 Janice Rieger, Designer

This project was done during the COVID-19 pandemic—entirely online and at a distance—using entirely online/digital engagement tools—online survey, online workshop, and delivering an animation which can be shared virtually or used in online/virtual training delivery.

While designers are no stranger to engaging in online data collection and engagement methods, there is a tendency towards face-to-face methods, especially for workshops. While, in this project, the workshop was not the most effective aspect of the project, it wasn't a detriment to the project at all, and we still managed to develop a deeper insight into some of themes which came out of the survey, and to get feedback on the storyboard for the animation.

We found ourselves using a variety of online or digital engagement methods, which we came to discover was also far more useful/appropriate/effective for accessing participants—for enabling participation from people who are famously busy and, in these circumstances, located across multiple locations across the South Brisbane region which Metro South Addiction and Mental Health Services are responsible for. Regardless of whatever challenges COVID presents, getting clinicians and other members of staff to come together in one location would always be difficult.

A survey was extremely helpful for enabling as many people as possible to participate and was a familiar method of engagement which is presumably more in-line with the way in which this particular group usually shares feedback. By starting off with an experience-based survey, we were able to ground the entire process and outcomes in their experiences.

Designers need to listen more to understand clinicians' expertise and respect their experience of working in this system day to day. As designers, we have the ability to bring a diverse perspective, but we can never understand the challenges and barriers in complex systems. Designers can only start to map the system to collaboratively identify pain points and places for opportunities with clinicians. As a senior designer with 25 years' experience working across several continents and with diverse industries, I would argue that working with health care systems and all of the stakeholders is one of the most challenging. I had the opportunity when I was a junior designer to work with a senior project manager on a large new Children's Hospital and it was extremely rewarding to see all of the different stakeholder groups, the diverse stakeholder meetings, and how under one project it brought together people from almost every sector. As an example of this, because this was a hospital in a city that is multicultural, a chapel in the hospital was not felt to be appropriate. The hospital had patients and their families from diverse religions and cultural backgrounds and so the design of the 'prayer' space was of extreme interest

to create an inclusive prayer space. So, a stakeholder group with representatives from almost all religions and spiritual groups was brought together to try to design a space (and its colors, shape, use of icons, artefacts, and water) so that it would be an inclusive space for all patients and families to come and use. This kind of engagement and inclusive co-design is an example of best practice that drives me to use creativity to unpack complex problems and to create inclusive design—a.k.a. design for all (DfA) [17].

In terms of what recommendations I would have for clinicians who want to work with designers, I would say that a symmetrical relationship needs to be set up from the start. Designers tend to want to lead design workshops and to create innovative solutions but often this is not done taking into consideration the lived experience and knowledge of clinicians and other users. I would also just recommend to clinicians to open themselves up to innovative and create ideas as often designers' ideas might not seem obvious or tangible, but it is in this collaboration and openness that great ideas emerge. So, it is a symmetrical and dependent relationship between clinicians and designers.

4.4 Sarah Johnstone, Designer

Designers are well-versed in the practice of getting comfortable with the uncomfortable or unknown, and often find themselves working in diverse industries, contexts, and circumstances. In the co-design process, we embrace this by drawing upon the expertise of those we are designing with, leaning into our role as facilitators or guides in the design process. In some projects it can be a case of providing a set of fresh eyes who can offer a unique perspective or solution to a seemingly obvious situation. This was certainly the case in this project where my colleague, Janice and I were invited to partner with Multicultural Mental Health Coordinators Karen Beaver and Ruby Chari from Metro South Addiction and Mental Health Services (MSAMHS) to uncover potential barriers preventing consumer access to interpreters when accessing healthcare services. While my previous design research experiences have had a specific focus on increasing engagement from the perspective of people from Culturally and Linguistically Diverse (CALD) backgrounds, this project was a new opportunity for me to co-design strategies to enhance access from the perspectives and experiences of those who deliver services as part of an innovative healthcare improvement strategy (HEAL) which brings designers and healthcare professionals together to bring design thinking to wicked problems within the healthcare environment.

Going into this project, I had no prior knowledge or experience of the interpreter system, or the broader service design at MSAMHS. Despite preliminary findings from our partners indicating that misinformed concerns over costs and budgetary constraints may be discouraging staff from using interpreter services, I was eager to keep an open mind. While the survey confirmed these concerns, it also revealed the deep awareness and understanding the survey respondents had of not only how

to use the system, but also the importance of the service for CALD and other (e.g., Indigenous or hearing impaired) consumers who require additional communication support. I was excited to see the level of detail provided in the survey by clinicians and administrative staff about what worked, what didn't work, and their detailed ideas for how to improve the system overall. I did not anticipate that the survey would provide such deep and diverse insight and ideas for how we can improve the system at the outset of the project, many of which could be implemented right away, indicating the value of drawing upon the expertise of those who use the system.

As designers, and outsiders of the system, I believe we were able to identify some of the less obvious factors, which not only have a negative influence on service uptake but are much more difficult to solve, and in some cases rely upon education and behaviour change strategies to create change over time. One example of this was a brief story shared through the survey by a clinician about a situation in which one of their clients was so grateful to have been provided an interpreter that she cried, after not having one at previous appointments. We realised that this story was an opportunity to apply a strengths-based approach, rather than a deficit or criticism-based approach, for encouraging positive behaviour change and fostering a culture of inclusion. We achieved this in the animation by highlighting the value of having an interpreter available for CALD clients (such as the one in this story) rather than placing blame on the clinicians within the team who had not previously booked an interpreter for this client. This story further demonstrates the benefit of having an interpreter present to enhance understanding and the importance of offering one, regardless of any assumptions about the need based on appearances or presumed English proficiency.

While it is too early to determine the impacts of the education animation on service uptake, this design approach demonstrates the potential of designing solutions based on the lived experiences of those who used the service in addition to centring the thoughts and feelings of those who the service most seeks to impact—the consumers. From my experience, I found this project to be a great example of the benefits of co-design for healthcare service improvement for drawing on the unique skillsets and experiences of both designers and health professionals for creating innovative design solutions.

4.5 Thalia Brunner, Animator

The HEAL Interpreter project was part of my HDR internship with QUT. I saw this project as an exciting opportunity to explore my creative skills within a collaborative environment whilst extending my understanding of current, important healthcare matters. The project began for me with an initial meeting with Janice and Sarah. It was at this point where I gained an important understanding of the aims, objectives and how animation could be best used as a communicative tool to improve the understandings and usage of interpreter services within healthcare. I learned a lot about the healthcare challenges for CALD clients during this first meeting. This

helped inspire me to create and deliver an animation that could help minimise these barriers by improving understanding and healthcare experiences for the clients.

My role as an animator on this project was to create a 2D animated video comprising of two parts: appointment and post-appointment, designed from discussions between the creative team and appropriate clinicians and clients. The first stage of my creation process involved designing a storyboard (an illustrated shot-by-shot plan for the animation) to establish the desired messages and visual themes. This was then discussed within the co-design workshops and healthcare teams before animation began. It was valuable to spend time on this phase to explore different perspectives and approaches as part of the co-design approach.

Projects of this nature often have the challenge of communicating all the important information into a short timeframe, but this is where animation is particularly powerful and the perfect visual medium. Animated storytelling devices can transform the viewer's experience, offering a unique perspective of concepts such as those discussed within this project, and connect people to messages in ways words cannot.

While animation itself is a powerful method of visual communication, the approach of a co-design model intertwined within the animation process enabled a unique form of creation that allowed for the project to dynamically evolve. Constant feedback from the target audience ensured that the visual aesthetics and narrative structure delivered a strong, effective message.

I was very pleased with the outcomes of this project, the viewer/team response, and what I was able to achieve working as the sole animator. In addition, this has been a valuable personal learning experience where I was able to increase my understanding and awareness of healthcare experiences for CALD clients and gain an insight into the different perspectives. I enjoyed the experience animating for the HEAL Interpreter project and the opportunity to utilise my skills within an important context whilst working within a collaborative environment.

5 Discussion

A number of techniques can be used to gather the experiences of service users in healthcare; however, healthcare staff and researchers often default to more traditional quantitative methods rather than qualitative, often adding constraints to the richness of insight and depths of understanding of the experiences of users such as how it feels to deliver or be the recipient of care [18]. By emphasising the value of lived experience, alongside authentic and equitable collaboration between designers and clinicians, the participatory methods of Experience Based Co-Design may become a new salient and efficacious approach in healthcare quality improvement [19]. Actively and deeply engaging with users ultimately enables co-design because it ensures "all aspects of subjectively experiencing a product or service—physical, sensual, cognitive, emotional, kinetic and aesthetic" [1, p. 308] are identified and addressed, thus improving the service experience [19].

The collaborations between clinicians and designers to solve complex problems in healthcare and to promote Just access to healthcare is an example of best practice—evidenced by the recent recognition of two national awards in Australia— *National Good Design Award Australia* for Social Impact, Australia, 2021 and *National Good Design Award Australia* for Design Excellence, Australia, 2021.

Co-design processes represent not the act of paternalistic *leading*, but collaborative and inclusive *following*: we did not intend to create animations to increase the uptake of interpreter services, nor did we intend to create a new exploration of experience-based service design. Through allowing the process and participants to wholly contribute we were able to capture the experience of patients as well as the experience of clinicians and administrators through narrative explorations ultimately informing the resultant output and outcomes of the project. Co-design is a journey often without a predetermined path and it is important for everyone involved to come together and to trust in one another and the process. Experience became central to our process in understanding the limited uptake of interpreter services for clients who identify as CALD or those that are Deaf. By drawing on the knowledge, skills and lived experiences of service users, we were able to redefine experience-based service design beyond just an improvement method.

6 Conclusion

The project involved creative interventions (animations) to demonstrate the potential benefits of storytelling and creative engagement to enhance service design and uptake of interpreter services, ultimately providing direction for designing more inclusive engagement practices [12]. This project was a great example of how the co-design process can allow for the inherent knowledges and skills sets of both clinicians and designers to merge and create innovative and appropriate design solutions.

By bringing forth the lived experience and first-hand insights and stories of clinicians, and the problem solving and creative skillsets of designers, we can arrive at new ways of addressing complex service and systemic problems to transform healthcare, and to uphold the right to just access to healthcare for all.

References

1. Bate P, Robert G (2006) Experience-based design: from redesigning the system around the patient to co-designing services with the patient. BMJ Q Saf 15(5):307–310
2. Donetto S, Pierri P, Tsianakas V, Robert G (2015) Experience-based co-design and healthcare improvement: realizing participatory design in the public sector. Des J 18(2):227–248
3. Brun J-P, Dugas N (2008) An analysis of employee recognition: perspectives on human resources practices. Int J Hum Resour Manag 19(4):716–730
4. The pscyhology of employee engagement (2023) Workday

5. Bradwell P, Marr S (2017) Making the most of collaboration an international survey of public service co-design. Annu Rev Policy Des 5(1):1–27
6. Hagen P, Rowland N (2011) Enabling codesign. http://johnnyholland.org/2011/11/enabling-codesign/
7. Rieger J (2020) Right to participate: co-designing disability policies in Australia. QUT Centre Justice Brief Pap 12:1–4
8. Rieger J (ed) (2020) Reframing universal design: creating short videos for inclusion. Australian Universal Design Conference
9. Knapp P, Benhebil N, Evans E, Moe-Byrne T (2022) The effectiveness of video animations in the education of healthcare practitioners and student practitioners: a systematic review of trials. Perspect Med Educ 11:309–315
10. Su Y (ed) (2022) The persuasive impact of animation in health care sciences services: a rhetoric-based literature study. In: HCI international 2022–late breaking posters: 24th International conference on human-computer interaction, HCII 2022, Virtual event, 26 June–1 July 2022, Proceedings, Part I. Springer
11. Moreno R, Mayer RE (2000) Engaging students in active learning: the case for personalized multimedia messages. J Educ Psychol 92(4):724
12. Johnstone S (2021) Enhancing ecologies of care for CALD women through care-full creative engagement. PhD thesis, Queensland University of Technology
13. Mayer RE, Fennell S, Farmer L, Campbell J (2004) A personalization effect in multimedia learning: students learn better when words are in conversational style rather than formal style. J Educ Psychol 96(2):389
14. Jakus D (2018) Visual communication in public relations campaigns. Market Sci Res Organ 27(1):25–36
15. Bevan H, Robert G, Bate P, Maher L, Wells J (2007) Using a design approach to assist large-scale organizational change: "10 high impact changes" to improve the National Health Service in England. J Appl Behav Sci 43(1):135–152
16. Rieger J, Hadley B, Barron S, Boulton S, Parker C (2023) Codesigning access: a new approach to cultures of inclusion in museums and galleries. In: Cachia A (ed) Curating access: disability art activism and creative accommodation. Routledge, Oxon, pp 183–195
17. Mikus J, Høisæther V, Martens C, Spina U, Rieger J (eds) (2020) Employing the inclusive design process to design for all. In: Advances in industrial design: Proceedings of the AHFE 2020 virtual conferences on design for inclusion, affective and pleasurable design, interdisciplinary practice in industrial design, Kansei engineering, and human factors for apparel and textile engineering, 16–20 July 2020. Springer
18. Dimopoulos-Bick T, Dawda P, Maher L, Verma R, Palmer V (2018) Experience-based co-design: tackling common challenges. J Health Des 3(1):86–93
19. Miller E, Zelenko O (2022) The caregiving journey: arts-based methods as tools for participatory co-design of health technologies. Soc Sci 11(9):396

Associate Professor Janice Rieger from QUT's School of Architecture and Built Environment and the QUT Design Lab, has research and teaching interests that encompass issues related to spatial justice and creating cultures of inclusion, including Spatial Justice and Ableism; Diversity and Inclusion; Design for Health, Wellbeing, and Social Inclusion; and History and Theory of Spatiality and Disability Studies. Janice has been creating cultures of inclusion since 1994 and continues with this research program today.

Dr Sarah Johnstone is a design strategist, at the QUT Design Lab. She specialises in 'designing for diversity', co-design processes, and designing accessible/low-fi creative/arts-based community and stakeholder engagement tools.

Karen Beaver is a Clinical Nurse Consultant working in Metro South Addiction and Mental Health Services, Queensland Health. Karen has general and psychiatric nursing qualifications and works across inpatient and community settings. Karen has been in a Multicultural Mental Health Coordinator (MMHC) position for 19 years and is considered the most senior and experienced person in this type of role. The MMHC role provides transcultural clinical consultation support and direct clinical services for culturally and linguistically diverse (CALD) consumers. Other components of the MMHC role include service development and quality improvement activities, as well as developing community partnerships and responding to local community needs.

Ruby Chari has a Bachelors of Occupational Therapy and Masters In Clinical Rehabilitation and is a senior psychosocial mental health practitioner with significant specialist expertise working with culturally and linguistically diverse clients and those from refugee backgrounds. She brings decades of public sector mental health experience spanning acute, subacute and community rehabilitation. More recently, Ruby has worked in the not-for-profit social care sector providing occupational therapy assessment and therapeutic services under the NDIS scheme. Ruby is a respected practitioner in the field and is passionate about helping consumers achieve their personal and rehabilitation goals. Ruby is registered with AHPRA, and is a member of OT Australia.

Thalia Brunner has a passion for creating and sharing stories in engaging and innovative ways. Her skills and interests lie in areas of animation and virtual production, using technology to assist understanding and communication. Her QUT PhD thesis is currently under examination.

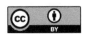

Co-designing the Palliative Care Hospital Experience with Clinicians, Patients, and Families: Reflections from a Co-design Workshop with Clinicians

Evonne Miller, Patsy Yates, Sarah Johnstone, and Maryanne Hargraves

1 The Palliative Care Context

Illness, death, and dying are an inevitable part of the human experience. As a society, however, we spend very little time thinking, talking about, or planning for the end of life or palliative care, which is the provision of end-of life support to a person with a life-limiting illness and their carers. Palliative care is person and family-centred care that maximises quality of life until death, enabling the management of pain and symptoms. These symptoms may be physical, emotional, spiritual, and/or social. The process of confronting and preparing for death can be challenging for individuals and their families, who work to maintain control and find meaning in the dying process, and for clinicians, who aim to provide quality care and enable dignity at the end-of-life [1, 2].

Depending on their individual preference and situation, as well as the illness type and progression, people can die at home, in hospices, in residential aged care, and in hospital. In this chapter, we focus specifically on how a sample of clinicians would redesign the palliative care hospital experience in one private hospital in Brisbane, outlining our specific co-design approach and activities to enable others to learn from and potentially apply our methods in their own co-design context.

E. Miller (✉)
QUT Design Lab, School of Design, Queensland University of Technology, Brisbane City, QLD, Australia
e-mail: e.miller@qut.edu.au

P. Yates · S. Johnstone
QUT, Brisbane, QLD, Australia
e-mail: p.yates@qut.edu.au; sarah.johnstone@qut.edu.au

M. Hargraves
St Vincent's Private Hospital, Brisbane, QLD, Australia
e-mail: m.hargraves@qut.edu.au

© The Author(s) 2024
E. Miller et al. (eds.), *How Designers Are Transforming Healthcare*,
https://doi.org/10.1007/978-981-99-6811-4_12

2 The Value of Co-design

Co-design is an inclusive and collaborative approach, designed to foster open communication, creativity, and a sense of shared ownership among participants. Bate and Robert [3] first advocated for the philosophy and method of experience-based *co-design* in health, arguing that services should be co-designed *with* the patient, not *around* them. These principles of co-design are now deeply ingrained into healthcare. The principles of co-design, also known as participatory co-design, co-creation, co-production, co-innovation, human-centred design have become the spirit of our times, the Zeitgeist, in healthcare quality improvement [4]. Co-design is a collaborative design-research approach which is based upon a partnership between a designer (or design team) and the user(s) of a design [5], with experience-based co-design (EBCD) used to engage diverse groups of people in empathising, ideating, problem-solving, co-creating, innovating, prototyping, envisioning, and iterating. The argument for co-design in healthcare is simple. This collaborative user-centred approach helps enable the ideal vision for person and family-centered care that is, "a partnership among practitioners, patients, and their families (when appropriate) to ensure that decisions respect patients' wants, needs, and preferences and that patients have the education and support they need to make decisions and participate in their own care" [6, p. 7].

At its best, co-design helps to enable patient and family centred care by ensuring that the voices, insight, and wisdom of those receiving the care are integrated into practice, listened to and their experiences. As McKercher [5] outlines, **co-design is a movement and a mindset that emphases** making things and learning together, moving from a translational focus (on products and products) to a transformation process that produces outputs alongside social transformations. The creative participatory approaches of codesign—kinaesthetic, visual, sensory, interactive, oral—facilitates "self-discovery and moving people from participants to active partners" (p. 15), enabling "people to see themselves and each other differently" [5, p. 17].

> Co-design is an approach to designing with, not for, people …. The primary role of co-design is elevating the voices and contributions of people with lived experience. Beyond writing on sticky notes, co-design is about how we are being (our mindsets), what we are doing (our methods) and how our systems embrace the participation of people with lived experience (social movements) (p. 14).

Co-design sessions can and should be what Mezirow [7] described as a transformative learning experience: participants (learners) (1) obtain new information and insights (2) which results in evaluating past ideas and understanding, and (3) a process of critical reflection of questioning and examining things from a fresh perspective, which results in (4) a fundamental, transformative change in their perspective.

Creating the environment for a transformative learning experience within a codesign workshop, where co-learning, creativity, innovation, and collaboration is fostered, is not straightforward. Surprisingly, while there is a growing body of literature on group facilitation methods and the value of co-design mindsets and processes,

specific details on the tools, techniques, processes, and activities within co-design sessions remains limited, especially in the palliative care context.

As Sudbury-Riley et al. [8] recently noted, a service design perceptive (which underpins co-design) is a valuable and novel person-centred approach for shaping palliative care services, and uncovering "real opportunities for service improvement" (p. 3). Deploying a Trajectory Touchpoint Technique (TTT), Sudbury-Riley et al. [8] journey mapped seven key processes with 239 participants (palliative care patients and their families) from eight different palliative care providers over 4 years, with their study providing invaluable patient-centred insight into what matters in the entire experience—not only clinical care factors. For example, alongside clinical pain management, what might be initially viewed as the 'smaller' details were in fact critical for patients and their families: whether it was aromatherapy, hair care, access to pets and creative activities (art, music, craft) and social interaction with others, service users expressed a broader perceptive on what 'good palliative care' looked like for them.

In the reminder of this chapter, we reflect on and share the co-design approach we deployed to reimagine the palliative care experience at one service. The participating service included both inpatient and home care programs supported by an interdisciplinary team who provided services to people with a range of life-limiting conditions. As this project was conducted during the COVID-19 pandemic when in-person and group participation was restricted, and because our consumer participants had life-limiting illnesses which meant they had limited energy and were vulnerable to infection, we structured participation differently. Clinicians working in the participating service engaged in one 3 h in-person co-design workshop, while consumer engagement was via individual "bedside" consultations offering an abbreviated version of the workshop. Sudbury-Riley et al. [8] also deployed bedside consultations in their palliative care service design project, noting that it enabled very ill individuals to participate. This chapter focuses primarily on the staff perspective from the workshop.

3 The Co-design Workshop for Clinicians

Thirteen clinicians and service providers representing a range of health professional disciplines and volunteers came together for a fast-paced 2-h workshop to share their knowledge, experience, and aspirations for palliative care from the perspective of both the hospital and community care experience. Over the course of the workshop, participants engaged in several different design-based research activities which were specifically tailored and aimed at encouraging wild ideas, uncovering perceived barriers to change, and developing practical solutions for improving the palliative care journey for patients and their families. The project received human research ethics approval from both the university and hospital committees, with all participants providing informed consent. Two researchers led the workshop, alternating between leading the conversation and taking written notes, with other data

including an interactive, collaborative digital platform (Mentimeter) and participant worksheets, with drawings and written feedback.

In designing the workshop, we drew on principles from appreciative inquiry (a positive psychology and storytelling lens) alongside co-design and design sprint approaches. Design sprints, for example, typically comprises of five key iterative steps (Empathize, Define, Ideate, Prototype, and Test), with co-design approaches amplifying the voice of end-users. A design sprint typically comprises three phases (inspiration, ideation, implementation), variously emphasising both divergent (multiple wild, improbable, and radical ideas) and convergent (focused) thinking processes to enable innovation. The six key stages in this palliative care co-design workshop processes, alongside key findings, are outlined below—starting with (1) connection and creativity; then (2) empathy mapping (imagining and learning about the user group's experience); followed by (3) ideation (creative brainstorming); (4) barriers to change; (5) focussed idea-storming; finishing with (6) the process of prototyping and pitching one innovative solution.

3.1 Step 1: Connection and Creativity—Creating a Psychologically Safe Space Which Fosters a Co-design Learning Mindset

In creating this co-design session for palliative care clinicians and service providers, we were aware that a critical desired outcome was the co-creation of innovative, game-changing ideas. Co-design can be a powerful force for collaboration and creativity, however the development and sharing of innovative ideas will only happen in a group setting if there is a safe space for reflective dialogue, active collaboration, and learning. It is the facilitator's role to create and hold a psychologically safe space for sharing, and to encourage the intellectual risk taking that leads to deep, truly transformative ideas. As Page et al. [9] explain, "collaborations require the right emotional conditions and appropriate incentives for intellectual risk taking, including appropriate support mechanisms that help groups and individuals explore new fields" [9, p. 90].

One strategy that the design team frequently deploys is to use drawing as an icebreaker activity, asking participants to start by drawing—and then sharing—a *"moment of exceptional practice—when they felt inspired and motivated in their work"*. The positive focus is an intentional appreciative inquiry-inspired approach. Developed by David Cooperrider, appreciative inquiry draws on positive psychology and storytelling, and is the purposeful search for what is best in people and organisations [10].

With the aim of starting the session in a positive mindset, participants were invited to share their vision for palliative care in one word through an aspirational word cloud. Using a QR code linked to an interactive, collaborative digital platform (Mentimeter), the participants described the ideal palliative care journey using

HEALING LOVING LIVELINESS
PERSONALISED SUPPORTIVE HOPE FAIR SEEMLESS
 LOVED UNCONDITIONAL UNDERSTOOD INCLUSIVE
 SACRED

Fig. 1 What does the ideal Palliative Care journey look like?

words such as **supportive, inclusive, healing, personalised, and sacred**, as Fig. 1 illustrates.

The second activity, based on an appreciative inquiry approach, invited staff members to recall, sketch, and share an individual 'exceptional moment' when they were really engaged, excited, and proud of themselves and their work. After sketching these moments, selected participants shared these with the larger group, with the images then pinned to the wall, gallery-style. Participants' stories centred around the moments when they were able to truly support patients and their families, and went beyond their role to provide personalised care and support.

As Fig. 2 illustrates, drawings depicted actions such as providing patients with their favourite food, organising for them to leave the hospital for the day and go to their favourite restaurant or to have a picnic in park, moving all the beds by the window so patients could watch fireworks along the river, hoisting and wheeling a patient down to the garden to enjoy the sun with their wife, or simply sitting with patients during the night and holding their hands as they are dying. One participant shared an exceptional moment when they went out to help a distressed family member find a car park so they could see their loved one who was close to dying. Another participant recalled a moment when they offered a patient's wife to have a "last cuddle" and lay-down in bed with the patient in his last hours. These first two activities enabled staff to step out of the day-to-day mindset of service delivery and the broader challenges associated with creating change, and to remind them of both the bigger picture as well as the little gestures and initiatives that can make all the difference to patients and their families during this emotional journey.

3.2 Step 2: Personas and Empathy Mapping—Imagining and Learning About the User Group's Experience

The second step was to foster empathy, through personas and empathy mapping. Personas are fictional characters designed to help us better consider, imagine, and step into the shoes of another—to have empathy for their unique experiences, feelings and perspectives, and then use that empathetic imagination and understanding to guide actions. Here, participants were invited to empathise with Anne, a 67-year-old living with a chronic illness and recently diagnosed with a life limiting illness, by reflecting on what she *Says, Thinks, Does, and Feels,* using a traditional empathy map activity sheet, as illustrated in Fig. 3. Through activating empathetic

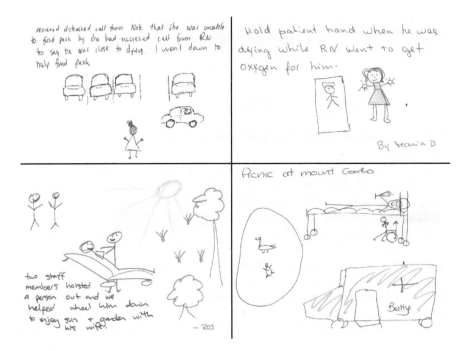

Fig. 2 Sketching exceptional moments

Fig. 3 Empathy mapping, with persona—the findings of which are summarised in Table 1

imagination, personas and empathy maps enable people to imagine and step into the shoes of another. Specifically, Anne was described as a retired 67-year-old who lives at home with her husband. Anne has two adult children, although they both live inter-state. For the past 10 years Anne has been living with a chronic illness but has recently been diagnosed with a life limiting illness.

Table 1 Consolidated findings from empathy mapping exercise

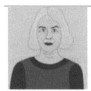

Anne is a retired 67 years old who lives at home with her husband. Anne has two adult children, although they both live interstate. For the past 10 years Anne has been living with a chronic illness but has recently been diagnosed with a life limiting illness.

Says	Thinks
I'm worried everything is getting worse	Wants to plan
Can I go on a clinician trial to get better?	Wants time & space
Doctors don't know everything, they've got it wrong…	Would like to stay at home but worried for husband caring for her
I only just retired. We had so much planned	Seeking support
I'm worried I won't get home from the hospital. It's Palliative Care. Is this the end?	Wants to be heard
I've never had pain like this. What does that mean?	*What does dying feel like?*
Why me?	*How will I manage at home?*
This is unfair	*What will happen to my family?*
I'm only 67	*Will I be able to see my children again? How do I spend time with my children?*
	How much longer do I have?
	Losing my independence
	I'm still young! Lots to do…
	Maybe the doctors are wrong
	What is going to happen to me now?
Does	**Feels**
Gets frustrated or shuts down	Worried
Lives at home	Tired
Manages chronic illness	Anxiety
Advance Care Planning	Unable to rest
Gets up by herself instead of waiting for help	Frustrated
Appears distressed	Scared

(continued)

Table 1 (continued)

Friend/neighbour (ex RN) willing to help	Helpless
	Grateful
	Angry
	Relief
	Hopeful
	Loved
	Afraid
	Down emotionally
	Sad
	Pain
	Ambivalence—wanting pain to end but still to live
	Disconnection from family/lonely
	Why me?

3.3 Step 3: Creative Ideation—'Wild Ideas' for 'Disrupting the System'

Following the empathy mapping exercise, and before becoming stifled by challenges, facilitators led the participants through an exercise to dream up three 'wild' ideas using a basic floor plan or 'mud map' of the hospital. Framed as 'Disrupting the System' participants were invited to work as groups to annotate the floor plan (Fig. 4) by (1) adding something new, (2) taking something away, and (3) replacing something with another thing. Some of the ideas were focused on improving or enhancing what was already at the service, such as making the lift wider, improving the AV (CDs MP3s, better WIFI, bigger TVs, movies), and creating a bigger staff room and family lounge. Features to add included a library and fish tank, and to turn to some rooms into an activity room, family room, counselling room, or another staff room, and install windows and skylights to these spaces. A popular idea was to replace the riverside wall with large windows and full glass doors that open onto the balcony with room for hospital beds, and to add a 'verandah' around the full perimeter of the building with pot plants and greenery which provides patients access to 'sunshine and fresh air'. Participants also suggested a gym/activity room, a playground area, animals, more vending machines, a short order menu from the kitchen, and a patient-friendly and accessible garden. The only suggestion to remove or take something away was to move the morgue entrance away from ground floor to somewhere with more private access.

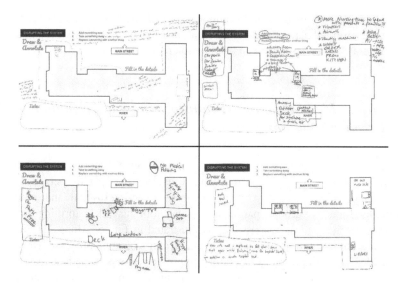

Fig. 4 Activity sheets—'Disrupting the System'

3.4 Step 4: Identifying Barriers to Change—Staff, Space, Social, and System

Upon completion of the 'wild ideas' activity, participants were invited to ease back into a more pragmatic mindset, and unpack potential barriers towards bringing these ideas to life and challenges more broadly. In this activity, designed as more of a game, contributors (working in teams) each began with a piece of coloured paper (orange = staff, space = green, social = pink, system = yellow) and were asked to write one challenge or barrier relevant to that category, before folding the paper to conceal their answer and passing the paper on to the next person. This activity called 'Write-Fold-Share' was inspired by a collaborative art method called 'Exquisite Cadaver' (from the original French term Cadavre Exquis) whereby a collection of words or images are collectively assembled in sequence, which in this case included the additional element of not being allowed to see what the previous person had wrote. At the end of the activity, participants unfolded the paper and played 'Challenge Bingo' to discover the common challenges.

Across the board, the most common perceived barriers to change were a lack of funding, a lack of space, and lack of time for staff to spend with patients. Participants noted that the hospital environment was busy and task-orientated, which limited the time staff had to engage with patients on non-clinical tasks. The Covid-19 pandemic exacerbated existing issues of social barriers and disconnection for patients and their families, with limited car parking and public transport options mentioned.

Physical space, both indoors and outdoors, was a barrier. Participants mentioned small rooms, limited patient and family areas, and that patients were often unable to easily access outdoors areas in beds and recliner chairs.

3.5 Step 5: Idea-Storming—Brainstorming and Formulating Creative Solutions

The second-last activity focused on brainstorming creative solutions, with clinicians provided a handout which instructed them to explore the specific perspectives of Place, People, and Process along the journey from Home-to-Hospital (and sometimes Hospital-to-Home). In groups, participants engaged in this "idea-storming process", developing as many ideas as possible, as illustrated in Fig. 5. Alongside ideas for simplifying and streamlining the admission and communication processes (for example, establishing a single point of access, improving access to patient records and discharge summaries, the clash between electronic community systems and paper-based wards), there were many ideas centred on enhancing the patient journey. Ideas groups proposed included: educating family members about pain medication for home-based care; the potential of an app to aid communication; developing clear, written information and instructions outlining what to expect when transitioning from the community setting to the hospital (i.e. bring your own clothes), while not making any promises (i.e. promising a certain procedure will be done on admission); and improving intake and discharge processes, perhaps by having patients create and share their own 'care history/preferences' summary for clinicians.

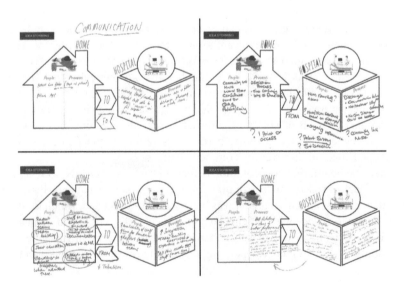

Fig. 5 Idea Storming along the Home-to-Hospital/Hospital-to-Home Journey

3.6 Stage 6: Prototyping and Designing Change

In the final activity, participants were asked to generate and develop one preferred solution from the previous idea-storming phase, developing a name for the solution, alongside detailed descriptions about WHAT the idea is, WHY it is important or needed, HOW it works, and HOW it can be implemented, both in the short-term and long-term. Each group pitched their idea to the group, and were given some large 'fun money' to vote for and invest in their favourite ideas.

Figure 5 illustrates some of the solutions teams developed, from a 'End of Life Suite' to improving admission and discharge processes, to team-building activities. In describing the 'End of Life Suite', this team suggest trialling a family friendly end of life suite with additional rooms (bathroom, lounge, and kitchenette), with a view of a river, away from the noise, for family members to spend quality time with their loved ones at the end of their life. Specific details, as indicated in the sketch, include adjustable air-conditioning and lighting, adjustable partitions for creating flexible spaces, a sound system, pot plants, lamps for a 'homely feel', a kitchenette area with microwave, sink, and fridge, and a play area with games, craft materials, and toys. This space would, they felt, improve access for First Nations and culturally and linguistically diverse (CALD) families, as well as families with young children and for disability access (Fig. 6).

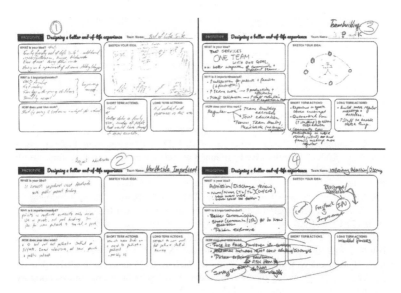

Fig. 6 Prototyping design ideas for a better end-of-life experience

4 Conclusion

Ultimately, co-designing the palliative care experience served as a transformative learning and collaborative team-building process. The process encouraged participants to reflect on their own exceptional care practices and then envision what an ideal end-of-life care experience might look like. The empathy and journey mapping processes reminded participants that providing exceptional palliative care is not solely about clinical interventions but also involves attending to emotional and psychological needs, creating a supportive and inclusive environment, and ensuring individuals and their families feel heard, respected, and valued.

The iterative co-design activities of idea-storming, barrier identification, and prototyping demonstrated the power of collaborative innovation in generating transformative solutions, encouraging participants to think creatively and generate a range of imaginative ideas that could positively transform the palliative care system. These co-design activities intentionally created a psychologically safe space for creativity and collaboration, fostering a dynamic exchange of ideas aimed to shape meaningful and practical improvements in palliative care. Translation and dissemination were a key component of our project. Ongoing operational and Covid-19 restrictions delayed a planned in-person exhibition which was intended to share the co-design processes and findings alongside providing unique visual insight into the palliative care journey by featuring both photographs taken by both participants (a photovoice approach) and a professional documentary photographer including the voices of patients and their families that were not able to be reflected in this paper. An online event is being planned, with these photographs and details on the co-design process and broader project activities and outcomes available on the project website.[1]

References

1. Virdun C, Garcia M, Phillips JL, Luckett T (2023) Description of patient reported experience measures (PREMs) for hospitalised patients with palliative care needs and their families, and how these map to noted areas of importance for quality care: a systematic review. Palliat Med 37:898–914
2. Cohen-Mansfield J, Skornick-Bouchbinder M, Cohen R, Brill S (2017) Treatment and communication–that is what matters: an analysis of complaints regarding end-of-life care. J Palliat Med 20(12):1359–1365
3. Bate P, Robert G (2006) Experience-based design: from redesigning the system around the patient to co-designing services with the patient. BMJ Q Saf 15(5):307–310
4. Palmer VJ, Weavell W, Callander R, Piper D, Richard L, Maher L et al (2019) The participatory zeitgeist: an explanatory theoretical model of change in an era of coproduction and codesign in healthcare improvement. Med Humanit 45(3):247–257

[1] https://research.qut.edu.au/design-thinking-sprints/improving-the-palliative-care-experience/

5. McKercher KA (2020) Beyond Sticky Notes: doing co-design for real—mindsets, methods and movements. Beyond Sticky Notes, Sydney
6. Institute of Medicine (2001) Envisioning the national health care quality report. National Academy Press, Washington, DC
7. Mezirow J (1991) Transformative dimensions of adult learning: ERIC. Jossey-Bass, San Francisco
8. Sudbury-Riley L, Hunter-Jones P, Al-Abdin A (2020) Introducing the trajectory touchpoint technique: a systematic methodology for capturing the service experiences of palliative care patients and their families. BMC Palliat Care 19(1):1–13
9. Page GG, Wise RM, Lindenfeld L, Moug P, Hodgson A, Wyborn C et al (2016) Co-designing transformation research: lessons learned from research on deliberate practices for transformation. Curr Opin Environ Sustain 20:86–92
10. Cooperrider D (2005) Appreciative inquiry: a positive revolution in change. Koehler Publishers, San Francisco

Professor Evonne Miller is Co-Director of the HEAL (Healthcare Excellence AcceLerator) initiative and Director of the QUT Design Lab. Professor of Design Psychology at Queensland University of Technology, Evonne is a leading voice on the value of arts and design-led innovation in healthcare transformation, bringing a collaborative, pragmatic, and fresh interdisciplinary approach to problem solving. She is the author, co-author, or editor of four books, exploring how we can create places that foster planetary and human health.

Distinguished Professor Patsy Yates is the Executive Dean of the Faculty of Health, Queensland University of Technology (QUT). Patsy is a Registered Nurse with extensive experience as a leader in education and research in the health sector.

Dr Sarah Johnstone is a design strategist, at the QUT Design Lab. She specialises in 'designing for diversity', co-design processes, and designing accessible/low-fi creative/arts-based community and stakeholder engagement tools.

Maryanne Hargraves is the Executive Manager, Clinical Development Research & Innovation at St Vincents Private Hospital Brisbane and Northside.

Part IV
Strategists

Designers function as strategic facilitators, empowering and enabling clinicians and consumers to collaborate in reimagining the future and co-designing a sustainable, responsive, and improved healthcare system. To enable others to experiment with co-design, design thinking and futures thinking approaches, the chapters in this section describe, in detail, the methods, approaches, and tools deployed.

From designing new service delivery models to deploying an appreciative inquiry visual communication approach for understanding and communicating organisational change, these projects intentionally expand the array of possibilities available for people wishing to transform healthcare—an approach very much represented in Fig. 1, the box we thought out of.

Fig. 1 The box we
thought out of. (Credit:
Simon Kneebone)

Empathy in Action: A Rapid Design Thinking Sprint for Paediatric Pain—Perspective-Storming, Pain Points, and the Power of Personas

Evonne Miller

Design thinking is a problem-solving approach that places humans at the centre of the process, prioritizing empathy, collaboration, and creativity. It has gained widespread acceptance in healthcare, where design-led approaches and related concepts such as participatory co-design, co-production, co-creation, and co-innovation are regarded as the "new Zeitgeist of quality improvement" [1, p. 247].

There are at least three reasons why design thinking and co-design approaches have become so popular in healthcare: empathy, collaboration, and creativity. Firstly, one of the fundamental principles of design thinking in healthcare is empathy. Empathy means understanding the feelings and experiences of patients, their families, and other stakeholders. It involves 'putting oneself in their shoes' to gain a deep understanding of their needs, desires, and challenges—and then altering and co-designing processes and systems to better meet user needs. Through deep empathic understanding of the challenges and experiences of stakeholders, the argument is that the resulting solutions will be more effective, efficient, and satisfying for everyone involved.

Secondly, the design thinking process provides a framework for collaboration between healthcare professionals, patients, and their families, with this process fostering a sense of ownership and shared responsibility for the solutions developed. Design thinking approaches acknowledge that *'all of us are smarter than any one of us'* [2, pp. 26–27]. Thirdly, the process encourages participants (healthcare professionals, patients, and their families) to be creative—to think 'outside the box' when developing solutions, and then to prototype them, to test and refine solutions in a rapid and iterative manner. There are, as Dell'Era et al. [3] note, four kinds of design thinking: solving wicked problems by leveraging creativity (*Creative Problem*

E. Miller (✉)
QUT Design Lab, School of Design, Queensland University of Technology, Brisbane City, QLD, Australia
e-mail: e.miller@qut.edu.au

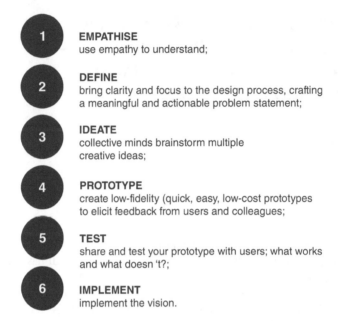

Fig. 1 The six key iterative steps of the design thinking approach

Solving); accelerating the development process to quickly and effectively launch new solutions/products (*Sprint Execution*); engaging staff with new innovation mindsets, approaches, practices, and methodologies that foster innovation and change (*Creative Confidence*), and creating innovative visions that support new strategic directions (*Innovation of Meaning*). The diverse sprints HEAL have run have been a mix of all of these.

As Fig. 1 illustrates, design thinking is a typically iterative approach comprising of six key steps: empathise, define, ideate, prototype, test, and assess (these steps will be described in detail, later in this chapter). The 'magic' of a design thinking sprint is that each of these steps intentionally side-steps existing or traditional solutions in favour of innovative, collaborative, and creative problem solving.

1 This Design Sprint Challenge: Reducing Procedural Pain for Children

This chapter documents the rationale, processes, and value of running a shorter time-condensed (1 h) design sprint focussed on a specific challenge: *how might we reduce procedural pain for children*? Procedural pain is short-lived acute pain associated with medical investigations and treatments, for example from blood tests,

immunisations, IVs/Port access, dressing removals and changes, and nasogastric tube insertions.

As every infant, child, and adolescent will experience pain during their life, four transformative goals have been identified to deliver transformative change in paediatric pain: (1) make pain matter, (2) make pain understood, (3) make pain visible, and (4) make pain better [4]. Many healthcare providers have also committed to *The Comfort Promise,* a pledge to do at least four things (numbing, sucrose or breast-feeding, comfort positioning, and distraction) to lessen pain and fear during procedures. Preventing procedural pain is connected to paediatric medical traumatic stress and trauma-informed care, and can also help reduce staff vicarious trauma (which, unaddressed, leads to compassion fatigue and burnout). And, as Eccleston et al. [4] argue, we must continue to innovate and think differently about pain as *"how much of what we do (or fail to do) now for children in pain will come to be seen as unwise, unacceptable, or unethical in another 40 years?"* (p. 75).

This design sprint on how we might reduce procedural pain for children was held at the Queensland Children's Hospital, during their annual week-long event *Dream Big.* Clinical stakeholders had been working towards reimagining procedural care, and connected with the HEAL team to potentially run a design sprint on this topic. They had three key aims for the session: (1) to understand the experience for children, young people, and their families, and staff who are involved in procedural care; (2) to brainstorm and design ways to achieve optimal (more calm, more comfortable) procedural care for all stakeholders; and (3) to identify the next steps to achieve this. Before describing the activities and outcomes of this specific design sprint, I will first reflect on the origins, role, and philosophical underpinnings of design sprints.

2 Design Sprints—Origins, Role, and Philosophical Underpinnings

The specific design and duration of design sprints approaches varies, from half a day to a week to months. In business, teams engage in co-design sprints that range from half a day to a week (for example, see [5]), working through a series of brief and structured activities designed to facilitate collaboration and creativity, sharing knowledge, skills, and experiences whilst generating new ideas and user-centred solutions in this focused, time-bound period. Given the context of this project—specifically, the existing interest in reducing paediatric pain and the aim to run this sprint during a week-long event with busy clinicians—the decision was made to condense the sprint time down to one intense hour in order to: (1) introduce clinicians to the value of the design thinking processes for seeding innovations and building collaborations; and (2) demonstrate that—with the right structure, design activities, and facilitation, even a 1 hour design thinking sprint can be a positive transformative learning experience.

3 Creating 'Liminal Spaces' for Transformative Learning Experiences

Regardless of the time duration, design sprints and co-design workshops are a power tool for educating and engaging staff with healthcare improvement initiatives. My approach is grounded in an appreciation of Mezirow's transformative learning theory [6] (see chapter "Thinking Differently: Six Principles for Crafting Rapid Co-design and Design Thinking Sprints as 'Transformative Learning Experiences in Healthcare"—[7]), and Meyer and Land's [8] threshold concepts. Meyer and Land developed the threshold concepts framework to convey that a 'crossing over' is needed for certain learning that is critical to a particular discipline, resulting in an 'irreversible conceptual transformation' in learners. The idea is that learners enter a transitional or liminal state, with this learning process both 'troublesome' and 'transformative'. At their best, design sprints are characterized by this liminality—a threshold or transitional moment 'in and out of time', where a new perspective opens. As Matthews and Wright [9] discuss in chapter "Exploring Clinical Healthcare Challenges and Solutions Through a Design Thinking Education Program for Senior Health Professionals" of this book, while non-designers are unlikely to move beyond a 'novice' level of design expertise, the experience may trigger an interest in design-led approaches—and could even transform how participants think or feel or believe. This liminal space is ambiguous and creative, as people try out new ways of understanding and being, reappraising their role and place in the world—and design sprints/co-design workshops provide the perfect place for such experimentation and transformation.

Drawing on an analysis of LEGO serious play workshops on service innovations, Piironen [10] defined collaborative workshops as creating three specific spaces: liminal space (transformative experiences), liminoid space (the experience is enjoyable, as people disengage for everyday routines, but not change-inducing), or everyday space (participants do not engage and/or are cynical during and after the experience). Facilitators, therefore, should be aware of (1) the transitional/transformative nature, while intentionally (2) moving people from everyday space into liminoid and/or, ideally, liminal space—so that they come out with a transformed way of perceiving, understanding, or interpreting a previously held view. As design sprints and co-design sessions involve working with diverse groups, with different ideas that disrupt their usual ways of thinking and challenges people's existing beliefs, assumptions, and perspectives, this process provides a unique opportunity for a shift in perspective, a new way of thinking—that is, what Jack Mezirow [6] would label as a transformative learning experience. With creativity—and associated characteristics of cognitive flexibility, divergent, and convergent thinking—not always adequately developed in formal curriculum [11], participation in a design sprint/co-design session offers healthcare clinicians and consumers a different, liminal space for a potentially transformative learning experience.

4 The Six Steps in This Design Thinking Sprint

In this 1-hour design sprint, participants were introduced to the six-step design thinking process: *Empathy—Define—Ideate—Prototype—Test—Implement*, focused on how to create a pain-free journey for two personas: 5 year old Annabelle (in hospital for a MRI with cannulation) and 16 year old Tiffany (who has a chronic heart condition). The very first step in the design thinking process is empathy, which Daniel Pink [12] memorably defined as 'standing in someone else's shoes, feeling with his or her heart, seeing with his or her eyes' (n.p.). Nursing scholar Theresa Wiseman [13] has identified four key attributes: (1) to see the world as others see it, (2) to be non-judgemental, (3) to understand another's feelings, and (4) to communicate that understanding. In the context of healthcare, the 4-min video *Empathy: The human connection to patient care* [1] powerfully illustrates what empathy means for consumers and clinicians, and often in co-design workshops, a video is created as a tool to trigger deeper understanding and empathy. Participants may also be asked to think of and share the perspective of the target user group, or to conduct research to understand their unique perspective.

At this juncture, it is important to note the importance of creating a psychologically safe space for participation. Design thinking sprints bring together a diverse range of stakeholders to ideate, prototype, and test solutions to complex problems—typically, the pace is intense, people have differing experiences and strong opinions, and there can be conflict, disagreement, and difficult conversations. It is the facilitators' role to create a psychologically safe environment, where all voices, ideas, and perspectives are respected and heard, and creativity flourishes.

For this to happen, the facilitator must clearly set the ground rules for participation, and clearly communicate the process, rationale, and outcomes. This can be as simple as outlining basic rules of respectful communication, active listening, and being open to new ideas, to outlining that a design sprint is about thinking differently, stepping outside our comfort zone, and doing that requires becoming comfortable with uncertainty. It is essential to always respect people's time, by starting and finishing on time—and, ideally, providing food and refreshments. Finally, being clear about the origins and purpose is key: who are the project owners/leaders, what is the process, timelines, and impact: who has ownership of the outcomes? What is the purpose of the day and who will see/action the findings? Participants are tired of ongoing 'fake' consultations, so it is important to be crystal clear about the purpose and how the outputs will be used—in many of these HEAL projects, we have served as outside facilitator for this process, and in fact other people (the clinician team) hold responsibility for taking the outputs forward—and participants need to be clear on the overall project objectives, their role, and where the design thinking sprint sits.

[1] h t t p s : / / w w w . y o u t u b e . c o m / w a t c h ? l i s t = P L 5 q Z Y i p p V H 6 m K r I B J H dy55s-81aYtLiQQ&v=cDDWvj_q-o8&feature=emb_title

4.1 Step 1: Empathy-User Personas and the Empathy Mapping Task

In this design sprint, we started by asked the 50+ participants (sitting at tables in groups of 5–6) to engage with two user personas: Annabelle and Tiffany—see Table 1. User personas are fictional characters that represent the characteristics, behaviours, emotions, and pain points of a specific target user group. By providing a critical reference point throughout the design process, personas are an inspiring, compelling, and memorable driver for change that enable participants to (1) better understand, empathise with, and design for users' unique experience; (2) identify and understand key pain points; and (3) develop creative, innovative, user-centered solutions. Typically, personas are co-designed and research-based, created from interviews, focus groups, observations, quantitative and qualitative data and may, in the medical context, draw on actual situations or cases to trigger the deep reflection and discussion needed to ensure outcomes respond to users' real-world context. Personas can also be created before or sometimes during the workshop. As Stickdorn

Table 1 Two personas—Annabelle and Tiffany

Annabelle 5 years old	Annabelle's family live on the outskirts of Brisbane with 3 children with no other family support. Both parents work full time with financial pressures. Annabelle has experienced significant health concerns since her birth due to a chronic health condition requiring lots of investigations and hospital interventions (needles, MRI scans etc.,) causing significant anxiety for the child and family every time they need to visit the hospital. All of this impacts Annabelle's time at prep and her access to developmental activities. People treat her with care and concern. Annabelle is a very likeable little girl, with interests in crafts, and is very social. While Annabelle makes friends easily, she is more shy and withdrawn around adults.
	The family have had to become health literate, trying to make sense of clinical language and managing appointments. The parents are not tertiary educated so this has been challenging and often overwhelming for them. Mum managed this through support with girlfriends and playgroup whereas Dad is very isolated and angry at the staff if his child is in pain. This experience is stressful for the entire family. The siblings are often placed with friends every time Annabelle goes to the hospital. Annabelle's behaviour is challenging for days after visits to the hospital, including being withdrawn and teary, and not eating. Today she is coming in for an MRI with cannulation. Both her parents will be with her to support her.
Tiffany 16 years old	Tiffany is a high achiever at school. She loves music and is very committed to a band she plays in with friends. She is the only child of her parents who divorced when she was 5. She has lived with a chronic heart condition requiring multiple major surgeries over 16 years. She lives on the Gold Coast with her mum and sees her dad weekly. Her parents work hard to do everything they can to support Tiffany and have done for 16 years.
	Tiffany has had long stays in the hospital and becomes extremely anxious prior to any visits to the hospital. Surgery is often a planned event and her anxiety builds weeks prior to it. She finds it hard to concentrate on her academic work and becomes teary, resulting in sleeplessness and social avoidance. Tiffany's parents find this time stressful also and it often triggers patterns of conflict between the two of them.

and Schneider [14] explain, the value of personas is that they enable a team to all get on the same page—to really build empathy and deep understanding of the needs, tasks, priorities, and experiences of specific user groups. It is this shared empathic understanding that provides a solid basis for action, with some companies even developing life-sized cardboard cutouts of their personas to bring to meetings as a reminder!

Whether it is through personas, empathy, or journey maps, good design always starts with listening, understanding, and deep empathy. A successful design thinking sprint requires preparation and co-creating personas in collaboration with key participant groups (clinicians, consumers etc) who have lived experience of the issue is essential, as well as connecting with any data/statistics. The personas here were developed with clinical teams.

In a different project, focussed specifically on virtual care and remote patient monitoring in the regions, we presented three different personas for the one scenario: a GP, specialist, and a consumer, Anne who had COPD. The persona of Anne so resonated with one consumer during the design sprint that he publicly shared his wife's journey with the group: his wife died in the car outside a regional hospital, was brought back to life, and then spent the next year in and out of hospital (living away from her regional home, in a large city), before receiving a lung transplant. The consumer, Geoff, shared his hope that contemporary technologies might have enabled him and his wife to stay at home, rather than have COPD disrupt their lives. That is the power of a well-crafted persona—it resonates, is memorable, and facilitates the deep, reflective group conversations that fosters the innovation, collaboration and creativity needed to tackle entrenched challenges.

After quickly creating a team name, participants in this sprint were asked to pick one of these two personas (or create their own) and, in teams, collaboratively complete an empathy map about what she would be thinking, feeling, and fearing about her trip to the hospital today for an MRI with cannulation. Empathy maps vary in formats, but typically position the user at the centre of a large sheet of paper, which is decided into quadrants that explores the user's external, observable world, and their internal mindset. In groups, participants discussed the categories outlined in Fig. 2—what does their chosen persona "say, think, do, and feel, and the "pains and gains" from the experience. Each group worked together to complete the worksheet, discussing, and sharing their own experiences, and bringing Tiffany or Annabelle's attitudes, behaviours, and experience to the front of mind. To further create atmosphere, background music from the 1980's teen pop star singer Tiffany was played. As this was a time-constricted sprint, after 5 min creating an empathy map, one group shared their reflections with all.

4.2 Step 2: Define

Step 2 in the Design Thinking process is to define the problem: the definition of a meaningful and actionable problem statement brings clarity and focus—and ensures everybody is clear about the goal. A good problem statement is human-centered and

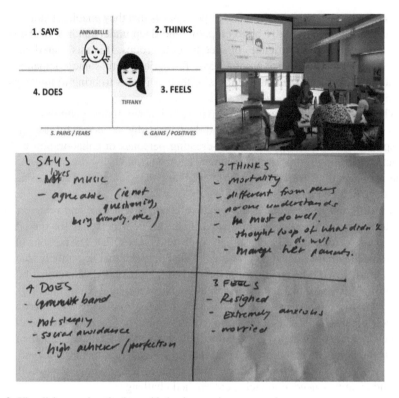

Fig. 2 Visualising user's attitudes and behaviours using an empathy map

user-focused—here the starting problem was how to reduce procedural pain for children, which was refined to be: *how might we create a more comfortable, calm experience?*

4.3 Step 3: Ideate

The third step in the design thinking process is to ideate—to think HMW (how might we) create more comfort and calm for Annabelle and Tiffany, and their families. Here, I added in an extra layer of perspective-taking. As well as asking groups to explicitly think about key touchpoints in the patient's journey (*before, during, and after the procedure*), each person at the table was instructed to advocate for a specific perspective—to think about what could be done to improve the experience

from one of five different perspectives of: *the patient, the family, the staff, the space, and technology.*

This purposeful perspective-taking approach is one I have developed, which I term perspective-storming. It is inspired in part by Edward de Bono's Six Thinking Hats [15] metaphor, where the conceptual wearing of a different coloured hat or perspective enables the wearer to think critically about how to approach a problem. For example, when wearing the black hat, the focus is on being practical and realistic, the green hat wearer embraces creativity, the yellow hat is optimism, and the red hat wearer values intuition.

My colleague Debra Cushing and I have developed an approach we term 'theory-storming' [16, 17], which explicitly encourages thinking about design solutions through different theoretical lenses: for example, *nudge* theory, then *affordance* theory, then *biophilia* theory, and so on. It extends the creative design-thinking process of abductive, divergent, and convergent thinking (in essence, thinking in different ways—abductive is the simplest, most logical exploration; divergent is non-linear, creative, emergent thinking; convergent thinking is narrowing down on a solution) to being guided by *different theoretical lenses.* In the 'perspective-storming' process, participants are encouraged to each 'be the voice' of a different perspective—and in other projects, we have in fact had people wear hats to signify the perspective that they were embodying. Perspective-storming encourages thinking about solutions through multiple different lenses, and helps to foster generative, innovative thinking.

Each group was asked to generate a minimum of 10 ideas in 20 min—with the purposeful perspective taking and rapid pace designed to purposely encourage rapid, innovative, out-of-the box thinking—with teams encouraged to use the phrases of *"I like, I wish, what if".* Teams iteratively shared all their ideas for change with the entire group. A different colour was used for each perspective (e.g., technology was purple post-it notes, space was blue), and teams pinned their post-it note ideas onto large butchers' paper around the room. As well as writing their team name on each post-it, teams noted where in the patient journey—before, during, after (B, D, A)—their idea belonged, as Fig. 3 illustrates. There were five butchers sheets for each perspective (the *patient, the family, the staff, the space, and technology*), and, to help with idea sharing, the facilitators sorted post-it's into rows of "Before/During/After".

After teams had ideated and brainstormed, everyone looked at and read the other groups ideas. Then, using red sticky dots, voted for their favourite: each person had five dots to vote with. This voting process generated much discussion and extended ideas, as participants saw and were inspired by the innovative ideas others had (Fig. 4).

Interestingly, while there is a large literature on group facilitation practices, specific knowledge on how best to facilitate co-design and design thinking sprints is limited. Starostka et al. [18] recently developed a taxonomy of design thinking facilitation, outlining how the approaches they observed in their research were very different—either a method or cofacilitation approach. The two facilitators they observed were very different, doing design thinking (DT) either as (1) *DT understanding*—a set of tools/methods versus a mindset, (2) *DT focus*—on either the

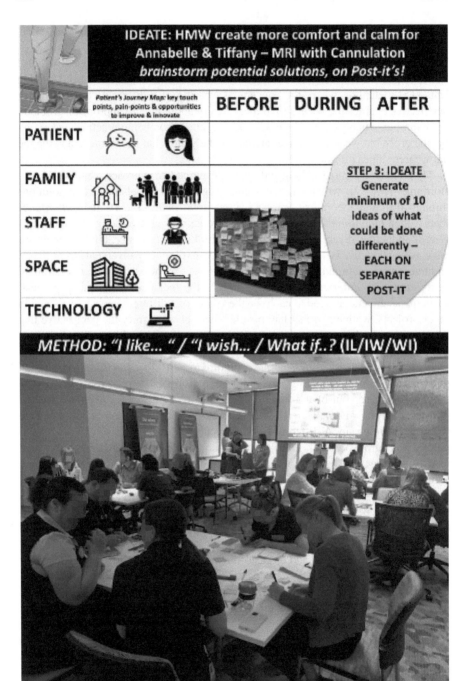

Fig. 3 The ideation task, with guidelines (top), the teams working hard to compete the activity (bottom)

Fig. 4 Sharing ideas and voting for favourites

solution or the problem, (3) *DT process*—a planned or emergent approach to the workshop, and (4) *DT leadership*—the leadership was either individual or shared.

In reflecting on these two very different approaches, Starostka et al. [18] concluded that each approach has specific strengths and weaknesses, and the subsequent success of the DT session really depended on the group's specific characteristics, development, and expectations—that is, DT facilitation practices need to adapt to the context of the group and the project. What is important, as Wrobel et al. [19] have noted, is that as external third parties, facilitators have the capacity "to 'remain neutral' toward the team, its members, and their ideas (in comparison to, for example, a team leader)" (p. 424)—and, indeed, that independence and neutrality was an important component of the HEAL ethos.

4.4 Step 4: Prototype

Having been inspired by the ideas of others, teams were now tasked with generating one preferred solution. Working back in their groups, teams had 10 min to decide on and prototype one solution that they would pitch to the room. It is important to note that a prototype is the tangible representation of an actual idea ([20]—chapter "Prototyping for Healthcare Innovation"). Design prototypes vary in their degrees of fidelity—the level of detail and functionality. Low-fidelity prototypes may be made from paper and cardboard, while high-fidelity prototypes are closer to the final version. Prototypes, Brown [2] reminds us, should "command only as much time, effort and investment as are needed to generate useful feedback and evolve an idea" (p. 19), and so in this situation, the only materials teams had were large markers and paper.

Teams sketched their ideas on butchers' paper, and then presented it the group—in less than 1 min. These solutions were then pinned around the room and participants voted for their favourite—dotmocracy (dot-voting) in action! The quick and simple method of dot voting is a fun way to visually capture the mood, views, and priorities of people in the room. As Table 2 illustrates, participants generated many innovative ideas to increase comfort and calm for kids and families—from

Table 2 Some ideas generated to increase comfort and calm for kids and families

	Before	During	After
Children & Family— Choice, Control & Comfort	**Preparation/Plan**—Develop with child/adolescent and family and CHQ prior to coming. Identify: preferences for staff, rooms, techniques, music etc., low stim or high stim needs; special needs; Interests—music, sport etc.; Options to bring a friend/pet	**Distraction games/ techniques** during procedures – Virtual reality glasses – Mindfulness – Playing with equipment prior	**Presents Box!**
	Preview of team and location to familiarise (virtual or photos?)	**Wearable technology** prior and during to monitor physiological signs (e.g., prompts to adjust analgesia)	**Feedback loop** Check in on afterwards to see how we did and what we can do better
	App, videos, tips provided to kids and families to prepare: Introduce staff to increase familiarity; Tips for parents—what to say and do	**Control** Where possible, kids can play some role in administering their own procedure.	
	Peer mentoring support for preparation		
Spaces	**Carpark**—Virtual or creative journey from carpark to procedural space (e.g., Music, Calm aquarium—touch screens in hallways etc. with fish etc)	**Procedural spaces** (treatment rooms, surgical areas, scanning areas) are calm, comfortable and welcoming: *Art on ceilings; Resource packs set up; Lighting—dimmed where possible; Music; Soft furnishings; Scents—essential oils; Rewards box; TV*	Offer private spaces where indicated for debriefing
	Foyer—Provide familiar faces and spaces as per the app. Music in foyer	**Waiting areas** that are highly comfortable with sensory/ virtual options. High stim versus low stim preferences. Calm spaces, weighted blankets, fleeces beanbags etc	Calm low stimulation retreat areas for recovery. Use Southbank nature spaces for part of the journey
Staff—up-skill and support	A staff member is tasked—**prepare proactively & thoughtfully** for child's arrival eg. Favourite music playing or topic they love eg. Cricket	**No stressful conversations** in front of child. A **Toolkit** for staff: The right words; Listening; Connection to child's emotions; The right questions; The right process; Giving choices (space, equipment preferences etc); The right timing; Distraction strategies; Debriefing techniques	**Debriefing opportunities** for staff

distraction games/techniques during procedures (virtual reality, mindfulness, playing with equipment prior), to redesigning the car park so the journey is calm from the car to the clinical spaces (murals, apps, VR) or tasking a staff member to prepare proactively and thoughtfully for the child's arrival (favourite music playing or screen showing a topic they love, e.g., cricket), as well as extending The Comfort Promise in staff actions.

While there was no time for Step 5: Test or Step 6: Assess, this condensed 1 h design-thinking sprint achieved its aim: it brought together a diverse range of stakeholders from across the hospital to discuss different approaches to managing pain, and generated much energy and enthusiasm for developing, testing and implementing some of the ideas generated. A critique of design thinking is that it simply takes too long, and that its is challenging for staff to renegotiate roles and expectations [21]: our approach shows the value of a condensed version, albeit in the first instance with staff only (participants included clinicians and service providers).

The rapid pace and purposeful perspective taking was designed to encourage innovative, out-of-the box thinking—but I think it is important that design sprints are enjoyable experiences: people give up their valuable time to participate—so they should both learn from and enjoy the experience! Whether it is chocolates, mints, post-it notes on walls and coloured pens and stickers on the tables, large poster-size personas pinned to the walls, or collaborating for the honour winning the infamous "design legend" paper hat (as the prize for the winning idea, I often have on offer a large colourful paper hat that the team leader is photographed wearing, in front of their wining idea), design sprints should foster a creative atmosphere of fun. This helps participants shift from a fixed, analytical approach to the more fluid, creative thinking needed for innovation, accessing the creative, imaginative, intuitive right side of their brain.

From a 1-h design thinking sprint, there was much positive and reflective dialogue, and insightful ideas for purposeful action—which the project teams took forward, to refine and develop further with larger teams of consumers (children, youth, and their families) and clinicians as co-creators of any initiatives. This design thinking sprint served as a powerfully engaging way to connect with, clarify, and mobilize participants' energies and priorities, growing an existing movement for improvement and change in procedural paediatric pain. It also introduced clinicians to design thinking methods, and encouraged the sharing of ideas and knowledge, leading to greater buy-in, support, and more innovative 'out of the box' thinking and solutions. Good design sprints resonate, are memorable, and facilitate the deep, reflective group conversations that foster the innovation, collaboration, and creativity needed to tackle entrenched challenges.

References

1. Palmer VJ, Weavell W, Callander R, Piper D, Richard L, Maher L et al (2019) The participatory zeitgeist: an explanatory theoretical model of change in an era of coproduction and codesign in healthcare improvement. Med Humanit 45(3):247–257
2. Brown T, Katz B (2009) Change by design: how design thinking transforms organizations and inspires innovation. Harper Business, New York
3. Dell'Era C, Magistretti S, Cautela C, Verganti R, Zurlo F (2020) Four kinds of design thinking: from ideating to making, engaging, and criticizing. Creat Innov Manag 29(2):324–344
4. Eccleston C, Fisher E, Howard RF, Slater R, Forgeron P, Palermo TM et al (2021) Delivering transformative action in paediatric pain: a Lancet Child and Adolescent Health Commission. Lancet Child Adolescent Health 5(1):47–87
5. Knapp J, Zeratsky J, Kowitz B (2016) Sprint: how to solve big problems and test new ideas in just five days. Simon & Schuster, New York
6. Mezirow J (1990) Fostering critical reflection in adulthood. Jossey-Bass Publishers, San Francisco
7. Miller E (2023) Thinking differently: six principles for crafting rapid co-design and design thinking sprints as 'transformative learning experiences in healthcare. In: Miller E, Winter A, Chari S (eds) How designers are transforming healthcare. Springer
8. Meyer JH, Land R (2005) Threshold concepts and troublesome knowledge (2): Epistemological considerations and a conceptual framework for teaching and learning. High Educ 49:373–388
9. Matthews J, Wright N (2023) Introducing design thinking for senior health professionals. In: Miller E, Winter A, Chari S (eds) How designers are transforming healthcare. Springer
10. Piironen S (2022) Producing liminal spaces for change interventions: the case of LEGO serious play workshops. J Organ Chang Manag 35(8):39–53
11. Ingram C, Langhans T, Perrotta C (2022) Teaching design thinking as a tool to address complex public health challenges in public health students: a case study. BMC Med Educ 22(1):270
12. Pink DH (2009) Drive: the surprising truth about what motivates us. Riverhead Books, New York
13. Wiseman T (1996) A concept analysis of empathy. J Adv Nurs 23(6):1162–1167
14. Stickdorn M, Schneider J (2012) This is service design thinking: basics, tools, cases. Wiley, Hoboken
15. Ed B (1997) Six thinking hats: an essential approach to business management. Little, Brown & Company, Boston
16. Cushing DF, Miller E (2020) Creating great places: evidence-based urban design for health and wellbeing. Routledge, New York
17. Miller E, Cushing D (2021) Theory-storming in the urban realm: using Nudge theory to inform the design of health-promoting places. J Des Strategies 10(1):112–121
18. Starostka J, Evald MR, Clarke AH, Hansen PR (2021) Taxonomy of design thinking facilitation. Creat Innov Manag 30(4):836–844
19. Wróbel AE, Cash P, Lomberg C (2020) Pro-active neutrality: the key to understanding creative facilitation. Creat Innov Manag 29(3):424–437
20. Chamorro-Koc M (2023) Prototyping for healthcare innovation. In: Miller E, Winter A, Chari S (eds) How designers are transforming healthcare. Springer
21. Donetto S, Pierri P, Tsianakas V, Robert G (2015) Experience-based co-design and healthcare improvement: realizing participatory design in the public sector. Des J 18(2):227–248

Professor Evonne Miller is Co-Director of the HEAL (Healthcare Excellence AcceLerator) initiative and Director of the QUT Design Lab. Professor of Design Psychology at Queensland University of Technology, Evonne is a leading voice on the value of arts and design-led innovation in healthcare transformation, bringing a collaborative, pragmatic, and fresh interdisciplinary approach to problem solving. She is the author, co-author, or editor of four books, exploring how we can create places that foster planetary and human health.

Asking the Right Questions: Cancer Wellness and Stroke Care

Jessica Cheers

"There is nothing more frustrating than coming up with the right answer to the wrong question."
—Tim Brown, IDEO [1]

Imagine you are presented with two questions. The first: how can we support the wellness of cancer patients at the Princess Alexandra hospital? The second: how can we provide Queenslanders with equitable access to timely stroke care? These questions have some similarities—they are both about healthcare, they are both about access, and they both impact the wellbeing of patients. Yet, when an Experience Designer from HEAL was presented with these problems, she approached them very differently. Through these two case studies, this chapter will explore the notion of asking the *right* questions—using design thinking to dig deeper than the initial problem, uncovering the questions, methods, and people that will lead to the right solution.

1 Case Study 1: Cancer Wellness

1.1 The Problem

The conversation around wellness as a crucial compliment to medical cancer treatment is ever-growing. Yet, in Queensland there is currently no public cancer centre specifically designed to holistically treat all aspects of the self—mind, body and spirit. The Cancer Wellness Initiative (CWI) was established by Princess Alexandra Hospital's (PAH) Cancer Services and funded by the PA Research Foundation to "advocate and innovate towards the provision of integrated, streamlined wellness

J. Cheers (✉)
QUT, Brisbane, QLD, Australia
e-mail: j.cheers@qut.edu.au

support to all cancer patients receiving care at the Princess Alexandra Hospital" [2]. Initially, the vision was to establish a physical centre where wellness programs and support could be delivered. However, with the sudden and unexpected wide-spread shift towards online modalities in 2020 due to the COVID-19 pandemic, the team needed to reimagine the service delivery model to meet the wellness needs of people with cancer at the PAH without the ability to provide in-person care.

1.2 The Process

1.2.1 Reimagining

Before the CWI approached HEAL to collaborate, they had already held multiple consumer workshops and begun to scaffold ideas for the design of their service. They had decided to establish a physical centre within the hospital that offered wellness support, creating a website that alluded to this centre. The website was simple, offering information about the initiative and other wellness programs at the PAH. Realising that a brick-and-mortar centre was no longer viable in the foreseeable future, in 2020 they approached HEAL with their vision and journey thus far.

When I first sat down with Jodie Nixon, Elizabeth Pinkham, and Emma McKinnel from the CWI to understand which areas of their service might benefit from a designerly lens, it was clear that the team's aspirations for the initiative had become hazy in the transition from physical to digital delivery. Together we untangled their initial purpose and goals from their imagined outcomes, mapping the future of the service. They reviewed the current online presence, analysed similar platforms, and created personas around the different types of people who the service might cater for. They also began to map the journey of people with cancer—from diagnosis to treatment and long-term care—to understand when and where patients currently needed support. It was immediately clear that their understanding of patient needs was outdated and didn't reflect the current state of their care. They had already begun to imagine the possibility of a digital solution; however, they hadn't asked patients if this aligned with their needs. They needed to re-connect with end-users— people with cancer and patients at the PAH—to better understand if and how their current and emerging needs could be met with an online offering.

1.2.2 Co-designing

The team invited four people with cancer—previous or current patients of the PAH—to the hospital for a co-design session (Fig. 1), exploring their wellbeing needs at various points throughout their cancer experience. It was important that the team didn't pre-empt or assume a need for online resources by asking the wrong questions. Therefore, they developed a new set of questions, including:

Fig. 1 Co-design session

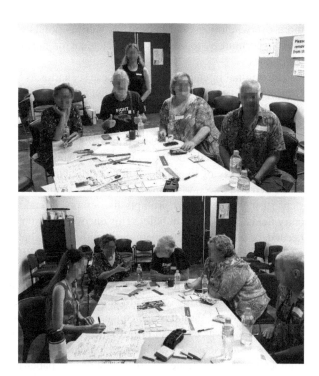

1. Where and how have you sought wellness information in the past?
2. What are the scenarios in which you might want or need wellness information?
3. What would your ideal cancer wellness resource look like? Including:

 (a) What would make this information more beneficial than what already exists?
 (b) How would you like the information to be structured?
 (c) How can we make this resource accessible to you?

The workshop began with an introductory discussion around "Dr. Google" and participants' relationship with online information. Following this, participants were asked to explore *scenarios* in which they have sought or would seek cancer wellness information, creating scenario cards for each and sorting them into four phases: *diagnosis*, *during treatment*, *after treatment*, and *long term*. Scenarios are employed across a number of broader Participatory Design (PD) techniques, for example *Theatre for Design* [3], the *Scenario Oriented Design Game* [4], the *Character game* [5] and *SPES* (Situated and Participative Enactment of Scenarios) [6], as well as in the process of methods like journey mapping. In these scenario-based design methods, scenarios are constructed either around the participants' everyday life or fictitious situations, allowing participants to explore the use of a product, service, or technology, contextualised in a meaningful setting. In this instance, scenarios were used to understand the complexities of all stages of the cancer experience, identifying moments in which participants might seek wellness information. This generated a rich discussion around moments in which wellness information may be

more overwhelming than helpful, as well as points at which people with cancer seek opportunities to regain some element of normalcy and integrate wellness techniques.

The original intention was to use these scenarios as the foundation for a *Scenario Game* [4]—a type of *Exploratory Design Game* in which participants physically act out scenarios. Participants would select a scenario and act it out, using props like computers to demonstrate how they would seek wellness information. However, the discussion generated from the scenarios alone was so rich that this stage was deemed unnecessary. Instead, the group organically shifted into an informal journey mapping process, laying the foundation for participants to explore potential design solutions. Selecting scenarios one-by-one, they mapped out their information-seeking steps, using paper-based prompts like empty Google search boxes, web domain entry fields, and speech bubbles. This uncovered instances where more support was needed, or the current information was either overwhelming or inaccessible.

The next stage of the workshop was inspired by **PICTIVE** (Plastic Interface for Collaborative Technology Initiatives through Video Exploration). PICTIVE was devised as an experimental participatory technique for systems design, with plastic simultaneously referring to the literal plastic pieces offered for explorative making, the malleability of the interface concepts, and the artificiality of the low-level prototypes that emerge as a result [3]. In the PICTIVE process, participants first devise scenarios and discuss the design problem/constraints before being supplied with a number of low-tech materials (office supplies, paper-based mock-ups of interface elements, and tools like scissors and pen) to create low-fidelity mock-ups (prototypes) of design solutions (Fig. 2). Following the session, higher fidelity prototypes are presented back to users for further discussion and testing. The methods used in the co-design workshop were largely inspired by PICTIVE, with some modifications to suit the context. Given the short format of the workshop, much of the PICTIVE process was collaborative, and emerged organically from the discussion of scenarios. Designs were actively tested and critiqued by all participants, and were resolved throughout the workshop to produce a unified vision. Materials consisted of printed paper-based interface elements—for example text fields, drop-down menus, videos etc.—with space for participants to label each element and imagine specifics like the type of imagery, search terms, or length of videos. Participants could also create their own elements, or select from existing photographs or icons.

Following the informal PICTIVE session, the group considered how these solutions might practically meet the needs of the original scenarios, as well as how information could be organised in an online platform to suit all four stages of the cancer experience.

1.2.3 Sensemaking

To make sense of the workshop outcomes and translate them into actionable recommendations, the team went through a process of thematic analysis. Multiple data sources were used, including audio and video recordings as well as tangible

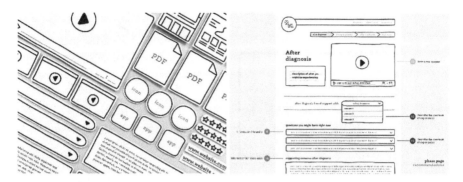

Fig. 2 Low-fidelity prototype

workshop outcomes like scenarios and PICTIVE prototypes. The process of thematic analysis followed a six-phase approach: (1) familiarising ourselves with the data, (2) generating initial codes, (3) identifying themes, (4) reviewing potential themes, (5) defining and naming themes, and (6) producing the report [7]. This analysis formed the basis of a report presented to the CWI team, which included initial goals, documentation of workshop activities, six key themes supported by workshop quotes and related codes, a series of recommendations based on each theme, and preliminary website wireframes.

The following insights emerged from the workshop:

1. Cancer wellness information should be **digestible**
 "We're given so much information at once that it gets overwhelming"
2. Cancer wellness information should be **consistent and reliable**
 "I didn't know until one of the other patients told me about…"
3. Cancer wellness should be presented in a way that is **normalising**
 "I need reassurance that what I'm experiencing is normal"
4. Cancer wellness should be **site-specific** to the PAH
 "I want to know what's happening at the PAH"
5. The platform should support the **shift in mindset** from cancer treatment to wellness
 "In the beginning it was all about the cancer, then my mindset shifted"
6. The platform should **support supporters** of people with cancer
 "Half of the battle was communicating all of this information to "the committee"—my partner, family and friends".

1.2.4 Developing

Over the next 12 months, the Cancer Wellness Initiative website was developed by the team. Clinicians created and organised a wealth of informative wellness resources while the platform was designed and developed. The website was designed from the ground up based on consumer needs. To aid in relevance and **digestibility**,

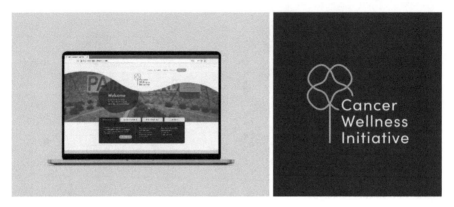

Fig. 3 Website prototype

consumers could order information based on their specific concerns. They could also browse information by stage, whether they were *after diagnosis*, *during treatment*, *after treatment*, or *long term*—accommodating their **shift in mindset**. The information provided was **site-specific** to the PAH, referencing local wellbeing programs and providing resources that were developed by clinicians at the hospital. The team provided resources that people with cancer could give to their family and friends, **supporting supporters**. All information was presented in a way that **normalised** their experience and was evidence-based, so that patients could feel rest assured that it was **consistent and reliable** (Fig. 3).

Alongside the website design and development, a brand identity was created for the initiative, drawing from the existing branding for the PA Research Foundation to communicate familial ties to the hospital.

1.2.5 Evaluating

Once the first iteration of the website had been developed, it was presented back to one of the original co-design participants for usability testing. They provided feedback on the language of the resources and images/icons used throughout, but otherwise felt that the website aligned with their vision and would meet the needs of cancer patients at the PA hospital. Changes recommended by the consumer and clinical team were implemented in the lead-up to the launch of the website.

1.3 Learnings

The key take-away from this collaboration was the importance of engaging with end-users throughout the entire design process, especially when the initial goals change or new limitations are imposed throughout the life of the project. The team

found themselves making assumptions about what people with cancer wanted and needed, and began to re-conceptualise the project based on ideas that didn't accurately represent end-users' current needs, rather than asking questions. Asking the right questions at the right time led to a wealth of insights—enough to build a platform that responded directly to the needs of patients at all stages of cancer. Given the overwhelming over-abundance of cancer information online—let alone general health information—it was crucial to determine if a digital solution was actually wanted and needed. The project resulted in an authoritative, evidence-based, virtual home for patients seeking cancer wellness information, programs and services, which resonated with consumers. Insights from the collaborative process were crucial in ensuring that the CWI platform would be valuable and meaningful rather than tokenistic or adding to patients' feeling of overwhelm.

2 Case Study 2: Stroke Care

2.1 The Problem

The hours following the onset of a stroke are crucial, with each additional minute affecting the viability of treatment and potential for life-long health impacts [8]. However, a person's experience during these critical hours can vary wildly depending on where in Queensland they are and which hospitals they attend. Arbitrary hospital transfers are one of the primary reasons for treatment delays, resulting in diminished quality of life for many patients. Currently, decision-makers within Queensland HHS often do not have a full understanding of the variation that exists across the state, including how each element of the patient journey impacts on the next.

2.2 The Process

2.2.1 Sensemaking

This project had clear goals and parameters from the outset: put simply, the team wanted to comprehensively map variations in stroke care across the State. While the problem of inequitable stroke care affects consumers the most, the source of the problem lies with clinicians and decision-makers across Queensland, who are operating in a complex system without a birds-eye view of how its parts fit together. Mapping the problem wouldn't *solve* the problem of inequitable stroke care, but it was a crucial first step—ensuring that the problem itself was understood.

Knowing that the team needed support to ask the right questions of clinicians and decision-makers and accurately map stroke care, Katherine Jacques from the The Statewide Stroke Clinical Network (SSCN) sat down with me to plan the process.

To truly represent the complexity of the system, it was clear that the team needed to undergo a comprehensive mapping process with multiple stakeholders across several workshops and informal consultations. Beyond this, they would need to create a series of infographics that conveyed the information in multiple levels of complexity, highlighting inequity at a glance while also providing a nuanced picture of the problems at hand.

2.2.2 Stakeholder Workshops

After several initial sensemaking discussions, I produced a rough initial map that was a culmination of all existing diagrams, documents, and insights the team had gathered. The initial mapping was based around a persona, Jenny, who was a 55 year-old woman, from the central Queensland town of Emerald, with type 2 diabetes and Undiagnosed Atrial Fibrillation. While aspects of the persona were fictitious, the data was real—all figures used throughout the mapping were based on patient data collected across Queensland.

The team embarked on four human-centred co-design workshops involving clinicians from across the state, both virtually and in-person. Over the course of these workshops, a comprehensive map was developed, which encompassed every possible scenario that could occur, from the onset of stroke symptoms through to rehabilitation and secondary prevention. The map was exhaustive, even including risk factors and prevention measures prior to symptom onset. All of the clinicians and services involved in each stage were mapped, revealing unexpected questions for paramedics and other clinicians who were contacted as part of the collaborative process. After the most comprehensive map had been developed, a number of simplified maps were created to compare and contrast the care a person would receive under different circumstances. The comparison was profound, with more than a 7-hour difference in the time to initial treatment based on the location of the patient at onset. At several stages throughout the process, the SSCN Steering Committee provided feedback, as did the broader SSCN network at a Clinical Forum.

2.2.3 Outcomes

Seven Infographics were created in total, including one infographic that could be easily broken into individual stages for the sake of presentations that related specifically to one part of the process, for example *imaging*, *transport*, or *post-procedure* care. The final infographics are freely available from the SSCN intranet page to all clinicians across Queensland, for use in their local settings to support and enhance understanding of the variation in existing systems of care for stroke patients, and to assist them in identifying local areas for improvement. These detailed mappings include both quantitative and qualitative impacts on patients and the healthcare system, demonstrating where current practice is not meeting Clinical Care Standards and putting forward a compelling case for change (Fig. 4).

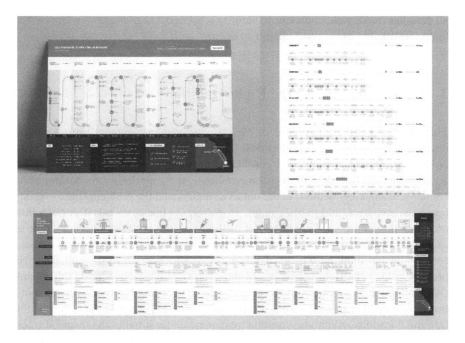

Fig. 4 Infographics used in the project

2.3 Learnings

While the outcome of this project will impact the care that consumers receive when they have a stroke, consumers were not involved in the collaborative process. This was because the problem of inequitable stroke care is a system problem, not a consumer problem, and the best way to solve it was to first understand the system itself by talking to the many clinicians and stakeholders who operate within it day-to-day. Design Thinking brought two things to this process: a series of well-designed, legible, and usable maps with varying degrees of detail; and a collaborative process that asked the right questions from the outset. Asking questions that specifically related to Jenny (the consumer persona) ensured that responses were specific and nuanced, based on real data rather than broad generalisations. Asking questions about each individual health professional involved, from onset to post-treatment, revealed additional unexpected questions, which prompted further consultations. For example, the team contacted a paramedic who explained the exact sequence of events involved in a handover, as well as the number of vehicles typically available in smaller regions. Finally, constantly questioning the presentation of the data and the format resulted in a series of maps that were easy to understand, flexible, and usable. By asking the right people the right questions, this project resulted in the most comprehensive mapping of stroke care in Queensland, which can be used by

all decision-makers and clinicians to identify what needs to change and advocate for the resources that can support change to occur.

3 Conclusion: Asking the Right Questions

This chapter presented two case studies: a consumer engagement project which resulted in the design and development of a cancer wellness website, and a stakeholder engagement project which resulted in the comprehensive mapping of statewide stroke care. Both projects were undertaken by the same designer who employed similar sensemaking methods at the outset to understand the problem space—using personas, scenarios, and journey maps. However, the questions asked through this process led to entirely different project methodologies and design solutions. These examples illustrate that—regardless of a project's context, methods, people, or outcomes—design thinking will always bring a simple strength to the collaborative process: asking the right questions. In the context of cancer wellness, this meant challenging the assumptions of the project team and asking whether a digital solution was wanted or needed by consumers. In the context of stroke care, this meant framing questions around the consumer experience, questioning the nuanced roles and actions of each clinician, and constantly evaluating whether the presentation of the data could be more impactful. Both projects resulted in usable solutions that responded directly to the needs of consumers and stakeholders—the right answers to the right questions.

References

1. Brown T (2009) Change by design: how design thinking transforms organizations and inspires innovation. Harper Business, New York
2. CWI (2020) Queensland Cancer Wellness Initiative. https://www.qldcancerwellness.org/
3. Muller MJ, Wildman DM, White EA (eds) (1994) Participatory design through games and other group exercises. In: Conference companion on Human factors in computing systems
4. Brandt E (ed) (2006) Designing exploratory design games: a framework for participation in participatory design? In: Proceedings of the ninth conference on Participatory design: expanding boundaries in design, vol 1
5. Vaajakallio K, Mattelmäki T (2014) Design games in codesign: as a tool, a mindset and a structure. CoDesign 10(1):63–77
6. Iacucci G, Kuutti K, Ranta M (eds) (2000) On the move with a magic thing: role playing in concept design of mobile services and devices. In: Proceedings of the 3rd conference on Designing interactive systems: processes, practices, methods, and techniques
7. Braun V, Clarke V (2014) What can "thematic analysis" offer health and wellbeing researchers? Int J Qual Stud Health Well-Being 9:26152
8. Tai Y, Yan B (2013) Minimising time to treatment: targeted strategies to minimise time to thrombolysis for acute ischaemic stroke. Intern Med J 43(11):1176–1182

Jessica Cheers is a User Experience designer, PhD candidate at QUT, design educator and all-round playful human. She has an Honours degree in Interactive and Visual Design from QUT, and her PhD is exploring how varying degrees and types of play—from tangible making to games and role playing—might impact both facilitator and end-user engagement with complex healthcare problems.

The Art of Transformation: Enabling Organisational Change in Healthcare Through Design Thinking, Appreciative Inquiry, and Creative Arts-Based Visual Storytelling

Evonne Miller, Sarah Johnstone, and Abigail Winter

Implementing organisational change and transformation in complex healthcare systems is a notoriously difficult process. However, change is a defining feature of healthcare as new policies, technologies, and practices (from models of care to workforce and governing structures, strategy and/or operations) are continually introduced, altered, or retired. In this chapter, we explore the value, processes, and impact of intentionally using design and arts-based approaches to engage clinicians and consumer in a reflexive dialogue about organisational change—in this example, changes to how rehabilitation care was to be delivered.

1 Healthcare Is a Complex Adaptive System, Resisting Linear, Universal Solutions

In reflecting on how best to engage people in change dialogues, it is critical to acknowledge that healthcare is a complex adaptive system: it responds in different and fundamentally unpredictable ways, defined by unpredictability, uncertainty, competing and changing demands, and high levels of interdependence and connectivity [1]. As Greenhalgh and Papoutsi [2] explain, this means—unfortunately—that

E. Miller (✉)
QUT Design Lab, School of Design, Queensland University of Technology, Brisbane City, QLD, Australia
e-mail: e.miller@qut.edu.au

S. Johnstone
QUT, Brisbane, QLD, Australia
e-mail: sarah.johnstone@qut.edu.au

A. Winter
QUT Design Lab, Queensland University of Technology, Brisbane City, QLD, Australia
e-mail: a.winter@qut.edu.au

© The Author(s) 2024
E. Miller et al. (eds.), *How Designers Are Transforming Healthcare*,
https://doi.org/10.1007/978-981-99-6811-4_15

there are no linear, universal solutions or set of methods, arguing that "the conventional scientific quest for certainty, predictability and linear causality must be augmented by the study of how we can best deal with uncertainty, unpredictability and generative causality" (p. 2).

Developing, in part, out of a systems thinking approach, a complexity science perspective emphasises the relationships, interactions, interdependencies and feedback loops between agents and their environments: interventions and changes in healthcare does not occur in a controlled environment. Rather, change occurs in "settings comprised of diverse actors with varying levels of interest, capacity, and time, interacting in ways that are culturally deeply sedimented, and have often solidified" [3, p. 7].

2 Using Appreciative Inquiry and Creativity for Reflection and Projection

In encouraging people to reflect on the present and reimagine the future, our unique approach to co-design thinking sprints draws on an awareness and appreciation of futures thinking, systems thinking, and complexity science, and is also strongly grounded in the strengths-based appreciative inquiry approach. First developed by Cooperrider et al. [4], appreciative Inquiry (AI) is a strengths-based model that encourages change agents to look at people, systems, and their organisation with 'appreciative eyes'. Instead of the traditional deficit-based model of "what's wrong? What the problem?", appreciative inquiry is a strengths-based "earch for the best in people and their organizations.

Purposely using positive questions, such as "What is currently working?" and "What would work best in the future?", a complete appreciative inquiry approach typically follows a four-step, 4D process: Discover, Dream, Design, and Destiny (often starting with a 5th D: Define). As Cooperrider and Godwin [5] explain, what is essential in AI is the respectful and collaborative design approach; after all, "individuals' commitment to change is directly proportional to the degree to which they are engaged in designing the change and that everyone in the system—not just researchers and consultants—are potential 'experts' with valuable insights for the change process" (p. 739).

Interestingly, although design thinking and appreciative inquiry are conceptually aligned, they are rarely explicitly linked. Over a decade ago, however, the originator of AI Cooperrider supplemented it with a new framework that explicitly linked design theory with appreciative inquiry, positive organisational scholarship, positive psychology, and sustainable enterprises. Titled IPOD (innovation-inspired positive organization development), the theory of change underlying IPOD outlined three stages in creating strengths-based organisational innovation: (1) the elevation and extension of strengths, (2) the broadening and building of capacity, and (3) the establishment of the new and eclipsing of the old [5]; for another rare exception linking AI with design thinking, see also [6].

3 Arts-Based Research and Arts-Based Knowledge Translation

Alongside codesign and design thinking workshops which enable people to share their knowledge and insights, imagine the future, and cocreate solutions, creative arts-based approaches are powerfully impactful, engaging, and accessible forms of communication that serve to engage, educate, motivate, and transform. From multimedia digital storytelling to films, theatre, dance, poetry, and photography, there is growing awareness that the creative arts are a powerful tool for (1) engagement; (2) promoting new ways of understanding; and (3) knowledge translation, with the use of the arts to disseminate research-based knowledge termed arts-based knowledge translation [7].

In this project, we used two visual arts-based approaches to engage and educate. Firstly, a professional documentary filmmaker created two short films [1] that captured the local rehabilitation experience from the perspective of clinicians and consumers. Secondly, we deployed a visual story-telling approach to build connections across these dispersed sites; despite working together for years, and being less than a 1-h drive apart, clinicians had limited knowledge about where and how their counterparts worked. As Noel Tichy explains, "the best way to get humans to venture into unknown terrain is to make that terrain familiar and desirable by taking them there first in their imaginations" [8, p. 5401] and we did that here through the visual methods of photovoice and photography.

Gillian Rose [9] has identified three reasons for the appeal of visual methods: they generate rich data; explore 'taken-for-granted' experience; and foster participatory, collaborative approaches to date collection and knowledge creation. Photovoice is a participatory action research strategy, where the camera becomes a research tool: essentially, people are asked to take photographs of a key issue or topic under investigation [10], with these photographs then shared to educate and create change. Alongside participants' photographs, the project also deployed a professional photographer whose understanding of composition and lighting further enabled the creation of aesthetically and visually compelling images, supplementing and complimenting participant's photovoice (see [11] for a discussion of the value of including both photovoice and professional photography in research).

4 The Rehab Project: Part 1, the Co-Design Sprint

The specific focus of this design sprint was exploring how one hospital and healthcare service (connecting six hospitals and health services across 10,000 kilometres) could better activate a smaller (22 bed) rural hospital as a step-down site for the rehab ward at the larger regional hospital. With the surrounding population expected

[1] https://research.qut.edu.au/heal/projects/connecting-rehab-services-across-west-moreton/

to double over the next decade or so (to more than 588,000 by 2036), the broader project focus was on reimaging how rehabilitation was delivered at multiple sites. After visiting both the hospital sites, as well as a community-based facility, the HEAL project team developed and deployed a co-design sprint as a place for reflection, conversation, and creative collaboration, along with an arts-based digital storytelling and photovoice project.

In a 3-hour workshop in March 2021, over 75 clinicians and consumers shared their expectations, hopes, dreams, and fears about the proposed changes to create seamless care transitions between rehab services at the two hospitals, generating ideas about preferred priorities and solutions to the challenge of a growing and ageing population which will increase demand for public hospital services. The first part of the sprint focussed on understanding the system (Activities 1–3), with the last part (Activities 4 and 5), focused on transformation—the guiding question was: *how might we create a positive, seamless rehab journey between these two hospitals for consumers, specifically our personas of Don, Ruby, or Clara.*

4.1 Activity 1: Drawing, Reflecting On, and Sharing a Moment of 'Exceptional Practice'

The first 'ice-breaker' activity in the workshop was for participants to draw a moment of "exceptional practice": a moment when they were engaged, excited, and proud of their work, or (for consumers) experienced exceptional care. Figure 1 shares these sketches: when a patient spoke for the first time in 6 weeks; of taking a patient (after 14 months of in-patient treatment) to visit their rural property for a picnic; the ward Christmas party (bringing staff and patients together to celebrate); or when staff worked to bring a much beloved and missed dog into the hospital to visit its owner. The specific task instructions are outlined below.

- *Recall a special moment of exceptional practice when you were really engaged, excited, & proud of your work. Take 4 min to remember & draw this experience. Add a title, key descriptors (dot points), and your name (optional).*
- *Table Share (3 min): Share your exceptional experience with the group: what were the common themes? Pick one story that illustrates the shared themes.*
- *Joint Analysis (3 min): Each table shares one story to the other groups. As a table respond to the question: what does a great rehab experience at this hospital look like? Write it down on a sheet for the research team to collect with your drawings to pin to the walls.*

Whether it is sketching a self-portrait, a work experience, or initial prototype ideas, the visual language of drawing (1) enables complex and abstract ideas to be communicated in an engaging, accessible, and memorable way and (2) helps create a shared understanding between diverse stakeholders, with the focus on the positive

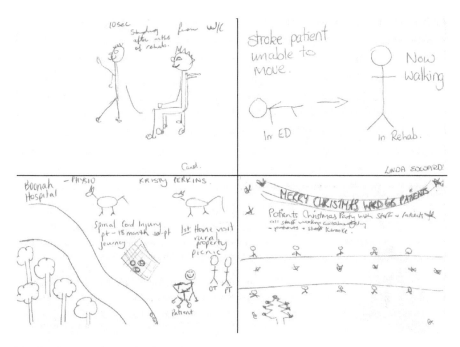

Fig. 1 Moments of exceptional practice

an intentional appreciative inquiry-inspired approach (see [12] for deploying drawing in a research context).

4.2 Activity 2: Empathy Mapping, in Storyboard Comic Form

Continuing with the visual language of drawing, participants were asked to create (draw) a comic strip to illustrate a typical rehabilitation patient journey between two facilities: before, during and after admission to hospital, using one of two provided personas. Table 1 illustrates these: 82-year-old Don (carer for his 78-year-old wife, Ruby, who has diabetes and had a stroke a week ago) or 59-year-old Clara, whose complex medical history and multiple comorbidities included kidney disease, early-stage chronic obstructive pulmonary disease (COPD), and frequent falls. A fall from her mobility scooter led to an infected gash, sepsis, and a stay in ICU, triggering a referral to rehab.

After selecting one of these personas (or creating their own), the groups created a story of transitioning between facilities through the medium of a comic. They were asked to show the best and worst scenarios, along with what patients, their families, and staff "think, feel, and do" as they engage with the rehab system. Participants were shown some examples of comics, and remined that they did not need to be a professional artist to tell a story, but to use drawings and thought clouds,

Table 1 Introducing Don and Clara

Carer Persona	
	Don, Aged 82, Carer for wife—Ruby (78 years). Retirement Village in Brassell, Ipswich. They have two children who live interstate, and 22 year old granddaughter who lives in Ipswich and visits once a fortnight.
	About Ruby:
	Ruby has Type II Diabetes and several other co-morbidities. Her health conditions are managed by her GP at Brassall. She had two toes amputated 3 years ago, secondary to her Diabetes, and walks with a four-wheeled walker. Ruby is quite frail. She weighs 95 kg and is 5′6 (which categorises her as bariatric).
	In years gone by, they participated in some activities on site (i.e., chess & water aerobics) but with Ruby's declining health, this doesn't happen much anymore.

Current Situation: They currently receive home cleaning services once a fortnight and Don provides light assistance with Ruby's showering and dressing. He also completes the domestic duties to the best of his abilities. They receive meals on wheels three times per week.

Don is in good health but is finding his carer responsibilities for Ruby fatiguing and is struggling to safely support her with some of her showering and dressing tasks.

Ruby suffered a stroke a week and 2 days ago and is an inpatient in the Acute Stroke Unit. Ruby can walk with assistance but has right leg and arm weakness (particularly fine motor issues) and difficulty expressing herself (moderate expressive aphasia). She is a candidate for Rehabilitation and the team is currently considering the plan and options for Ruby's ongoing care.

Don has received phone calls from the hospital providing updates on Ruby's care over the last week and a half but is not sure what is all means. He is also feeling lonely and isolated with her being in hospital.

Patient Persona

Table 1 (continued)

Carer Persona	
	Clara, Aged 59, lives alone in parent's original home (built in the 1930s) in the back of Bundamba, QLD. There are five steps at the front and rear of the house and an original claw foot bath (she lies down to wash).
	Clara presents to the hospital approximately every 6 months following a fall or a deterioration at home but has not required any prolonged inpatient stays. In the past, she has been linked to services but once home she has cancelled them because she feels she can manage independently.
	Clara walks with a single-point stick while in her home and uses a mobility scooter to go to the shops for groceries every second day. She attends the local medical centre but doesn't have a GP (they seem to change frequently).

Current Situation: Clara presented to the hospital 3 days after sustaining a gash to her leg from an old fence paling getting on her mobility scooter. QAS transported her to the hospital following a visit to the medical centre. They were concerned the gash had become infected and she was showing some signs of sepsis.

Clara became very unwell while in inpatient and spent 9 days in ICU. She was then transferred to the general medical ward and has been there for 3 days. The treating team are concerned about how much she has deteriorated. While Clara has previously declined services, she is now feeling anxious and concerned about returning home and says this episode has given her a "real fright".

One of the treating doctors has approaches the Rehabilitation Registrar while they were reviewing another patient on the ward and has asked for advice about Clara and her ongoing care.

speech bubbles, and captions to narrate the experience. Comics were pinned to the wall for discussion, with participants using "callout cards" to add scenes or comments to other groups' scenarios. Figure 2 illustrates how, in a playful and engaging manner, the comic strips illustrated key touchpoints in the patient journey.

4.3 Activity 3: Reflecting on the System and Change, with the Fears, Hopes, Myths, Legends Matrix

The workshop continued with a systems analysis, designed to identify and surface deeply-held feelings about the proposed changes. Using separate post-it notes for each category, participants was asked to individually list their *Hopes, Fears, Myths, and Legends*—from two different perspectives: clinicians and patients, as Fig. 3 illustrates. Participants individually wrote and pinned these to the corresponding

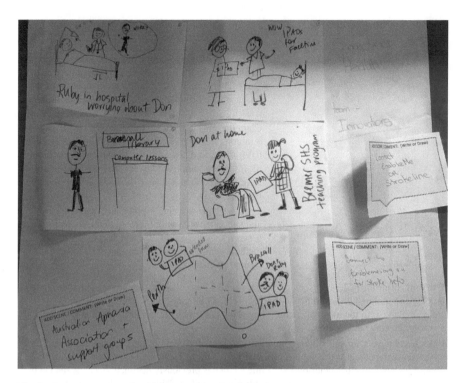

Fig. 2 Empathy mapping, in storyboard comic form

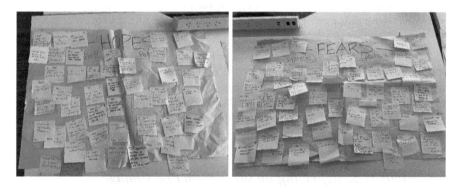

Fig. 3 System analysis matrix, shown here 'Hopes' (left), and 'Fears' (right)

butchers' paper on the wall, before the HEAL team led a quick overview summary of insights back to the entire group.

Hopes centred on maintaining and improving care standards, reducing waiting lists, developing virtual care and for supportive leadership so that "the rehab ward can continue the amazing work that we do". *Fears* highlighted concerns about coordinating care and sustaining quality ("how do I know patients are receiving good

care?"), and of "letting go", and of "change, not being in control, and not been told". *Myths* centred on a handful of common areas, mainly from the clinician perspective: (1) workload—that they would be over-worked due to a lack of resources, (2) patient safety—that patients would fall through the cracks, and "rural hospitals are just for maintaining patients and can't provide all appropriate care", and "will this older facility have the resources?", that "effective rehab cannot be done [just] anywhere", and "we'll have no visibility of the patients"—in other words, trust. Finally, *Legends* (which is a question about what we believe to be true) centred on staff pride and commitment: as the best rehab in the state, a leader in the field, with a great team culture. The value of the Hopes, Fears, Myths, and Legends (HFML Matrix) activity is that it quickly surfaces organisational culture, highlighting cultural norms and values, as well as beliefs and fears about the proposed change—information which provides change leaders important insight into the blocks and barriers that impeding the change, while also identifying the supports and stories that could be amplified and built upon in messaging [13]. Given the strength of emotion around the changes, a stretch afternoon tea break was scheduled after this activity, to provide a physical and psychological break between activities.

4.4 Activity 4: Ideation—Creative Brainstorming, with a 'Perspective Storming' Lens

The last hour or so of the workshop centred on transforming the system, through creative brainstorming (aka, ideation activities). With open, creative and informed mindsets developed from the previous activities, participants now engaged in a creative brainstorming process—to explore what could be done to create a *positive, seamless Rehab journey for Don, Ruby, or Clara*. To spark diverse ideas, each person at the table was instructed to (1) speak from a specific perspective (either as the patient, the carer/family, the staff, the space, the technology, or the communication) and (2) to explicitly consider key touchpoints in the patient's journey map—before, during, and after rehab. The focus here was generating multiple ideas quickly (a minimum of 10 per table), but also to encourage multiple different perspectives—which is why participants were asked to be "the voice" of a specific lens, and to explicitly consider how technology might improve this, and how a space lens might, etc.

This 'perspective—storming' approach is inspired by Edward de Bono's Six Thinking Hats [14] mindset, where people are explicitly asked to mentally adopt a different mindset or 'hat': the yellow hat is the mindset of optimism, the red hat represents intuition, the green hat creativity, and so on. Building on and expanding the thinking hats mindsets, Miller and Cushing [15, 16] developed what they term 'theory-storming', which encourages people to view a built environment challenge through the lens of a specific design theory (e.g., playable design, inclusive design, biophilic design); similarly, in this activity, we explicitly instructed participants to

view and advocate for potential solutions through the lens of a specific perspective, which is why we have termed this approach 'perspective-storming'. The value of such an approach is that enables diverse, divergent thinking, and it is also sometimes easier for participants to share ideas under the guise of what 'technology might do' than framing the solution as their own idea. Ideas were written on coloured post-it notes (a different colour for each perspective—e.g., green for space, yellow for technology), and pinned to butcher's paper around the room. All participants were encouraged to walk around the room, to be inspired by the diversity of ideas all teams generated, and to vote for their favourites.

4.5 Activity 5: Designing Change—Developing and Pitching Your Prototype

In the final workshop activity, back in table groups, participants picked one idea to develop and pitch to the room as a prototype for designing change. The idea could be one they had originally developed, or it could be one they had seen from other groups, or (ideally) an amalgamation of ideas. In the intentionally short time of 20 min, participants were instructed to develop a prototype (a low-fidelity representation of their idea) to show and pitch to the room. They could use whatever method suited them; for example, drawing, the comic form from earlier, or annotating printed maps on their table depicting the two hospitals. The pitches centred on how clinicians ensure the planned changes supported their shared values of providing a quality, effective, and consumer-centred rehabilitation care experience, with two teams proposing a bus service between the two hospitals, with other ideas including developing a suite of digital resources showcasing the care experience and tips for continuing rehab at home. Teams pitched their ideas, with participants voting on the winner. What is significant is that, in a fast-paced 3 hours, fears and hopes about the change were surfaced, alongside ideas to improve the experience—with this feedback providing invaluable insight for management teams leading the change initiative.

5 The Rehab Project: Part 2, Photovoice, Photography and Digital Narratives

Several weeks after the co-design workshop, clinicians and patients at both hospitals were invited to participant in a photovoice project for an exhibition designed to showcase the rehab experience at both sites. Participants asked to take a photograph, with an accompanying narrative story, about something that was meaningful to them about the rehab experience in that location, with a professional photographer and documentary filmmaker also visiting both sites. Figure 4 highlights some of

Fig. 4 Visual images, photovoice, and professional photography, in the exhibition

these images, as well as the exhibition boards in situ at the larger hospital, with the exhibition sharing the photographs alongside the co-design processes and findings. The exhibition was exhibited at both hospitals, with positive feedback.

From the moment of installation, the exhibition had a positive impact and achieved its goals of engaging and education. For example, one of the images is of a small herbal tea garden (comprising of mint, chamomile, lemon thyme etc) in a planter box at the smaller hospital, which clinicians encourage patients to tend for and pick, to create their own fresh herbal drink every morning as part of the 'Boonah Breakfast Club' (as depicted in the right image of Fig. 4). As we were installing this image on the walls of the hospital, clinicians at the larger hospital commented on what a great initiative this was, and how they were not aware this was taking place at the smaller hospital. As intended, the exhibition effectively broke down barriers and facilitated communication and idea-sharing across the two-healthcare setting, while also serving as a powerful reminder of the importance, processes and life-changing impact of rehab. This is demonstrated in middle photograph in Fig. 4 which depicts Linda, the stroke Clinician Consultant shaving a patients face. When taking this photo Linda shared that "it's not always the big things—it's the little things that make me feel like I've made a difference".

6 Conclusion

Both the co-design workshop and visual methods provided opportunities to connect people in an honest, respectful, and transformative dialogue about the possibilities and challenges of change. One of the most important, yet often under-appreciated truths of system change is that it must engage, educate, support, and connect people, because as Rieger et al. [17] explain:

> Transforming a system is really about transforming the relationships between people who make up the system. For example, far too often, organizations, groups, and individuals

working on the exact same social problems work in isolation from each other. Simply bringing people into relationship can create huge impact [17, p. 7].

Our arts-based design thinking processes provided a collaborative, visual mechanism to rapidly explore creative solutions, providing a (1) unique place for clinicians and consumers to connect to discuss the proposed change and strategies to enable quality care, while (2) the visual methods enabled reflection and then new conversations about care practices.

References

1. Plsek PE, Greenhalgh T (2001) The challenge of complexity in health care. BMJ 323(7313):625–628
2. Greenhalgh T, Papoutsi C (2018) Studying complexity in health services research: desperately seeking an overdue paradigm shift. BMC Med 16:95
3. Braithwaite J, Churruca K, Long JC, Ellis LA, Herkes J (2018) When complexity science meets implementation science: a theoretical and empirical analysis of systems change. BMC Med 16:1–14
4. Cooperrider DL, Stavros JM, Whitney D (2008) The appreciative inquiry handbook: for leaders of change. Berrett-Koehler Publishers, San Francisco
5. Cooperrider DL, Godwin LN (2011) Positive organization development: innovation-inspired change in an economy and ecology of strengths. In: Spreitzer GM, Cameron KS (eds) The Oxford handbook of positive organizational scholarship. Oxford Academic, Oxford, pp 738–750
6. Sriharan A, Smith T, Shea C, Berta W (2021) Using design thinking and appreciative inquiry to modernize curriculum and transform student learning. J Health Adm Educ 38(1):285–296
7. Archibald MM, Caine V, Scott SD (2014) The development of a classification schema for arts-based approaches to knowledge translation. Worldviews Evid-Based Nurs 11(5):316–324
8. Tichy N (2007) The leadership engine: how winning companies build leaders at every level. Harper Collins, New York
9. Rose G (2014) On the relation between 'visual research methods' and contemporary visual culture. Sociol Rev 62(1):24–46
10. Wang CC (1999) Photovoice: a participatory action research strategy applied to women's health. J Women's Health 8(2):185–192
11. Miller E (2021) Creative arts-based research in aged care: photovoice, photography and poetry in action. Routledge, Oxon
12. Miller E (2023) Drawing ageing: using participant-generated drawing to explore older australians expectations and experiences of ageing in a retirement village. Soc Sci 12(1):44
13. McCarthy E (2013) The dynamics of culture, innovation and organisational change: a nano-psychology future perspective of the psycho-social and cultural underpinnings of innovation and technology. AI & Soc 28:471–482
14. Ed B (1997) Six thinking hats: an essential approach to business management. Little, Brown & Company, Boston
15. Miller E, Cushing D (2021) Theory-storming in the urban realm: using nudge theory to inform the design of health-promoting places. J Des Strategies 10(1):112–121
16. Miller E, Cushing D (2023) Redesigning the unremarkable. Routledge, New York
17. Rieger KL, West CH, Kenny A, Chooniedass R, Demczuk L, Mitchell KM et al (2018) Digital storytelling as a method in health research: a systematic review protocol. Syst Rev 7(1):1–7

Professor Evonne Miller is Co-Director of the HEAL (Healthcare Excellence AcceLerator) initiative and Director of the QUT Design Lab. Professor of Design Psychology at Queensland University of Technology, Evonne is a leading voice on the value of arts and design-led innovation in healthcare transformation, bringing a collaborative, pragmatic, and fresh interdisciplinary approach to problem solving. She is the author, co-author, or editor of four books, exploring how we can create places that foster planetary and human health.

Dr Sarah Johnstone is a design strategist, at the QUT Design Lab. She specialises in 'designing for diversity', co-design processes, and designing accessible/low-fi creative/arts-based community and stakeholder engagement tools.

Dr Abigail Winter is a results-driven writing specialist, collaborative mentor, and independent researcher, skilled in the analysis of words and data for user needs. Abbe is a researcher trainer, leader, and mentor, with over 20 years' experience in quality assurance, and change and project management. While her PhD focused on what helps workers in higher education cope with large-scale organisational change, and she was part of the small team that created and developed the concept of academagogy (the scholarly leadership of learning), her more recent research has focussed upon professional identity, developing writing skills, and reflective practice.

Thinking Differently: Six Principles for Crafting Rapid Co-design and Design Thinking Sprints as 'Transformative Learning Experiences in Healthcare'

Evonne Miller

In delivering the HEAL (Healthcare Excellence AcceLerator) initiative to ten hospitals and health services across the vast state of Queensland, I have designed and delivered over 30 rapid co-design sessions and design thinking sprints on diverse topics including virtual, connected, and integrated care; planning for the pandemic; reducing procedural pain; and improving patient safety and the care experience. In this chapter, I reflect on and share my process and learnings in the form of six key principles that outline the highs and lows, missteps and mistakes, stories, and lessons learnt.

1 The Value of a Co-design Approach in Healthcare

Co-design, alternatively labelled experience-based co-design, participatory design, co-creation, and co-production, is a collaborative approach to transformative problem-solving that acknowledges, privileges, and increases the participation and involvement of key stakeholders in the design, development, and implementation of solutions (see Vargas et al. [1]) for a detailed discussion of the distinction between co-creation, co-design, and co-production). Best conceptualised as form of participatory action research, in the healthcare context co-design positions consumers (patients) and staff as equal partners working together to improve the experience of healthcare by innovatively re-designing a service, initiative, or product. The experience and voice of patients is prioritized, as we see in Fig. 1—with co-design enabling staff to truly 'see' the patient's experience and place at the centre of quality improvement initiatives.

E. Miller (✉)
QUT Design Lab, School of Design, Queensland University of Technology, Brisbane City, QLD, Australia
e-mail: e.miller@qut.edu.au

© The Author(s) 2024
E. Miller et al. (eds.), *How Designers Are Transforming Healthcare*,
https://doi.org/10.1007/978-981-99-6811-4_16

Fig. 1 "Hey—you're getting me!". (Credit: Simon Kneebone)

While such active engagement with consumers has been described as "the new Zeitgeist—the spirit of our times in quality improvement" [2, p. 247], experience-based co-design (EBCD) emerged from pioneering work conducted in 2007 by Paul Bate and Glen Robert in an English head and neck cancer service. Bate and Robert [3] were the first to advocate for the philosophy and method of experience-based *co-design* (EBCD) in health, arguing that instead of redesigning health systems *around* the patient, services should be co-designed *with* the patient. Key to their participatory EBCD approach [1] was ethnographic storytelling and visual methods (film and photography) to document key experiences and moments (touch points) in

[1] Download the toolkit here: https://www.pointofcarefoundation.org.uk/resource/experience-based-co-design-ebcd-toolkit/

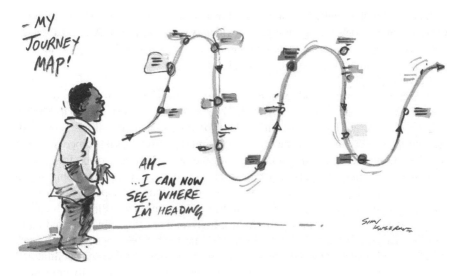

Fig. 2 The patient journey. (Credit: Simon Kneebone)

the patient journey (Fig. 2), with the aim of designing better experiences around these—from redesigning the physical environment to changing logistical or clinical care processes. As Bate and Robert explain, the task of EBCD is to (1) access patient's "unique and precious" personal knowledge of the process, service, product, or system and (2) "utilise it in the service of a better design, and a better experience for the user" [3, p. 24].

Bate and Robert advocated for user experience to become a 'core competency' in understanding and reimaging healthcare, and over the last two decades numerous collaborative health research projects have demonstrated the value, benefit, and specific methods for stakeholder engagement and co-production via EBCD [4]. Typically, these initiatives have been co-led by clinicians and consumers. To date, it unfortunately remains relatively rare to see design professionals sharing this leadership role—which is the focus of this book: to recognise and strengthen what an experienced professional design lens brings to healthcare improvement (see [5, 6]). In this chapter, I will document lessons and reflections on the process of running co-design workshops—what we also often call design thinking sprints—to provide some ideas, inspiration, and resources to those project leaders who are beginning the process and seeking more information on how to facilitate such activities.

2 The Design Sprint—A Time-Constrained Creative Approach

A design sprint is a time-constrained creative approach to idea generation which, at its best, combines the principles of design thinking, innovation, positive psychology, and business strategy. Interdisciplinary teams come together to focus on one

wicked healthcare challenge, and work through the phases of a design thinking cycle to rapidly develop, prototype and (ideally) test solutions. A typical design sprint can range in duration from hours to a day or a week, with Knapp et al.'s [7] Google Ventures approach a 5-day five-phase process facilitating a small group of 5–8 diverse people.

The co-design sprints and sessions I describe in this chapter have a very different flavour, purpose, and structure—typically 2–3 h to a day at most, and up to 80–100 people in the room. Especially during the COVID-19 pandemic, it has been challenging to expect busy clinicians to devote significant time to the process. While true EBCD projects can take months of engagement, there is a place for shorter, focussed events that engage, educate, inspire, and connect. As chapter "Empathy in Action: A Rapid Design Thinking Sprint for Paediatric Pain—Perspective-Storming, Pain Points, and the Power of Persona" in this collection shows [8], when focussed and engaged, even a 1-h sprint can produce high-quality ideas, concepts, and innovations that project teams can take forward to be further developed, co-designed, tweaked, and tested with end-users. As an external university-based facilitator, I tend to pragmatically view these co-design sprints—which are typically embedded in larger projects—as a first critical space for inspiration, excitement, dreaming, and exploring, with the problem owners subsequently taking carriage of the project management and strategic decisions needed to propel the next steps in the process.

3 The Co-design Sprint—A Place for Transformative Healthcare Learning Experiences

While it is relatively well-established that co-design workshops/sprints enable the sharing of ideas and generation of improvement initiatives, an under-appreciated benefit of the type of sprints we run is that they can also serve *as transformative healthcare learning experiences.* Before discussing how a transformative learning experience might look like in healthcare, a reminder that transformative innovation is shifting failing systems so that they are viable for the future. As Leicester [9] explains it, transformation is more than change or improvement: it is a fundamental and intentional systemic shift that is part of a continuous longer-term change process with differing phases (emergence, diffusion, reconfiguration) at different levels in the system (micro, meso, macro; or landscape, regimes, or niches), influenced by mechanisms, processes, and actors, with different personalities, perspectives, priorities, and worldviews. Of course, the transformation process is complex, messy, and imperfect, and requires people becoming comfortable with—not overwhelmed by—complexity. Denning [10] famously explained that:

> Transformational innovation entails a transition from a mode of operating that is known and secure to one that is unknown and potentially chaotic. Transformational innovation requires offering or doing something fundamentally different; a metamorphosis most organizations don't excel at.... Such a shift will never be easy because it puts in question existing strategies, jobs, careers, processes, brands, customers, and culture [10, p. 11].

Healthcare is intensely focussed on innovation, improvement, and transformation, acutely aware of the need to provide value-based care: better, high quality, yet more efficient patient care at a lower cost. As transformational innovation is not easy, Austin [11] argues for an organisational vision that emotionally engages as well as scenario planning that begins in the future, enabling people to imagine and 'step into' multiple alternative futures. Future-orientated co-design sprints and workshops enable participants to look at things in a different way, and thus are an activity that helps to create a future-ready, change-ready workforce. Indeed, the entire co-design and design thinking process, as outlined throughout this book, begins with empathetic engagement with the experience of others, followed by collaborative framing and idea generation, prototyping, and testing.

Designed with reflection and intention, co-design sprints and workshops can serve as a critical transformative learning experience, helping equip and empower participants for the changes facing healthcare. Sociologist Jack Mezirow's *Transformational Learning* Theory [12] argues that adult learners can adjust their thinking based on new information—transformative learning begins when individuals purposely and critically reflect upon and question their assumptions of what they believe to be real, true, or right. By definition, a transformative learning experience goes beyond simple knowledge acquisition as exposure to a disorienting dilemma that challenges typical mental schemas and triggers *a significant shift in an* individual's perspective or attitude.

Mezirow [12] argued this occurs through ten distinctive elements of transformative learning: a disorienting dilemma, self-examination, critical assessment of assumptions, recognition of discontent and identification with similar others, exploration of new options, planning, acquiring knowledge for plans, experimenting with new roles, building confidence, and reintegration into one's life. Alongside having a clear problem to solve (the disorienting dilemma), my primary intent in designing and running any co-design/design thinking sprint is to create a transformative learning experience for participants. This requires intention, planning, and clear communication, and is guided by six key principles, described below.

4 Principle 1: Reflect on Your Facilitator Role, to Be an 'Empathic Provocateur'

I would like to start by considering the role of the facilitator. In planning a design thinking/co-design session, as well as the design literature, there is a large invaluable body of work on the group facilitation process; Heron [13], for example, has identified six dimensions of facilitation: planning, meaning, confronting, feeling, structuring, and valuing, with an associated key facilitative question to consider for each domain:

1. *Planning—How shall the group achieve its objectives?*
2. *Meaning—How shall meaning be given to and found in the experiences of group members?*

3. *Confronting—How shall the group's consciousness be raised about these matters?*
4. *Feeling—How shall the life of feeling and emotion within the group be handled?*
5. *Structuring—How can learning be structured?*
6. *Valuing—How can such a climate of personal value, integrity and respect be created?*

Explicit consideration of such questions means asking oneself: *"if I was a partici-pant, what would I want to see, learn and experience?"* [14, p. 16]—that is, looking at the experience, not from the facilitator perspective, but from the participant per-spective. Jones [14, p. 16] recalls being told by one person how they were in a staff meeting and knew there were 84 ceiling tiles and 24 fluorescent lights in that meet-ing room: you do not want to design an experience like that for your participants!

In contrast, the best design sprints serve as transformative learning experiences. The best facilitators, Mezirow reminds us, should act as an "empathic provocateur" moving between affirming and questioning, intentionally shifting, disorientating, and transforming participants' frame of references: "encouraging participants to face up to contradictions between what they believe and what they do … and dis-crepancies between a specific way of seeing, thinking, feeling and acting and other perspectives" [12, p. 366]. As an "empathic provocateur", our words and actions challenge and reframe participants' frames of reference—and shape the co-design/design thinking experience. From the facilitator's perspective, Judi Apte [15] has developed four helpful rules for facilitating transformative learning, and argues that each session should: (1) confirm and interrupt current frames of reference; (2) work with triggers for transformative learning; (3) acknowledge a time of retreat or dor-mancy; and (4), finally, develop the new perspective.

In designing a co-design/design thinking session, it is helpful to remember, as Peter Senge [16] reminds us, that generating change is about creating creative ten-sion: the gap between the vision (what we want to create, our aspirations; the way things could be) juxtaposed against the current reality (the truth; the way things are). Senge [16] encourages us to imagine a rubber band stretched between our vision and current reality: when stretched, this rubber band creates tension—and the only way this can be resolved is to be pulled, either towards the vision or reality. Whichever occurs, Senge [16] argues, depends on whether we hold steady to the vision—and the co-design/design thinking process can be a powerful tool for gen-erating support for that vision.

5 Principle 2: Embrace an Appreciative Inquiry—Inspired Approach by Sketching a 'Positive Moment'

A defining feature of my design sprints is that we get right to work; perhaps in con-trast to other facilitators, I rarely have people formally introduce themselves to the entire group, instead we dive straight into the creative design process. I typically

start with an appreciative inquiry—inspired approach—see chapter "The Art of Transformation: Enabling Organisational Change in Healthcare Through Design Thinking, Appreciative Inquiry, and Creative Arts-Based Visual Storytelling" [17], asking participants to recall and then sketch a moment at work when they felt inspired and at their best; a 'positive, inspiring moment'. Participants label and describe their sketch, also signing it if they wish. These sketches are then shared at tables, with a few shared with the broader group—this process of recalling, drawing, and then sharing positive moments creates an energising buzz, creating a positive energy and start. It is also a wonderful way to remind participants that the workshop is not about perfection, but about communicating and developing ideas.

Figure 3 shows some of these images from recent sprints—participants drew patients when they achieved health rehabilitation goals (standing or walking for the first time), when service or health system changes had a positive impact (accessing rehab services over the weekend), or how they had successfully implemented changes that boosted morale (a weekly online Teams meetings, where each member shared a win), with the honest, authentic character of these sketches resonating. The art and process of sketching helps participants better explore, explain, and envision concepts and ideas, playing a critical role in stimulating collaborative group reflection and dialogue (see Miller [18], for an exploration of using drawing and sketching in a research project focused on creatively depicting hopes, fears, and expectations of ageing).

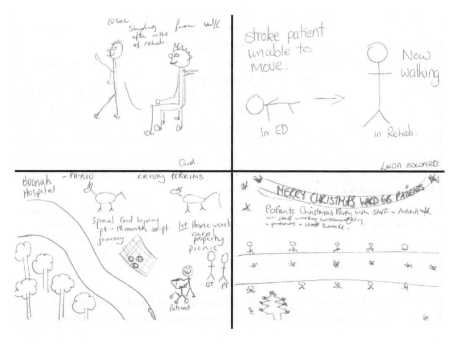

Fig. 3 Sketching a 'positive, inspiring moment at work'

Fig. 4 Headline exercise examples

Sketches are then pinned to the wall, creating a powerful visual wall of positive moments. In one session, a participant shared they had once coordinated a similar reflective drawing activity and the power of these sketches meant they subsequently formed the cover of their organisation's annual report. What is clear is that this process of thinking and communicating visually is an enjoyable way to commence a codesign sprint/workshop, enabling people to distil and communicate what motivates them very clearly, quickly, and memorably. Sketching is a critical component of the design and design thinking process [19], which is why the idea pitching process in HEAL projects frequently had participants craft a media 'headline' (newspaper, magazine, or online) simply conveying their concept idea alongside an illustrative drawing, as in Fig. 4, towards the end of each session.

This pitch process is an important component, as this is where participants can convince others of the value, impact, and importance of their idea—and that the organization should commit time, resources, and money to it. The best idea pitches are compelling: they have a memorable name, concept, and slogan, typically starting with an empathetic story (linked to the consumer voice or persona) illustrating the challenge and the proposed transformative solution. A quick note here on the quality of ideas. As management guru Peter Drucker [20] pointed out, more than 30 years ago, we must remember that we are often poor judges of the potential impact of an innovative, game-changing ideas:

> In the innovative organization, the first and most important job of management is…to convert impractical, half-baked, and wild ideas into concrete innovative reality…. Top management, in the innovative organization, knows that new ideas are always 'impractical.' It knows that it takes a great many silly ideas to spawn one viable one, and that in the early stages there is no way of telling the silly idea from the stroke of genius. Both look equally impossible or equally brilliant [20, p. 540].

Participants will then typically rank the proposed solutions on different criteria (is it doable, timely, sustainable, transformative, impactful etc), with one project developing and using a four R rating scale which asked: is the idea *radical* (disruptive potential); *relevant* (momentum in the system); *realistic* (in a resource constrained environment) and *resilient* (sustainable)? Increasingly, I have asked groups to

collaboratively rank and allocate large 'fake' Monopoly—style money to their preferred ideas, as Fig. 4 illustrates.

Over longer sprints/workshops, participants can develop and share more sophisticated prototypes illustrating their pitch; for example, in a 3-day design sprint during Singapore Design Week 2022, focussed on medication management for seniors, one group brought in a pineapple on banana leaves to illustrate their concept of food as medicine while another presented their idea in song and a third developed more sophisticated prototypes of their app idea. A well-presented pitch and prototype enables people to emotionally connect with and remember the idea, but as Brown [21] astutely reminds us, prototypes "should command only as much time, effort, and investment as are needed to generate useful feedback and evolve an idea" (p. 19). As audiences increasingly have shorter and shorter attention spans, sketching remains a powerful tool for clearly and compellingly connecting people with alternative visions. There is magic in sketching, for the process of turning internal thoughts, feelings, and thinking into a tangible and visible drawing provides critical perspective and distance from the problem [22].

6 Principle 3: Purposely Surface, Don't Dodge, the Hard Stuff

While it can be tempting to focus on the more exciting and positive process of idea generation, often the topics discussed may be contested. If that is the case, then engaging in structured activities that surface people's worries and fears is worthwhile. The activity I like to use is entitled: *Hopes, Fears, Myths, and Taboos*—what I call a HFMT Matrix. Ask people to silently, individually, complete a separate post-it note for each hope, fear, myth, and taboo (things people know but cannot say) about the proposed change, and to then put the post-its on the appropriate butchers paper on the wall. I often ask participants to complete this task from two different perspectives: staff and consumers, and to write an S or C in the corner of the post-it. Tables may choose to discuss these issues, or to move to the next phase: using sticky dots to indicate the issues they agree with most. The facilitators might choose to group these, or simply to call out the top few issues for a group discussion. The HFMT Matrix is a powerful tool for surfacing and discussing simmering issues, and can provide leadership teams with some deep and tangible insight.

7 Principle 4: Amplify Consumer Voice—Storytelling, Personas, and Empathy Maps

Often the most memorable and transformative components of co-design is when clinicians learn from and collaborate with consumers, who bravely share their most personal of experiences to help improve the system for others. While it is ideal to have consumers engaged to directly share their experience, the reality is that the

honest sharing of personal health challenges in public forums requires significant engagement, energy, and courage; therefore, instead of and/or alongside the direct voice of consumers, personas (fictional characters) are a critical component of design sprints/workshops. Ideally, personas are research-based, created from workshops, interviews, observations, quantitative and qualitative data, or, in the medical context, drawing on actual cases to trigger deep reflection and discussion, helping ensure any initiatives are connected to the real-world context.

HEAL project personas have typically been developed collaboratively, with consumers and clinicians, with this process taking significant time and attention. Table 1 shows how, in one project, we worked with ten consumers to craft three distinct personas and scenarios that were a representative composite of their experiences—and during the workshops, one consumer presented each persona to the large group, who then re-designed the experience of healthcare for Mae, Skylar or Will. Good personas will ring true, so that in the discussion of them, the characters and situations resonate, enabling us to imagine, and step into the shoes of another—to have empathy and use that empathetic imagination to guide our actions. By serving as archetypes, personas assist with strategizing and communicating, and are critically important in the first step of the designing thinking process (Empathize), where participants are asked to complete an empathy or journey map.

In a different project focussed specifically on virtual care and remote patient monitoring in the regions, we presented three different personas for the one scenario: a GP, specialist and a consumer, Anne, who had COPD. The persona of Anne so resonated with one consumer in the workshop that he publicly shared his wife's journey with the group: his wife died in the car outside a regional hospital, was brought back to life, and then spent the next year in and out of hospital (living away from her regional home, in a large city), before receiving a lung transplant. Geoff shared his hope that contemporary technologies might have enabled him and his wife to stay at home, rather than have COPD disrupt their lives quite as much. Whether it is through personas, empathy maps or the powerful narratives of real-life consumers, good design—and good healthcare—always starts with listening and deep empathy. Sometimes the first empathy task in a workshop might be for participants to select and co-create their own persona and develop a scenario that works from their own lived experience.[2]

[2]Access the worksheet for this activity from the design thinking projects, from qut.design.

Table 1 Co-creating personas and scenarios with consumers

Persona & Scenario 1: Mae—and the GP-specialist referral pathway in the regions	67 year old Mae lives in Tambo, a small rural town on Dharawala land about 3.5 h away from Longreach and 12 h from the closest hospital in Rockhampton. Mae has had a hard time establishing a relationship with a GP over the years, with what feels like a constant revolving door of clinicians in Tambo. Her care has been very fragmented, having to travel long distances and bouncing between GPs and specialists—only to find her records were lost or delayed in the transfer between the GP and hospitals. Mae has osteo-arthritis, is pre-diabetic and overweight, and had knee replacement surgery 3 years ago. After spending months on a waiting list, she travelled the 12 h to Rockhampton for her first specialist appointment—only to be told by the orthopaedic surgeon that she needed to lose weight before being considered for the surgery. Mae is now experiencing pain in her other knee and is concerned this knee may also need to be replaced. Given the months of appointments, rehabilitation, and recovery last time, she wishes the process was simpler and there were other options. *If we were to positively transform and improve Mae's healthcare experience, what would this interaction with her GP and her pathway from primary to secondary care look like?*
Persona & Scenario 2: Skyler—and smoother transitions—from in-patient to at-home care	19 year old Skyler is neurodivergent, with Autism Spectrum Disorder and a history of depression. They identify as non-binary. They have been in and out of hospital for the past 18 months, with fatigue, headaches, dizziness, slowed thinking ('brain fog'), pain in muscles and joints, along with anxiety and depression—and while there is some disagreement, the main diagnosis appears to be long-Covid. Skyler has been in a large urban hospital for the past week. The environment—noises, lights, smells, and procedures—has aggravated their ASD, and they have experienced a lot of system-imposed stress. Previously, they have been misgendered by health professionals and had major difficulties changing their name in the hospital system. They are technology-savvy, and they are wondering if maybe technology could monitor or connect them better with different specialists—but who should they talk to? How can they better manage and monitor their physical and mental health, and connect with the community support systems out there. *What could be changed to positively transform and improve Skyler's transition from in-patient to at-home care?*
Persona & Scenario 3: Will—unwell, at home, at night	Will is 15 years old. After coming home from school, he has had a worsening headache. After dinner, he informs his parents Saki and Takehsi that his headache is now quite severe. He is upset and in distress. His parents are not exactly sure where to turn for advice—as their GP clinic was closed, they did a quick google search on headaches in adolescents. At 8 pm, they rang 13 Health who reassured them about how to monitor the situation, however Will's headache is worsening. It's a cold evening and the local emergency department is known to be very busy—they rang the after-hours doctor, but the predicted wait time was 3–4 h. At 10 pm, Saki and Takehsi take Will to the emergency room; he speaks to the triage nurse who performs a review and asks them to take a seat in the waiting room. *Where and how can we re-design the after-hours healthcare experience and pathways?*

8 Principle 5: Holding Space for Engaged, Meaningful, and Creative Conversations

Whether it is an incremental shift in thinking or radically new ideas, co-design sprints offer invaluable space, time, and air for teams to reflect, share thoughts, feelings, and beliefs, to co-create and imagine, and to have engaged and meaningful conversations about the very real wicked problems they face. All facilitators have a different approach and style, but what distinguishes a design sprint/workshop from other gatherings is that it follows a 'designerly' future-focused, inspiring, visual, and practical methodology. As facilitator, it is your role to provide a psychologically safe space where creativity, collaboration, and innovation can thrive. This is not easy, as you must balance different and dominant personalities, interpersonal power dynamics, and internal politics and agendas.

Thoughtful and inclusive facilitation, however, proactively manages any dissent and moves the group forward. Rehearsing potential answers to challenges is helpful, as is proactively monitoring teamwork processes and group mood to minimise people being disengaged and distracted by "dissent, inertia, resistance, or criticism" [23, p. 128]. Having chocolate on the tables helps, as does remaining engaged your facilitator role—to help keep participants authentically engaged in the process, you must remain alert, watchful, and truly present. This means actively listening and 'floating' across the different individuals and table groups, listening, engaging, supporting, directing, and redirecting groups, as appropriate.

In reflecting on the facilitation process, I am reminded of a common saying in tertiary education: 'from sage on the stage to the meddler in the middle', which essentially reframes the role of teaching from presenting/lecturing from a lectern to being actively co-learning on tables with students. Facilitation is similar, in that you must 'float' across groups, to help ensure they are listening to, learning from, and building on the ideas of others.

As a facilitator, you must also clearly communicate the day's agenda, processes, and outcomes, and keep a close eye on the clock: do not disrespect people's time and busy schedules by going over time. You must start and finish on time, and that may mean adjusting your planned schedule. For example, at a recent full day co-design sprint, we intended to have the afternoon focussed on developing and then pitching improvement ideas. Our original intent was to ask teams to apply the SCAMPER technique as they developed their idea from seven different perspectives about what could be: Substituted, Combined, Adapted, Modified/Magnified, Purpose, Eliminated, and Rearranged/Reversed (SCAMPER). However, this group was finding the process of generating creative ideas challenging enough, and so we decided on the day to not undertake the SCAMPER activity, and instead to allocate more time on idea generation and development. HEAL projects typically developed and use large pre-populated handouts, known as a design canvas, which groups completed, which is easier logistically than blank butchers paper when working with larger groups.

As facilitator, you should also build in a critical and self-reflective review process after each codesign sprint/workshop, asking: *what did we learn, what worked well, what did not, and where to next?* Consistent with this open spirit of reflection

and improvement, HEAL has been characterized by an intentional focus on open innovation [24], which means that where possible all the processes, outcomes, reflections, and resources, (including videos) are freely available online for others to access, [3] facilitating the sustainability, scale, and spread of our approach.

9 Principle 6: Make the Experience Memorable, by Engaging with the Peak-End Rule

Finally, a thoughtfully-designed session that results in a transformative learning experience is one that—in its construction—has paid close attention to participants' experience and the peak–end rule, a psychological heuristic in which people judge an experience based on how they felt at their 'end' and its most intense point—the 'peak'. The session needs to create multiple opportunities for participants to be 'wow-ed' by hard-hitting memorable moments and then finish with a 'peak-end' experience—typically, the final idea pitch and voting process serves as an emotionally engaging peak-end experience, and I will then summarize the journey and activity outcomes on the walls and tables surrounding us.

As Daniel Kahneman [25] explains in his work on cognitive biases, people have two types of "selves": the 'experiencing self' who is living in the moment, and the 'remembering self', who looks back and 're-narrates' the experience. As the facilitator, your focus needs to be on creating such moments—whether it is the HFMT Matrix, the appreciative inquiry sketch, the empathy created from the personas, or the hum of energy generated as participants brainstorm diverse ideas, develop, and share their pitch. As HEAL projects have been collaborative, at the end of the sprint, the project owners (clinicians and project managers) we worked with to formulate the focus, activities, and objectives have the core responsibility to integrate the knowledge generated into the broader organization; typically, a report is compiled and ideas selected to continue for further development.

10 Conclusion

Running a good co-design sprint/workshop, and crafting a transformative learning experience, requires thought and intention. Well-crafted co-design sprints and workshops provide a safe space for inter-professional shared learning, for people to connect with diverse others, to question and challenge long-held assumptions, to reflect, and to explore and share different ways to tackle the wicked challenges facing healthcare. To thrive in today's VUCA (volatile, uncertain, complex, and ambiguous) world, people must become 'change-ready'—as futurist Alvin Toffler [26] explained, the illiterate of the twenty-first century will not be those who cannot read or write, but those who cannot learn, unlearn, and relearn.

[3] Visit: https://research.qut.edu.au/heal/

Such transformation does not just magically happen. I argue that the iterative processes of exploring, explaining, and envisioning that occurs inside good co-design sprints/workshops provides the perfect transformative space for unlearning and relearning. Such questioning, reflecting, learning, relearning, and transformative change is often uncomfortable but required for transformative innovation. I end this chapter with a poem (from [23, p. 130]) which shows how, at their best, participatory co-design sprints/workshops really can be powerful transformative learning experiences that foster creative innovation and thinking differently—we are transformed; not "the same coming out as we were going in" [23, p. 129].

Out there in the air,
there is a field where fresh ideas come and go.
Joining, we start to move with new frequency in relationship with ourselves,
with others, and even the field itself.

Moving more freely, we see new things;
and the old, familiar views, a-new.
This opening, this broad space, is the place of letting go,
of running, where so much is born.

We see a beautiful, broad field in red-orange-yellow.
We've entered this broad space, by design.
Leaving all we know behind hoping to find what we are looking for:
Big thinking, brainstorming, ideation.
Rhythm. Relationship

It is in this open, seemingly boundless place,
that things often get too open.
Too loud, too fast, too loose.
A little … wild.

References

1. Vargas C, Whelan J, Brimblecombe J, Allender S (2022) Co-creation, co-design, co-production for public health: a perspective on definition and distinctions. Public Health Res Pract 32(2):3222211
2. Palmer VJ, Weavell W, Callander R, Piper D, Richard L, Maher L et al (2019) The Participatory Zeitgeist: an explanatory theoretical model of change in an era of coproduction and codesign in healthcare improvement. Med Humanit 45(3):247–257
3. Bate P, Robert G (2007) Bringing user experience to healthcare improvement: the concepts, methods and practices of experience-based design. Radcliffe Publishing, Oxford
4. Slattery P, Saeri AK, Bragge P (2020) Research co-design in health: a rapid overview of reviews. Health Res Policy Syst 18(1):1–13
5. Ku B, Lupton E (2020) Health design thinking: creating products and services for better health. MIT Press, Cambridge, MA
6. Nusem E, Straker K, Wrigley C (2020) Design innovation for health and medicine. Springer, Singapore
7. Knapp J, Zeratsky J, Kowitz B (2015) Sprint: how to solve big problems and test new ideas in just five days. Simon & Schuster, New York
8. Miller E (2023) Empathy in action: a rapid design thinking sprint for paediatric pain—perspective-storming, pain points, and the power of personas. In: Miller E, Winter A, Chari S (eds) How designers are transforming healthcare. Springer, Singapore
9. Leicester G (2020) Transformative innovation, 2nd edn. Triarchy Press, Axminster

10. Denning S (2005) Transformational innovation: a journey by narrative. Strateg Leadersh 33(3):11–16
11. Austin J (2018) Transformative planning: how your healthcare organization can strategize for an uncertain future. Health Administration Press
12. Mezirow J (1991) Transformative dimensions of adult learning. Jossey-Bass, San Francisco
13. Heron J (1999) The complete facilitator's handbook. Kogan Page, London
14. Jones ML (2021) Mastering facilitation: a guide for assisting teams and achieving great outcomes. CRC Press, Boca Raton
15. Apte J (2009) Facilitating transformative learning: a framework for practice. Aust J Adult Learn 49(1):169–189
16. Senge PM (1990) The fifth discipline: the art and practice of a learning organization. Doubleday, New York
17. Miller E, Winter A (2023) Connecting rehabilitation teams: a design-led, arts-based and appreciative inquiry inspired approach to organisational change in healthcare. In: Miller E, Winter A, Chari S (eds) How designers are transforming healthcare. Springer, Singapore
18. Miller E (2023) Drawing ageing: using participant-generated drawing to explore older australians expectations and experiences of ageing in a retirement village. Soc Sci 12(1):44
19. Hoffmann AR (2020) Sketching as design thinking. Routledge, London
20. Drucker P (1973) Management: tasks, responsibilities, practices. Harper & Row, New York
21. Brown T, Katz B (2009) Change by design: how design thinking transforms organizations and inspires innovation. Harper Business, New York
22. Agerbeck B (2016) The idea shapers: the power of putting your thinking into your own hands. CreateSpace
23. Neal P, Neal C (2011) The art of convening: authentic engagement in meetings, gatherings, and conversations. Berrett-Koehler Publishers, San Francisco
24. Chesbrough HW (2003) Open innovation: the new imperative for creating and profiting from technology. Harvard Business Press, Boston
25. Kahneman D (2012) Thinking fast and slow. Penguin Press, London
26. Toffler A (1970) Future shock. Random House, New York

Professor Evonne Miller is Co-Director of the HEAL (Healthcare Excellence AcceLerator) initiative and Director of the QUT Design Lab. Professor of Design Psychology at Queensland University of Technology, Evonne is a leading voice on the value of arts and design-led innovation in healthcare transformation, bringing a collaborative, pragmatic, and fresh interdisciplinary approach to problem solving. She is the author, co-author, or editor of four books, exploring how we can create places that foster planetary and human health.

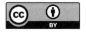

Part V
Instigators

This section focuses on how designers are instigators, and as such, are widely sharing their design process, mindset, and methods—as Fig. 1 illustrates. It is this openness and generosity of spirt that really distinguishes the HEAL design team; from developing and sharing design thinking resources to mentoring and working closely with interested stakeholders from diverse disciplines, the focus is on sharing our message that the design process offers a fresh way of thinking that has significant transformative potential for healthcare.

Fig. 1 I have a visitor?
(Credit: Simon Kneebone)

Bringing the University to the Hospital: QUT Design Internships at the Queensland Children's Hospital Paediatric Intensive Care Unit (PICU)

Anastasia Tyurina, Abigail Winter, and Leighann Ness Wilson

This study explores two phases of a Work Integrated Learning (WIL) Industry Partnership program, which was facilitated through a Tier 2 Research Centre project at the QUT Design Lab. The WIL Partnership program exposed QUT undergraduate design students to a healthcare setting and gave them the chance to collaborate with QUT researchers and healthcare professionals at the Queensland Children's Hospital Paediatric Intensive Care Unit (PICU) in Brisbane, Australia as part of the HEAL PICU Partnership Project. The QCH PICU Partnership Project started in November 2020 conducting family and staff engagement and storytelling to guide the future development of visual communication, wayfinding, and interior design solutions. The project's goal is to offer family-centred care by allowing families to be fully involved in their child's hospital care, and work as equals with staff to achieve the best results for the child, family, and hospital [1].

This research explores the impact of participating in a practical healthcare project on the self-perceptions of undergraduate design students. The objective is to gain insights into how this experience shapes their developing professional identity, sense of self-efficacy, and understanding of themselves as designers. By working in collaboration with researchers and industry partners on a real-world healthcare project, the study seeks to evaluate if this environment has any influence on the students' career aspirations and employment intentions.

The results of this study provide valuable information for educational institutions and industry partners. By understanding the impact of real-world healthcare projects on students' professional development, educators can make informed decisions about the type of project-based learning experiences they offer to their students. For

A. Tyurina (✉) · L. Ness Wilson
QUT, Brisbane, QLD, Australia
e-mail: anastasia.tyurina@qut.edu.au; lm.murray@hdr.qut.edu.au

A. Winter
QUT Design Lab, Queensland University of Technology, Brisbane City, QLD, Australia
e-mail: a.winter@qut.edu.au

E. Miller et al. (eds.), *How Designers Are Transforming Healthcare*,
https://doi.org/10.1007/978-981-99-6811-4_17

industry partners, this research can shed light on the benefits of collaborating with educational institutions and provide insights into how to design meaningful and impactful partnerships.

Overall, this research contributes to a better understanding of how real-world healthcare projects can support the professional development of undergraduate design students and inform the design of future project-based learning experiences in this field.

1 Problem

It is common for many design programs to focus on studio-based learning and design projects, rather than hands-on experience in real-world settings. This can limit the exposure of design students to different environments and industries, including healthcare [2].

Design students rarely have the opportunity to work in a hospital setting as part of their education. Hospitals are complex and highly regulated environments, and there are often strict rules and procedures in place that must be followed. As a result, it can be challenging for design students to gain access to these environments and to conduct research or complete design projects within them.

Despite these challenges, there are some programs and initiatives that aim to provide design students with the opportunity to work in a hospital setting. These programs often involve partnerships between universities and healthcare organisations, where students are able to work on design projects that address real-world challenges in a hospital environment.

2 Process

2.1 Phase 1—Visual Communication and Interactive Design Materials for the Co-design of a More Therapeutic Environment for PICU Families and Staff

The way that information is communicated to parents about the PICU environment and its rules is widely recognised as having a significant impact on the culture within the PICU and the relationships between health care professionals and families. Research by Butler, Copnell, and Hall [3] highlights the importance of carefully considering the language used in these communications.

In addition to the environment and rules, PICU staff recognise that parents and families need access to a range of information, including details about their child's current condition and post-discharge care. Laudato et al. [4] stress the importance of providing this information through various sources and mechanisms, given the diverse needs of families.

Consistent and effective communication with stakeholders, clinicians, and the public is also crucial in creating and maintaining the desired culture in the PICU. This

includes ensuring that the language used in these communications aligns with the goals and values of the PICU.

During the first semester of 2021, seven students from the Bachelor of Design (Visual Communication) and Bachelor of Creative Industries (Interactive and Visual Design) were selected to participate in the PICU Partnership Project team. They chose to complete a Work Integrated Learning project to help create visual communication and interactive design materials for the co-design of a more therapeutic environment for PICU families and staff. This involved working on parent/staff engagement and storytelling activities to inform a proposal for interior design and wayfinding. The proposal aimed to reimagine key shared spaces and develop long-term communication strategies for PICU families and post-discharge. Supervised by Dr. Anastasia Tyurina from the QUT Design Lab, students worked closely with Jane Harnischfeger (Nurse Educator, Paediatric Intensive Care, Children's Health Queensland Hospital and Health Service) and Matthew Douglas (Digital Engagement Manager, Communications and Engagement Unit, Children's Health Queensland Hospital and Health Service).

As per the guidelines of the Engagement Strategies brief given by the PICU Partnership Project Team, the students created visual and interactive elements for the engagement activity materials. This included online materials, posters, and fly-ers to promote the PICU Marketplace, materials for the PICU Marketplace itself, as well as data visualisations and infographics.

By using student-designed materials, the PICU Partnership Project team has been able to be flexible in an uncertain and unstable situation of developing requirements and shifting accessibility, due to the Covid-19 pandemic. The undergraduate design students have been informed by the data gathered by researchers and have been involved in all stages of the design material devel-opment. The students have been able to engage with teaching and research staff from the university, as well as staff from the hospital to help the broader HEAL team with their engagement resources and the presentations of analysis (Fig. 1).

Once the data analysis was finished, the students had the chance to come up with design solutions for unfamiliar context. They did this by collecting data from pri-mary sources and considering feedback from both parents and PICU staff about engagement strategies. The students also identified challenges and opportunities for design within the PICU, and played a role in shaping the design briefs for wayfind-ing, signage, and visual communication. Finally, the students created designs that were based on their own research, which could be implemented in the PICU envi-ronment (Fig. 2).

Students developed design solutions such as an AR comic, design concept for MYQCH App, proposal for refurbishing the PICU library space, Parent Journal, and interactive screen content. Some of them are shown below. Students have also pro-vided their project statements and reflections.

"During our time there in the PICU, we noticed there were little to no kids' inter-active pieces that would keep them occupied, the only area that kids are able to run around is the balcony, providing if there is no bad weather. With that in mind, our idea is to create an AR comic strip to portray real-life success stories in the

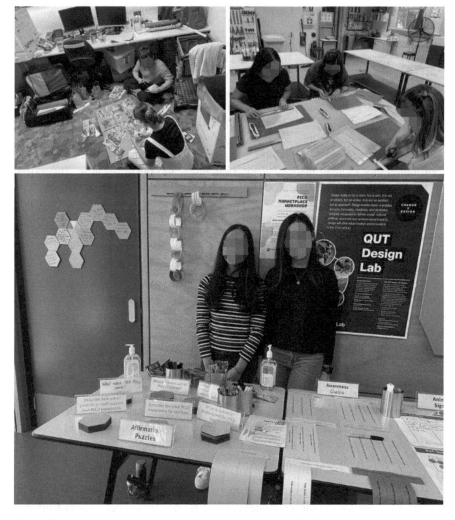

Fig. 1 Students creating materials for Marketplace and distributing them during the visit at PICU QCH

PICU. Our targeted audiences are the kids and parents/family members"—students Claire Tan and Sylvia Wong say (Fig. 3).

Joshua Hayes and Caitlyn Bradford [5] state that "Our prototype has been designed to form as an extension for the My QCH app. It has been specifically designed for the families and parents of the QCH PICU ward. It aims at increasing the communication. The main goal of the app is to foster the sense of community and create a safe space for families to retain also provide information. We believe

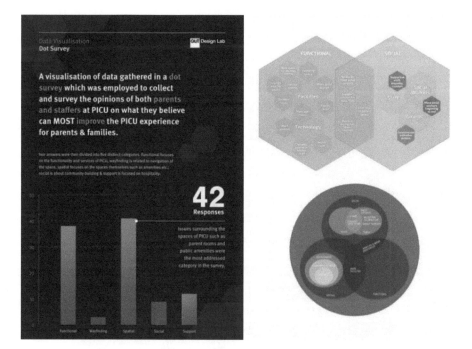

Fig. 2 Infographic visualising data gathered in a dot survey by Josh Hayes (left), and Infographic visualising data gathered in Affirmation Puzzles and Awareness Chain activities by Claire Tan, Sylvia Wong, and Kelly-Anne Kirk

that providing a digital, alternative revenue of communication it will increase the support for families and provide piece of mind while being at PICU to make their experience more pleasant."

Niharika Shah proposes a concept of refurbishing the PICU library space to create a comfortable environment for siblings, kids, and their parents to spend some time away from their mundane routines in their own rooms. "The library would be an 'after hours' library which can be used to sit and relax. A Vinyl or PhotoTex sticker could be used to paste an illustration at the back of the shelving to give it more depth and texture. By doing so, the space would already be transformed into something new. To add to this, there would be an interactive element to the library space wherein the kids at PICU would be able to paste a glow in the dark butterfly or bug or animal or some sort to the wall that could illuminate in the dark. This could be made out of Luminous, which is a paper that is glow-in-the-dark and would be perfect for this purpose. The cave depicts the low times that every parent and child is going through at PICU whereas the glow-in-dark element looks at the light at the end of the darkness. This metaphor can act as a ray of hope and can also make some times at PICU enjoyable," Niharika says.

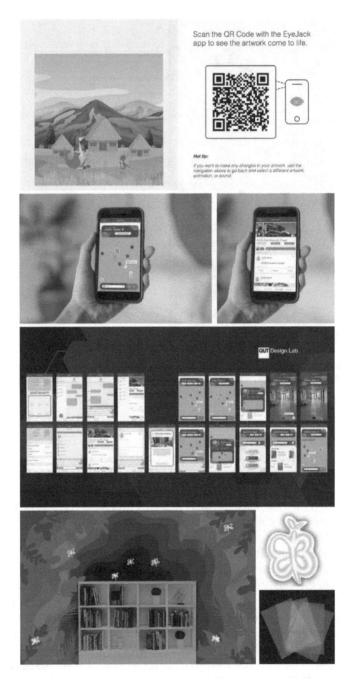

Fig. 3 AR Comic by Claire Tan and Sylvia Wong (top), MYQCH App Proposal by Caitlyn Bradford & Joshua Hayes (middle), Proposal for refurbishing the PICU library space by Niharika Shah (bottom)

2.2 Phase 2—Extending the PICU Partnership into Virtual Reality

In an extension to the initial WIL student project, a new group of Bachelor of Design (Interior Architecture and Interactive Design) students were invited to participate in the visualisation of the PICU Partnership project. Six students were involved, two from interactive design and four from interior architecture. This project was established to turn the concepts created by Leighann Ness Wilson as part of the PICU Partnership Project (Ness Wilson, 2024, Chapter 20 "NICU Mum to PICU Researcher: A Reflection on Place, People, and the Power of Shared Experience" of this book) into virtual reality.

Supervised by Leighann Ness Wilson and Dr. Anastasia Tyurina from the QUT Design Lab, students worked closely with Jane Harnischfeger, Nurse Educator, Paediatric Intensive Care, Children's Health Queensland Hospital and Health Service.

Over a series of design-studio sessions, Leighann and Anastasia worked collaboratively with design students developing concepts, sharing ideas, and providing feedback and mentorship. The design-studio sessions enabled students to experience an authentic design brief and project, engage in design dialogue and creative problem solving, and receive formative feedback throughout the development of the design solutions [6, 7]. Students were also invited to a project pitch late in the PICU Partnership project to see the scope and nature of the project, and were given a tour of the PICU facility early in the process.

The four interior design students selected a specific spatial zone to concentrate on, developing concept plans, creating three-dimensional computer models and developing concept boards with images of colour, finishes, furnishings and fittings. The students reflected on their own theoretical understanding of colour and user-experience from their undergraduate study and combined this with specific research around family-centred care and design in healthcare that was often the focus of design-dialogue in the studio sessions.

To further the WIL student experience, we constructed the student team using a multidisciplinary approach, frequently seen in industry [8]. The interior design students created three-dimensional models of the foyer spaces within PICU before liaising with the interactive design students, who took these models into specific software that enabled virtual reality.

In mid-November 2021, the team from QUT was ready to present back to the staff and families of PICU. Basing the engagement on the successful model of the PICU Market Place (discussed in Ness Wilson, 2023, Chapter 20 "NICU Mum to PICU Researcher: A Reflection on Place, People, and the Power of Shared Experience" of this book), this instalment comprised large, printed posters created to communicate the design of the PICU entry foyer. The concept boards and 3D visualisations were printed onto large format posters and displayed in the foyer space itself. To the side, a dedicated laptop and VR equipment was set up with seating for participants. In total 15 participants experienced the virtual reality tour,

guided by Hannah, a QUT student who talked them through the spaces, providing reassurance and commentary to limit the confusion and disorientation sometimes experienced in virtual reality.

Participants and visitors to the two days of VR PICU Marketplace were invited to provide feedback on their experience. Question framing was developed by Leighann Ness Wilson, in conjunction with the students who facilitated the data collection process. Questions focused on specific feedback to design concepts and to the virtual reality experience itself. This data can be incorporated into future pitching to QCH Foundation to potentially fund its construction. Students prepared a formal record of the project through video and photography, which was included for presentation in the second Market Place (Fig. 4).

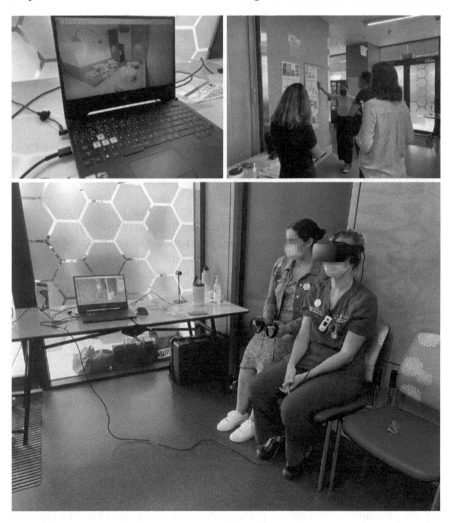

Fig. 4 3D visualisations of design concepts and a VR model presented to PICU clinicians and parents during PICU Market Place

3 Evaluation of Outcomes for Student Interns

The research team conducted an online survey with the QUT undergraduate students after they have finalised their internships.

Survey Questions asked about professional identity development, enjoyment, learning, and future possibilities (research and employment-related). Specific questions are included in Appendix at the end of this chapter.

Of the five (5) respondents to the survey, four were female and one was male. They enjoyed the final design, working on a real-world project—"the opportunity to work on something that could possibly be utilized down the road", creative freedom, interactions with staff and families, working in a team, and learning different ways to use design thinking. Things they didn't enjoy ranged from "Nothing" to delays in feedback and having to work from home rather than in the hospital or with the design team (due to Covid-19 restrictions), and the slow and erratic pace of the work—"it felt like a bit of a design experiment of which we only played just a small part".

In terms of future employment, three respondents could definitely see themselves working as designers in healthcare, while the other two might, but it would not be their first choice. As for learnings from the unit, the respondents valued the teamwork, the design tools they used (Figma and Adobe Illustrator were mentioned specifically), and having a real-world experience—"I really felt that I learned a lot through interacting with staff and family members during the workshop". Table 1 shows the main things respondents learned from teaming with hospital staff, which broadly fall into design thinking (including skills of empathy and communication), employability skills (such as the technologies used and the ability to design for actual clients), and site-based knowledge of how designers could work in healthcare.

All agreed that the benefits to the community were in giving the PICU community a voice. There was also consistency in the insights they gained from working with hospital staff—first-hand experience of hospital bureaucracy and style guides, and the opportunities to showcase their own abilities.

All of the respondents could see the link between the project and research—one student commented "design proposals … had to be informed by … data", while another valued that "the research conducted before and during this project allowed us to create more specifically-targeted solutions to ensure the user was being well considered in the designs". They also increased their understandings of research,

Table 1 Three main things learned from teaming with hospital staff on the project

1	2	3
Empathy	Plan for the unexpected	Communication
How the hospital works	Empathy	Designing for clients
Design thinking	Role of a designer in healthcare change	Wider future career choices
Role of a designer in the hospital	A research-based approach to design	Technologies

including that research takes time and effort prior to designing—"research is accumulative, and not something that is instantly gained after doing one quick survey of the environment", and that presentations and visualisations of the data gathered are important parts of the design process. Finally, empathy was also raised as an important cross-over design/research skill—"co-designing allows the parties to be in each other's shoes and experience what they are going through".

Empathy was also suggested as a possible benefit of partnering similar projects in the future with medical students, as that would give both groups understandings of each other's perspectives and knowledge, and allow the development of better multidisciplinary design solutions "that are more effective and targeted to the issues".

The QUT undergraduate students involved in the Phase 1 of the project were: Caitlyn Bradford, Niharika Shah, Kelly-Anne Kirk, Joshua Hayes, Claire Tan, Naomi Jang, and Sylvia Wong. The QUT undergraduate students involved in the Phase 2 of the project were: Kealey Geddy, Nicolas Loh, Hannah Torrisi, Danielle Greer, Reegan Johnston, and Kirsteen James.

4 Outcomes

By using a variety of storytelling and engagement techniques, gathering important feedback from consumers, and fostering collaboration between clinicians and designers, the PICU Partnership project has laid the foundation for a thrilling new chapter in the design of PICU, aimed at enhancing the experience for families with a critically ill child.

One of the key benefits of student involvement in research activities is that it provides hands-on learning opportunities. Instead of simply reading about design processes and theories in a textbook, students can apply what they have learned in real-world situations. This makes the learning experience more engaging and memorable, as students are able to see the tangible results of their efforts. As a result, students are more likely to retain what they have learned and apply it in their future careers.

Working in small groups during research activities also encourages students to develop their critical thinking skills. By collaborating with their peers and sharing ideas, students can see problems from different angles and come up with innovative solutions. This is an important skill for designers, as it allows them to approach design tasks with a fresh perspective and find creative solutions to complex problems. As students work together in small groups, they also learn the importance of teamwork and the value of each individual's contribution to the overall success of a project.

In addition to the academic benefits, student participation in research activities also helps to develop their professional skills. By working with clients and stakeholders, students gain real-world experience in communicating their ideas and presenting their work. This not only helps to improve their communication skills, but

also their confidence, as they become more comfortable in professional settings. As they present their work to clients and stakeholders, students also learn the importance of being able to articulate their ideas effectively, a skill that is essential in any design career. Overall, student participation in research activities provides a well-rounded learning experience that prepares students for success in their future careers.

Design students who work in a hospital setting often develop a strong sense of social responsibility, as they are exposed to real-world challenges and the impact their designs can have on people's lives. Through their work in a hospital, they see first-hand the importance of design in improving patient outcomes and creating a more positive healthcare experience. This experience creates in them a sense of purpose and a desire to use their skills for the greater good.

Working in a hospital setting also provides students with an opportunity to learn about the unique needs of patients and healthcare professionals, and to design solutions that meet those needs. Through their work, they learn about the unique needs of patients and healthcare professionals, form close connections with members of the community, and gain a deeper understanding of the importance of empathy and the role of design in creating positive change.

Students had an opportunity to reflect on their own professional pathways and developing professional identity, to make meaning of themselves as designers in a real-world setting. The project has enabled the students to see design as a driver for positive impact and change, and to change the paradigm of design for change through application of skills they have learned.

5 Future Development of the Project

The HEAL team anticipates that this project will serve as a prototype for future university research initiatives that engage undergraduate students. By connecting the students to both academics and Higher Degree Research (HDR) students from the QUT Design Lab, and with actual hospital practitioners and support staff, the project has elevated HEAL into a multi-dimensional knowledge creation experience across the university, bridging the gap between the university and the hospital through a design-driven healthcare framework.

The collaboration between design students and medical personnel through the HEAL project is seen as a promising step towards fostering more partnerships between the two fields in the future. The hope is that this project will lay the foundation for further collaboration between design students and medical personnel, providing opportunities for both groups to work together on design projects that address real-world healthcare challenges. This will help to bring together the unique perspectives and skill sets of each group, allowing for the creation of innovative solutions to complex healthcare problems [9].

It is also possible that the collaboration could extend to medical students as well. Medical students are often interested in the design of healthcare facilities and

equipment, and they could benefit from working alongside design students on projects that explore these topics. This collaboration would provide medical students with valuable design experience, and it would allow design students to gain a deeper understanding of the medical field and the unique needs of patients and healthcare professionals.

By working together, design students and medical personnel can learn from each other and build bridges between the fields of design and healthcare. This will lead to the creation of more innovative and effective healthcare solutions, and it will help to prepare the next generation of designers and medical professionals for careers in these fields.

6 Conclusion

The Queensland University of Technology (QUT) is taking its Work Integrated Learning (WIL) program for design students to the next level through industry partnerships and research in the healthcare sector. Queensland Health, a government authority, is playing a vital role in this partnership, which will help QUT's design students be equipped to work in transdisciplinary ways that align with both government and university priorities, especially in a post-Covid-19 world.

The success of this model opens the door for its potential rollout in other QUT Design Lab projects in the healthcare sector in 2022 and beyond. Hence, conducting research and evaluation is crucial to ensure it meets the personal, professional, and developmental needs of the students.

Undergraduate design students have gained valuable hands-on experience through stakeholder engagement, including client interviews and delivering workshops, which inform the design process. They have discovered the importance of first-hand information from stakeholders in the co-design process and have learned about the culture and processes involved in being a designer.

This research highlights the positive impact of real-world WIL projects, which aligns with QUT's Blueprint 6 to "ensure all students experience practical and relevant learning and assessment" and "pursue partnerships with industry and engagement with the community to enable courses to draw upon current real-world practice and innovation", thereby supporting QUT's Real World Learning Vision and the QUT Design Lab's aim for the HEAL projects to transform healthcare.

Appendix—Evaluation Survey Questions

1. What is your major in the Bachelor of Design?
2. What is your gender identification?
3. What aspects of this project did you enjoy, and why?
4. What aspects of this project did you not enjoy, and why?

5. What activities contributed most to your learning in this unit and across this project, and why?
6. Can you see yourself working in healthcare design when you graduate?
7. What have been benefits to the community?
8. How did the staff at the hospital give you insight into what's required in a professional/healthcare project?
9. What are the three (3) main things you've learned/gained from teaming with medical staff on this project?
10. Do you see a link between the project and research? If yes, what?
11. How did this project further your understandings of research (e.g., co-design)?
12. What benefits do you think there would be to work in small groups with medical students in this WIL program?

References

1. Foster M, Whitehead L, Maybee P (2016) The parents', hospitalized child's, and health care providers' perceptions and experiences of family-centered care within a pediatric critical care setting: a synthesis of quantitative research. J Fam Nurs 22(1):6–73
2. Cooper L, Orrell J, Bowden M (2010) Work integrated learning: a guide to effective practice. Routledge, Oxon
3. Butler AE, Copnell B, Hall H (2019) The impact of the social and physical environments on parent–healthcare provider relationships when a child dies in PICU: findings from a grounded theory study. Intensive Crit Care Nurs 50:28–35
4. Laudato N, Yagiela L, Eggly S, Meert KL (2020) Understanding parents' informational needs in the pediatric intensive care unit: a qualitative study. Prog Pediatr Cardiol 57:101172
5. Bradford C, Hayes J. My QCH app proposal 2021. https://spark.adobe.com/page/sAsJ7h3LJaLTf/
6. Orr S, Shreeve A (2018) Art and design pedagogy in higher education: knowledge, values and ambiguity in the creative curriculum. Routledge, Oxon
7. McLaughlan R, Lodge JM (2019) Facilitating epistemic fluency through design thinking: a strategy for the broader application of studio pedagogy within higher education. Teach High Educ 24(1):81–97
8. Wrigley C, Mosely G (2022) Design thinking pedagogy, facilitating innovation and impact in tertiary education. Routledge, Oxon
9. Jones P (2013) Design for care: innovating healthcare experience. Rosenfeld Media, Brooklyn

Dr Anastasia Tyurina is a Senior Lecturer in Visual Communication at the QUT School of Design, and the QUT Design Lab. As a design researcher and a new media artist, she is interested in creating visual experiences that promote social change, better health and wellbeing.

Dr Abigail Winter is a results-driven writing specialist, collaborative mentor, and independent researcher, skilled in the analysis of words and data for user needs. Abbe is a researcher trainer, leader, and mentor, with over 20 years' experience in quality assurance, and change and project management. While her PhD focused on what helps workers in higher education cope with large-scale organisational change, and she was part of the small team that created and developed the concept of academagogy (the scholarly leadership of learning), her more recent research has focussed upon professional identity, developing writing skills, and reflective practice.

Leighann Ness Wilson is an interior designer and educator who inspires future primary educators through design thinking and creativity. She also works independently as an education consultant, developing and providing workshops and learning experiences to students and teachers. Currently Leighann is researching the impact of design thinking as a pedagogical approach on pre-service primary teachers for her Doctor of Philosophy (PhD).

Exploring Clinical Healthcare Challenges and Solutions Through a Design Thinking Education Program for Senior Health Professionals

Judy Matthews and Natalie Wright

Despite seeming like an obvious fit, the formal intersection of design thinking and health is relatively recent. Design thinking or human-centred design is a powerful iterative and collaborative creative problem-solving process that delivers novel and high value solutions to complex challenges that meet the needs, desires, and constraints of end users. Grounded in empathy, design thinking is recognised as a key tool for navigating a multi-layered definition of health [1, 2]. Health professionals with high levels of empathy have been found to elicit therapeutic change more efficiently. Indeed, notions underpinning healthcare innovation include suggestions that physicians who increase empathy, a fundamental element of the therapeutic relationship between clinicians and their patients, make vital contributions to improving health outcomes. For these reasons, design thinking is increasingly included in health professional education [3, 4].

In the USA, Innovation Catalyst initiatives aim to grow a network of innovators trained in human-centred design, who can introduce and champion innovation strategies within their own organisations and help other safety net organisations discover new ways to apply design thinking to critical organisational challenges. Early signs indicate that these Catalysts, exposed to curriculum focused on empathy, exploration, experimentation, and entrepreneurship, are making inroads at their institutions, spurring cultural change across a continuum of activities including applied innovation, introducing new programs and technology and process improvement [5].

This chapter describes the processes and outcomes of a professional development initiative with similar intentions, developed and customised to introduce selected senior health professionals to the basic dimensions and benefits of design

Matthews and Wright are joint first authors of this chapter, with authorship order alphabetical.

J. Matthews (✉) · N. Wright (✉)
QUT, Brisbane, QLD, Australia
e-mail: jh.matthews@qut.edu.au; n.wright@qut.edu.au

© The Author(s) 2024
E. Miller et al. (eds.), *How Designers Are Transforming Healthcare*,
https://doi.org/10.1007/978-981-99-6811-4_18

thinking (human-centred design), and provide an opportunity to develop a design mindset and creative confidence in exploring and experimenting with practical improvements and solutions. Through two facilitated half-day face-to-face workshops, designed to familiarise participants with the process and various design thinking tools, 30 Queensland Health Clinical Excellence (CEQ) Fellowship recipients and senior health executives were empowered to reframe and enact their own design-led quality improvement projects and future-focused scenario-based speculative designs, to value-add to the legacy of the 2020–2021 Health Excellence AcceLerator (HEAL) project. Additionally, a suite of five online modules and a recorded discussion between the two facilitators and Director of the QUT Design Lab captured reflections and insights on the value of applying a design thinking methodology in healthcare contexts, highlighting key learnings for both clinicians and designers.

Outputs and outcomes from the initial workshops highlight examples of how a design thinking process and mindset were used to reframe design challenges to deliver innovative practical solutions for cultural empathy, service design, and systems design projects. Some participants from the first workshop applied the design thinking processes in their own projects that have been reported elsewhere in this book.

Findings from the delivery of the initial two face-to-face workshops demonstrate the appetite of health professionals to actively engage in and collaboratively explore design thinking approaches for the generation, prototyping, and presentation of new creative solutions to healthcare challenges. The benefits of clinicians collaboratively experiencing and experimenting with design thinking processes, problem framing and problem solving are discussed, as well as reflections on future educational interventions needed to increase the productive collaboration of designers and clinicians/health professionals working within the health sector.

1 Why Design Thinking in Health Care?

Design thinking is a human-centred approach to innovation that draws on the designer's toolkit to integrate the needs of people, the possibilities of technology, and the requirements for business success [6]. In creating value for others, designers exercise an open and complex productive reasoning pattern, which builds upon induction, conventional problem solving, and analytical reasoning, and relies on creating a working principle ('how') and a product/service ('what') in parallel [7]. Design thinking can be described as a designer's mindset—an attitude that demonstrates creative confidence [8], uses empathy in its interactions with stakeholders, embraces ambiguity, takes an optimistic perspective, values learning from failure, translates ideas into tangible artefacts, and is continuously iterating to test out new possibilities. The characteristics to look for in a design thinker are "*empathy* and a people-first approach, *integrative thinking* to combine multiple perspectives,

optimism regarding potential solutions, *experimentation* to explore constraints, and *collaboration* with others from diverse disciplinary backgrounds" [6, p. 87].

Design thinking focuses on users and their explicit and latent needs. In any context, its purpose is delivering optimal outcomes for users, often by asking them to reflect on their actual needs. Research reveals that using a human-centred approach delivers better and more appropriate solutions in health, education, and management [4, 9].

As a problem-solving process, design thinking is increasing in popularity in the health care sector [4, 6, 10]. Specifically, design thinking and human-centred design have been shown to generate new, imaginative, and high-value solutions to long-standing challenges and issues [11, 12]. An indication of interest and investment in further application of design thinking is its direct inclusion in medical education [4, 13]. A recent review of 15 articles where design thinking frameworks were used in health professions education found a range of outcomes including self-efficacy, perceptions, and solutions for specific problems [4].

2 Design Thinking in Healthcare Education

The skillset required for healthcare professionals to optimise the healthcare experience is a combination of scientific knowledge, technical aptitude, and affective qualities such as compassion and empathy. Empathy is at the core of effective patient-centred care that is found in kindness, compassion, and dignity, recognises the role of the patient's family and support system, understands the influence of the physical environment in healing, and responds to the patient's psychological, emotional, spiritual, and social needs [14].

Developing a public health workforce that can understand problems from a user-centred perspective not only has utility in problem-defining and solution-finding for healthcare products and services [7], but also provides healthcare professionals with the critical skills for creativity, innovation, and empathy to engage meaningfully with community members and more effectively approach historically burdensome challenges [15].

Harvard Medical [16] recognises the importance of operationalising empathy into the health system by "directly incorporating the patient's voice" when "redesigning care processes with empathy-centred design thinking". 'Clinical empathy', defined as "the ability to *observe* emotions in others, the ability to *feel* those emotions, and finally the ability to *respond* to those emotions" [17, p. 55], constitutes an important skill for health and social care professionals, and brings benefits to patients, medical students, and health practitioners alike. Guidi and Traversa [18] reference multiple studies which highlight improved satisfaction and positive clinical outcomes for patients—therapeutic effectiveness, shorter hospitalisations, improved physiological responses, patient wellbeing, and economic advantage—as well as benefits for health practitioners including increased well-being and job satisfaction preventing burnout, and decreased malpractice claims. Further, they

propose the notion of 'empathic concern' in healthcare, suggesting that clinicians embrace 'engaged curiosity', non-verbal attunement, and the effort to imagine the other's experience to gain a deeper and more comprehensive understanding of the patient's experience.

Despite efforts to promote the value and importance of a person-centred approach in healthcare, studies show a decline in empathy among medical students as they proceed through their training, and adoption of low levels of empathetic engagement in clinical settings [19, 20]. This is attributed to factors such as stress, understaffing and increased workload to meet operational targets, the lack of adequate time and long working hours, work culture, the focus on therapy within a siloed academic culture, and inadequate focus as an underlying objective in the teaching process of health and social care undergraduate students and continuous lifelong education of professionals [19–21].

Attempts to improve empathy in medical and nursing schools and clinical practice over the years have largely focused on communication/social skills and perspective taking [20]. The relationship between empathy and healthcare is particularly prominent in 'Narrative Medicine' [22], an approach focused on promoting the importance of storytelling and encouraging the empathic encounter between health practitioner and patient. Guidi and Traversa [18] stress the importance of further research in this field due to its efficacy in teaching and promoting empathic concern in healthcare.

Similarly, in the design realm, narrative inquiry and storytelling, giving insight into the nuanced thoughts, feelings, and experiences of others, has been proposed as a method which aligns design solutions with the multiple dimensions of physical, emotional, spiritual, and interpersonal needs of patients and caregivers, and offers a new way to effectively communicate design ideas [23]. Utilising the skills of passive ethnographic listening and observation, evidence suggests that students of design using this method experience heightened self-reflection, acknowledge diverse perspectives, and are encouraged to design for the whole person—essentially cultivating empathy. Additionally, narrative inquiry can encourage creativity and innovation, and reduce surface misconceptions and tensions with stakeholders, therefore being an effective instrument for problem definition [24].

3 The HEAL Design Thinking for Clinicians (DT4C) Education Program

With the intention to provide a foundational understanding of design thinking processes, skills and mindsets, incorporating some of the aforementioned methods, the HEAL Design Thinking for Clinicians (DT4C) Education Program for clinical professionals used a two-phase process. A summary of these phases is shown in Fig. 1.

Phase 1: Design, development, and delivery of two face-to face half-day workshops with clinicians, exploring design thinking within the context of their workplace projects with CEQ participants from 2020 and 2021 Fellowship cohorts. Design thinking frameworks and hands-on methods were explored, generating

Fig. 1 Phases of the design thinking for health education initiative

useful insights and lessons, as well as generating potential new solutions to their workplace problems.

Phase 2: Design and development of an online 'Introduction to Design Thinking' course, which provides five modules expanding on information about each phase of the design process with specific healthcare examples tailored to clinical professionals through videos and textual resources.

This course was supplemented by production of a video capturing reflections and further discussion about of the application of design thinking frameworks in healthcare by the facilitators of the Phase 1 workshops and the Director of the QUT Design Lab.

4 Phase 1: Design Thinking for Health Face-to-Face Workshops

Seeking to achieve long-term and wide-reaching cultural change within Queensland Health through the Clinical Excellence Queensland (CEQ) program in 2020, it was suggested that the CEQ Fellows, a peak group of current and future leaders (including doctors and allied health professionals selected from clinical facilities statewide) could be instrumental in embedding the principles and practices of design thinking for healthcare improvement across Queensland hospital and health services. Fellows from the Clinical Excellence Queensland (CEQ) Fellowship scheme in both 2020 and 2021 were invited to participate in a half-day face-to-face *Introduction to Design Thinking* workshops developed and facilitated by the design team from the QUT Design Lab.

Initially, the design team was tasked with designing and facilitating a customised 3-hour interactive workshop to provide 2020 health professionals with a general understanding of the mindset, principles and practices of design thinking. It was then repeated for the 2021 cohort. These workshops provided an opportunity for

CEQ Fellows to apply this learning to projects of their own choosing, in order to provide a foundation for future design thinking, design doing (co-creating and enacting design-led change initiatives), and design visioning (future-focused scenario-based speculative design).

4.1 Face-to-Face Workshop Format

Each workshop began with a discussion about design and design thinking using Herb Simon's stance which proposes that "everyone who devises courses of action aimed at changing existing situations into preferred ones is a designer" [25, p. 101]. The human-centred approach was then introduced utilising the Stanford d.school process [26], which is commonly used in educational settings. This process utilises the phases of Empathise, Define, Ideate, Prototype, and Test, as shown in Fig. 2.

The importance of developing design thinking mindsets and 'creative confidence' [8] with repetition of experimentation and practice on the journey to developing design thinking expertise, was emphasised.

Participants in each workshop worked in small groups of 4–5 for the workshop duration, experiencing the design thinking process, experimenting with various design thinking skills, and exploring and sharing possibilities for their work in teams. Various templates and examples were utilised throughout the workshop to demonstrate how design thinking can be integrated into health care projects.

The **Empathise** phase, highlighted as a defining differentiation in this thinking approach, involved focusing on the patients and staff in the participants' work contexts, and developing a contextualised clinical workplace scenario to explore during the workshop. First, participants were asked to reflect on their patients and develop a *Persona*—a composite character who embodies the needs, interests, wants, and desires expressed by real users, preferably an 'extreme' user. This Persona became the human face of the design—the end-user that the whole team could imagine clearly.

Participants were then challenged to put themselves in the user's shoes to develop an *Empathy Map* summarising the traits, feelings, behaviours, and needs of patients during their clinical experience. This part of the process particularly focused on behaviours, as those could be remembered by the participants from real-life situations in their workplace scenario. That empathy map was then used by each team to agree on their biggest problem that needed to be solved in the scenario space.

Empathise – Define – Ideate – Prototype – Test

Fig. 2 The Five Steps in the Design Thinking Process Framework, popularised by the d.school. (*Source: Authors*)

In the **Define** phase, participants were invited to frame the challenge as a *"How might we…?"* question—a not-too-broad, not-too-specific way of reframing insights in order to turn those challenges into a generous array of possible future desirable outcomes.

The **Ideate** or idea generation phase then provoked participants to brainstorm ideas to solve the *"How might we…?"* question. They were encouraged to develop a 'moonshot'—an audacious attempt to solve the problem with a radically different way of thinking, that values creativity over cleverness. At the end of this phase, each team discarded their practical solutions, and selected one idea that was either 'delightful' or 'a longshot' to progress.

During the **Prototype** phase, groups of participants used basic materials (pens, paper, string, glue, scissors, and the like) to create ways to communicate the selected solution idea for evaluation. Situational narratives which were developed included: (i) Improving patient communication in waiting areas—ensuring current information about progress as well as delays while waiting for diagnosis and treatment; (ii) Improving facility access and physical environment for patients with chronic respiratory disease; and (iii) Improving the obstetrics process and outcomes for remote Indigenous patients relocated from offshore islands to the mainland.

In the **Test** phase, each team showcased their solution to the larger group in a 3 min 'elevator pitch' using props created in the prototype phase. Each team then had the opportunity to evaluate and modify their prototype on the basis of the questions and feedback received, and to exchange detailed feedback with another team.

Finally, all participants were asked to **Reflect** on the process and what had been learned during the workshop.

4.2 Outputs and Outcomes of Face-to-Face Workshops

Participants were highly engaged throughout the face-to face workshops, enthusiastically participating in developing visual and action-oriented rapid prototyping skills, and reflecting on the needs of users and the current challenges in their particular health-related contexts. Examples of output from activities from Workshop 1 include: a visual prototype of a potential solution generated to provide information on an Arrivals and Departures Board for use in Waiting Rooms (Fig. 3—top); and an artefact for prototyping a solution for better communication and connection for remote Indigenous obstetric clients (Fig. 3—bottom).

Evaluation comments from participants included, "Where can I learn more? Loved it" and "I'm keen to continue in this space using some these tools and tasks within my workplace." They also expressed disappointment that the 2020 CEQ Fellows collaboration with the QUT Design Lab had begun so late in their Fellowship, asking whether they could be involved in future sessions, as they saw value in repetition of both learning and doing the design thinking process for

Fig. 3 Visual prototype of
Arrivals and Departures
Board concept (top), and
the solution for improving
communication for
Indigenous obstetric clients
(bottom)

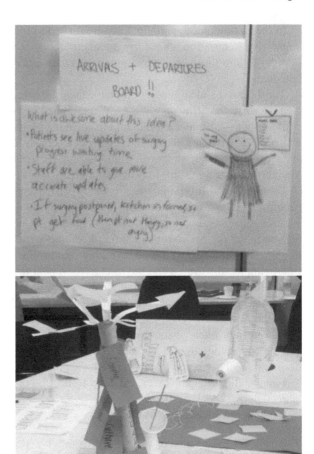

ongoing projects. As a result, the workshop was offered in May to the 2021 CEQ
Fellows cohort, and CEQ alumni from 2019 and 2020 were also invited.

The challenges identified and explored by groups in the second workshop
include: Induction procedures; individual pregnancy records, obesity issues; issues
in suicide prevention, mobile dental health and KPI's for the future. Experiencing
the design process and designing ideas and prototyping potential solutions with this
diverse range of challenges and solutions created a community of ideas, with indi-
vidual participants and their groups collaboratively learning from each other, as
shown in Fig. 4. An example of a Prototype from Workshop 2 providing some solu-
tions for an obesity challenge, is shown in Fig. 5.

Major insights from these initial workshops demonstrated that there is a strong
appetite in Queensland Health for new ways of thinking about problems, as most
students from both cohorts viewed the content as relevant to improving their
responses to public health challenges and generating novel solutions. Participant
comments from the initial workshop, including "Please continue collaboration

Fig. 4 Visual Capture of Scenarios from six groups of Clinicians in Face-to-face Workshop 2. (Source/credit: Simon Kneebone (permission granted))

Fig. 4 Visual Capture of Scenarios from six groups of Clinicians in Face-to-face Workshop 2. (Source/credit: Simon Kneebone (permission granted))

(between CEQ and QUT HEAL Bridge Lab)", and "How can we maintain a relationship with QUT Design Lab and HEAL post Fellowship?" speak to the strength of value that participants saw in learning this new way of thinking and doing, their excitement about generating new ideas and translating them into actionable solutions, and the desire to keep experimenting with designers.

Specifically, the importance of the Clinical Excellence Queensland (CEQ) portfolio and their projects was mentioned. As one participant commented in response to a question about how design thinking can add value to their work, "Thinking more bigger picture and what are impossible ideas that maybe CEQ can help push forward".

Learning outcomes were clearly best achieved when learners focused on applying tools to challenges they had either personally experienced or were familiar with. When participants began to put themselves in the position of the patients, staff, and family members, they were able to connect to the wider problems on a deeper level, truly understanding what they thought, felt, and recalled. CEQ Fellows, selected to participate in the program to work on challenges for healthcare in their own workplace, were given additional tools to buttress their research with affective narratives

Fig. 5 Multiple factors exploring obesity challenge- defining the challenge, and components (top), and Visual of Potential Obesity Solution—'Wellness Lifestyle Centre' (bottom)

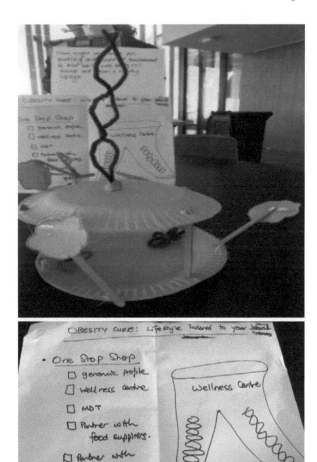

of compelling human experience. This involved exploring end-users' experiences through three modes of storytelling (verbal, written, and visual), to inspire new approaches. Use of the first person narrative in some cases motivated the teams to heighten empathy in ways that led to sensitively-designed, patient-centred outcomes.

Furthermore, clinician evaluations of the workshop reported a valuing of the design thinking process as a structured collaborative methodology that enables new perceptions of challenges, increased feelings of self-efficacy in engaging with problems, and a new **solution-based approach** to address specific problems.

The highly experienced Clinicians in the face-to-face workshops were highly motivated and focused on their workplace projects. They had deep knowledge and empathy with their patients from their immersion in the challenges they were addressing. The solutions that they designed, developed prototyped, and tested for their projects involved both service and system design elements.

Participants in the face-to-face workshops were deeply aware of the physical, social, and well-being challenges of their patients, demon- strating empathy with their situations. As clinicians are largely engaged in providing services to clients, the workshop groups demonstrated a strong focus on service design, finding new ways to develop solutions that met the social and functional needs of their patients, and proposing new approaches to designing systems that were more patient-centred, or that simplified or unified existing services.

5 Phase 2: Design Thinking for Health Online Program

Following the success of the introductory program of face-to-face CEQ workshops, a five module 'Introduction to Design Thinking' course for online, asynchronous delivery was developed to extend the QUT Design Lab CEQ DT4C education initiative. Each individual online module is less than 30 min and includes PowerPoints, customised resources and templates (eg. for Personas, Empathy Maps, Storyboards), reflection questions, and provocations and challenges. A video toolkit guides participants through the five phases of the design thinking process in more detail, providing extra tools relevant for the healthcare setting.

As shown in Fig 1, a video-recorded discussion and reflections of members of the QUT HEAL Design Lab captured the design team's insights about the education and training initiative and the collaborations and outcomes for the greater HEAL project.

5.1 Designers Working with Medical Professionals

Designers delight in collaboratively working with others to improve the health and wellbeing experiences of individuals, families/carers, and communities using design thinking. Designers are facilitators, clarifying design processes, stimulating and disrupting status quo, and capturing the overt and latent needs and interests of users. Teaching design thinking to health professionals often includes mapping the patient journey [27–29] and customising the design sprint to create solutions for diverse situations. While some transformative ideas were generated during the sprints, future iterative sessions would be required to further prototype and test these ideas with stakeholders, with input from designers or researchers to prevent the premature curtailing of ideation by focusing on contextual healthcare system constraints, and encourage maturation of initial concepts to delivery.

Medical professionals are closely engaged in developing solutions for the medical, health, and wellbeing challenges that often extend beyond the presenting medical conditions. Design and design thinking have been used extensively in health contexts regarding new products [30, 31], new and better services [32], patient friendly spaces [6], and patient-centred health and hospital systems [33–35].

Participants in the workshops discussed in this chapter were highly experienced health professionals, selected from a competitive application process and fully engaged with projects in their workplace contexts, targeting their issues of concern. They were curious and committed to exploring an alternative process for defining and solving problems and displayed the essential characteristics of empathising with their patients, an openness to ideas and risk taking, and a willingness to collaborate with other likeminded professionals in idea generation, prototyping, visualising, and experimenting.

In alignment with the literature, the relevance of design thinking to developing empathetic public healthcare systems and the intention to embed these professionals as design 'catalysts' in various areas of the healthcare system, calls for more in-depth and experiential learning, led by experienced designers [36].

While participants indicated their satisfaction with the learning outcomes and a greater understanding of key design thinking concepts, the strengths of the design thinking approach stem from its emphasis on the processes which must be practised repetitively to build 'creative confidence' and a design mindset [37, 38]. In the half day design immersion sprints described here, it was unlikely non-designers will move beyond a 'Novice' level of design expertise, but this seeded the opportunities to promote self-regulated learning which move them towards an 'Advanced Beginner' or situation-based level, suitable for facilitating learning with others in their workplaces [39, 40], dependent on the complexity of the problems being tackled [41].

The design processes of immersion in the patient's context, empathising with the patient and their carers, engaging in ethnographic conversations, defining the challenges, generating ideas, and prototyping new possibilities increases the self-efficacy of health professionals [4] and their patients [42]. For this reason, literature suggests a focus on facilitating empathy and problem-finding learning processes for public health students through case-based learning, interviews, role-playing, group work, and community engagement. This recognises that creativity—essential for dispelling assumptions and finding new ways to explore challenges, involving significant cognitive flexibility, divergent, and convergent thinking and associative and analogical thinking—is not currently adequately developed in formal curriculum [36].

We recognise that designers who work with less experienced practitioners than those in our workshops may have different starting points for exploring a design thinking and doing process. Such work may require closer analysis of their patients and their patients' journeys [43], with longer time for immersion in the challenge/opportunity space, and a longer focus on empathy and latent needs of their patients in preparation for design thinking workshops. Identifying the range and needs of diverse stakeholders and their involvement may also require extra time. However, as research has indicated [11, 12, 44], the engagement and involvement of designers at the front end of problem framing and defining as well as in working with stakeholders in an iterative fashion, provides new effective and productive solutions for patients and professionals. Service design thinking and doing [32] is indeed the focus of future work of designers with health professionals.

The CEQ DT4C education program fostered relationships among the Fellows and with the design facilitators that catalysed future project discussions and action towards quality improvement initiatives across the state. This engagement emphasised the importance of providing both physical and virtual environments for interprofessional learning in design thinking that cultivate socialisation, networking, collaboration, and sharing. While this program's intention was to provide a foundational understanding of how design thinking for healthcare professions, alongside learnings developed from other HEAL projects as case studies, priorities for future curriculum development could include:

- Incorporating a design thinking approach to future interprofessional curricular development to ensure that the program directly targets the needs of all stakeholders including health care consumers, practicing clinicians, senior health professionals, and administrators, providing insights into the expectations, gaps, and goals of learning and practice in the current healthcare environment.
- Fostering a community of practice to allow for individuals from both healthcare and design to continue working together.
- Incorporating more effective and longitudinal evaluation strategies, ascertaining needs for future learning and supporting individual project development.
- Integrating training opportunities which respond to specific clinical environments and involve community-based participation, where clinicians can offer new perspectives and demonstrate leadership in process improvement outside their own workplaces.
- Providing learning opportunities in which clinicians and senior health professionals can work together more regularly and longitudinally with designers in simulated environments using patient care scenarios, to develop and deliver better solutions to complex issues.
- Providing more targeted professional development with designers and healthcare professionals collaborating on building actionable empathy skills, problem-finding and creative learning processes in the healthcare sector, capitalising on opportunities to mutually bridge the gap between 'good design' and patient-centred care.

Designers working in healthcare, despite the best of intentions to create impactful change, also face logistical challenges in ensuring products, environment, and service design outcomes and co-design processes are relevant and appropriate for users whose needs, expectations, and desires can be very dynamic. Additionally, while dedicated clinicians and health professionals are eager to embrace alternative thinking, sometimes healthcare administration can restrict collaborative processes and ideas for change. Increased operationalisation of care provision and focus on targets and protocols, understaffing, isolation of medical from social care, and systemic structures and practices have been identified as factors which impede continuity of care, from including empathic design considerations for products, services and environments [19]. Often it is also difficult to develop productive relationships, or even find the time for informal conversations to build trust with users and healthcare

professionals within their workplaces for mutual learning, due to their stressful and time-constrained roles in busy, unpredictable environments.

The HEAL Project, including this Education program, provided a rare opportunity, unconstrained by these external pressures, for the design team to gain detailed insight into the challenging interactions of a cohort of extraordinarily dedicated clinicians with their patients, staff and administrators in the healthcare system, along with the time to mutually reflect on productive future collaborations for quality improvement in healthcare.

Staying true to the user-centred nature of design thinking, to develop the capabilities and mindsets of design thinkers, and provide ongoing opportunities for a shared language to emerge between health professionals and designers, requires significant time, energy, and empathy from stakeholders and healthcare administrators. Multi-tiered conditions and systems must be created in institutions to broaden the definition of empathetic healthcare to include ongoing interactions between healthcare professionals, patients, and designers. This involves promoting policy decisions regarding targeted and ongoing training for healthcare professionals, ensuring the workplace conditions for cultivating empathy amongst healthcare professionals, and developing implementation and evaluation of empathy-promoting policies across all phases of healthcare access and provision [19]. The development of empathetic skills must be supported through continuous and personal development education programs and supervised sessions, as well as habituation through lifelong reflection, action and relationship building [19, 21].

While the HEAL DT4C education program and associated case studies have demonstrated a promising approach towards disseminating design thinking capability throughout a state healthcare system, more coordinated educational interventions need to be developed and evaluated longitudinally. Evidence-based research is required to measure the impact of similar educational interventions on healthcare students and professionals in developing skills and mindsets for effective problem definition and co-design of healthcare products and services in conjunction with designers. Equally, recent experiences during the Covid-19 pandemic have highlighted the need to provide ongoing professional development for healthcare professionals to cultivate and maintain the critical skills of creativity, innovation, and empathy. There is value in developing programs in conjunction with health and medical schools and institutions building on existing concepts of 'narrative medicine' through design thinking.

With a clearer understanding of how design thinking education implemented during training or in healthcare settings could enhance and encourage empathic concern, educational collaborations between designers and health professionals such as this one will become ubiquitous and continue to improve the holistic quality of clinical care.

References

1. Asch DA, Terwiesch C, Mahoney KB, Rosin R (2014) Insourcing health care innovation. N Engl J Med 370:1775
2. Valentine L, Kroll T, Bruce F, Lim C, Mountain R (2017) Design thinking for social innovation in health care. Des J 20(6):755–774
3. Madson MJ (2021) Making sense of design thinking: a primer for medical teachers. Med Teach 43(10):1115–1121
4. McLaughlin JE, Wolcott MD, Hubbard D, Umstead K, Rider TR (2019) A qualitative review of the design thinking framework in health professions education. BMC Med Educ 19(1):1–8
5. Center for Care Innovations (2014) Catalysts 2013: final evaluation report. Center for Care Innovations, Oakland
6. Brown T (2008) Design thinking. Harv Bus Rev 86(6):84
7. Dorst K (2011) The core of 'design thinking' and its application. Des Stud 32(6):521–532
8. Kelley D, Kelley T (2013) Creative confidence: unleashing the creative potential within us all. London, William Collins
9. Brown T, Martin R (2015) Design for action. Harv Bus Rev 93(9):57–64
10. Vagal A, Wahab SA, Butcher B, Zettel N, Kemper E, Vogel C et al (2020) Human-centered design thinking in radiology. J Am Coll Radiol 17(5):662–667
11. Abookire S, Plover C, Frasso R, Ku B (2020) Health design thinking: an innovative approach in public health to defining problems and finding solutions. Front Public Health 8:459
12. Altman M, Huang TT, Breland JY (2018) Design thinking in health care. Prev Chronic Dis 15:E117
13. Sandars J, Goh P-S (2020) Design thinking in medical education: the key features and practical application. J Med Educ Curric Dev 7:2382120520926518
14. Frampton SB, Charmel PA, Guastello S (2013) The putting patients first field guide: global lessons in designing and implementing patient-centered care. Jossey-Bass, San Fransico
15. Deitte LA, Omary RA (2019) The power of design thinking in medical education. Acad Radiol 26(10):1417–1420
16. James TA (2023) Trends in medicine: building empathy into the structure of health care. 26 Mar 2023. https://postgraduateeducation.hms.harvard.edu/trends-medicine/building-empathy-structure-health-care
17. Finset A (2010) Conceptual explorations on person-centered medicine 2010: emotions, narratives and empathy in clinical communication. Int J Integr Care 10(Suppl):e020
18. Guidi C, Traversa C (2021) Empathy in patient care: from 'clinical empathy' to 'empathic concern'. Med Health Care Philos 24:573–585
19. Kerasidou A, Bærøe K, Berger Z, Brown AEC (2021) The need for empathetic healthcare systems. J Med Ethics 47(12):e27
20. Yu CC, Tan L, Le MK, Tang B, Liaw SY, Tierney T et al (2022) The development of empathy in the healthcare setting: a qualitative approach. BMC Med Educ 22(1):1–13
21. Moudatsou M, Stavropoulou A, Philalithis A, Koukouli S (2020) The role of empathy in health and social care professionals. Healthcare 8:26
22. Charon R (2001) Narrative medicine: a model for empathy, reflection, profession, and trust. JAMA 286(15):1897–1902
23. Carmel-Gilfilen C, Portillo M (2016) Designing with empathy: humanizing narratives for inspired healthcare experiences. Health Environ Res Des J 9(2):130–146
24. Danko S (2006) Humanizing design through narrative inquiry. J Inter Des 31(2):10–28
25. Simon HA (1996) The sciences of the artificial, 3rd edn. MIT Press, Cambridge, MA
26. Stanford University Hasso Plattner Institute of Design (2018) The design thinking bootleg. https://dschool.stanford.edu/resources/design-thinking-bootleg
27. Lewrick M, Link P, Leifer L (2018) The design thinking playbook. Wiley, Hoboken
28. Lewrick M, Link P, Leifer L (2020) The design thinking toolbox. Wiley, Hoboken

29. McCarthy S, O'Raghallaigh P, Woodworth S, Lim YL, Kenny LC, Adam F (2016) An integrated patient journey mapping tool for embedding quality in healthcare service reform. J Decision Syst 25(Suppl 1):354–368
30. Ku B, Lupton E (2020) Health design thinking: creating products and services for better health. MIT Press, Cambridge, MA
31. Nusem E, Straker K, Wrigley C (2020) Design innovation for health and medicine. Palgrave Macmillan, Singapore
32. Stickdorn M, Schneider J (2012) This is service design thinking: basics, tools, cases. Wiley, Hoboken
33. Prakash M, Johnny JC (2015) Things you don't learn in medical school: caduceus. J Pharm Bioallied Sci 7(Suppl 1):S49
34. Liedtka J, Salzman R, Azer D (2017) Design thinking for the greater good: innovation in the social sector. Columbia University Press, New York
35. Australian Healthcare and Hospitals Association (2020) Experience based co-design toolkit. https://ahha.asn.au/experience-based-co-design-toolkit
36. Ingram C, Langhans T, Perrotta C (2022) Teaching design thinking as a tool to address complex public health challenges in public health students: a case study. BMC Med Educ 22(1):270
37. Jobst B, Köppen E, Lindberg T, Moritz J, Rhinow H, Meinel C (2012) The faith-factor in design thinking: creative confidence through education at the design thinking schools Potsdam and Stanford? In: Plattner H, Meinel C, Leifer L (eds) Design thinking research: measuring performance in context. Springer, Berlin, pp 35–46
38. Rauth I, Köppen E, Jobst B, Meinel C (eds) (2010) Design thinking: an educational model towards creative confidence. In: DS 66-2: Proceedings of the 1st international conference on design creativity (ICDC 2010)
39. Dorst K (2015) Frame innovation: create new thinking by design. MIT Press, Cambridge, MA
40. Wright N, Wrigley C (2019) Broadening design-led education horizons: conceptual insights and future research directions. Int J Technol Des Educ 29:1–23
41. Mosely G, Wright N, Wrigley C (2018) Facilitating design thinking: a comparison of design expertise. Think Skills Creat 27:177–189
42. Wolstenholme D, Downes T, Leaver J, Partridge R, Langley J (2014) Improving self-efficacy in spinal cord injury patients through "design thinking" rehabilitation workshops. BMJ Open Qual 3(1):u205728.w2340
43. Simonse L, Albayrak A, Starre S (2019) Patient journey method for integrated service design. Des Health 3(1):82–97
44. DiCarlo JA, Gheihman G, Lin DJ (2021) Reimagining stroke rehabilitation and recovery across the care continuum: results from a design-thinking workshop to identify challenges and propose solutions. Arch Phys Med Rehabil 102(8):1645–1657

Associate Professor Judy Matthews facilitates human-centred systems design with individuals, groups, and organisations, through design thinking, design-led innovation, and action research, creating inclusive, collaborative relationships and outcomes. With an extensive background in human services, Judy has worked with members of government, private sector and non-government agencies and their stakeholders to identify user needs, overcome barriers to innovation, and developing, testing, and embedding proactive agentic behaviour and human-centred customised solutions.

Dr Natalie Wright has 18 years Interior Design commercial practice experience gained in Australia, Japan and the UK. Natalie's research interests are focused around socially responsible, collaborative and inclusive design; community engagement and service learning; design thinking and design-led innovation approaches for students and educators in the secondary and tertiary contexts; and the role of design in the 21st century creative knowledge economy.

Co-designing Design Thinking Workshops: From Observations to Quality Improvement Insights for Healthcare Innovation

Marianella Chamorro-Koc, Levi Swann, Natalie Haskell, James Dwyer, Luke Wainwright, and Jodie Hosking

Healthcare transformation and innovation brings changes to practices, challenges to uptake, and potential benefits to end-users. With these divergent complexities, the approaches that healthcare institutions use to embrace changes and the strategies employed to address those challenges are of critical importance. Design Thinking strategies are increasingly being employed in healthcare quality improvement approaches to facilitate innovation pathways and better health outcomes.

Healthcare innovation is part of a dynamic learning culture that characterises the healthcare sector. According to Persaud [1], such a learning culture is reflective of high-performance workplaces promoting continuous improvement, best practices, innovation, integrated data analytics, and evidence-based decisions. Innovation in healthcare can take many forms, from therapies and procedures, devices and tests, to professional training, management, and service delivery models [2]. It is in this broad context of healthcare innovation where quality improvement plays an important role. It provides performance measures upon which to benchmark innovations against to prove and secure benefits for end-users while outweighing the challenges of the changes that innovations might bring. Quality in healthcare is measured by seven characteristics: efficacy, effectiveness, efficiency, optimality, acceptability, legitimacy, and equity [3]. Achieving quality improvement across all characteristics requires a systematic approach. Combined and ongoing efforts of all involved (healthcare professionals, patients and their families, researchers, payers, planners, and educators) are required to make the changes for better patient outcomes (health), better system performance (care) and better professional development [4, p. 2].

M. Chamorro-Koc (✉) · L. Swann · N. Haskell · J. Dwyer
QUT, Brisbane, QLD, Australia
e-mail: m.chamorro@qut.edu.au; levi.swann@qut.edu.au; natalie.haskell@qut.edu.au; j21.
dwyer@qut.edu.au

L. Wainwright · J. Hosking
Queensland Health, Brisbane, QLD, Australia
e-mail: luke.wainwright@health.qld.gov.au; Jodie.Hosking@health.qld.gov.au

© The Author(s) 2024
E. Miller et al. (eds.), *How Designers Are Transforming Healthcare*,
https://doi.org/10.1007/978-981-99-6811-4_19

With increasing demand for healthcare resources, individualised patient care and the higher cost of healthcare, quality improvement methods enable healthcare systems to make, measure and assess change and the effects of a change, while feeding the information back into the system and adjusting until results are satisfactory [5]. Increasingly, qualitative methods for quality improvement include participatory approaches and ethnography in healthcare contexts. For example, Vougioukalou et al. [6] explain that ethnography provides rich insights into the views and concerns of healthcare professionals and patients and captures their diverse and complex perceptions. Due to the nature of healthcare environments where long-term observations of the same participants are limited, Vougioukalou et al. [6] refer to focused and rapid ethnography formats and their limitations. They bring attention to a mixed-method ethnographic quality improvement method that includes observations of co-design processes in addition to interviews and questionnaires. Such ethnographic observations and co-design processes reveal practices of healthcare services delivery, often involving not only healthcare professionals and patients, but also infrastructure, spaces, and objects. Buse et al. [7, p. 2] explain that objects and spaces in healthcare settings provide a lens for examining care practices and make visible the tacit and non-verbal aspects of care practices.

In their book *Materialities of Care*, Buse et al. [7] discuss how the infrastructure and spaces in which healthcare services are provided are also part of the practice of providing care. The trending medical drama genre of television shows portraying emergency rooms and medical practices provide a glimpse of the multiple interactions taking place as part of the complexity of the healthcare system. While television fiction might be inaccurate in presenting medical procedures, it makes visible to the general public the myriad of devices, spaces, and equipment that health care professionals interact with as part of their daily medical practices.

In this article, we share our approach to Human Centered Design in Design Thinking sessions, through the use of an observation technique that was piloted with the CSDS team in February 2021 as part of the HEAL initiative. Our approach to implement a Design Thinking session combined two different worlds of knowledge and processes through a co-design approach. This project was conducted with QUT Ethics Approval number 107031.

1 Organisational Context of the Study

We conducted this study with the Clinical Skills Development Services (CSDS) team from the Metro North Hospital and Health Service (MNHHS) in Queensland. The core business of CSDS is to deliver specialised training for healthcare professionals; these are through simulation education programs or technical simulations of medical procedures and techniques. In the Queensland healthcare sector, they contribute to healthcare improvement through training, collaboration and innovation. CSDS is based at a 3000 m2 purpose-built facility on the Royal Brisbane and

Women's Hospital campus. The Service supports a network of satellite sites across Queensland and is considered one of the world's largest providers of healthcare simulation. The CSDS team comprises a diverse group of professionals from different specialties (instructional & product designers, web and online learning developers, videographers, administrators, nurses, doctors, and clinicians). All members of the team contribute to the facilitation and delivery of the different programs and sessions. Its world-class service is one of a kind nationally and is globally recognised as excellent.

One of the areas in which CSDS has specialized is in running Design Thinking workshops for diverse healthcare professional groups. These are delivered through their Innovation Hub for a broad variety of needs and to address complex problems in healthcare. For example, they are used to develop new ideas, such as VR applications, through to reviewing models of care or developing novel simulation training programs. Many of the CSDS team members are versed in Design Thinking methods and are expert facilitators of this type of sessions in the healthcare context. From a research perspective, and with the purpose of generating new knowledge to support capability building of their team, CSDS engaged with QUT Design Lab researchers to collaborate in exploring opportunities to input novel approaches to their Design Thinking workshop toolkit and strategy.

2 Design Thinking in Healthcare Innovation

Design Thinking in healthcare settings refer to co-design processes that are inherently visual [8–10], where physical design tools, including 3D representations of environments and tactile models, enable teams to discuss and collaborate, reflect and initiate enquiries [11–14]. It is this visual quality that makes Design Thinking effective for exploring the inherent complexities of healthcare settings, which involve not only clinicians and patients, but all that surrounds the provision of care, from the infrastructure and technology in place, to support teams and carers, procedures and data workflows, the emotions and experience of all involved [15].

Design Thinking workshops are well known across various sectors, from education to business and to healthcare. Design has a potential to envision alternative futures for health care through new forms of innovation [16]. A design approach based on a holistic understanding of problems constitutes a prerequisite for innovations in complex contexts where problems are open, complex, dynamic, networked, and have a wicked character [17]. Design Thinking workshops provide a human-centered framework for problem solving and foster exploring needs and ideas for a particular group of users [18]. The term Design Thinking (DT) is commonly used when discussing design from a process or innovation perspective and is increasingly being adopted as an approach to innovation. The UK Design Council refers to DT as a way to "get to the heart of the problem quickly and suggest radical, innovative solutions" [17].

3 The Opportunity: Observations in Design Thinking Processes

Co-design techniques employed in healthcare contexts adopt known IDEO or Stanford school Design Thinking strategies. There are no strategies that employ observations as input for those Design Thinking strategies in co-design workshops. The CSDS team wanted to explore whether observations would be a useful input in their Design Thinking strategy toolbox.

Amongst many other problems, the COVID-19 pandemic has disrupted the practices of healthcare, administration processes, regulations, and supply chains of medical products, equipment and instruments, requiring increasingly agile ways of working and innovation in the delivery of services. When looking at areas such as enhancements to service delivery, CSDS run a number of workshops to facilitate problem identification, problem solving, and training. The CSDS team at MNHHS is dedicated to healthcare improvement through training of procedures and simulation of new techniques, collaboration across departments of QLD Health, and supporting innovative solutions to emerging problems. The facilitation of Design Thinking workshops fulfils a key goal of creating an environment for key stakeholders to connect and approach problems differently. CSDS calls it the *Ideate Collaborate Innovate* approach.

Traditionally, CSDS has followed a co-design strategy similar to the ones run by IDEO U, a North American-based design consultancy that is delivering commercial Design Thinking courses online through their IDEO U brand. CSDS found this strategy inspiring but limited to a set type of problems they can address in healthcare innovation. One of the limitations they found is in the inability to include field observations as part of the components of their current ideation sessions. Elaborating on observed problems would broaden their opportunities to develop new strategies for their design workshops to enhance the shared learning experience of participants, and the *Ideate Collaborate Innovate* approach.

The collaboration between CSDS and QUT Design Lab aimed at broadening the horizons of CSDS' innovation services and to uncover their next steps as facilitators of these workshops for QLD Health. Building on a shared understanding that healthcare practices are evolving at fast pace due to new technologies, affecting interactions and processes, the combined team agreed to develop a capacity-building session to include field observations as part of CSDS' Design Thinking strategy. The underpinning theoretical approach comprised a socio-technical lens focus on people's interactions with other people, infrastructure, services and objects, in addition to a Human Centred Design approach, all integrated within the steps of the Design Thinking workshop strategy. The goal of the proposed workshop strategy was to explore whether this approach could help participants understand how to identify people-activity-context aspects from an observed problem, and how to work with those insights to identify potential solution paths, for quality improvement and innovation.

4 The Project: Including Observations as an Activity in a Design Thinking Workshop

CSDS has been supporting clinical improvement for several years and incorporating Design Thinking into healthcare. Using techniques from simulation-based education debriefing [19, 20], Design Thinking [17] and improvement science [21, 22], the facilitators at CSDS deliver workshops to support Queensland Health. These techniques were already part of the CSDS innovation and improvement strategy.

In Design we employ Human Centred Design (HCD) to work with observations as data. In this approach, by breaking down an observation into people-activity-context [23, 24] components, designers and researchers gain insights about what triggers problem areas and what prompts solutions. The People-Activity-Context (PAC) approach provides a suitable strategy for a Design Thinking workshop in a healthcare setting, as it can factor in the range of complexities and their interactions among one another. This project was used to pilot the strategy at a session with the CSDS team as participants. It consisted of one 3-h Design Thinking workshop, where we delivered our method for working with observations. At completion of the workshop, the CSDS participants were invited to comment about the usefulness of this strategy by completing a five-question questionnaire. Their responses were analysed to gain insights as to the how this approach extended (or not) their Design Thinking toolkit for healthcare innovation.

5 Participants and Recruitment

Fourteen participants took part in the workshop, each selected from the CSDS staffing pool. They had a wide a wide range of professional backgrounds all within healthcare. Participant recruitment was organised by CSDS. Selected staff were emailed Participant Information and Participant Consent forms (QUT Ethics Approval 107031), prior to initiating any activity. Once signed consent forms were received by QUT researchers, the research commenced.

6 Workshop Procedure

The Design Thinking workshop procedure comprised three stages: Stage 1: Preparation of a video prior to the workshop, Stage 2: Conduct of the Design Thinking workshop, and Stage 3: Debrief session post-workshop. Each stage comprised additional steps, which are detailed in the following sections.

6.1 Stage 1: Preparation of a Video Prior to the Workshop

Two weeks prior to the workshop, participants from CSDS were provided instructions to record short videos that communicated a problem relevant to the healthcare setting. The videos would be used to apply the PAC based observation method during the workshop. The instructions explained that each video should consider the following topic suggestions:

- A technical interaction (e.g., people using a CSDS technology)
- A process issue (e.g., a workflow that needs improvement)
- A space problem (e.g., use of multipurpose spaces)
- A protocol issue (e.g., people's comments of how they experience the said problem).

To identify issues for the videos, a problem identification session was delivered internally within CSDS. The session used the 5 whys tool [25] to identify and clarify potential problem topics. The group identified four problem statements. In discussion with the QUT Design Lab team, the four problems were further reduced to one that focused on the CSDS course development process. The agreed problem statement was chosen because it touched on several aspects of the service and lent itself to an observational activity.

Once the problem statement had been identified, each participant produced a 1-to-2-min video with their personal perspective of the problem. All videos were uploaded to Padlet (Fig. 1), an online collaboration platform, for them to share with the QUT group before and during the workshop.

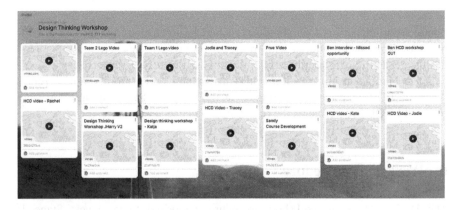

Fig. 1 Padlet board shared with CSDS team

6.2 Stage 2: Conduct of the Design Thinking Workshop

The Design Thinking session was conducted at the Innovation Hub of the CSDS building, which is equipped with interactive screens and digital post it notes that allow people to work and annotate from their phones and send directly to the room's screens. The duration of the workshop was 3 h and comprised two distinctive parts: Part 1 Problem Exploration, and Part 2 Future Focus.

6.2.1 Part 1: Problem Exploration

Participants were grouped into teams of four. An icebreaker activity was conducted, in which a short sample video with an example of a problem that might occur in a healthcare context was shown. The QUT group used this example to walk CSDS participants through the approach for analysing a video using PAC. In addition, the icebreaker activity ensured participants were able to engage with the session material and technology.

Following the icebreaker, Problem Exploration using the participant-recorded videos began. The first stage was a 40-min User Centred observation and Team Brainstorming of the problem by watching other participants' videos. The intention was to broaden the participants' perspectives of the problem by understanding it from different points of view. In their teams, participants discussed each of the videos and annotated their ideas and comments on digital post it notes. Annotations focused on both positive (gains) and negative (pains) events and situations observed (Fig. 2).

The second stage was a 10-min PAC Analysis and Visual Clustering. PAC stands for People-Activity-Context, and it is an analysis strategy employed in Design. The application of this strategy to the video-recorded observations allowed us to break down the observations recorded as annotations into workable categories for discussion and analysis. Each team discussed their annotations and categorised them as either People related, Activity related, or Context related. Where an annotation belonged to multiple categories, the annotation was duplicated and moved to each respective category (Fig. 2).

The final stage of Part 1 was a 15-min team discussion and idea generation of what aspect of the problem to work with, and what possible solutions there might be. The intention of this discussion was to develop some initial thinking about potential avenues to explore in Part 2 of the workshop. At the end of Part 1, participants had either annotated in digital post-it notes on the room screens or had employed paper and markers and pinned this up on the room walls. Each team's work was visible for all participants to view. A 30-min tea break followed.

Fig. 2 Problem
exploration at the digital
screens of the CSDS
Innovation Hub (top
image), and Visual
clustering with digital
post-it-notes (bottom
image)

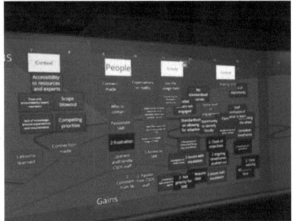

6.2.2 Part 2: Future Focus

Part 2 was dedicated to resolve in more detail the solutions that each team had proposed in Part 1. We employed the LEGO® Serious Play® methodology and ™LEGO bricks as a resource for participants to 'make' a solution. LEGO® Serious Play® is a methodology that engages non-designers in design related activities with a strong co-design focus [26]. Since 2010 it has been available as a community-based model, where Lego bricks are employed as a tool to generate innovative ideas and solutions to a predefined problem. A key component of the methodology is the open-ended play context that enables fast and adaptable activities [27]. The physical nature of Lego pieces makes it suitable for the collaborative and creative ideation stages of co-design [27, 28]. In the Future Focus session participants used Lego bricks for Design Thinking in four key stages.

The first stage was a warm-up in which participants performed a quick prototyping activity, requiring them to make a boat with 10 Lego pieces. The goal was to

Fig. 3 Interpreting ideas with LEGO blocks

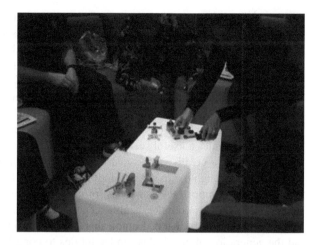

engage participants and familiarise them with the Lego process. The second stage was a 20-min individual prototyping task. Following on from the PAC analysis, the identified problem was discussed in teams, and each participant created an individual prototype as a metaphor to represent the challenge and/or solution, taking turns to share their interpretations and findings (Fig. 3). The third stage required the co-creation of an ecosystem of how their individual solutions could work together. This involved the groups physically combining the individual Lego prototypes, utilising storytelling strategies to reflect on key themes that emerged from the final combined model. They could make changes to their Lego prototypes in order for all solutions to be part of the one eco-system. This prototyping process was used as training to aid communication with diverse stakeholders, to create a shared story, and identify key insights to guide future actions and decision making.

In the final stage of Part 2, each group consolidated and pitched their solution ecosystem. This involved creation of a video reflecting on the key discoveries and insights that had emerged from the co-design process, consolidating the workshop activities and outcomes, using role playing and/or storytelling methods to synthesise the identified problems, insights and take-aways for future development. Each team pitched their idea to the room.

7 From Observations to Prototyping and Storytelling

The adapted LEGO® Serious Play® method was enhanced by the participants' qualitative discoveries through the use of observation and the PAC analysis of the videos. These preceding activities were critical to setting up the problem definition and pathways for solutions, as it enabled the participants to have a shared experience of the identified problem and collectively uncover insights that would be difficult to obtain without the use of observation. Observing the pre-recorded videos and PAC

analysis as a co-design exercise enabled a more tangible and immersive context to be explored and allowed for new insights by participants as they observed scenarios first-hand that would have been potentially difficult for them to witness and/or experience otherwise. As suggested by Allen, "observational research can highlight patterns of behaviour or idiosyncrasies that would normally be overlooked" [29, p. 24]. A key consideration is the content and quality of the pre-recorded videos to avoid generalisations or oversimplification. The participants' feedback reflected this, in identifying the importance of selecting a suitable problem or theme for the exercise, and what constitutes a useful scenario to record.

Encouraging a creative mindset for the purpose of a Design Thinking session was possible through the introduction of a range of methods typically employed by designers (observation, PAC analysis, prototyping, storytelling) that enabled participants exploring a complex health scenario to brainstorm and ideate in diverse ways. As discussed by Ku & Lupton this 'Health Design Thinking' approach can aid the generation of novel ideas and solutions to complex health problems, where observation and research informs "active making and discovery" [30, p. 34]. This experience correlates with the literature. In developing the LEGO® Serious Play® methodology, Kristiansen and Rasmussen found there was value in enabling groups "to see the entire system that they were part of. This helped them envision scenarios and be better prepared for the future. By having a complete picture of their current system—a perspective that involved team roles, relationships, and culture—and testing the system with specific scenarios, team members gained more confidence, insight, and commitment in dealing with future events" [31, p. 3] through the prototyping and co-design process.

Co-design was a critical component of the workshop design and embedded into both the Problem Exploration and Future Focus sessions. As suggested by Ku & Lupton, co-design enables the synthesis of team members' diverse and overlapping areas of knowledge within the design process [30, p. 24]. It is widely recognised that healthcare is an area undergoing rapid transformation, with shifts to more collaborative partnerships across health sectors [32, p. 186]. Employing co-design workshops with diverse stakeholders, like these run by CSDS, enables a collaborative evaluation and redesign of complex health systems that can be more representative of the diverse knowledge and skills of key stakeholders. It not only facilitates a collective understanding of the problem, but ideally an inclusive and shared vision of future solutions and pathways to action in the design and delivery of health services.

8 Lessons from the Pilot Workshop

Feedback sheets were provided to the CSDS team following the workshop to provide comments about the strategy of the overall workshop. Feedback was then later clustered into themes relative to each stage of the workshop. Overall, the CSDS

team considered it a unique method and saw the benefit of it for some types of process examination. Observations are now under consideration for use in the CSDS Design Thinking facilitation kit. Despite the generally positive reception to the approach, there were several issues and limitations identified. The clustered feedback for each stage of the workshop is summarised in the following sections.

9 Pre-activity Feedback

The following positive feedback was identified in relation to the pre-activity:

- Feedback was useful

- The feedback provided by the QUT team on unsuitable videos was found to be useful. It enabled the CSDS team to rethink their approach and ensure the video content was suitable for observation.
- Useful for developing a shared understanding

- The video creation process led to a greater and shared understanding of many of the problems experienced by participants. It was noted that the videos helped to prompt thinking about problems from others' perspectives and understanding their own conceptualisation of the problem.

Feedback for improvement of the pre-activity, which included the preparation of videos for use in the workshop, included the following:

- Video requirements and purpose were not clear

- The CSDS team had not used videos for the purpose of observations before, which presented a challenge for them to understand the objectives of the videos. Many of the initial videos created by CSDS were interviews with staff involved with various processes. The QUT team evaluated these to be unsuitable, as they did not include observable information. With further clarity of the purpose, the CSDS team were able to create suitable videos. It was suggested by CSDS staff that the instructions needed to have clearer requirements and explanation of purpose.
- Facilitator in problem identification
- It was suggested that it would be useful for a facilitator to be present during problem identification and initial planning of the videos. This would have helped clarify requirements and led to the selection of suitable problems to be filmed.
- Focus on one video
- In the interest of covering a range of potential problems, each participant was required to create an individual video. The feedback received was that it may have been beneficial to narrow down the problem and focus on one video only, potentially created in groups.
- Difficult to create and inflexibility

- Some participants found the process of creating a video difficult due to the specific format and challenges for articulating the chosen message. It was noted that video is a suitable medium for representing some issues but not all issues. A suggestion was to allow for greater format flexibility by allowing participants to select alternative formats to communicate their message, depending on what is most suitable.

10 Workshop Feedback (Part 1: Problem Exploration)

The following positive feedback was identified in association with the first stage of the workshop:

- Understanding others' perspectives

- Making sense of observations from different people's perspectives was identified to be a helpful and enjoyable approach.
- Usefulness of PAC tool
- Although there were comments identifying the difficulty of understanding the PAC tool, other participants noted that the PAC tool was a useful approach and could be easily understood. It was helpful to participants to further understand the problem from different contexts. It also encouraged ideation of solutions of aspects not considered before.
- Facilitators helped understanding

- During the workshop, each group was accompanied by a facilitator. This was found to be highly valuable when discussing the problem, and to keep the team with the scope of the workshop timing.

In the first stage of the workshop delivery, the following themes were identified in the feedback for improvement:

- Broader group discussion on videos

- Participants were organised into small groups to work through workshop activities. Participant feedback indicated that it would have been good to discuss directly with the broader group to clarify any questions about the observations.
- PAC framework needs more understanding

- The PAC framework was introduced at the start of workshop session. However, participants identified that they did not fully understand the framework and would need to spend further time to understand it.

11 Workshop Feedback (Part 2: Future Focus)

The following positive comments were received in the second stage of the workshop delivery:

- Shared understanding

- The eco-system activity was powerful to demonstrate the value of all ideas and how different perspectives could be integrated into a single workflow. The making of a model with Lego was considered as an unexpected and successful strategy that allowed for more comprehensive discussion between individuals and across teams, effectively adding conversations and the sharing of ideas.
- Useful for ideation

- The use of Lego to represent ideas demonstrated that even abstract processes can be distilled into diverse parts or problem solving and then combined to form a larger system. Participants identified that the Lego took them out of their comfort zone, pushed their creative thinking and assisted in articulating their thought process.

In the second stage of the workshop delivery, the following comments for improvement were received:

- More discussion time needed

- Participants commented on the need for more discussion on the implementation of solutions and ecosystems they created. This included suggestion of identifying components that could be practically implemented over the short and long term.
- Better clarity on purpose

- It was identified that the purpose of the Lego activity was not clear and that participants were unsure of where it was leading. More clarity around the outcome was needed, to scaffold the Lego prototyping process as a creative problem-solving activity.

12 Post-activity: Action and Implementation

In addition to comments on the pre-activity and workshop delivery, feedback was provided on next steps and any additional items. A common area of feedback was regarding the translation of workshop outcomes into actions and implementations. It was identified by QUT and CSDS that this would give participants an opportunity to reflect on outcomes as potential tangible actions that could then be explored further in follow-up sessions.

13 A Co-design Process: Rethinking the Use of Observations in Design Workshops for Healthcare Innovation

We compiled the process and issues identified in the feedback questionnaire and presented it into a MIRO board (Fig. 4), for a co-design review session with CSDS.

We organised a 1-h session to discuss the three areas identified in Fig. 1: general issues, pre-activities, and problem exploration, to also include discussion on future focus. We contextualised the discussion from the perspective of CSDS clientele, identifying who might be future participants of these type of sessions if they were to deliver it as part of their *Design Thinking for Innovation* services.

CSDS' clientele is defined as: anybody within healthcare; that includes people working in a Hospital, the Royal Brisbane Hospital (RBH) administration team—supervisors and management (not clinical background), teams coordinating outpatient administration, food service, admin, and executives coordinating teams—allied health, social workers, pharmacists, pathology staff, physio, occupational therapists, speech pathologists, podiatry, midwifery.

The CSDS team felt that this type of approach that includes video recording observations is more suitable for anyone who is involved in a physical process of healthcare services (Fig. 4). They identified the need to use observations in:

- scenarios with more physical attributes—patient journey, system testing in a particular department.
- patient flow—a systems view of how patients interact with the healthcare system.
- Emergency Departments which are looking at this, but all the way through the process is useful
- hospital avoidance process.
- exploring how we interact with patients—empathy and building disclosure.
- investigating patient-centric patient experience.

The redesign proposed a three-session workshop approach:

- **Pre-activity workshop (1–1.5 h)**

- The pre-activity workshop would facilitate the problem identification and a shared understanding of the scenario to be explored. The workshop would be run approximately 2 weeks before the second workshop. Goals and activities would be:

 - Problem identification.
 - Pain and Gains to enable an open forum for discussion.
 - Play exemplar video and observations introduction.
 - Scaffold how to approach the video and form teams to create the nominated number of videos.

- **Main workshop (2 h)**
- The main workshop is largely unchanged, with Part 1 and Part 2 remaining.
- **PART 1**

Fig. 4 Miro board employed for co-design session with CSDS team (top image), and Improvements identified throughout the co-design session (bottom image)

- The exemplar video and observation's introduction are removed (to run in the Pre-activity workshop).
- The Pains and Gains method is removed (to run in the Pre-activity workshop, this allows more time to focus on the PAC analysis).

- **PART 2**
- Part 2 remains unchanged. The takeaways from Part 2 are further expanded on in the new post-activity workshop session
- **Post-activity workshop (1–1.5 h)**

- The post-activity workshop has been added to unpack the ecosystem findings further and identify implementable solutions. The workshop should be run approximately 2 weeks after the main workshop.

 - The findings are unpacked with tools used by CSDS currently, such as the Desirability, Feasibility, Viability method.
 - Actionable tasks are able to be consolidated and allocated.
 - Other stakeholders are also able be included to aid discussion and future pathways.

- Key to this workshop is providing an ongoing transparency on how the workshop findings are being actioned.

14 Discussion

This project provided the opportunity to contribute with new knowledge in Design Thinking strategies for healthcare innovation. The project delivered: (i) a HCD Design Thinking strategy suitable to use in the context of healthcare practices and; (ii) a workshop protocol that was tested and experienced first-hand by the CSDS team tested. Our HCD Design Strategy consists of four parts: problem exploration, future focus, prototyping and storytelling. Our workshop protocol proposes three stages of implementation: Stage 1 pre-workshop, Stage 2 main workshop, Stage 3 post-workshop.

Heiss and Kolshagina [13] discuss the use of Tactile Tools for Design Thinking in healthcare contexts through five case studies. They found that such tools enable participants to map meanings onto forms or objects (e.g., diagrams) they had created as part of the Design Thinking process. In Heiss and Kolshagina's [13] study the use of shapes allowed participants to create processes, patterns, and represent roadblocks, and in doing that, the tool provided a medium to discuss complex healthcare challenges as well as interdisciplinary collaboration across clinical teams and designers.

The Co-Design session enabled us to reflect on the workshop delivery and redesign the workshop strategy to align with CSDS's training structure and client expectations. The session critically evaluated the participants' experiences of the workshop alongside the CSDS perspective. Key was the ability for CSDS to be immersed in the training, viewing it from the participants and also the trainer's role.

The project is not yet complete. CSDS believes in a train-the-trainer style 'do one, teach one' approach. Therefore, validation of this process before they introduce this approach within their practices requires another session where they deliver it to us. This learning mode would help them build confidence in the process.

Three key reflections for designers or educators working in healthcare are:

- The choice of scenario is critical to using the tools effectively. The patient journey was identified as a valuable case study and suitable for use. Look for a scenario that has a systems view of how patients interact with the health system.
- Reflect the current emphasis in Queensland Health on the Patient, and Empathy in the healthcare context.
- Be aware of your language. Rather than the term 'problem,' a better term could be 'scenario' to encapsulate and look at processes that are also working well.

References

1. Persaud DD (2019) Designing a performance measurement system for accountability, quality improvement, and innovation. Health Care Manag 38(1):82–88

2. Dixon-Woods M, Amalberti R, Goodman S, Bergman B, Glasziou P (2011) Problems and promises of innovation: why healthcare needs to rethink its love/hate relationship with the new. BMJ Qual Saf 20(Suppl 1):i47–i51
3. Donabedian A (1990) The seven pillars of quality. Arch Pathol Lab Med 114(11):1115–1118
4. Batalden PB, Davidoff F (2007) What is "quality improvement" and how can it transform healthcare? Qual Saf Health Care 16(1):2–3
5. Baily MA (2008) Quality improvement methods in health care. From birth to death and bench to clinic: the Hastings Center bioethics briefing book for journalists, policymakers, and campaigns garrison. The Hastings Center, New York
6. Vougioukalou S, Boaz A, Gager M, Locock L (2019) The contribution of ethnography to the evaluation of quality improvement in hospital settings: reflections on observing co-design in intensive care units and lung cancer pathways in the UK. Anthropol Med 26(1):18–32
7. Buse C, Martin D, Nettleton S (2018) Materialities of care: encountering health and illness through artefacts and architecture. Wiley, Hoboken
8. Bresciani S (2019) Visual design thinking: a collaborative dimensions framework to profile visualisations. Des Stud 63:92–124
9. Crilly N, Moultrie J, Clarkson PJ (2004) Seeing things: consumer response to the visual domain in product design. Des Stud 25(6):547–577
10. Paroutis S, Franco LA, Papadopoulos T (2015) Visual interactions with strategy tools: producing strategic knowledge in workshops. Br J Manag 26:S48–S66
11. Dalsgaard P (2017) Instruments of inquiry: understanding the nature and role of tools in design. Int J Des 11(1):21–33
12. Hansen NB, Dalsgaard P (eds) (2012) The productive role of material design artefacts in participatory design events. In: Proceedings of the 7th nordic conference on human-computer interaction: making sense through design
13. Heiss L, Kokshagina O (2021) Tactile co-design tools for complex interdisciplinary problem exploration in healthcare settings. Des Stud 75:101030
14. Inie N, Dalsgaard P (2020) How interaction designers use tools to manage ideas. ACM Trans Comput Hum Interact 27(2):1–26
15. Sanders EB-N, Stappers PJ (2008) Co-creation and the new landscapes of design. CoDesign 4(1):5–18
16. Valentine L, Kroll T, Bruce F, Lim C, Mountain R (2017) Design thinking for social innovation in health care. Des J 20(6):755–774
17. Thies A (2015) On the value of design thinking for innovation in complex contexts: a case from healthcare. IxD&A 27:159–171
18. Ward ME, De Brún A, Beirne D, Conway C, Cunningham U, English A et al (2018) Using co-design to develop a collective leadership intervention for healthcare teams to improve safety culture. Int J Environ Res Public Health 15(6):1182
19. Bauchat JR, Seropian M (2020) Essentials of debriefing in simulation-based education. In: Mahoney B, Minehart R, Pian-Smith M (eds) Comprehensive healthcare simulation: anesthesiology. Springer, Cham, pp 37–46
20. Rudolph JW, Simon R, Dufresne RL, Raemer DB (2006) There's no such thing as "nonjudgmental" debriefing: a theory and method for debriefing with good judgment. Simul Healthc 1(1):49–55
21. Kitson A, Harvey G, McCormack B (1998) Enabling the implementation of evidence based practice: a conceptual framework. BMJ Qual Saf 7(3):149–158
22. Lemire S, Christie CA, Inkelas M (2017) The methods and tools of improvement science. N Dir Eval 2017(153):23–33
23. Benyon D, Turner P, Turner S (2005) Designing interactive systems: people, activities, contexts, technologies. Pearson Education, Harlow
24. Benyon D (2014) Designing interactive systems: a comprehensive guide to HCI, UX and Interaction Design. Pearson Education, Harlow

25. Serrat O, Serrat O (2017) The five whys technique. In: Knowledge solutions: tools, methods, and approaches to drive organizational performance. Springer, Singapore, pp 307–310
26. LEGO Group (2022) LEGO serious play. https://www.lego.com/en-us/seriousplay
27. Denio D, Reuther D (2016) Build to lead. O'Reilly Media, Sebastopol
28. Peters D, Loke L, Ahmadpour N (2021) Toolkits, cards and games–a review of analogue tools for collaborative ideation. CoDesign 17(4):410–434
29. Allen T (2019) Solving critical design problems: theory and practice. Routledge, London
30. Ku B, Lupton E (2020) Health design thinking: creating products and services for better health. MIT Press, Cambridge, MA
31. Kristiansen P, Rasmussen R (2014) Building a better business using the Lego serious play method. Wiley, Hoboken
32. Jeffs L, Merkley J, Sinno M, Thomson N, Peladeau N, Richardson S (2019) Engaging stakeholders to co-design an academic practice strategic plan in an integrated health system: the key roles of the nurse executive and planning team. Nurs Adm Q 43(2):186–192

Professor Marianella Chamorro-Koc investigates Industrial Design research that explores people's interactions and engagement with technologies as part of the emerging technological shift to person-centred digital solutions. Her transdisciplinary applied research is demonstrated in proof-of-concept prototypes of health-tech devices for people's self-management of their health, advancing self-health technology innovations and championing viable local manufacturing transformation.

Dr Levi Swann , QUT School of Design, and the QUT Design Lab, applies design-led approaches to explore the complex interactions among humans, technology, and their environments. He has worked across several industries including agriculture, aviation, health, and business. His work has led to innovative strategies and deployable interventions within these industries, as evidenced by over 15 industry commissioned reports.

Dr Natalie Haskell , now at Griffith University, research focuses on advanced manufacturing workflows and industries being disrupted by these shifts, contextualised within sustainability frameworks, and applied user-centered design research practices. Her research projects include working with local SMEs to explore the opportunities of advanced manufacturing with a focus on additive manufacturing, industrial design workflows and design for health.

James Dwyer is a QUT Industrial Design graduate and is currently exploring advances in human-robot interactions in his Master of Philosophy. With a background in electronics, coding and sensor technologies, he now looks to apply what he has learned from these experiences to interactive health technologies.

Luke Wainwright is a highly experienced critical care nurse who has specialised in simulation-based education, training, and healthcare facility design for over a decade. Currently employed as the Assistant Nursing Director for Simulation and Education at the Clinical Skills Development Service, Metro North Health, and as an Adjunct Lecturer at the University of Queensland.

Jodie Hosking is a highly skilled administration professional, spending the last thirteen years leading high-performing multi-disciplinary teams and driving strategic re-alignment. Currently employed as the Business Services Manager at the Gold Coast Waterways Authority, and holding qualifications across project management, leadership, management and business.

Part VI
Practitioners

This concluding section captures voices from inside the healthcare system, both the consumer and clinician turned public servant/policymaker. Their perspective provides invaluable lived experience into the challenges, successes, and opportunities for change within the healthcare system, and the unique value of a design lens. We see this in Fig. 1, which highlights the importance of the collaboration between designers and health care experts in order to provide the best possible service to consumers.

Throughout this book, we have argued that healthcare transformation can be supported through a design-led approach to innovation: a human-centered, inclusive, future-orientated and system-wide lens which questions, deeply reflects on, and re-examine everything that is currently taken for granted. Professional designers, as Don Norman [1] has recently noted, have the capacity and ability to serve as "enablers, facilitators, and resources, aiding community members to meet their concerns" (p. 183). The stories throughout this book have illustrated how designers, in partnership with consumers and clinicians, are transforming healthcare, and so it is appropriate that these final chapters highlight the unique user perspective.

Fig. 1 Do you have a
designer on call? (Credit:
Simon Kneebone)

Reference

1. Norman DA (2023) Design for a better world: meaningful, sustainable, humanity centered.
 MIT Press, Cambridge, MA

NICU Mum to PICU Researcher: A Reflection on Place, People, and the Power of Shared Experience

Leighann Ness Wilson

1 A Familiar Face

I recognised her immediately. You don't forget those people. Not from those times. My heart began to hammer as I made the decision to speak up and share my story with the room.

My name is Leighann Ness Wilson, and 10 years ago, at my 30-week obstetric check-up, I was put into an ambulance and taken to the Royal Women's Hospital where I gave birth, prematurely, to a baby girl. Rose was born weighing 1070 g (or 2 pound 6 ounces in the old measure). After she was born via emergency caesarean she was immediately whisked away by a team of awaiting medical staff and admitted to the Neonatal Intensive Care Unit (NICU). From that moment I was the mother of an infant in intensive care, a role which required me to immediately navigate the terminology, environment, equipment, and rules associated with this completely unique experience of parenting.

Fast forward 9 years and I found myself sitting in an initial project meeting for the PICU Partnership Project, one of eight key projects within the Health Excellence AcceLerator (HEAL) initiative. HEAL, a collaboration between the QUT Design Lab and Clinical Excellence Queensland, brought design-led researchers into healthcare settings across a variety of projects. The PICU Partnership Project, led by Dr. Natalie Wright, comprised a small team of QUT researchers, including Dr. Anastasia Tyurina, Dr. Judy Matthews, Dr. Sarah Johnson, and myself, with specialities across design thinking, interior architecture, and visual communication design. Alongside staff and families in the Paediatric Intensive Care Unit (PICU) of the Queensland Children's Hospital (QCH) in South Brisbane, we worked to imagine a more supportive environment for families of children in intensive care.

L. Ness Wilson (✉)
QUT, Brisbane, QLD, Australia
e-mail: lm.murray@hdr.qut.edu.au

Of the large number of people in that initial meeting, I found myself sitting right next to paediatric physiotherapist, Ali Ferguson. Towards the end of the meeting, I decided I would share my story. I spoke up, telling Ali, and the group, that I remembered her caring for Rose at the Royal Women's Hospital Neonatal Intensive Care Unit (NICU), some 9 years earlier. From that point, and throughout the entire project, I sensed the clinical staff looked to me not just as a researcher or designer, but as an ally. They said as much: "You're one of us", on the first tour of the ward that same day. I knew their world, and thus was afforded a level of inclusion, hard-earned by the most challenging experience of my life.

2 Immersion

Early in the project it was established that our focus would be the experience of the families with children in paediatric intensive care. This focus aligned with the ideals of PICU Liberation, already established by a devoted team within PICU at the QCH. PICU Liberation advocates for early mobilisation and builds frameworks that encourage families to become more involved in their child's care [1]. With a background in interior design, research, and education, I was able to apply my skills immediately.

I began what we called the immersion phase. I visited the ward on a weekly basis and was welcomed by Jane Harnischfeger, who found me a desk and was generous and gracious with her time. Jane arranged for me to meet with staff and families, visit special areas within the hospital, and was open and appreciative of our design methodologies throughout the process. I began with a spatial audit, documenting current conditions, taking photographs and measurements, and making notes about the layout, aesthetics, and function of the parent facilities in PICU. I approached my weekly visits to PICU with the upmost respect, knowing first-hand the nature of the environment I was in. An intensive care ward has a very specific dynamic, a paediatric intensive care ward even more so. Staff are highly skilled and professional, yet warm and empathetic; children are intensely unwell but are still children, and their parents are going through a uniquely complex, personal experience that can never be fully explained or understood. Knowing this, I worked quietly and discreetly. I embraced my subjectivity as a virtue, realising that I was an 'insider researcher', able to share experiences with the people I was there to study [2, 3]. As the weeks of observations and note-taking went on, I developed a growing sense of the design problems. I helped establish a sense of trust between members of the greater project team, and it was this trust and those relationships that enabled us to see the initial design opportunities within the project.

3 Family Focussed

The PICU Partnership Project was focused on the experiences of families visiting their child; the facilities, the spaces, the aesthetics, and the wayfinding and visual communication. Recognising and embracing the whole family while caring for the child or infant is known in the academic literature as family-centred care (FCC) [4], and is discussed in more detail in the chapter "'It Takes a Village': The Power of Conceptual Framing in the Participatory Redesign of Family-Centred Care in a Paediatric Intensive Care Unit."

I was very conscious about the way we spoke about the project, to all involved, but especially to the families. FCC is centred on the notion of partnerships, where values and information are shared [5], care is negotiated [6], and the competence and skills of both clinical staff and family members are acknowledged and utilised [7]. PICU Liberation is a standard of care. This was so much more than 'an interesting project' for the staff and families involved. In such an intensely personal, traumatic environment, it was vital that families were made aware that our research was not about the standard of care their child was receiving, but about the spaces, facilities, and environment that supported them as they visited the ward. Consistent with a recent study conducted with families in a Californian NICU, families are often reluctant to criticise practices or individuals caring for their child due to concerns this criticism would affect the level of care their child would receive [8]. Reflecting on my own experience as a NICU mum, I remember trying to be extra friendly to all our NICU nurses because I hoped when I left my baby with them overnight they'd look after her even more carefully. With this understanding, and the focus on the experience of families made clear, we began to plan how we would collect our data.

4 Meeting the PICU Families

I conducted a number of interviews with available PICU families throughout the project. I approached each interview, most of which occurred spontaneously, by relying on my intuition as a researcher and my emotional connection to the project focus. The time spent in PICU to understand the environment in the immersion phase meant that my interview style could be conversational and relaxed without use of notes or prompts [9]. I used the shared experience and depth of understanding from my own experiences with Rose to establish an emotional connection, which I then used to interpret each individual interview I conducted [10, 11].

The first parent interview occurred when I sat myself in the PICU parent lounge, in the corner of the Riverside section of the ward. Scott came in to make a cup of tea and I said hello. It was clear he wanted to chat, his baby daughter asleep and his wife busy expressing her breast milk. Scott and I spoke for a while and easily built rapport, after I briefly shared my own experience as a pre-term parent. I got Scott's consent to audio-record our discussion in which he spoke mostly about the lack of

toilet facility in the ward for parents, something that became a key talking point over the course of the project for other families too. Because there isn't a parent bathroom on the ward, family members visiting their children in intensive care must exit the ward entirely to use the toilet. They must then buzz the nurse in their child's room from outside the large, secure entry doors to be allowed back into the ward. In Jane's speech to the HEAL Symposium she asked the question, "What message are we sending families if we're not meeting their fundamental, basic human needs? How can families advocate for true partnership and decision-making rights when we don't even provide them with an accessible toilet?!"

5 Strategy Design

As my weekly visits progressed, we began to discuss methods for engaging with families. Dr. Sarah Johnstone and I met in a QUT studio, and used design thinking strategies to brainstorm engagement methods. We discussed ideas and collated our thoughts with post-it's, cutting out images and hand-written notes, and moving these around to create visual representations of the methods we wanted to pursue (Fig. 1a). All engagement strategies were linked to design-based theories, including appreciative inquiry (AI) [4, 12, 13], photo-voice [14], and scenario building [15]. We presented to others in our QUT research team and decided on a three-tiered approach of static interactive posters (for families and staff), a parent pack, and a co-design workshop. As data collection methods, these were to be combined with the overall understanding gathered from the regular site visits, observations, and family interviews.

Implementation of the engagement strategies began in earnest in March 2021, with Visual Interaction Designer and lead on the WIL engagement project, Dr. Anastasia Tyurina, developing visuals for interactive posters that were positioned in the staff room, balcony, and corridors (Fig. 1c). The displays included a range of prompted questions such as 'I wish we had....', based on the *dream* phase of the AI process [4]. The visual approach and inclusion of WIL students is discussed further in the chapter "Bringing the University to the Hospital: QUT Design Internships at the Queensland Children's' Hospital Paediatric Intensive Care Unit (PICU)."

The parent pack (Fig. 1b) consisted of a series of prompted sheets to gather parent response at a time that suited them. They were delivered in brown paper bags around the ward, with the idea being parents could return completed forms to staff. On reflection, this did not yield the amount of engagement we were hoping for, but we now have a digital version that was developed by our WIL students that could be trialled in similar projects in the future.

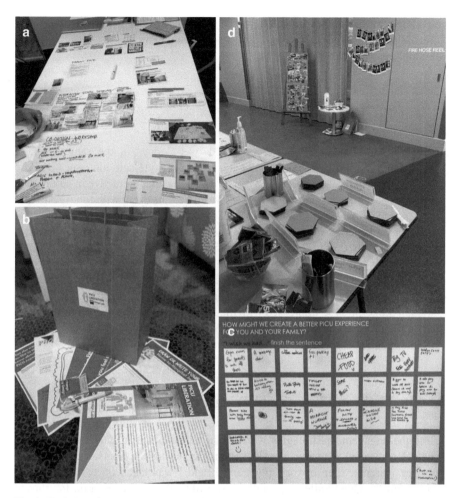

Fig. 1 Brainstorming engagement methods (**a**), the parent pack (**b**), interactive display on PICU balcony (**c**), and the PICU marketplace (**d**)

6 Rethinking Co-design

As we came closer to the date set aside for our co-design workshop, it became clear that this was not the right approach. It was not just the numerous Covid-related lockdowns that effected this aspect of our planning, it was the nature of an intensive care environment. The clinical staff and families of PICU were simply unable to commit to a specific time on a specific day. Motions to cancel this engagement strategy entirely were made, but I was determined, believing we needed something else. I suggested we utilise similar engagement activities but deliver them in a drop-in fashion, in a much more responsive approach that

considered the nature of an intensive care ward. The team agreed, the PICU Director loved the idea, and my brand new engagement strategy, the PICU Marketplace was born.

7 The PICU Marketplace

The PICU Marketplace (Fig. 1d) was held over 2 days in the same week (a Wednesday and a Friday) and comprised six drop-in style activities, set up in the central corridor. The activities were visually engaging and interactive in nature, and none required a long commitment of time. We staffed the event with four QUT team members and a rotating group of six of Dr. Tyurina's WIL students. It was important to me that we kept our numbers low, so as not to overwhelm or discourage families from approaching us as we manned the stations. This more casual, drop-in approach was extremely effective. Essentially, staff, parents, and visiting relatives could choose to ignore and walk by, observe and not engage, engage directly, or return to engage at a time that suited them and their day in PICU. Director of PICU, Dr. Christian Stoker, was so impressed with the Marketplace as an engagement strategy that, as the project was wrapping up, he discussed plans to host future events for staff and families utilising the same engagement method.

8 Site Visits and Emotional Triggers

While the engagement strategies were taking place and that data was being collected, I continued with my weekly site-visits. During the visits, I continued to interview parents when opportunities arose, and I was taken on two special site visits. I saw the Quiet Suite, a specially-designed facility in the QCH for families of deceased or dying children and babies to say goodbye, and Hummingbird House, a purpose-built facility in Chermside for paediatric patients requiring palliative care. Both experiences were formative in increasing my empathy for the design problem while appreciating the nature and specifics of the spatial and functional requirements of the family experience in PICU. They also shone a light on more opportunities we had to make improvements to the current space.

Most notably, from my perspective, was how the Hummingbird House facility maintained an element of play within the space [16]. Though attention to detail in terms of medical requirements and functionality was paramount, there was an ambiance of calm, and detailed features that facilitated a clear understanding that this space was designed for children. Colour-changing artworks controlled by patients, changeable artifacts as discussion points, playful features scaled to suit the children, and natural materials and artworks all provided inspiration for our concept to evolve.

I felt the emotional impact throughout the project, but particularly when visiting spaces like the Quiet Suite and Hummingbird House. The emotion I experienced as

a researcher is increasingly acknowledged and explored in the literature, in a number of studies that describe emotion and shared experience inform approaches to social research [17]. Personally, I found standing in the space where 56 families said farewell to their child in 2020 alone, and then a few hours later being on the side-line of my children's touch football game, an odd experience. A few close friends saw that I was affected by this, and allowed me to talk it through. I became able to acknowledge that while the opportunity to be involved in this project was an incredible gift, it was also triggering the trauma that I had experienced 9 years prior. I needed to give myself space from the project as I became more and more attached [17].

9 The Power of Shared Experience

I have no doubt in my mind that my experience as a NICU Mum informed my delivery of this project. In the interviews especially, I could see that when I shared my experience as a NICU parent, the families really opened up to me. Beyond empathy, this shared experience played a vital role in my approach with two of my most memorable interviews, with Tiarna and Tim. I met Tiarna and her infant son when they were in PICU following a surgery and I was immediately struck, and impressed, by how involved Tiarna was in the care of her child, embodying the ideals of family-centred care. She wore her PICU Mum status with fierce pride. We spoke at length about the empowering potential of involvement in the care of your child when circumstances make you feel helpless [18]. Tiarna shared that she used to take home washing each day because she wanted to dress her own son. It wasn't until 4 months after they had arrived at PICU that she was told there was a laundry facility that parents could use. "I was lugging washing home every single day, and I'd bring back a box of washing every morning." Unsurprisingly, Tiarna has become the first parent advisor within the PICU Liberation team, and continues to share her experiences for the betterment of others.

Another pivotal parent interview conducted during this project came along unexpectedly during a Wednesday visit when Ali rang through, knowing our team were on ward. A Dad was awaiting surgery for his 4-year-old son, and they said they were happy to talk to us. The team immediately looked to me, so I took the audio recording software and my notebook to Level 9. There, I met Tony who shared his experience of using the PICU family lounge. He walked from his son's room on Hillside to the Riverside parent lounge to make a cup of tea, and told me he didn't like the feeling of walking past 'all those sick kids' along the way. As he made his way to the parent lounge, he was twice asked by staff if he was lost. Eventually he found the room and made a cup of tea in a little styrofoam cup. In his own words "I went there once, never again". One cup of tea. We chatted easily, and when I told him briefly about Rose, our connection grew. The value of his voice enabled others to consider the complexity of the family experience in PICU [19].

Both Tony and Tiarna spoke to me about the importance of making connections with other families. Tiarna found comfort in talking to other parents who were going

through similar experiences. She told me about an idea she'd had to provide a way for parents to leave messages for each other in little mailboxes that she called the PICU Parent Connection. "Like even something as simple as 'you've got this'." Tony told me he felt especially inclined to connect with other Dads.

10 Staff Input and the HEAL Symposium

Towards the end of our engagement process we found that staff members also began to share and confide in us, perhaps testament to our research group's ability to actively listen, and spend time in the environment. Particularly vital to this was the Appreciative Inquiry model which ensured we incorporated all the many compliments and gratitude expressed by families in our discussions. The project aims were always clearly focussed on the experiences of the families and not about the standard of medical care and expertise within PICU, which are second to none.

Themes of connection and support were becoming apparent alongside the functional spatial requirements like a bathroom, laundry, and expressing room. Grief became another reoccurring theme, and as a project team at one of our PICU Market Stall days we witnessed two families coming and going through the main entry corridor on the worst of all the bad days. "We train families to grieve like Ninjas." Seven words with a huge impact. I heard these words from a staff member who wishes to remain anonymous, during a discussion at the Photo Talk station. When we shared this comment at the HEAL symposium, an event where we shared insights from the HEAL projects to over 300 attendees, I struggled to contain my emotion. As I spoke about how the PICU Partnership Project was using design thinking to make a difference, I could tell that others saw it too. This was a project that could make a significant impact through design-led research. The imperative that something had to change with this environment was clear. Doctors hiding in the expressing room to cry, families having little escape from the distinctive and full sensory aesthetic that is Intensive Care, children having nowhere inviting to play while they visit their siblings, and parents leaving the ward to use the bathroom and then becoming anxious, fearing they are disturbing their child's nurse when they press the buzzer to return.

11 Concept Design

After wrapping up the research component of the project, Dr. Anastasia Tyurina and I worked hard to summarise our findings and present our outcomes with a design proposal delivered back to PICU. With the support of the Liberation team, we were guided to include explicit links to the Strategic Vision of the Hospital [20], including the vision and purpose of the QCH, 2020–2024 and the National Safety and Quality Health Service (NSQHS) Standards [21], specifically *Partnering with Consumers and Comprehensive Care.*

In early September 2021, some 8 months after that initial meeting, we presented our findings. In one comprehensive presentation we told the story of the project. We began with a summary of the project, pointed to the standards and strategic plan, and clearly described the ward using visuals and colour-coded floor plans denoting different types of spaces used by PICU families. We then described our engagement approach, consisting of the static visual displays, the parent pack, and the PICU Marketplace, alongside interview techniques and site visits. The collected data was visually summarised by Dr. Anastasia Tyurina in an extension to the project with her WIL students, and we used thematic analysis [22] to colour code key words from interview transcripts and notes.

I then presented our design solution, starting with the overall concept of activating the central parent entry corridor as a parent-space. The design was presented using a model of: problem summary with photographs of current spaces, original interview data highlighted with key words (specific to that problem), and then the concept name, spatial goals, floor plans (including options), and finishing with concept images, summary of design concept, and key words. Aligning each of the 'problems' with the original interview data (quotes taken directly from the interviews) proved a powerful technique. This is what clinicians call the 'consumer voice', and presenting this as a key informer of our design concept was impactful, often emotionally triggering, and gave each issue the required gravitas. Essentially, we turned problems into opportunities, and the concept was especially well received due to our clear, unambiguous, and positive approach.

12 Presenting the Concept

In the first instance we developed solutions that responded to the need for quiet spaces for the families of PICU. Reflective spaces where parents can retreat, take a phone call, meet with clinical staff or social workers, and find reprieve. Currently, PICU has two interview rooms, but these are controlled, bookable spaces and quite underwhelming in terms of furnishings and aesthetic. Our concept aimed to rebrand and rethink the interview room approach, and provide spaces that hold parent needs in terms of meeting, grief, and reflection. Spatial options were presented in terms of location, with natural light being a priority. Key words of *talk*, *retreat*, *grieve*, and *meet* were presented alongside visual concepts that had a purposefully different feel from the patient rooms in terms of lighting, ceiling treatments, and furnishings.

The second focus included the main talking point of the entire project; the parent toilet. The current process of parents needing to leave the ward and be buzzed back in by their child's bed-side nurse was addressed, as were other spaces that provided feelings of comfort and empowerment, namely the nursing mothers' expressing room and the family laundry (currently found in a storeroom). Empowerment and family-centred care were key here, with two layout options proposed for consideration due to the impact/reshuffle of other facilities and storage. In one option we not only included a toilet for families on the ward, but a shower and vanity as well. These spaces were presented using simple but elegant finishes and panelled storage alongside the key words of *renew*, *wash*, *cleanse,* and *near*.

Our final focus was to address the failings of the current position of the 'family lounge' in one corner of the 'Riverside' section of the ward. I interviewed countless families who were affected by this positioning. 'Hillside' families who didn't want to walk past all the rooms and sick children to get there. Some didn't even know there was a family lounge, and 'Riverside' families were surprised to learn that there was no family lounge over on the other side of the ward. In addition to the crucial repositioning of this facility to a more central, visible location, we created opportunities for incidental social connection, community, and support across PICU families. The interview data was plentiful regarding the need for connection with other families, and while this connection may not be sought formally or with any regularity, it was still important. From an interior design perspective, I could see that incidental connections could be supported spatially, and set out to do so. Our design proposal provided a centralised and larger kitchenette, family lounge spaces, sibling play space, a range of seating options, and display space for PICU to generate a deeper sense of community and connection to the families. Three different layouts were proposed, each incorporating toilet and quiet spaces with key words of *family*, *re-fuel*, *support*, and *welcome*. In terms of interior design concepts, timber panelling reminiscent of neighbourhood fences were proposed to offer warmth and a variety of privacy levels to the various spaces, attention to detail within shelving and artifacts allowing a sense of playfulness to emerge, and brightly coloured flooring to denote spaces was offered.

13 PICU Response and Another Project

The initial presentation was so well received that Dr. Tyurina and I were invited back two more times to present to other stakeholders. By that stage, we were essentially telling the story of the PICU Partnership Project. We described the processes that made our project unique and used consumer voice and data to promote design improvements in PICU. The overarching message became quite simple: families of a child in intensive care need to feel comfortable when they visit their child. They need spaces to grieve and retreat, and they need to feel connected to the staff, the ward itself, and the other families going through that uniquely challenging situation. The PICU staff and QCH are continuing to work through internal considerations to develop our vision into reality.

With excellent foresight, Dr. Anastasia Tyurina co-organised a second WIL project, consisting of Interior and Interactive Design students to create a virtual reality model of the space. I was invited into this project to mentor the Interior Design students as they worked to create a 3D model and develop concept boards for preliminary designs created for PICU. With the 3D model then created, the two Interactive Design students enabled the model to be viewed using virtual reality. In mid-November 2022, we returned to PICU with another iteration of the Marketplace. We displayed the concept boards and set up screens and space for staff and family members to experience a 3D visualisation of the central corridor space using a virtual reality headset. Whilst in the VR space,

one of our students provided commentary for the user, to explain what they were seeing. As a team, we developed a series of questions to gather feedback on the design itself, as well as the experience of being inside the VR model. In total, we gathered data from over a dozen clinicians and two family members during the course of the day.

14 Feeling Proud

Looking back at that initial meeting, and considering all that was achieved, I feel immensely proud. Towards the end of the project, Jane would introduce me as 'Leighann, our designer from QUT, who is also a NICU Mum'. I felt honoured to share the stories of the PICU parents I connected with, and use their voices to amplify the need for our design vision. Based on the feedback we had to each of our final presentations, I knew our work had made a difference. Making genuine connections with the PICU families using shared experiences, and then using that to inform my design process, was something quite unique to this HEAL project. As part of our design methodology, we used immersion, observation, interviews, and a myriad of engagement strategies that had the families of PICU at the heart of every step. In the act of applying design thinking and research strategies in a healthcare setting, I know that my lived experience was significant, and therefore, I would like to dedicate this chapter to my daughter Rose, for whom I am forever grateful (Fig. 2).

Fig. 2 Rose and me, a proud prem mum

15 The Legacy

The HEAL Partnership Project would not be possible without the input from every single parent we spoke to. At the end of our first concept presentation, Ali, Rose's physio who I'd recognised at that very first meeting, took me aside. She told me that Tony's young son had passed away, his condition being 'incompatible with life'. Having made such a special connection with his father, and sharing their story at the HEAL Symposium, I felt the loss keenly. I sobbed into Ali's shoulder. 'This is part of his legacy' she said as she comforted me, and I completely agree. Rest in peace little man.

References

1. Walz A, Canter MO, Betters K (2020) The ICU liberation bundle and strategies for implementation in pediatrics. Curr Pediatr Rep 8(3):69–78
2. Berger R (2015) Now I see it, now I don't: researcher's position and reflexivity in qualitative research. Qual Res 15(2):219–234
3. Braun V, Clarke V (2022) Thematic analysis: a practical guide. SAGE, London
4. Trajkovski S, Schmied V, Vickers M, Jackson D (2015) Using appreciative inquiry to bring neonatal nurses and parents together to enhance family-centred care: a collaborative workshop. J Child Health Care 19(2):239–253
5. Gallant MH, Beaulieu MC, Carnevale FA (2002) Partnership: an analysis of the concept within the nurse-client relationship. J Adv Nurs 40(2):149–157
6. Casey M (2008) Partnership—success factors of interorganizational relationships. J Nurs Manag 16(1):72–83
7. Wiggins MS (2006) The partnership care delivery model. J Nurs Adm 36(7/8):341–345
8. Sigurdson K, Profit J, Dhurjati R, Morton C, Scala M, Vernon L et al (2020) Former NICU families describe gaps in family-centered care. Qual Health Res 30(12):1861–1875
9. Boje D, Rosile GA (2020) How to use conversational storytelling interviews for your dissertation. Edward Elgar Publishing, Cheltenham
10. Munkejord K (2009) Methodological emotional reflexivity: the role of researcher emotions in grounded theory research. Asia Pac J Mark Logist 4(2):151–167
11. Sorsa MA, Kiikkala I, Åstedt-Kurki P (2015) Bracketing as a skill in conducting unstructured qualitative interviews. Nurse Res 22(4):8–12
12. Cooperrider D (1985) Appreciative inquiry in organizational life: toward an applied science of social innovation. Case Western Reserve University
13. Cooperrider DL, Fry R (2020) Appreciative inquiry in a pandemic: an improbable pairing. J Appl Behav Sci 56(3):266–271
14. Miller E (2021) Photovoice: learn about and use this participatory creative-arts method. Int J Integr Care 20(S1):200
15. Stables K (2020) Signature pedagogies for designing: a speculative framework for supporting learning and teaching in design and technology education. In: Williams PJ, Barlex D (eds) Pedagogy for technology education in secondary schools: research informed perspectives for classroom teachers. Springer International Publishing, Cham, pp 99–120
16. Hummingbird House. Who we are 2021. https://hummingbirdhouse.org.au/who-we-are/
17. Loughran T, Mannay D (2018) Emotion and the researcher: sites, subjectives, and relationships. Emerald Publishing Limited, Bingley

18. Coyne I, Cowley S (2007) Challenging the philosophy of partnership with parents: a grounded theory study. Int J Nurs Stud 44(6):893–904
19. Holloway I, Freshwater D (2007) Narrative research in nursing. Blackwell, Oxford
20. Children's Health Queensland Hospital and Health Service (2022) Strategic plan 2020–2024. https://www.childrens.health.qld.gov.au/wp-content/uploads/PDF/our-strategies/chq-strategic-plan.pdf
21. Australian Commision on Safety and Quality in Healthcare (2021) The National Safey and Quality Health Serive (NSQHS) standards. https://www.safetyandquality.gov.au/standards/nsqhs-standards
22. Braun V, Clarke V (2006) Using thematic analysis in psychology. Qual Res Psychol 3(2):77–101

Leighann Ness Wilson is an interior designer and educator who inspires future primary educators through design thinking and creativity. She also works independently as an education consultant, developing and providing workshops and learning experiences to students and teachers. Currently, Leighann is researching the impact of design thinking as a pedagogical approach on pre-service primary teachers for her Doctor of Philosophy (PhD).

Designers as a Catalyst for 'Designability': Reflecting on the Origins of HEAL and Its Vital Role in Transforming Healthcare in Queensland

Satyan Chari

Can healthcare innovate itself? Answering this question is central to making progress against the many pressing challenges that beset the sector globally. Eminent healthcare design scholar Professor Peter Jones considered this question in the very first chapter of his 2013 book 'Design for Care: Innovating Healthcare Experiences' [1]. With respect to the North American care system, Professor Jones suggests that 'innovating' itself is not something healthcare has done particularly well—one only needs to look at the how fragmented and incomprehensible some parts of the healthcare are (sometimes as a direct result of *purported* innovation activities). Through case studies and commentaries, the rest of the book builds a focused case for change (and partnerships with design disciplines) to support future transformation efforts.

The ideas, challenges and experiences described in 'Design for Care' share similarities with the case studies and reflections contained in previous chapters of this book. Together, they underscore the vast untapped opportunities for transformative change for healthcare organisations to make investments in design partnerships. As the HEAL initiative has shown, 'triads' of healthcare teams, consumers, and designers, seem to invariably succeed more frequently (and more sustainably), as discussed in chapter "'It Takes a Village': The Power of Conceptual Framing in the Participatory Redesign of Family-Centred Care in a Paediatric Intensive Care Unit" [2], than when healthcare teams and consumers choose to prosecute an innovation agenda alone. What conclusions can be drawn from this?

Ever since the seminal 2001 Institute of Medicine report 'Crossing the Quality Chasm' [3], many of the persistent problems in healthcare quality have been described in the language of gaps, omissions, shortfalls, and deficits. Within that framing, it is tempting to express the problem of innovation as a mere deficit (in design skills, access to expertise and so on). However, the experiences accrued across the many HEAL projects completed so far suggests the impacts of our design

S. Chari (✉)
HEAL, QUT Design Lab, Queensland University of Technology,
Brisbane City, QLD, Australia
e-mail: satyan.chari@health.qld.gov.au

© The Author(s) 2024
E. Miller et al. (eds.), *How Designers Are Transforming Healthcare*,
https://doi.org/10.1007/978-981-99-6811-4_21

partnerships have been more catalytic than that—*transformative* rather than *transactional.*

It has been fascinating to witness the HEAL program evolve into its present form—from its modest germinal phase in 2019, to a period of explosive and opportunistic growth during the early months of the COVID-19 pandemic, to more recent maturation of relationships between the QUT design community and local health services into streams of longer-term steady collaboration. Along the way, we have had the opportunities to observe, interpret, connect, and interpolate findings from the rich body of collaborative work compiled over the past 4 years. Unexpectedly, working with designers has taught me as much about healthcare as it has about design practice and the creative disciplines. From my vantage as the co-director of the HEAL Bridge Lab, it's been increasingly apparent to me that the role designers can play in healthcare goes far beyond the technical and creative design skills they 'add' to improvement projects. Rather, designers (through the vehicle of embedded collaborations with healthcare teams) can catalyse shifts that make healthcare more conducive, receptive, and accommodating to design interventions—in other words, designers can make healthcare more 'designable' (and, by extension, innovation-friendly). At first glance, this may seem a trivial point, however the implications for healthcare innovation practice are profound.

1 Promoting 'Designability'—The Art of Making 'Hard Systems' More Malleable

Most experienced colleagues in healthcare improvement will agree that change-making in healthcare is not for the faint of heart. Priorities are often hotly contested, consensus (if ever achieved) can be fleeting, resources are rarely enough, and even well-resourced initiatives will often see 'improvements' expelled as soon as the project concludes. Indeed, the acknowledged failings of the 'improvement science' paradigm in healthcare is a central reason for the emergence of new fields like implementation science [4], and greater interest in alternative 'complex systems' approaches [5]. Unfortunately, implementation science has little offer when 'implementable' research evidence is weak (or when practice change is driven by other factors—like consumer expectations). On the other hand, while complex systems science offers deep insights into system performance issues and the nature of change-making in complex systems, the language and methods of the field can be a little mystifying (even inaccessible) for the average clinical improvement team. Thus, in the Venn-diagram of the myriad healthcare improvement challenges today, the bulk of 'in-the-trenches' rapid service enhancement work falls in 'white space' between a traditional improvement paradigm and the emerging implementation paradigm. These are perhaps best understood as clinical innovation opportunities, and typically where HEAL projects were deployed. But unlike the familiar arc of most improvement projects, we saw entrenched issues seemingly dissolved through

collaboration with designers. Even more remarkably, design collaborations catalysed journeys for various teams that did not fall away after the 'active' phases of projects finished. Designers left 'traces' in our system in ways that continued to enable innovation and an orientation towards 'designerly' thinking as teams went on to work on adjacent problems. What is occurring here?

While traditional (mechanistic, structural) conceptualisations of healthcare cannot offer satisfying explanations as to where from or why resistance emerges, complexity theory does offer some crucial clues. First, despite apparent 'inertia', complex systems are held in states of equilibrium through dynamic and dissipative (energy expending) relationships. Therefore, 'resistance to change' under a complex systems framing is better described as an adaptive and active phenomenon where a network of interdependent (human, technological and procedural) structures can experience tension (or torsion) when a certain change is imposed on the system, which then leads to the generation of several counteractive forces to return the system to its previous state of homeostasis. Practically, this can be seen when service changes create problematic trade-offs—such as when initiatives cause clinicians to juggle new priorities in addition to old ones, or when one group of consumers suffer service disruptions to accommodate others.

Overcoming resistance in a complex-systems framing entails navigation of the dynamics that hold systems (which include people) in current patterns, and altering them (weakening of some links while strengthening others) to allow new patterns to emerge. This idea is encapsulated neatly in a quote ascribed to legendary designer, systems theorist, and scientist, Buckminster Fuller: "You never change things by fighting the existing reality. To change something, build a new model that makes the existing model obsolete." Although HEAL designers (to our knowledge) did not explicitly apply systems thinking tools in HEAL projects, they operated in ways that were nonetheless aligned.

Repeatedly, HEAL design partnerships led to new insights about presenting problems that engendered novel ways of moving forward. The VOICeD program described in the chapter "Co-creating Virtual Care for Chronic Disease" [6] is an early exemplar. The experience designer engaged to support the clinical team took the brief (which was to lead the codesign of an interdisciplinary telehealth service for chronic disease management), but expanded the conversations 'upstream'. Jess, using design methods like journey mapping and persona development, worked with the project leads to unpick various assumptions about who service users were and how they might use the planned service innovations. By expanding the envelope of possibilities early (allowing more of the platform's eventual features to be subject to consumer co-design), the designer was able to make the end-product more 'designable'. Another example of designers transforming inflexible assumptions about what was possible in a system into a more malleable form came from the PICU liberation project. In chapters "'It Takes a Village': The Power of Conceptual Framing in the Participatory Redesign of Family-Centred Care in a Paediatric Intensive Care Unit," "Bringing the University to the Hospital: QUT Design Internships at the Queensland Children's' Hospital Paediatric Intensive Care Unit (PICU)," and "NICU Mum to PICU Researcher: A Reflection on Place, People, and

the Power of Shared Experience" [2, 7, 8], the clinical project leads describe how HEAL designers took a request for support (framed around what was thought to be feasible) and transformed it into what was necessary to achieve the ultimate goal of a reimagined care experience for children under intensive care and their families. The PICU liberation partnership morphed into a many-armed demonstration project, showcasing a multitude of design touchpoints across the entire consumer experience. Crucially, the PICU clinical team has continued down a design-led pathway as they seek to address new priorities for service change. This comes long after Bridge Labs-funded support has ceased. In this instance, the team's views on what is 're-designable' in their environment of work has been permanently transformed through working with designers.

While the previous examples highlight how design partnerships can shift perspectives within the system, we saw that designers in healthcare were fundamentally changing the system itself. Another HEAL project in the paediatric setting (but not discussed in this book) involved the use of play-based 'probes' to *codesign* a codesign toolkit to work with young children (who have just received a life-long diagnosis) in an outpatient setting. The *First 100 Days* project sought to build the tools that are needed to engage young people and their families fully and meaningfully in codesigning service innovations. The ground-breaking implications of such a toolkit have been recognised beyond the borders of the project with the larger health service looking to incorporate the findings and artefacts from the work into their strategic program for service codesign. This is another example of design partnerships making the system more designable, but in this instance, giving the system bespoke tools to 'innovate itself'.

The presence of HEAL projects in some health services also led to system leaders recognising how risk aversion was getting in the way of vital innovation within these organisations. Simple inquisitive questions like 'why not?', asked by credible academic design professionals, became powerful catalysts for systemic reworking of approval pathways, and of risk management procedures, creating conditions more conducive to solving the problems at hand.

2 The Future of Healthcare Design Partnerships

The HEAL initiative is still at the very start of what needs to become a global movement to reinvent and innovate the paradigm of healthcare improvement. Individuals who gravitate to healthcare disciplines are often naturally empathetic and humanistic. This should form the ideal substrate for consumer-centric service innovation. However, healthcare systems are often configured and incentivised in frustratingly complex ways, such that the lived reality of delivering and receiving care can seem impersonal and mechanical. At the sharp end of improvement work, design partnerships can help re-humanise care but, perhaps most importantly, organisations that support design partnerships at scale might be able to re-humanise their systems making healthcare a safer and higher quality experience for all.

References

1. Jones P (2013) Design for care: innovating healthcare experience. Rosenfeld Media, Brooklyn
2. Wright N, Ness Wilson L, Tyurina A, Harnischfeger J, Johnstone S, Matthews J (2023) 'It takes a village': the power of conceptual framing in the participatory redesign of family-centred care in a paediatric intensive care unit. In: Miller E, Winter A, Chari S (eds) How designers are transforming healthcare. Springer
3. Institute of Medicine Committee on Quality of Health Care in America (2001) Crossing the quality chasm: a new health system for the 21st century. National Academies Press, Washington, DC
4. Bauer MS, Damschroder L, Hagedorn H, Smith J, Kilbourne AM (2015) An introduction to implementation science for the non-specialist. BMC Psychol 3(1):1–12
5. Braithwaite J (2018) Changing how we think about healthcare improvement. BMJ 361:k2014
6. Cheers J, Puri G, Knack B (2023) Co-creating virtual care for chronic disease. In: Miller E, Winter A, Chari S (eds) How designers are transforming healthcare. Springer
7. Tyurina A, Winter A, Ness WL (2023) Bringing the university to the hospital: QUT design internships at the Queensland Children's' Hospital Paediatric Intensive Care Unit (PICU). In: Miller E, Winter A, Chari S (eds) How designers are transforming healthcare. Springer
8. Ness Wilson L (2024) NICU mum to PICU researcher: a reflection on place, people, and the power of shared experience. In: Miller E, Winter A, Chari S (eds) How designers are transforming healthcare. Springer

Dr Satyan Chari is Co-Director of the HEAL (Healthcare Excellence AcceLerator) initiative. Satyan leads engagement within Queensland Health's Clinical Excellence Queensland (CEQ) team and the wider health system. Clinically trained in occupational therapy and with a PhD in patient safety, Satyan has cross-disciplinary expertise in human factors engineering, participatory design, complexity science, and systems innovation. He advises globally on quality innovation programs.